MARCHA TRIUNFAL

-CORO GENERAL.-

Oh, Madero! ¡Madero! clamemos
a Patria empuñando el pendón
evemos al cielo los ojos
lude rugiendo el cañón!

Gloria eterna se han conquista
Esas tropas de heróico valor
Que de México han extirpado
La ponzoña de un cruel Dictador

Posada's

BROADSHEETS

Mexican Popular Imagery 1890–1910

PATRICK FRANK

University of New Mexico Press

Albuquerque

To the memory of my grandmothers,
Evelyn Risley (1910–1993) and
Myrtle J. Frank (1898–1994)

Paperback ISBN-13: 978-0-8263-1904-3

13 12 11 10 09 2 3 4 5 6

Copyright © 1998 by Patrick Frank
FIRST EDITION

Library of Congress Cataloging in
Publication Data
Frank, Patrick, 1953–
Posada's broadsheets : Mexican popular
imagery, 1890–1910 / Patrick Frank.
 —1st ed.
p. cm.
Includes bibliographical references and
index.
ISBN 0–8263–1903–3 (cloth).
ISBN 0–8263–1904–1 (pbk.)
1. Posada, José Guadalupe, 1852–1913—
Criticism and interpretation.
2. Broadsides—Mexico.
3. Mexico—Politics and government—
1867–1910—Pictorial works.
I. Posada, José Guadalupe, 1852–1913.
II. Title.
NE546.P6F73 1998
769.92—dc21 98–5841
 CIP

CONTENTS

EL VALLE NACIONAL

¡Ay! *onde* me la iba á espantar
Lo que era ser enganchado!
Creí que todo era Jauja,
Llegar y besar al santo.

Pero *mano* ¡que esperanzas!
Yo que pensé mejorar!
Pos ha salido el remedio
Mas *pior* que la *enfermedá.*

¡Ah que bien me encampanaron
Para el Valle Nacional,
Peso diario me ofrecieron,
Y una vida como no hay.

Es cierto que me lo dán,
¡Pero que duro, manito!
Mejor estuviera en México,
Dándole recio al pulquito.

Al *prencipio* que contento!
Hasta en coche me llevaron
Y cinco pesos medieron

Se trabaja muy refuerte
Todo el dia en el tabaco;
Ya me duelen las caderas;
Me van á *golver* cigarro.

Y no poder repelar,
Ni quejarse con ninguno....
Pos hora si la pitamos;
¿Quién me manda ser tarugo?

Hora si que como dicen,
O se bebe ó se derrama!
Que no puede uno sacarse,
¿Pos qué se entiende contrata?

Mejor me hubiera enganchado
Con gancho de carnicero!
Pos estuviera más bien
Colgado como carnero!

De la patada me va
En este lugar malvado;
Pensé que era esto muy *peche*
Y en esto que quedé chato.

Mijor está uno en la *chinche*
En la cárcel de Belén
Comiendo torito en caldo

Acknowledgments

This book is credited to only one author, but many persons and institutions contributed to its creation, and it is a pleasure to take a moment to remember them now. First and most important is the Amon Carter Museum in Fort Worth and its director, Rick Stewart. The generous funding that I received from ACM for my research travel and photographic services indeed made this book possible, and Rick was always available for consultation and support. I also gratefully acknowledge the many visits I had with Ron Tyler, director of the Texas State Historical Association. As editor of the last major American book on Posada, he was very helpful with advice and technical assistance. Other persons guided me through various collections of works by Posada in the United States: in Chicago, Mark Pascale of the Prints Department of the Art Institute gave much encouragement; in Washington, Harry Katz of the Prints and Photographs Division of the Library of Congress made available works, plates, and negatives; in Honolulu, Nancy Morris, curator of the Jean Charlot Collection at the University of Hawaii Library was always kind and generous; the entire staff of the Art Department of the Harry Ransom Humanities Research Center at the University of Texas at Austin patiently endured my requests for materials and prints; in Colorado, Cathy Wright, director of the Taylor Museum for Southwestern Studies of the Colorado Springs Fine Arts Center, showed great enthusiasm for this project from the beginning, making available the considerable collection of Posada works and suggesting collaborative endeavors. Several persons in Mexico also helped to make this book possible. In Mexico City, Ricardo Pérez Escamilla generously made available to me his collection of prints and periodicals and discussed with me many aspects of Posada's life and work long into one memorable evening; Alfredo Gálvez, curator of the Museo Nacional de la Estampa, guided me through that museum's holdings and shared many ideas with me. I am grateful to the Vanegas Arroyo family, who invited me into their home to review their collection of broadsheets and to discuss details of Posada's life from their unique perspective. In Aguascalientes, José Luis Quiroz, director of the José Guadalupe Posada Museum, generously opened the vaults to me and shared his knowledge of Posada's work.

If, as Leo Tolstoy wrote, art can be "a means of union" for people, "joining them together in the same feelings," then my collaboration with all of those who helped me with this book brought that view to life for me. Tolstoy knew that such shared endeavors and experiences were "indispensable for the progress toward well-being of individuals and humanity." I hope that Posada's art, whose popular character does not obscure deeper aesthetic merits, also provides such shared experiences for readers and leads them to want to look at the works themselves.

The dimensions of most of the illustrations correspond to the size of the paper used, rather than the size of the image. A half sheet is approximately 30 x 20 cm; a full sheet 40 x 30 cm; a double sheet 60 x 40 cm.

POSADA'S BROADSHEETS

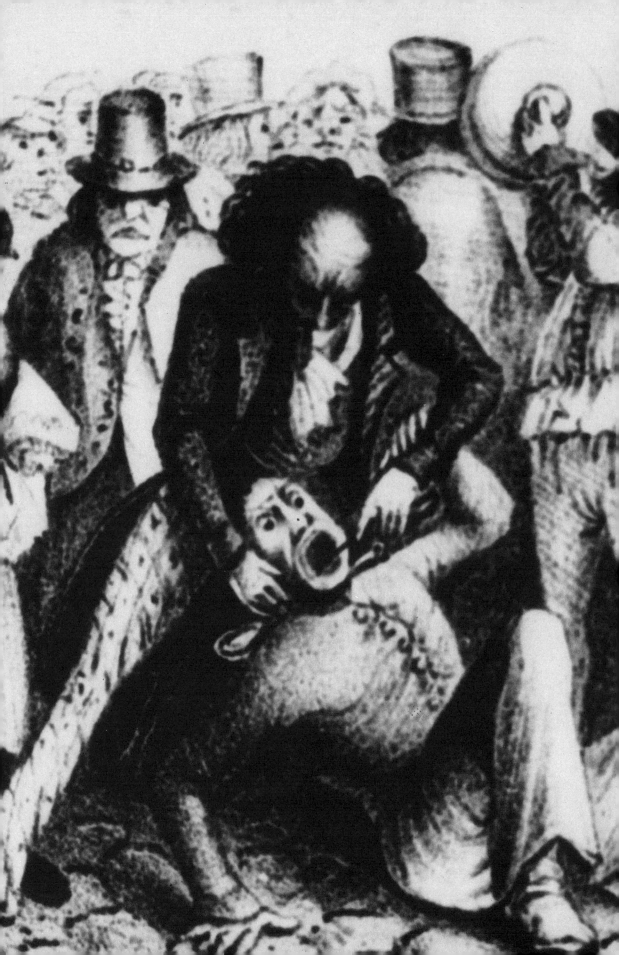

INTRODUCTION

It was indeed a solemn moment. To mark the 100th anniversary of Father Hidalgo's "Cry of Dolores," which had initiated Mexico's struggle for independence, a new monument was being dedicated along Paseo de la Reforma, the main avenue of the capital city. That afternoon of 16 September 1910, dignitaries from Congress, the Supreme Court, and the Cabinet, all the way up to General Porfirio Díaz himself, attended ceremonies at the base of the column. Most histories of Mexico dwell on the order and solemnity of these Independence Centennial events, noting that democracy was moribund at that time. Mexico was undergoing its usual ritual of re-electing General Díaz to yet another four-year term, but doubts about the legitimacy of the expected results prevailed. The leading anti-Díaz politician and the man who most believe had bested the old dictator in the voting, Francisco I. Madero, was under arrest in the northern city of San Luis Potosí, plotting the revolt against the regime that would break out that November and would eventually lead to the seven-year revolution.

But there is more to this piece of history. At the proper moment in the ceremonies, the country's poet laureate and Veracruz Congressional Deputy, Salvador Díaz Mirón, intoned a new verse for the occasion:

Hidalgo! Not from arrogance
Do I take inspiration; who for your noble deed
Owe you a hymn; in speaking I struggle
To do it with skill,
And attune my voice, which even if doubled
Hardly seems fit for such an occasion.[1]

This may not have been the first time that the poet felt his powers inadequate to a situation. Díaz Mirón, specially deputized by Congress and given an army, had spent most of the month of July searching the jungles of his native Veracruz for the gang, headed by the elusive outlaw Santanón, that had been terrorizing the European and American sugar planters in the territory. The outlaw gang consisted of mostly indigenous landless peasantry, and in pursuing them, the poet/congressman-turned-cavalryman was doing the bidding of foreign capital. That irony was lost on most of the dignitaries present, who heard the recitation continue:

There are crises in which a man
Thirsty for justice and renown
Dares to try his fate
And then challenges death itself
In sainted combat with the monster.
And today, Liberty, daughter of the strong,
Blesses a splendor which has lasted a century.

This was the same Díaz Mirón who in three months' time would write an eyewitness newspaper account of the execution of another bandit, the immensely popular urban criminal Jesús Negrete. At Negrete's trial the courthouse was packed out the door and down to the sidewalk with mostly poor people who came to see one of their own who had made fun of the authorities. The poet found himself with a unique vantage point for this final act; he too had been locked up in the dreaded jail for assaulting a fellow member of Congress, and his cell overlooked the patio where the firing squad carried out its deadly work. While no one at the independence ceremonies could have known that the poet laureate would later be charged with assault, many of them must have been aware of his past history as a duelist. Still, they apparently sat quietly while the reading concluded:

We wait tranquilly for the sun to rise
And the larks to sing of our new dispensation;
And in the sweet peace of this hour,
Save Our Lady
Of the Virgin Democracy
Who to us scowling, uneasy, and exhausted masses
Arrives in a radiant chariot.

In order to appreciate more fully the ironies inherent in such state-crafted theater, it is necessary to look beyond the official sources and view what was happening on the street. Mexico City at that time had a thriving broadside culture, dominated by the house of Antonio Vanegas Arroyo, who produced loose sheets for all kinds of events on short notice and usually accompanied by both prose and verse. Murders, suicides, natural disasters, bullfight gorings, folk

heroes: all were eagerly bought up by the capital's urban peasantry, and taken together, they form a "people's history" of life in Mexico City during the years bracketing the turn of the twentieth century. Study of these sheets and the circumstances surrounding their creation adds color and texture to more orthodox histories of events, including the stories of poets and bandits, but there is a further reason for looking closely at these ephemerae. In them we can get to know the work of the popular artist José Guadalupe Posada (1852–1913), who did most of the illustrations for the hundreds of Vanegas Arroyo broadsheets that survive.

One of the most prolific artists in history, he produced such a vast number of plates that they are in the thousands.[2] Posada's work encompassed chapbook covers, cartoons, announcements, newspaper and magazine mastheads, even cigar box lids. As in the ancient fable of the four men attempting to describe the elephant, the "Posada" that one ends up describing depends both on the phase of his work examined and the predilections of the examiner. I intend to offer here my own version of Posada, which I hope will contain its own grain of truth. It will be based on an examination of one major aspect of his work in more detail than has been attempted before, and it will be informed by my own somewhat anarchistic biases against rulers, ideological systems, and official cultures.

Posada's fame since his rediscovery by the muralists in the 1920s has far surpassed what he enjoyed in the relatively modest life that he lived. Born to a baker and his wife in Aguascalientes in 1852, he studied drawing with his brother Cirilo, a primary school teacher.[3] At the age of sixteen Posada apprenticed himself to the lithography shop of Trinidad Pedroza, and began creating satirical cartoons about local politics that were controversial enough to lead both him and his patron to seek safety from political harassment. They moved the shop to León de las Aldamas in the province of Guanajuato in 1872, where for the next sixteen years Posada produced magazine and book illustrations, cigar box designs, diplomas, party invitations, and many other types of commercial work. During these years, he married and had one son. For four years of his stay in León he taught lithography in the Escuela de Instrucción Secundaria, a vocational high school.

The most significant part of Posada's career began in 1888, when he relocated to Mexico City and set up a print shop downtown near the National Palace. His first jobs were magazine and book illustrations for the editor Ireneo Paz. Near the end of that decade he began working as an illustrator for broadsheet publisher Antonio Vanegas Arroyo, a post he filled until the end of his life. At the same time, he produced illustrations for many magazines, some of which were actively opposed to the Díaz regime. He died in early 1913, before the assassination of President Francisco I. Madero initiated the most violent phase of the revolution.

I have selected Posada's broadsheets of the Vanegas Arroyo shop for consideration because of their fame. This portion of his work has also survived in the largest numbers. Easily accessible, these broadsheets can be examined in several

large collections in museums and private homes and are the most widely exhibited, and hence the most widely known. The Vanegas Arroyo broadsheets of Posada have been the subject of several major and a great many minor exhibitions on both sides of the Mexico–United States border. It would be fair to say that Posada's reputation and esteem are based on this rather large body of work, which was created over a period of slightly more than twenty years during Posada's residence in the capital. Two areas of his output will not be covered in detail here. First, Posada's religious prints: his images of Christ, Mary, the Saints, and Apostles, while numerous, are by far the most conventional of his works. They make use of pictorial conventions that are as old as the Middle Ages and can be seen in the iconography of statues and paintings that adorn Roman Catholic churches around the world. The buying public apparently preferred conservatism in some aspects of religious imagery. A second area of Posada's broadsheet work that will be treated in somewhat less detail is the *calaveras*, the skeletal figures of persons of various social types. The antecedents and relevance of these images have been fully treated elsewhere.[4] When Posada and Vanegas Arroyo were creating these sheets, they probably did not think that art historians would be puzzling over them nearly one hundred years later. They were somewhat hastily produced, using equipment that was not on the cutting edge of technology. Posada's relief illustrations on metal plates were combined with hand-set type, and printed with black ink on coarse paper which was often colored with gaudy vegetable dyes. They ranged in size from about 15 x 10 cm to about 60 x 40 cm, and sold for a centavo or two. The Vanegas Arroyo family said that their sheets were sold all over Mexico, but their presence outside the capital is hard to detect.

The subject matter of the sheets was almost never "news" as commonly defined. The narrated events rarely pertained to the public events of civic life or to the practical needs of the readership. The vast bulk of the broadsheets would come under the heading "human interest story," according to the classic definition of Helen MacGill. The contents of the sheets were "interesting not because there is anything to be done about them; not anything that is urgent enough at any rate to require a revision of one's plans or attitudes."[5] A number of them were plainly sensational and meant to elicit moral condemnation, like the story of the woman who tortured children with burning matches, or the man who murdered his parents and ate his baby son. At times the subjects are more folkloric in nature, such as the Strong Man from Guadalajara, or the Rancher and the Buzzard. Often they deal with the popular culture of love and romance, or of the bullfight. Many sheets deal with brazen career criminals in a nonjudgmental or even heroic fashion. The guiding principle that Vanegas Arroyo seems to have followed in planning sheets was whatever he thought would sell. Between the beginnning of his employment and 1899, Posada shared the engraving duties with Manuel Manilla, but for the last thirteen years of his life, he worked practically alone.[6]

The metal plates that Posada produced for the broadsheets were done in relief so as to be mounted easily in a bed and printed along with raised type.

While it is at times difficult to be precise in describing the processes that he used, in general terms he made plates using both black-line and white-line techniques. The white-line technique involved gouging out the negative (white) spaces from a soft type-metal plate, leaving the subject in relief (see, for example, fig. 6). Black-line work for Posada probably meant drawing on a harder and lighter zinc plate with acid resistant ink, and then bathing it in a nitric acid solution that would lower the negative spaces (see fig. 11). While these descriptions of Posada's processes are not perfectly satisfactory, leaving some questions unanswered about how certain effects were achieved, this was how Posada's publishers recalled him working.[7] It is likely that his illustrations took a few hours to complete, and often only one or two hours.

We do not know where Posada lived, but his daily existence can be reconstructed. His shop, for most of the period under consideration here, was located at Calle Santa Inés No. 6, an address that today is called Calle de la Moneda No. 220-A.[8] This was a few blocks from the National Palace and the town square, the Zócalo, and around the corner from the Vanegas Arroyo print shop. For his broadsheet work, Posada was not paid on a piece basis, but rather with a salary of three pesos a day. Regarded as a good living wage, much higher than that of factory workers or day laborers who generally earned less than one peso per day, this was on a par with other artisans, and with police sergeants. Two photographs of Posada have survived, and these show him in a business suit, looking portly and well-fed. Descendants of his publisher recalled that he took annual vacations during the holiday season, at which time he would hole up at home with a barrel of tequila. The wall of his shop was decorated with a montage of lithographs of three French women doing the can-can, portraits of two female stars of the musical theater, and a print of Michelangelo's *The Last Judgment*.[9]

Posada's deeper thoughts remain a mystery. Although literate, he left behind no writings. Beyond the scanty evidence of his shop wall, we have no idea what art he preferred. We do not know if he attended exhibitions at the Academy of San Carlos, which was a few blocks away from his shop. His broadsheet work rarely shows influence of "high art" sources. Moreover, he was never reviewed by art critics of the day. No one seems to have commented in print on his work during his lifetime. While today we may regret this lack of information, it seems typical both of the artisan class of workers to which he belonged, and of his distance from the official culture of his day. His illustrations are his only legacy, and the broadsheet plates form its most substantial part.

In this book I want to examine these illustrations in the fullest context possible, beginning with the other material found on the sheets themselves: the text, poems, and headlines that typically formed the layout of those popular products. Keeping the word and the image together, besides preserving the integrity of the product that was bought and sold, illuminates both parts. Separating the contribution of editor and illustrator proves difficult. We do not know, for example, who usually had the idea to make a sheet about a given person or event. Presumably it was Vanegas Arroyo, but often it could have been Posada.

No matter who had the idea for a sheet, it seems certain that at some point the artist was presented with a poem or a story that required an illustration. In applying his imagination and artistic talent to the material at hand, Posada embellished and amplified it. From among the elements of a story he could choose which moment to illustrate. He could also interpret characters by endowing them with physical stature, posture, and facial expression. To a more limited extent, he could choose the size of the plate. We can learn a great deal about Posada's attitudes and modes of thought by examining the nature of his intervention in the material with which he worked. So this book is not only about Posada but also about his broadsheets.

The context of these products also includes the wider culture of Mexico City. Often the sheets treated material that also appeared in newspapers, such as crime stories or news events with their own illustrations. In addition, some of Mexico's literary figures wrote columns on life as they saw it, and these too can be usefully compared with broadsheet treatment of many subjects. The broadsheets frequently dealt with social types that appeared in novels of the day. Mexican authors seem to have been under the sway of the Realist movement, and many novels (most of which have been justifiably forgotten) contain descriptions of events or characters that parallel those found in the broadsheets. Retrospective analyses are also extremely helpful, be they work by historians of Mexico or autobiographical reflections by participants. By reimmersing the sheets as far as possible into the context of their times, we can hope to obtain answers to some of the following questions: What was their cultural function? Their class and gender base? What types of social endeavor did they support, and condemn? What political positions did they take? What relationship did they have with the power structure of their period?

We will see as we examine the broadsheets that their creation was constantly conditioned by the fact that for most of Posada's working life, Mexico was under the control of the dictatorship of General Porfirio Díaz, who at times censored the press and imprisoned journalists. For example, after a burst of imprisonments of journalists in the late 1880s, the newspaper *Pabellón Español* suggested that there be formed an "Imprisoned Journalists' Club," with the membership card being the entry ticket to jail. Luis Moncayo of *Padre Padilla* served one and a half years in prison in 1890–91 for publishing caricatures of President Díaz and some governors in ridiculous outfits. The offices of the opposition weekly *El Hijo del Ahuizote* were repeatedly raided in the 1890s. Editor Daniel Cabrera once described a raid on the paper's offices:

> It all happened in a moment, as if a lightning bolt had struck. The pressmen were thrown out into the street, leaving the sheets stuck to the press cylinders. Maybe a fire would have allowed us more time to save something. We were not allowed even a moment to put anything in order, not even the ink jars. The perfection of the system at shutting down editors rivaled that of machine guns in wartime.[10]

At one point, the editors hung a black funeral cloth from the balcony of their offices to mourn the death of press freedom. The caricaturist Jesús Martínez Carrión was jailed several times, and died of typhus contracted in the unsanitary Belén prison in 1906. The general attitude of the regime toward the press was best summed up by one author after the revolution:

> The feelings of the dictator toward the journalist's trade could be divided into three parts: scorn, as he judged journalists to be unscrupulous and without conscience; hatred, when they dared to attack him; and desire to seduce them, so that they would defend and praise him. Controlled by these motives, he bought, jailed, or used them, according to the needs of each case.[11]

Whether Posada or Antonio Vanegas Arroyo ever suffered imprisonment cannot be independently confirmed, though the publisher's family says that both did. If Posada were ever jailed, it was more likely to have been for his work on other magazines than for his broadsheet illustrations, which are far tamer than what normally garnered such punishment. As for Vanegas Arroyo, he seems to have been very cautious, as demonstrated by his treatment of politically sensitive current events. General Díaz, for example, was always depicted favorably, and no public official or business leader was ever shown in a negative light. In addition, the testimony of Blas Vanegas Arroyo, son of the founder of the shop, indicates that Antonio had a cordial personal relationship with General Díaz. When he moved the business to Calle Encarnación in 1885, among the jobs the shop undertook was bookbinding for government ministries. When questioned directly about whether Díaz imprisoned his father, Blas Vanegas Arroyo brushed the question aside rather quickly, and then proceeded to reveal other business connections between the two:

> Yes, I went to jail with my father, the same as Posada, when don Porfirio would secretly imprison us, too. Don Porfirio, however, treated my father very well. He called him "little teacher" and sometimes complained to him about the way the people, egged on by the press, despised his government. My father, who as a printer had something to do with this, would say to him, "What can you do, General? From time to time one has to let the people have some fun." General Díaz eventually offered to sell him some lots from the subdivision that was then taking place along Paseo de la Reforma, when those lots were being sold for twenty-five centavos per square yard.[12]

Whether this business deal had the effect of buying off Vanegas Arroyo can never truly be known, but it does indicate that Díaz looked favorably on the printer.

While Vanegas Arroyo and Posada avoided trouble with the authorities in their collaboration, certain aspects of their work together presented indirect opposition to the regime of Díaz and its cultural manifestations. I feel that the broadsheets, if not part of the organized opposition to the Díaz regime, are

equally distant from the administration's pack of supporters. We will find as we look more closely that the shop trod a fine line, expressing not opposition to the government, but a sort of alienation from it which at times grew obvious. The sheets spoke for the urban lower-class mestizo, and show a strong tendency to see things from their viewpoint rather than from that of established figures, be they for or against the regime. Posada's audience was alienated from the Europeanized urban culture that the establishment promoted, and preferred to hold on to rural roots. That audience also held to a traditional kind of morality, as taught by the Roman Catholic Church, but such teaching did not keep it from celebrating the occasional bandit who embarrassed the regime by successfully pursuing a career in crime. Broadsheet buyers as a group were not a counterculture but a subculture, with their own concerns, outlooks, and ways of thinking, and in their attempts to speak both to and for that group, Vanegas Arroyo and Posada stood on such ledges as the dictatorship granted them.

Some historians trace the roots of Posada's art to French sources, especially to Honoré Daumier, or possibly Jacques Callot, but the format of the broadsheet owes the most to more popular models. Throughout the nineteenth century in Paris, street criers went about hawking sheets imprinted with "from top to bottom, a headline, an image, and a text." These broadsides, called canards because of the resemblance of the cries of the youthful street vendors to the sound of quacking ducks, took as subject matter "all aspects of life, but with an evident preference for criminal matters. The choice among all the available news was guided by these same criteria: sensational news, a taste for anecdotes, priority given to the individual over the collectivity, and, generally speaking, for the concrete over the abstract."[13] In these broadsheets, vivid and somewhat crude illustrations competed for the reader's attention with shocking headlines such as "Horrible Murder," "Malicious Event," or "Murder after a Rape." At times the headline emphasized the news value of the events narrated: "Fresh Details," "Curious and Interesting News," or "News of Eight Murders." The text, in breathless detail and sensational language, dealt with the awful facts of the case usually followed by some rhymed lines that drew a moral to the story or expressed the supposed repentance of the perpetrator (fig. 1). Popular among the urban lower classes of Paris, some of these sheets made it across the Atlantic to Mexico City, where they influenced Vanegas Arroyo (see fig. 9). The similarities of headline, illustration, textual tone, and border between the Mexican and French sheets are too close to be coincidental. Moreover, this transatlantic borrowing took place at a time in Mexican history when the capital's upper classes were "francophile, Europeanized, ate French food, dressed in French style, spoke French, and passed their time at the Café Concorde," according to a recollection of the son of Posada's publisher.[14] While the readers of Mexico City broadsides were probably unaware of their continental antecedents, this European inspiration seems to be a part of the general Mexican fascination with "more advanced" societies that characterized official culture during the Díaz period.

1. *Horrible Murder.* Broadsheet with woodcut illustration produced in Paris by Charles Garson, 1833. 44cm x 31cm. Biblioteque National de Paris.

HORRIBLE ASSASSINAT

Commis -rue Traversine, sur deux individus, dont l'un a été percé de onze coups de tranchet, et l'autre a d'un coup de tranchet eut l'artère du bras droit coupé.

Lundi 16 juillet, il a été commis rue Traversine, un horrible assassinat sur deux personnes, qui ont été massacrées à coup de tranchet, dont une a reçu onze blessures, presque toutes mortelles ; les assassins se sont enfuis, deux d'entr'eux ont été arrêtés deux heures après. Cet assassinat a été commis rue Traversine, au coin de celle du Bon-Puits.

Les assassins ont lancé dans une chambre du n° 20, un énorme pavé, qui a failli écraser la tête d'un jeune enfant dans son berceau. Les mêmes individus ont cherché à étrangler un individu qui passait dans la même rue, Pierre Pochau.

COMPLAINTE.

Air : *De Joseph.*

Écoutez le récit d'un crime
Des disciples de Saint-Crépin,
Qui sont tombés sur leurs victimes
Comme de lâches assassins;
D'un tranchet l'un des trois armé
A porté au moins onze coups :
Le malheureux qui fut frappé
Est mort en tombant sur les genoux.

Le second chercha à se défendre
De ces horribles assassins,
Lorsqu'un coup porté vint lui fendre
Les deux artères de la main;
Enfin, luttant avec courage,
Cherchant à éviter la mort,
Il quitte le champ du carnage,
De son sang pleurant le sort.

Bientôt la justice informée
Se saisit de trois assassins,
Qui finiront leur destinée
Selon les ordres du destin;
Car la Providence divine
Ne laisse aucun crime impuni,
Et veut qu'un scélérat insigne
De ses forfaits paye le prix.

A Paris, chez GARSON, Fabricant d'Images, rue de la Huchette, n° 25. (*Affranchir.*)

DE L'IMPRIMERIE DE J. GRILLOT
Rue de l'un-Saint-Jacques, maison de la Rose Blanche

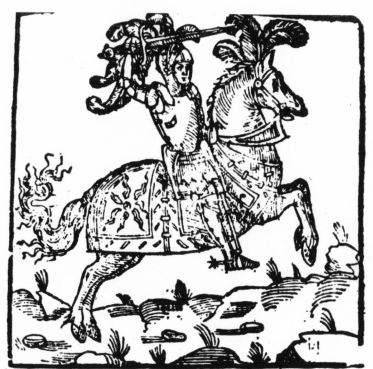

CRomance del noble valiente y no me
nos esforçado, flor de las cauallerias don Reynaldos te
Montaluan. Y trata como Carlomano lo tenia preso
para lo aho zcar, po z los falsos consejos de Gala-
lon, sino fuera po zel conde don Roldan, y co
mo fue de sterrado de la christiandad, y
como vino a ser Emperado z de
Crapisonda siédo de sterrado.
Decho po z Francisco de
Mederos, natural
de Benauentc.
có vn villá-
cico.

2. *Romance of the Noble and Not Least Forceful Flower of Chivalry don Reynaldos.* Woodcut chapbook cover, Granada, 1568. Biblioteca Nacional de Madrid.

3. *The Art of the Bullfight.* Illustration by José María Villasana in *La Patria Ilustrada* (Mexico City), 9 March 1885, page 151.

4. *French Customs.* Lithographic illustration in *La Risa* (edición americana) New Orleans, 6 January 1849, page 3.

Besides crime sheets, Posada frequently embellished printed versions of corridos, folk songs about rural heroes such as bandits (see fig. 33); these illustrations have different sources. The iconography of the corrido sheet illustration owes a great deal to Spanish predecessors, just as the Mexican folk song form is descended from the Spanish romance (fig. 2).[15] In both cases, verses relate the exploits of a solitary and often tragic hero in language that common folk can understand and remember. Posada may have seen printed Spanish romances, which were circulated in booklet form beginning almost as soon as the printing press reached Spain.[16] By the late nineteenth century Spanish leaflets were fad-

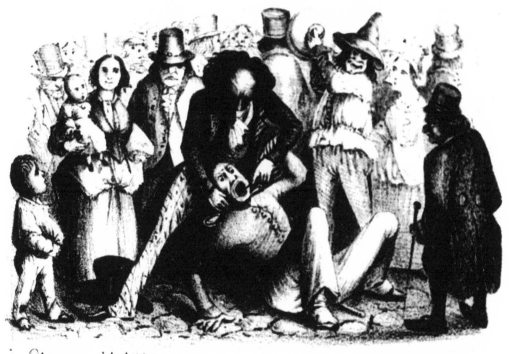

Muchacho, ¿es esa la ley del duelo?—Aqui no hay mas duelo ni mas quebranto, que si vd. no se da por vencido le quebranto cuantas costillas tiene en su cuerpo. Fr. Ger. Tomo VI. Cap. 155 Pag, 452.

ing in popularity due to the rise of magazine technology, and traffic between Spain and Mexico throughout the Díaz period intensified enough that older examples probably came over. Manuel Manilla also borrowed the heroic equestrian iconography for corrido sheets (see fig. 32), and perhaps Posada looked no further than that.

Other principal sources for Posada's style were much closer at hand: well-known illustrators and magazines. When he first settled in the capital, Posada made illustrations for *La Patria Ilustrada*, a monthly that also employed José María Villasana and Daniel Cabrera (fig. 3). The vigorously linear style and emphatic characterizations of the illustrations in that magazine would turn up later in Posada, especially in his black-line work for Vanegas Arroyo (see figs. 6 and 72). Many popular or humorous magazines that circulated in Mexico City in the middle nineteenth century contained lithographic or woodblock illustrations that also seem to have influenced him. For example, the magazine *La Risa*, which was published in New Orleans in the 1860s and circulated throughout Latin America, contained illustrations that exaggerated gestures and poses (fig. 4). It is only a short step from the two central figures in that illustration to the far more violent pair that occupy the foreground of a 1910 murder sheet (see fig. 10). A more direct example of stylistic influence is an illustration in the popular magazine *Fray Gerundio* (fig. 5). The figure on the left moves forward in a pose derived from the lunge in fencing. He has taken a step forward and

5. "My Boy, is that the rule of dueling?" Illustration in *Fray Gerundio* (Madrid), 21 June 1839.

bears most of the weight on the left leg as he reaches to restrain the attack. This pose, which suggests vigorous motion, was among Posada's standard props, and he used it numerous times in various types of sheets (see figs. 9, 27, 42, and 66). In some instances Posada adapted newspaper illustrations of current events for broadsheets (figs. 22, 23, and 43, for example). These drawings and photographs, which he almost never presented unaltered, provide fascinating clues to his working methods.

In spite of his dependence on the culture of magazine illustration, Posada's broadsheet art has its own distinctive and unmistakable style. These works—never ornate or flowery—avoid symbolic meanings, metaphysical speculation, and contemplative moods. His use of decisive and descriptive line enabled him to create works full of action, energy, and elemental power. In the people and situations he depicted, Posada expressed empathy with what Henri Bergson would call their *élan vital,* their vital spirit, the force of life pulsing through them. Bergson carefully distinguished the mere matter of a thing from its motion, its intention, its purpose. The intellect and the senses are made to perceive the matter, but the intangible spirit can only be captured by instinct or intuition. He wrote: "intelligence and instinct are turned in opposite directions, the former toward inert matter, the latter towards life."[17] It seems to me that Posada was highly sensitive to this vital spirit in nearly every subject he depicted. He had the *sympathy* that Bergson claimed was required of one who would penetrate the mere appearance:

> Our eye perceives the features of a living being, merely as assembled, not as mutually organized. The intention of life, the simple movement that runs through the lines, escapes it. This intention is just what the artist tries to regain, in placing himself back within the object by a kind of sympathy, in breaking down, by effort of intuition, the barrier that space puts up between him and his model.[18]

Posada never did exactly what Bergson urged, that is, to take "life in general" for his subject, and to communicate intuitions of its general rhythms and sensations. This was left to modern artists in France and Italy. Posada, rather, brings us intense moments in which individuals, acting under the combined sway of circumstance and their natures, act decisively to shape their world.

The vital energy with which Posada endowed his characters is not the baroque energy that José Lezama Lima claimed is so strongly rooted in Latin American art from colonial or even precolonial days to the present. This American Baroque, which is exemplified as much by the religious architectural sculpture of Kondori in Perú and Aleijadinho in Brazil as by the modern writing of Leopoldo Lugones, takes its cue from the daring inversions, intricate phrasing, and at times hermetic content of the poetry of Luis de Góngora. Says Lezama Lima: "In every American there is always a tamed *Gongorino.*"[19] Posada's work, for all of its restless energy, is too much rooted in reality; it is not intri-

cate, hermetic, ethereal, or elaborate. It has little in common with a portrait of a dying martyr and even less with a Churrigueresque altarpiece. Moreover, Posada's characters lack connection to God; they never swoon, for example, and they never seem to be acting on the urging of some higher power. Rather, they find sufficient impetus for their acts in their own person and situation. Each character in a Posada print, even when carrying out assigned duties or fulfilling some recognized cultural role, seems to be acting autonomously. Regardless of the story line, Posada does not moralize in his illustrations, even though the relevant text may clearly do so. The evil woman torturing the innocent girl (see fig. 6), the crowd pelting the criminal with rocks as she is carried off in a police cart (see fig. 7), and even the chief of the firing squad who gives the order to execute a murderer (see fig. 22) overflow with life, and Posada respected that energy however it showed itself. Even Lezama Lima was willing to make an exception for Posada: "His realism, if that word expresses it, is like the deepest point reached by a type of root that is necessary, inevitable, and deeply buried."[20]

Posada achieved these effects by manipulating simple media. In white-line work, his cuts are decisive and bold; in black-line prints, the lines are more free and vigorously spontaneous without being loose. Yet in each medium he resorts to similar devices. For example, characters at rest or moving slowly are often engirthed, as if their lungs were filled with air, giving a sense of incipient action, of gathering strength, to even motionless persons (see figs. 25 and 31). Sometimes the artist collapses space to crowd a composition (see fig. 36), thus concentrating the action so that the boundary of the work seems to want to expand. Also, he collapses time, so that the owner of the store is killed at the same moment that the jewelry is taken, rather than before (see fig. 36); the crowd jumps to its feet instantaneously with the tossing of the matador, not a split-second later (see fig. 54); the rifles of the firing squad report even before the commander's sword drops (see fig. 46). Finally, even motionless persons are never perfectly still. The witnesses at the execution toss their heads back. The murdered father of Norberta Reyes struggles in death-throes (see fig. 10). The already-killed police chief has arms and legs drawn up (see fig. 77). The dramatic action of Posada's subjects conveys a grain of believability. They rarely fall into caricature or burlesque.

We will see that over the course of Posada's career, he had a lively relationship with other sorts of visual imagery in the popular media. In creating plates for stories of the most spectacular crimes, and for many other types of stories, no photographs or drawings were available so he relied primarily on imagination; these I believe to be his best broadsheet works. In illustrating other more celebrated cases he often worked after seeing newspaper illustrations. Early in his career, these were drawings, but later they became increasingly photographic in nature, as the technology for reproducing camera work evolved. His treatment of these sources gives clear evidence of his artistic strategies, and is only slightly less interesting than his more imaginative plates. Near the end of his career, however, the repeated exposure to photographs seems to have dulled

his inspiration. Among his last works are some that seem to be mere transcriptions of news imagery, so that in a sense, he could be said to be a victim of the camera. Yet along the way he produced many works of unforgettable dramatic power that illuminated from a working-class perspective some compelling events of his time.

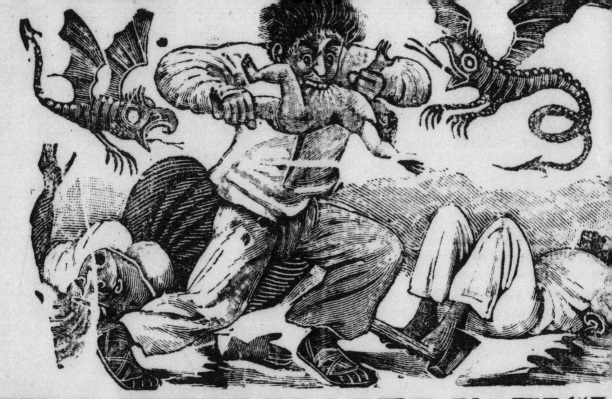

MUY INTERESANTE NOTICI

De los cuatro asesinatos por el desgraciado Antonio Sánchez en el pueblo
de San José Iturbide, Estado de Guanajuato, quien después del horrible crim
comió los restos de su propio hijo.

— || ~ || —

E' acontecimiento que **arriba** mencionamos, tuvo lugar de la manera siguiente:

Eran las tres y media de una tarde nebulosa, triste y fría, pareciendo que el cielo mismo, previendo lo que iba á suceder, se revestía de un marcado tinte de tristeza.

El infortunado y criminal antropófago Antonio Sánchez, llegó à su humilde casa acompañado de un individuo á quién le debía entregar los documentos de una finca cuya propiedad acababa de perder, y sus cariñosos y benévolos padres, comprendiendo que eso era una fatal locura de su hijo, se negaron á entregárselos, diciéndole afectuosamente:—Hijo mío, desde tu más tierna infancia primero, y luego en los más mejores tiempos de tu juventud, has disfrutado como has querido de los pa

sacian los mentidos placeres de la y sin que nada te importen las de cias de estos pobres viejos, quiere pojarlos de la única esperanz p eden tener para poder acaba b eves días, siquiera en una me tra quilidad, el único rincón que t p ra exhalar su último suspiro: de de haberla conservado tanto tie para que sirviera de amparo á tu sa y á tu hijo. No hijo mío, esta no puede ser vendida y mucho perdida en ese nefando vicio del j como dices que acaba de pasar.— si tan justas razones, dich s cari mente, hubieran si lo el más horr veneno para el alma del infame nio su semblante se demudó de u do horroroso á impulsos de la espa ira, arrojando por los inyectados mil rayos de ese fulgor siniestro engendra en las almas dep avada

SHOCKING CRIMES

Simply Sensational

More than half of Posada's broadsheets deal with news of the crime world, and some of this material represents rather extreme crimes. Perhaps it is the story of the man who strangled his wife in a fit of passion. Or the story of the woman who cut her infant son into pieces. Or the father who decapitated his pregnant daughter. Or the man who poisoned his entire family. Perhaps it is a less dramatic story of a quarrel between prisoners. Perhaps a military execution in another state, or news of the opening of a new correctional facility. Or an escape from such a facility. Or perhaps a brazen and perfectly planned jewelry store robbery, or a story of rural outlaws who evade the authorities for years. There is no escaping the ubiquitous presence of this theme in the material that came from the Vanegas Arroyo shop. If we accept the testimony from descendants of the original owner, that he produced what he knew would sell, then the urban lower classes of Mexico were fascinated by many aspects of crime, from the commission of the misdeed, to the arrest, to the exaction of the punishment.

Readers of broadsheets would have obtained an incomplete picture of Mexican crime, though, because many types of offenses simply never appeared there. The lighter sort of misdemeanors, such as drunkenness, fighting, and robbery, which were the most common reasons for arrests in Mexico City, were almost never treated in broadsheets. Similarly, crimes committed by upper-class persons were rarely seen. More humorous crime stories, such as clever acts or failed crimes, were similarly scarce.[1] On the other hand, certain types of crimes and criminals were greatly over-represented. Murders and executions were more common in broadsheets than in real life. Crimes committed by women were far more numerous in comparison to their actual numbers in the arrested

population. And rural bandits continued to be celebrated years after their deaths in reissues of sheets.

So the goal of Vanegas Arroyo was not to inform the public about the various types of lawlessness that existed at that time. Rather, these crime broadsheets seemed to have answered a kind of basic human curiosity about what people will do in extreme situations. How far will some people let hatred take them? How do people endure ordeals such as captivity? How much fear of death do they show, and what will they do when it stares them in the face? Is death as retribution different from innocent martyrdom? What kind of people commit acts that are unusual, rare, antisocial, or extremely violent? Do such acts require courage, foresight, quick-wittedness, or great strength? The world of crime is deeply involved with all of these questions. I sense that crime stories answer existential needs by allowing us, at a safe distance, to imagine ourselves in the many extreme situations that crime and its detection and punishment present. Crime's fascination arises from this usefulness, when we compare ourselves to the persons depicted, praised, condemned, enraged, subjected, or victimized. What would we do in a similar situation? What are we made of? Who are we? Some who may be prone to deride broadsheet culture as mere sensationalism generally have some other way of getting answers to these questions, be it through literature, art, religion, drama, mythology, or grand opera, all of which are shot through with similar stories of persons in extreme situations. For better or worse, this was one principal function of Posada's broadsheet crime stories, and grasping this point will help build bridges between those times and our own.

Shocking crime, a type that provokes horror, outrage, or fear, usually involves killing or wounding a member of one's own household or family or someone who is perceived as defenseless, or undeserving of mistreatment. Shocking crime is not perpetrated by a "professional criminal." Many cases of child abuse and alleged "crimes of passion" fall into this category. This type of crime was very common in Posada's broadsheets, a fact that suggests there was a ready market in Mexico City for crime news of this sort. The Vanegas Arroyo shop produced one of these sheets every week or two in the years surrounding the turn of the century. The illustrations Posada produced for these sensational sheets were among his best. In most cases there was no photograph of the perpetrator or the event, so Posada imagined the terrible scenes of cruelty that he depicted, creating works that surge with elemental and horrendous force.

Members of the lower orders of Mexican society shared this interest in sensationalism with their higher-class counterparts during the Díaz period. For example, it was widely believed that Mexico in general, and Mexico City in particular, was far more crime-ridden than most other parts of the world. Lawyer Miguel Macedo wrote in 1897 that Mexico City had about one murder per day, which averaged to about one hundred for every one hundred thousand inhabitants per year. In comparison, the district of France with the highest murder rate, which happened to include Paris, had twenty-five murders per million inhabitants. The statistics for Madrid suggested that there were only seven

murders annually for every one hundred thousand inhabitants. On adding up the crime figures, Macedo concluded, "one gets the impression that we are comparing a barbarous people with civilized peoples, no matter how strenuously we object to the labeling of our capital city as 'barbarous.'"[2] Over the last eleven years, leading up to 1897, he said, the total number of arrests per year exceeded a number equal to ten percent of the total population. The result was "a wave of criminality that every year gets higher, and if it is not stopped in the very near future, it will cause our entire lower-class population to live in prison for an average of several days per year.[3]

Persons close to the Díaz government establishment were heavily influenced by Comtian positivism, and tended to see crime as caused by environmental or racial factors which led, in turn, to moral or spiritual degradation. These beliefs were in accord with the scientific bias of Comte and his followers, who preferred to talk of what could be quantified. One criminologist, for example, noted that the unpredictability and dryness of the climate in the Valley of Mexico contributed to crime. Citizens who live in that area (which included Mexico City), he said, "have never been able to count on the future, neither for their life, nor their health, nor their crops, nor their mines, nor their destiny, nor even their daily subsistence. And this apparent lack of uniformity in the moods of Nature, repeated generation after generation . . . has enforced the deeply held belief that Nature is completely unpredictable and capricious."[4] This inconsistency led directly to the widespread vice of gambling, he said, which was an effort to duplicate the operation of nature in central Mexico. Persons who gambled were only acting in the way nature itself seemed to operate.

The unpredictability of nature also had strong influences on family life. A heavy emphasis was placed on outward stability, discipline, and family unity, as a counterweight, an effort to establish at least some space that seemed less capricious:. "If the Mexican head of family needed for his own security some links with outsiders, he also needed absolute loyalty among his charges."[5] While not bad in itself, the desire for stability could pass natural bounds, leading at times to repression or to violent overreaction if domestic tranquillity were breached by too many outsiders, by misbehavior, by desertion, or by adultery.

Population distribution influenced crime in two principal ways, according to this analysis. In rural areas, for example, the population was so thinly spread that governing became difficult. Local authorities were weak or ineffectual at carrying out even the most basic functions, and "these impotent governments were factors in corrupting public morals."[6] Sensing that the authorities were weak encouraged lawless behavior. A weak government also adversely influenced the average person's conception of civic life, or sense of belonging to a community. The general populace felt very little sense of commitment to public life, emphasizing rather their own personal gain along with preservation of family unity. In the capital city, the problem was, in some respects, the opposite. Overpopulation led to excess competition among workers for jobs and a resultant depression in wages. Subsistence by legal means was thus more difficult than it should be, to say nothing of saving for the future.[7] This state of

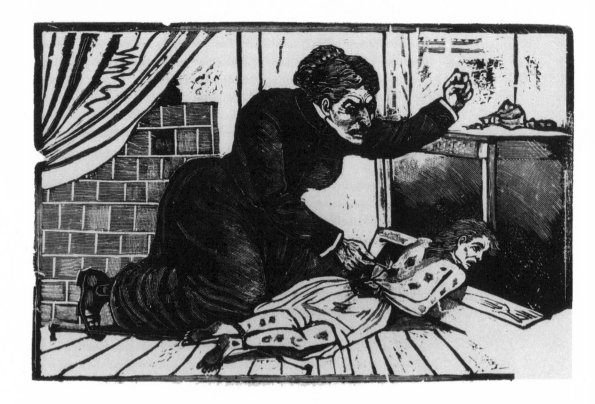

affairs encouraged fatalism about career advancement and about the probability of success in finding adequate compensation for labor. The option of crime was therefore attractive.

Most experts of the time agreed that Mexico's violent past played a role in the current problems. The viceregal period following the conquest had been relatively calm and stable, but since at least the middle of the nineteenth century, civil violence had been endemic. The American invasion, the Wars of the Reform, the battle to expel the French, and widespread rural banditry had radically undercut the sense of social peace and had habituated Mexicans to solving their problems by violence. More than that, the frequent wars and violence that seemed to characterize civil life in Mexico before the Díaz period, said one author, "created a profound impression on the Mexican soul. The brain was filled with scenes of struggle, blood, gunfire, battle, flight, murders, robberies, and kidnappings . . . As a psychic consequence of witnessing such scenes, flaming hatreds were born which were never put out."[8]

There were also racial causes to the current crime problem, said Julio Guerrero, echoing a commonly held Comtian belief that racial inheritance is a major determinant of personal destiny. In this regard, Mexicans were unfortunate, since the indigenous Mexican cultures, with their practice of human sacrifice, were thought to be among the bloodiest on earth. Three centuries of Catholic masses before and since independence seemed to calm the people, but without effecting any change in the deeper layers of consciousness. Aztecs remained Aztecs inside. And just as recessive genes can resurface at any time in

6. *The Crimes of Bejarano.* Restrike of a white-line print by Posada, 1891. Half Sheet. Amon Carter Museum. 1978.384.4

succeeding generations, "the ferocious tendencies of the Aztecs have reappeared. After ten generations there has returned to beat within the breasts of some of our compatriots the barbarous heart of the cult of Huitzilopoztli."[9] In sum, just as other races have their specific characteristics, crime seemed to be written into the Mexican national character. "If in the United States, for example, there arose an Edison . . . In London there was Shakespeare . . . Germany produced its Bismarck . . . Mexico was thus prone to spew its 'needlessly destructive types.' "[10]

Posada's broadsheets take a position that diverges in many ways from the "official" view. Murders were the subject of the vast majority of the sheets relating to shocking crime, neglecting other more common types of crime. The proportion of women perpetrators in the sheets was higher than their actual incidence in the population. Excluding executions, all of which were for crimes committed by men and which were relatively uncommon, about half of remaining the crime sheets dealt with female murderers. While it is difficult to find statistics that break down Mexican murderers by gender, the overall arrest rate in Mexico City for all crimes between 1891 and 1895 averaged about 80 percent men and 20 percent women.[11] So it seems that Posada's publisher selected the most sensational, unusual, or brutal crimes for treatment in broadsheets. Finally and most important, when there was an explanation in the broadsheet text for why the crime had occurred, it was never in agreement with any aspect of the official view.

One of the earliest shocking crimes that Posada treated was also one of the most sensational, and it seems to have been of great interest to broadsheet buyers and to others. It also shows that in representing this type of crime certain aspects of Posada's style were set quite early in his career. In 1891, Guadalupe Bejarano was convicted of torturing and killing the young girl Crescencia Pineda. She apparently subjected the child to repeated burns in various places on her body, resulting in death. Although sentenced to eight years in Belén, after she served only a few months the authorities extended her sentence to eleven years. The 1891 offense was not her first, however; she had been convicted of a similar crime against two other children (both girls) in 1876.[12] Posada made a total of three illustrations dealing with the 1891 crime; in only one case does the text survive.

The first illustration depicts the actual crime in progress (fig. 6). As was usual in Posada's depictions of crime scenes, the movement flows from left to right, from perpetrator to victim. This facilitates the traditional left-to-right reading typical of literate Western societies, and the prevalence of this characteristic in Posada's work may indicate that Posada thought of his audience as literate, like himself. The composition is dominated by the angry figure of Bejarano, who, even as she applies the burning instrument to the body of her victim, raises her other fist in anger as she displays a contorted countenance that indicates rage or even shouting. The diagonal of her body parallels that of the victim and, above, in the curtain in the upper left. The child seems a martyr, as her limbs are tied. Her facial expression betrays dread, and she arches her upper body under the

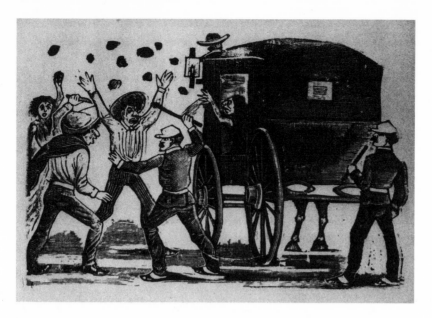

7. *Guadalupe Bejarano Being Taken to Jail.* Restrike of a white-line print by Posada, 1891. Dimensions unknown. Istituto Cultural de Aguascalientes, Mexico.

8. *Guadalupe Bejarano in Jail in Belén.* Broadsheet with white-line illustration by Posada, 1891. Full Sheet. Photograph © The Art Institute of Chicago, William McCallin McKee Memorial Collection, 1944.915.

impact of the flames. She is also mostly white, in comparison to the overwhelmingly dark figure of Bejarano. The three diagonals in the composition repeat like hammer-blows which, since they have no counterpart except for the carelessly suggested table at the right, heighten the drama of the scene. The handling of perspective in the print exudes a crudity that adds to its sense of raw violence. The principal vanishing point of the picture is near its center, at a point in the negative space near the breast of the perpetrator. This vanishing point is clearly indicated by the converging lines of the floorboards, which recede too quickly. The breast in many other artistic contexts symbolizes nurturing motherhood, and its prevalence and obviousness in the center of this picture of unmitigated evil, silhouetted against a white wall, is an extremely ironic touch. The table at the right has its own vanishing point, and it may have been added as an afterthought. The bricks at the left also seem to violate traditional perspective rules, as they seem to be pulled toward us, leaving barely enough space for the criminal to occupy. The far lower right corner of the scene is blank because the plate apparently broke early in the press run.[13] So here we have an excellent example of Posada's style for this type of subject: a scene of gratuitous violence rendered with dramatic characterizations and composition in a charged pictorial space with crude and ironic touches.

A second illustration shows the captured Bejarano being taken in a police wagon to jail as crowds jeer and throw rocks at her (fig. 7). She cordially returns this hatred, as she gestures out the window in a way that suggests malediction. The most complete example to survive, however, is the sheet titled *Guadalupe Bejarano en las Bartolinas de Belén* (fig. 8), which tells news of her trial. Apparently her son was an accomplice in certain respects, and at the trial the two accused each other of being the principal perpetrator of the deeds done to Crescencia Pineda. The poem printed below the illustration alludes to her earlier 1876 conviction as well. For the sake of simplicity, and to concentrate the drama of the

GUADALUPE BEJARANO en las bartolinas de Belen.
Careo entre la mujer verdugo y su hijo.

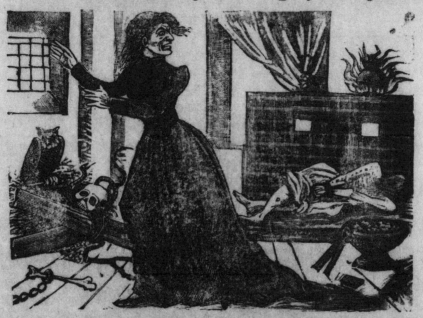

Las últimas noticias relativas á la *mujer verdugo*, se refieren al careo entre ésta y su hijo Aurelio, decretado por el Juez que conoce de la causa.

Hé aquí los pormenores que respecto á ese careo, da un periódico de la capital:

«En él la Bejarano se mostró más conmovida que indignada.

—Bien sé, dijo, que ésta acusación que sobre mí has lanzado, hará que concluya mis días en la prisión, pero nada diré respecto de su falsedad, te perdono. Los hombres me condenarán; pero Dios que vé en el fondo de los corazones, tendrá en cuenta el sacrificio que hago de mi liberad por que tú te salves. Que Él no te tome en cuentala calumnia que arrojas sobre tu madre.

Aurelio, pálido y abatido no contestó ni una sola palabra á los reproches de la desventurada. A las reiteradas preguntas del defensor para que negara algunos de los cargos de la Bejarano, él contestaba con el más profundo silencio.

—Quién sabe, continuó aquella, si tú serías el que golpeó á Crescencia y ahora mirando el cargo que puede resultarte, me achacas á mí tus obras.»

¡Que terrible debe ser para esa infeliz verse acusada por su propio hijo!

Ninguna esperanza le queda de poder hallar alguien que la consuele, que la vea siquiera sin horror. Sus mismas compañeras de cárcel rechazaron su sociedad y se ve obligada á permanecer en tan triste encierro, sin más compañía que sus remordimientos. Quizá en esas largas noches de la prisión vea reproducirse aquellas escenas del martirio de una inocente criatura, y su imaginación le presente el yerto cadáver de Crescencia por un lado y por el otro los útiles del tormento y en el silencio de su triste encierro le parezca escuchar el llanto y los gemidos que el sufrimiento arrancaba á la desgraciada victima.

Por muy criminal y muy cruel que se suponga á una gente, no es posible llegar hasta el punto de creer que le falte siquiera un instante en que el recuerdo de su crueldad y el remordimiento de su crimen vengan á causarle un martirio atroz.

No es posible negar á esta infeliz mujer la compasión que su triste estado tiene que inspirar. La expiación, sea la que sea, no dilatará mucho en castigar su crimen. Pronto la justicia humana pronunciará su fallo.

Con una crueldad atroz
la terrible Bejarano,
ha cometido la infame
el crímen más inhumano.

A la inocente Crescencia
martiriza de tal suerte,
que esta víctima inocente
halló una temprana muerte.

La infame mujer verdugo
encuentra un grande placer
en causar á esta criatura
un horrible padecer.

Iracunda martiriza
aquellas carnes tan tiernas
con terribles quemaduras
en los brazos y en las piernas.

Años hace que otro crimen
igual á éste cometió
y por el cual la justicia
á prisión la sentenció.

Y lo que más horroriza
al pueblo que lo ha palpado,
es que de su propio hijo
su cómplice haya formado.

Y á pesar de su maldad
es digna de compasión,
por lo que debe sufrir
encerrada en su prisión.

Cuántas veces en la noche
verá su sueño turbado
por el recuerdo terrible
de aquel crimen tan nefaudo.

El cruel remordimiento
debe traer á su memoria,
de aquellas tristes escenas
toda la pasada historia.

Y allá entre la negra sombra
de su oscuro calabozo,
de la víctima inocente
verá el espectro espantoso.

Y escuchará los gemidos
de aquel pecho acongojado,
y aquel llanto lastimero
por el tormento arrancado.

Y esta aterradora imagen
que vivirá en su delirio,
será su justa expiación,
será su eterno martirio.

Méjico.--Imprenta de Antonio Vanegas Arroyo, calle de Santa Teresa núm. 1.--Méjico.

scene, Posada focused all the evil force in the person of Bejarano, leaving the son out of all surviving pictures of the crime. In the present sheet the deed is done, and Bejarano strides away with arms slightly raised, stringy hair flying, and a crazed look similar to the earlier illustration. The scene is the same, as the brick fireplace is there, the floorboards, and the criminal in the same clothing. To further suggest an atmosphere of evil, and perhaps to compensate for the relative lack of action in this scene, Posada introduced in the lower left some accoutrements with symbolic significance: an owl, a skull, a bone attached to a chain, and some snakes. The skull suggests death, as does the bone on the chain, except that the latter refers to the captivity that Bejarano's victims suffered. The owl is a traditional symbol of perfidy in European art, as it does its carnivorous deeds only at night. The snakes, of course, allude to the temptation in the garden of Eden, and this detail heightens a link to Bejarano as the archetypal Evil Mother. The presence of the body on the hearth suggests human sacrifice, an offering to an unknown god. These symbolic details that seem to link the criminal to more ancient narrative traditions, while they add to the meanings present here, were very unusual for Posada in illustrating this type of story. Such allusions run the risk of being beyond the ken of the audience, and he rarely engaged in them. Bejarano was practically a household name in Mexico City, not only for members of the lower classes, but for readers of mainstream newspapers as well. When she was finally released in 1899 after serving eight years, the leading daily ran a front page story: "The nefarious crimes of Bejarano," it said, "awaken horrible memories in all of the inhabitants of this city."[14]

The lack of text accompanying the surviving prints by Posada on the crimes of Guadalupe Bejarano means that we have no idea if any explanation was offered for her unusual deeds. We have more complete information about later spectacular crimes, as many such broadsheets have survived. These usually included both an illustration and a text that told the story in great detail, and plainly stated the moral of the story or a cause of it. Often there was a concluding verse section in which the perpetrator supposedly expressed repentance. The broadsheets that narrate such crimes had other features in common: First, the crimes frequently took place outside the capital city. It seems that the Vanegas Arroyo shop received newspapers from around the country by mail, so that a bloody murder in a far-flung province could turn up, usually within two to three weeks, in a broadside. A second similarity was the minimal police role in these crimes. Beyond notifying the authorities, or a simple taking into custody, local officials had little to do in these crime stories. Police officers, if any appeared, were usually unnamed, and there was no "detection" or "crime solving." Finally, the forces of nature frequently played a major role. Sudden storms, lightning, and even earthquakes intervened decisively in one way or another. In general, the texts in these sorts of sheets strongly supported a traditional form of morality, and at times played directly into Roman Catholic teachings.

9. *Very Interesting News.* Broadsheet with white-line illustration by Posada, 1911. Half sheet. Amon Carter Museum. 1978.123

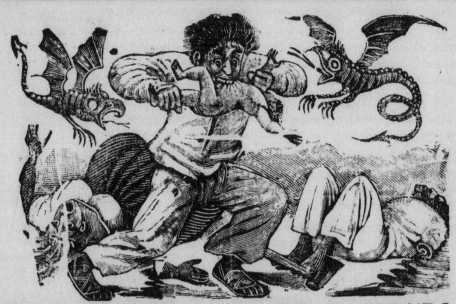

MUY INTERESANTE NOTICIA.

De los cuatro asesinatos por el desgraciado Antonio Sánchez en el pueblo de San José Iturbide, Estado de Guanajuato, quien después del horrible crimen se comió los restos de su propio hijo.

——||–||——

E' acontecimiento que arriba mencionamos, tuvo lugar de la manera siguiente:

Eran las tres y media de una tarde nebulosa, triste y fría, pareciendo que el cielo mismo, previendo lo que iba á suceder, se revestía de un marcado tinte de tristeza.

El infortunado y criminal antropófago Antoni Sánchez, llegó à su humilde casa acompañado de un individuo á quién la debía entregar los documentos de una finca cuya propiedad acababa de perder, y sus cariñosos y benévolos padres, comprendiendo que eso era una fatal locura de su hijo, se negaron á entregárselos, diciéndole afectuosamente:—Hijo mío, desde tu más tierna infancia primero, y luego en los más mejores tiempos de tu juventud, has disfrutado como has querido de los pequeños intereses que á costa de infinitos sacrificios y con mil privaciones y congojas tus ancianos padres han podido formar con el exclusivo objeto de labrarte un porvenir, y todavía no te

sacian los mentidos placeres de la vida y sin que nada te importen las desgracias de estos pobres viejos, quieres despojarlos de la única esperanza que pueden tener para poder acabar sus breves días, siquiera en una mediana tranquilidad, el único rincón que tienen para exhalar su último suspiro; después de haberla conservado tanto tiempo para que sirviera de amparo á tu esposa y á tu hijo. No hijo mío, esta casa no puede ser vendida y mucho menos perdida en ese nefando vicio del juego, como dices que acaba de pasar.—Como si tan justas razones, dichas cariñosamente, hubieran sido el más horroroso veneno para el alma del infame Antonio. su semblante se demudó de un modo horroroso á impulsos de la espantosa ira, arrojando por los inyectados ojos mil rayos de ese fulgor siniestro que engendra en las almas depravadas el nefando espíritu de la soberbia. Su ardiente, entrecortado y fatigoso aliento la terrible palidez de su semblante, la horrible contracción de todos los mus-

A case in point is the print called *Muy Interesante Noticia* (fig. 9). The crime story is told in greater detail than what would normally be found in a Mexican provincial newspaper; many details of mood and dialogue in the text would be very difficult to reconstruct, since most of the participants perished. Most likely, the text writer in the shop embellished the account to add to its emotional appeal, to simplify its characterizations, and to heighten the drama. The text alleges that the weather on the day of the crime was "cloudy, cold, and cheerless." Antonio Sánchez arrived at his house with a gambling partner to whom he owed a great deal of money, and asked his parents for the title deed to the house so that he could sell it to pay the debt. They told him they could consent to no such thing, that they could never "give up their only hope of living out their passing days with some measure of peace in the only little corner that they own." On hearing these tender entreaties, the criminal became very angry, and turned into an "appalling madman," with contorted face and bloodshot eyes. Availing himself of a hatchet, he proceeded to bury it in the head of his father, and when his mother and his wife let out shocked cries, he set upon them also, turning the house into a "horrible meat market." As if this were not enough, he entered the bedroom where his infant son was sleeping, and hacked him to death as well.

At this point the gambling buddy presumably gave up on collecting the debt and went to notify the authorities, who arrived shortly to find, in the midst of the scene of carnage, the murderer "tranquilly devouring the body of his own son." Sánchez was taken into custody and quickly sentenced to die at the firing squad at eight the next morning, with his body to be exposed to the public as a warning. (This type of speedy and severe justice was common in provincial cities.) The sentence was carried out, and the exaction seemed to satisfy earthly justice, but, according to the text, "divine punishment was still lacking." When the criminal had been exposed for about three hours, a sudden violent lightning storm blew up and destroyed the body, and floods soon washed it away.

Posada's illustration focuses not on the actual deed of murder, but on the perhaps yet more horrifying sequel, as the criminal stands among the bodies of his family members biting the limp body of the child. The artist has taken a few liberties with the text, pointing toward a desire to imbue with movement and heighten the drama of this gross cannibalistic event, which happened after the high tide of violence and bloodshed had passed. The bodies on the ground do not seem to lie perfectly still. The father on the right has his legs drawn up as his severed arm (a detail which the text does not mention) leaks blood in the viewer's direction. The hatchet lies over his feet. The body of the mother on the left is far less mangled, and shows signs of stirring, both in the legs and the arms. Regarding the infant, the text says that the murderer chopped the tiny body into four pieces "with two blows of the hatchet," but here it is seen complete, probably for easy recognizability. Moreover, the murderer is far from being in the tranquil state that the text mentions, as his legs suggest vigorous left-to-right movement, his elbows are extended, and the expression on his face betrays a mixture of madness and eagerness. There are no details of the room,

as three-dimensional space is created by foreshortening and overlapping the bodies. Two monsters hang suspended in the corners, with lizard-like torsos, the tails of devils, the tongues of snakes, and the wings of bats. These composite creatures occur often in Posada's images of shocking crimes. Their pedigree is ancient, as similar creatures can be seen in medieval manuscripts and European popular prints. Here they have three functions: First, they writhe about and extend their tongues in order to add motion and drama to a scene that lacks vigorous action. Eating, after all, is usually done in a stationary position, and these monsters counteract the scene's tendency toward stasis. In addition, they contribute to a sense of horror and dread. They let the spectator know that evil influences are powerfully present. Finally, they provide stability to the printing block. Presumably at this moment in the story there was only one person left standing, and if the print were left blank in the upper corners, the block would be subject to bending, and would not print well. (It still printed unevenly, as there are white spaces in the head of the mother and across the midsection of the criminal.) White space is negative space, in which the white parts of the block do not contact the paper. Keeping the corners off the printing surface while applying sufficient pressure to print the rest of the sheet is difficult, and would almost certainly cause the plate to bend toward the paper eventually. The problem of open space in the corners could have been as easily solved by including background details, as was done in the Bejarano print, but here Posada chose another device that adds to the mood.

This type of story of sensationalized domestic violence is by no means unique to Mexico, notwithstanding protestations of Mexican thinkers about a resurgence of sanguinary Aztec customs. These stories are as old as the printing press itself in European countries, and various theories have been advanced as to their social function.[15] In Mexico, the social function of this type of story was threefold: First, it provided something for people to talk about. The story of the man eating his dead baby, in its content and style of utterance, is one step away from popular folk tale. The parents and the criminal represent relatively simple polarities of good and evil. We do not know if Antonio Sánchez had any good characteristics. Neither can we know if the parents denied other things to their son. The grossness of the crime leads to the suspicion that Antonio was harboring other resentments against them as well, so that he saw this final denial as the last in a long train of abuses; but these complexities are omitted and his bloody deed stands out even more starkly. Next, the reconstructions of mood and speech style in the narration are incompatible with the more modern and impersonal atmosphere of "news." The parents implore him earnestly, with tears in their eyes, reminding him of all the sacrifices they have made for him in the past. Antonio's soul "was invaded by the most horrible poison." His sleeping child "was sweetly smiling" before being dismembered. The story is told as if from the mouth of some well-meaning parent, warning another about the pitfalls of ungrateful children. And third, the conclusion, with the disappearance of the perpetrator's body, sounds similarly folkloric. After all, the criminal's body was exposed for three

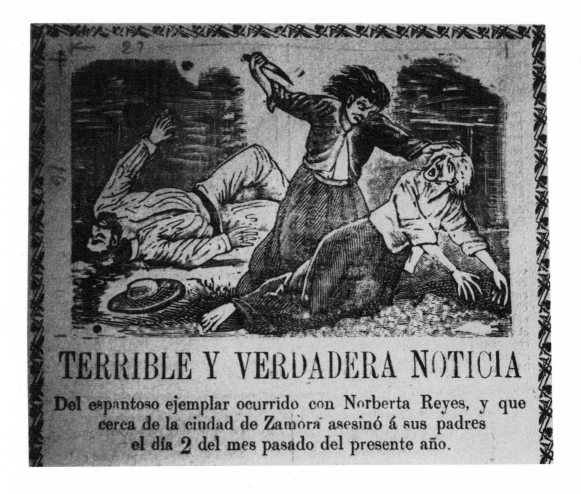

TERRIBLE Y VERDADERA NOTICIA

Del espantoso ejemplar ocurrido con Norberta Reyes, y que
cerca de la ciudad de Zamora asesinó á sus padres
el día 2 del mes pasado del presente año.

hours before the storm struck, a parallel to the three hours of Good Friday.
The tale shows the strong influence of oral culture, as if it were taken down
verbatim from a storyteller. It is located geographically, and the participants
are named, but otherwise it exhibits strong roots in folk tales.

After social function, a second function of this type of story was catharsis.
Most of us have felt a desire to commit crimes, even perhaps of the bloodiest
sort. The freedom of action enjoyed by Antonio Sánchez as he killed, dismem-
bered, and began eating his closest relatives is in some sense enviable. The
home environment can be fraught with interpersonal tensions, disagreements,
and frictions that produce anger and emotional energy in need of an outlet.
Rather than performing such deeds ourselves, we can read or talk about them.

Closely linked with catharsis is the function of reinforcement of traditional
morality. The two go hand in hand in these broadsheets, the one enabling the
other. This particular story carries more than one moral, and in that sense is
neither a passive nor fatalistic response to the problem of evil. Here we see
the ultimate cause of the crime: the vice of gambling. If the text writer was
ignorant of the underlying causes of gambling propounded by the dominant
social thinkers, he or she was obviously concerned about the effect of betting

10. *Terrible and True News.*
Portion of a broadsheet
with white-line illustra-
tion by Posada, 1910.
Half Sheet. Vanegas
Arroyo Family
Collection.

on the domestic economy. Another problem clearly delineated is the rather glaring lack of filial piety. Even before he murdered them, the son showed a lack of gratitude for his parents' past sacrifices and wanted to take further advantage of them by securing the deed to their house. He is portrayed as a bad son, so of course he got away with none of this. He was captured immediately and subjected to a firing squad, but even this was not enough retribution for these multiple sins. His ultimate punishment of dismemberment and disappearance, came allegedly from God. The story strongly supports traditional morality regarding thrift and respect for one's parents. This highly moral conclusion, it seems, also serves to enable the enjoyment of the story's cathartic aspects. We are freer to enjoy the "horrible meat market" in the illustration if we know that in the end the killer will be punished. As one author put it in a discussion of crime stories: "this moralizing was only a palate-cleansing sorbet at the end of a delightfully spicy reading experience."[16]

Posada's intervention in the sheet serves the cathartic function more than the moralizing or folkloric functions. As was usual in this type of broadsheet, he chose to depict the most shocking and depraved moment. If Posada had illustrated the story with the son gambling, or asking his parents for the title deed, or with a depiction of his later trial, or even lightning striking his dead body, the illustrations would better support moralizing functions. The monsters support that function by clearly showing evil influences, but they were also put there for other reasons. Posada's skill at depicting vigor and energy in the scene contributes to its cathartic aspects, charging it more fully with horror and violence.

Various morals were drawn out of these sensational stories, usually placing the causes of crime in personal morality and family relations rather than national trends, ancestral tendencies, or climatic conditions. The story of Norberta Reyes is an excellent example that brought forth one of Posada's greatest images (fig. 10). Like the previous example, this crime took place outside the capital in a small town. Anselmo Reyes and Pascala Rosas had only one child, a daughter whom they named Norberta. She was apparently possessed of "a capricious and irrepressible spirit" which made her "unbearable" to the townspeople but charming to her parents, who, the text suggests, may have doted on her too much because she was an only child. When she reached the age of sixteen she eloped with a man, being already accustomed to do whatever she wanted, and her parents heard nothing from her for a year and a half.

One day she suddenly returned to the house alone, "half naked, shockingly dirty, and with scars all over her body," about which she said nothing. After living at home for a short time, she began quarreling loudly with her parents, so that the neighbors began to notice, and the parents wanted to move to another town to avoid the scandal. Norberta was steadfastly opposed, since she hoped that her lover would one day return for her. She eventually seemed to give in, but on moving day she carefully hid a large carving knife on her person.

When the three stopped to camp for the night, and her parents were asleep, Norberta took out the knife and slashed her father's neck to such a degree that

his head was nearly severed from his body. When her mother began to stir, Norberta attacked her, stabbing her repeatedly so that "nearly all of her insides came out of her body and the poor woman was torn to pieces." The killer then began to wander back toward the village, but on the way got lost. She stopped to rest near the edge of a cliff, where she was attacked by wild dogs who bit her all over and threw her over the edge, where she died. The authorities found the bodies of her parents the next day and buried them, but they could not reach the body of Norberta at the bottom of the cliff, so she remained unburied. The lesson is clearly stated at the close of the text: "This singular example should teach parents their duty to not give in to their children too much, and to control their bad tendencies, even from the earliest infancy." Forty lines of poetry follow, written in the form of a lament by the criminal, in which she expresses great remorse for her deeds and begs her parents' forgiveness. It is a *décima,* a form in ten-line choruses that was used to impart moral lessons. The final chorus reads as follows:

> My parents, whom I adore,
> With cruelty unrestrained
> I left in a pool of gore,
> Their lives, their blood, all drained.
> Dear Mother, please forgive;
> Father, please exculpate;
> Punishment is my merited fate.
> If only in those desert climes
> I had died a thousand times
> Before unleashing my cruel hate!

Posada's illustration depicts the murderer in a veritable whirlwind of terror. A believable three-dimensional space is deftly suggested by overlapping and foreshortening of bodies in the darkness. The father lies at the left in a pose similar to the one seen previously, not quite dead, with legs partially drawn up, head thrown back, and one arm extended. His sombrero is on the ground next to a trail of blood leading to the wound in his neck. The mother has just begun to raise herself, but from the look of her hands, Norberta has pulled her off the ground by the hair as she is about to deliver the first blow with the already bloody knife. The murderer has the flying hair and a frenzied look as she draws the blade back as far as she can. The most amazing aspect of this image is the way Posada handled the figures of the mother and daughter. Norberta seems to be paused at the top of a vicious back-swing which will result in her putting her entire weight behind the blow. The expected diagonal movement is seconded by the direction of the blade, the glance of Norberta, and the arms of her mother. The latter seems to be defying gravity, as we expect that soon she will crash to the ground, mortally wounded, and that Norberta will literally have to pick herself back up from the fury of the blow she is about to deliver. There are no demons here, only darkness, misery, and pure savage desire. The hideous

¡¡Horrible y espantosísimo acontecimiento!!

UN HIJO INFAME QUE ENVENENA A SUS PADRES Y A UNA CRIADA EN PACHUCA.
TERRIBLE TEMPESTAD QUE SE DESARROYA EL DIA 8 DEL MES PASADO.

DON Rafael Hernández y Doña Catarina Sandoval, eran esposos, los cuales vivían en Pachuca. El único hijo que tuvieron en su matrimonio llamábase Ramón Hernández. Tal vez por ser único desde muy pequeño fué onjeto de todo el cariño de ambos padres, consintiéndolo exazeradamente, lo cual hizo que aquel muchacho saliera lo mas perverso que pueda darse.

A la edad de 25 años juntábase con infinidad de amigos perdularios, y con ellos contrajo los mayores vicios posibles: era jugador, enamorado y afecto a los bailes y a todos los vicios prohibidos en el mundo. A sus buenos padres les hurtaba frecuentemente mucho dinero y en la época actual ascendian aquellos robos a diez mil pesos.

El Sr. D. Rafael hizo propósito de corregirle por medio de reprenciones suaves; pero todo era en vano. Por fin el día 8 del mes pasado le dijo.— Oye, Ramoncito, no seas tan malo enmiendate, mira qué ya no me es posible soportar tus vicios. ¿Que motivo tienes para votar el dinero en tantas calaveradas? Diez mil pesos me faltan ya de la caja y si continúas lo mismo, me veré obligado a despedirte de casa.

El inícuo Ramón contestó:

—¡Eh. caramba! ya no es tiempo que me dés consejos es tarde; eso hubieras hecho cuan lo empezaba a tener vicios; entonces me hubieras reprendido y castigado; pero lo que es hoy no te hago caso. Lo que debes hacer es entregarme la herencia que me toca para largarme a otra parte donde ya jamás vuelvas a verme ni a saber de mí.

—¡Oh desgraciado, maldito! ¿por qué eres tan opuesto conmigo? ¡pues no te doy herencia por grosero y desnaturalizado!

Al oir esto Ramón se fué por otro lado: entró en la cocina renegando en silencie de su padre como un condenado; allí tomó una botellita vacía, se la guardó en la bolsa y se dirigió a la calle, con otro mal amigo, consiguió por medio de dinero un veneno muy activo para vengar las palabras de su pobre padre.

Allá en su corazón, decía el alevoso hijo; ¡Ah, viejos malditísimos, hasta que van a morir como las ratas, bien me la pagarán! También la criada es preciso que muera para que no me denuncie con la autoridad: ahora sí: ¡qué dicha! seré el absoluto propietario de los bienes de este vejancón y gozaré de todas las comodidades y pláceres del mundo.

Llegó a su casa simulando una franca alegría el pícaro, traidora e hipócritamente se hincó ante sus padres implorando el perdón por sus pasadas faltas. En esto la criada María Luz, anunció que ya la cena estaba hecha. Doña Catarina contestó que pusiera la mesa. Entretanto la criada ponía el mantel y los cubiertos, Ramón se dirigió violento a la cocina y vertió temblando todo el veneno en la cena. Rápido salió luego y se sentó en el comedor. La criada entonces se fué a probar los guisos para ver si les faltaba sal y luego los llevó a la mesa. El parricida no quiso cenar, diciendo: — No tengo hambre todavía.

A la mitad de la cena, Doña Catarina exhaló un grito y dijo ¡Jesús, Jesús, que me muero! Don Rafael dijo:—Lo mismo me sucede á mi:

Imprenta de Antonio Vanegas Arroyo.—2a Santa Teresa 40.—México.

scene is rendered with a perverse mastery of swirling motion, furious glances, and unconquerable anger.

In considering the dynamism and energy of Posada's work, it is relevant to note that according to eyewitnesses, a print of Michelangelo's *The Last Judgment* hung on the wall of his shop.[17] Copies of this painting circulated throughout France and Spain, and it is likely that one found its way to Mexico along with other European objects. Comparing the two is in the strictest sense a fruitless exercise, since the postures, bodies, and glimpses of the Sistine Chapel do not appear in the Mexican's work. Posada borrowed nothing of such iconography from European "fine art" for his broadsheets, though he did so on occasion for other types of illustrations. But the two, Posada and Michelangelo, do share an urge for restless compositions, populated with bodies that surge with elemental motion. Both were highly adept at managing the power they unleashed, as their compositions do not eddy away to mere disorganized chaos; energy for both seems to surge in waves that suggest deeper sources of power. Neither artist liked to depict figures in repose, motionless, or at rest. If we value Michelangelo in part for his dynamic and original treatment of the human figure, it seems that we ought to accord praise to Posada for the same characteristic.

It makes little sense to talk of stylistic evolution in Posada's broadsheet work. Later images resemble earlier ones, and different techniques are used in no apparent order. Images of notably greater expressiveness or polish appear at almost any point in his career. Many of the sheets are not dated, a fact that further complicates matters. At times in these crime sheets, Posada used a black-line technique, which yielded finer results and showed his draftsmanship to greater advantage (fig. 11). *Horrible y espantosísimo acontecimiento* recounts a story of murder from a family of a somewhat higher social level. As in the tale of Norberta Reyes, the criminal, a son, was an only child, and had been pampered by his parents, so that by the time he reached maturity he was subject to "all of the worst vices in the world," including theft of money from his parents. Once, in fact, his father was missing ten thousand pesos. When the son reached the age of twenty-five his father took him aside one day and told him that if he did not show signs of mending his ways he would have to leave the house. At this, the prodigal son asked for his share of the family estate immediately, and not being granted this, resolved to kill his parents by poisoning them. He carried out the deed, hid the bodies in the basement, stole the remaining money from the house, and fled with a friend.

Eight days later, the neighbors began to notice a strange odor and called the police, who entered the house and discovered the remains of the crime. In the meantime, the murderer began having nightmares in which his parents appeared, calling down God's curse on him and promising punishment. On the same day that their bodies were discovered, he was traveling toward the city of Colima when a hurricane blew up and lightning bolts struck him. The friend fell on his knees and prayed to the Virgin and the Saints, and was thus delivered from harm, but the murderer "was dragged about by a thousand demons," and

12. *Scandalous Event in a Hotel.* Anonymous illustration accompanying a news story in *El Imparcial* (Mexico City), 28 February 1899, page 1.

Don Fernando Martinez Saldaña mata, á balazos, á Don Alfredo Jaymes

ESCANDALOSO SUCESO EN UN HOTEL

his body could never be recovered. In this story the moral element is emphasized more than usual, as the text alleges that the priest in the town preached a sermon on the crime and asked that the story be spread far and wide as a lesson to parents. The broadsheet's text concludes: "Look, oh parents, what happened to the evil Ramón. Read these pages to your young children so that

they will learn to fear God, obey their parents, and always take the path of good."

The illustration focuses on the horrid crime rather than on the more dramatic moment of the son's disappearance in the tempest. We see the son in the center, pouring poison into a food dish. The servant, who had already taken a taste, lies dying at the right. As if to compensate for the lack of violence in the scene, four demons are present, two of whom seem to be urging on the criminal. Posada's usual sense of movement animates each of them, as they and the criminal stand with knees bent and arms raised. In this print, however, the inanimate objects show Posada's use of line to best advantage. The brick stove is drawn with confident and decisive strokes, especially in the inside of the arch, its weight and bulk deftly evoked. Similarly brisk lines issue from the candle on the wall. A deftly drawn still life at the left reveals poetically arranged pottery, skillfully modeled in light and shade. Since the violence quotient in this scene is very low, Posada evidently took pleasure in focusing attention on its minor aspects.

The capital city's leading newspapers were not, in fact, above printing such stories of murder, but when they did the tone was more sedate, the participants more in line with the paper's middle-class readership, and the moral was derived through different characterizations. In addition, the newspaper's art work lacked most of Posada's good characteristics. In 1899, when Treasury Department official Fernando Martínez shot his brother-in-law, insurance agent Alfredo Jaymes, to death in the lobby of the latter's hotel, the city's leading daily carried the story on page one (fig. 12).[18] Jaymes was married to María Martínez, sister of the murderer, but he had tired of her and had initiated divorce proceedings. The separation agreement required Jaymes to pay a monthly alimony, a fact he began to resent when he heard through friends that María was involved with another man. These friends told him that his wife was arriving by train in the capital with this fellow, so Jaymes hatched a plot. He dressed as a charro so as not to be recognized, and when the two arrived on the platform, he took the man aside and said to him, "I like the little cowgirl that's with you." Offended, the man then brought over a police officer, whereupon Jaymes unmasked himself and accused his estranged wife of adultery. Jaymes then lodged in the Hotel Central, engaged a lawyer, and sent a note to his brother-in-law Martínez, proposing that a settlement of divorce be granted without alimony, coupled with a judgment of adultery. Martínez went to the hotel and told him he would not be involved in the matter. A dispute arose in the lobby which concluded when Martínez took out a revolver and shot Jaymes three times. When the police arrived, Martínez "was at the front desk, seemingly calm, contemplating his victim." He confessed and was taken away.

It may seem that Jaymes was the wronged party here, since he was the unarmed victim of a vicious attack, and his wife was with another, but the newspaper went to some trouble to justify the murder by providing a great deal of background information. Jaymes's history was checkered, to say the least. He had been a police inspector, but resigned. Later he was arrested for insulting an

officer, and sent to Belén prison. Moreover, he was "from his youth involved in cruel deceptions." At one point, when he was serving as a sergeant in Veracruz and did not get a promotion, he faked his own suicide, and sent an angry note to his commanding officer blaming him for the deed. This resulted in a court-martial for Jaymes, who was then sent to the prison of San Juan de Ulúa in Veracruz. Regarding Martínez, the murderer, the story was quite different. The newspaper alleged that "reliable sources have informed us of the good background of this man." Married for the last ten years to the daughter of a good business family, whom he supported well, he was reported as "highly esteemed" by his supervisor in the Treasury Department.

The way the newspaper handled this story thus led to a moral about marital fidelity, but there was a less obvious reason for treating it in this way. The primary lesson, of course, had to do with standing by and supporting your spouse. Martínez's dependability is contrasted here with the apparent perfidy of Jaymes. But *El Imparcial* was also attempting to make the man who fired the shots into some sort of virtuous figure because he was an employee of the Treasury. The paper regularly received a government subsidy from that department, which was under the direction of José Ives Limantour, Mexico's leading Comtian economist of the day. Under the guise of encouraging literacy and newspaper reading, the Díaz government gave a monthly subvention to *El Imparcial* which brought its price down below that of all other daily newspapers. For most of the Porfiriato, it cost one centavo or two while most others cost three to six. At the same time, the newspaper became an unofficial propagator of the administration's view on most issues. So when the government bureaucrat murdered the insurance agent in midday in a public place, *El Imparcial* could not stand idly by.

The anonymous illustration on the front page indicates both the social goals of the newspaper and Posada's relative mastery of this type of work. The newspaper artist's use of line here is careful and calculated rather than decisive or free. This can be noted best in the panels on the floor and the shading marks in the trousers of the victim. In addition, Jaymes's raised arm has extra outlines that betray a lack of confidence in rendering tension and movement. The drawing also handles space somewhat clumsily. The feet of the two men would appear to place them several feet apart, yet the pistol seems to be discharging at point-blank range. Rather than Posada's purposeful collapsing of space for expression, or his skillful use of foreshortening, here we get a scene that lacks dynamic space. The artist pays only slight attention to details such as the sign above. The best-rendered figure is that of Martínez, and he looks every inch the gentleman. He carries out his self-imposed duty in a rather dispassionate manner, as he shows none of the volcanic life-force of Posada's violent killers. The newspaper artist, of course, would want to make this scene seem like a gentleman's quarrel over a matter of honor, and it must be admitted that he succeeded. But even though Vanegas Arroyo and Posada often borrowed crime stories from *El Imparcial*, they never saw them through its filters, nor from the perspective of the Comtian positivism of the day.

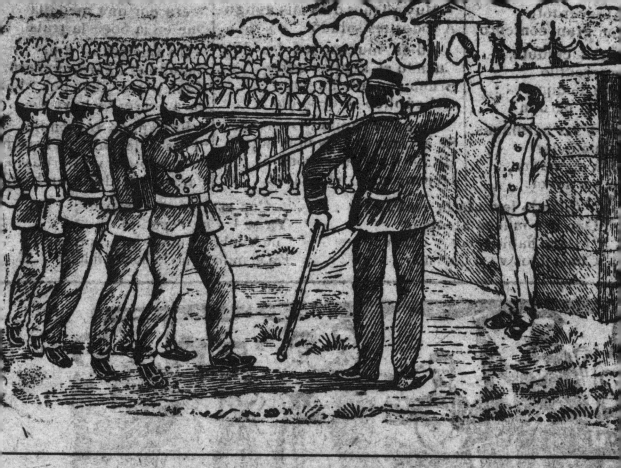

GRAN CORRIDO
DE
BRUNO APRESA

O LA OPERANDAD

a ventinueve de Abril
. aconteció
silaron á Apresa,
mujer lo causó

era un soldado raso
undo regimiento;
caballeria,
dió muerte á un sargento

lo mil novecientos dos
or Don B uno Apresa
r los día los tentado,
rímen *cometió*

inaban de Texcoco
egimiento

Seguir nos dice la historia,
Y lo debemos de creer,
Que ambos tenían relaciones,
Los dos con una mujer

El Sr D Bruno Apresa
Se encontraba haciendo guardia
Y cuando el Sargento pasó
Le dio un balazo en ia espalca

Tarbien á un cabo lo hirió
Con el mismo provectil,
'ues era el que acompañaba
Al Sargento Medellín

El Sr D Bruno Apresa
A Santiago el v en

Dos años duró en
Haciéndole una gran
Y el veintinueve de
Fué cuando lo fùsila

Entrando en la ca
Lloraban sus dos her
Sus lágrimas que llo
Ya todas eran en va

Bruno le dijo á la
Pero con mucho val
Dejen hablarle al T
Para pedirle un favo

El Ten ente se ace
Bruno: ¡que es lo q

PRISONS AND EXECUTIONS

Posada on the Wider World of Crime

The stories behind the most horrifying crimes illustrated by Posada involved the police and penal institutions only minimally, but both the police and prisons thematically dominated many of his other broadsheets. Some of these dealt with prison conditions, some with other types of punishments meted out by the justice system. Many answered the public's insatiable curiosity about executions. The criminals treated here were famous for only a short while, many of them for the single fact of their executions. Yet in these sheets, as in the pages exposing spectacular crimes, human drama is also played out. We see a panorama of emotions, actions, and reactions, not only from criminals, who were most often the protagonists of the extreme situations depicted, but from officials of various kinds who arrested, tried, executed, or otherwise punished them. Moreover, in these sheets the lower-class viewpoint of the illustrator and editor and their tendency to see the events from the perspective of the led rather than the leaders, of the accused rather than the accuser, of the outside rather than the inside of the system—is clearly presented. We will also see that this vantage point differs markedly from that of persons who were active opponents of Porfirio Díaz's regime.

Background information on the Mexican justice system helps clarify the content of the broadsheets. From today's perspective, Don Porfirio's minions were highly efficient prosecutors of crime. A historian recently noted that between 1905 and 1909 the courts of the Federal District charged an annual average of 11,296 persons with crimes of all kinds, and found 97.5 percent of them guilty.[1] This apparent success was due in large measure to the structure of investigation and indictment. Each criminal case was under the direction of an investigating magistrate (*juez de instrucción*) whose functions combined those of judge, investigator, and prosecutor. These magistrates operated with relative freedom when

interrogating prisoners, collecting other relevant facts about the crime, and, at times, coercing statements from the accused or from witnesses. During an investigation, which could take from several days to weeks in the case of serious crimes, the prisoner was held incommunicado in Belén. Only after an indictment was drawn up could the accused hire a lawyer, and by that time many had confessed, signed other self-incriminating statements, or divulged compromising information.

An example of this system in action may be seen in the case of Rodolfo Gaona, at that time Mexico's most famous matador and one of its greatest celebrities. Accused of rape in 1909 without being indicted, Gaona ran afoul of the system and came away rather shocked. He recalled in an autobiography that the judge was "bent on making me sing." He continued, "That magistrate had no respect for a man unjustly accused, and against whom there was no evidence. Ever since then I have had a horror of magistrates, and I think, that if they treated me this way, having a lawyer and friends and money, how would they treat the poor people who fall into their hands!"[2] This system, whose abuses were serious enough to be radically modified in the post-revolutionary constitution of 1917, was borrowed from Spanish precedents.

Focusing most of the system's power on the magistrate lent an aspect of fatefulness to the criminal justice process. Once a person was arrested, they were usually "done for;" little room remained for freedom of action by the accused or by their defenders in fashioning a defense. The system thus acquired an aura of inevitability, a sense that the grinding of its wheels was inexorable. This structure also meant that investigations and trials, compared with punishments, were a far less common subject of broadsheets.

A few statistics bear out this sense of efficiency of the justice system, and also point out the types of crimes and criminals that predominated. In the years 1891 to 1895 inclusive, an average of 12,171 crimes were reported each year.[3] Seventeen percent of these, or an average of 2,159, were robberies; 58 percent, or 7,067, were "woundings," a category that included crimes from fighting to assault to attempted murder; 3.1 percent, or an average of 380 per year, were reported as murders. Most of these woundings and killings were deemed to be caused by transitory angers, bar fights, or other passional episodes. Miguel Macedo, the criminologist who would later head the Federal District Penitentiary, said that well-planned crimes, "elaborately hatched in secret and planned for a long period" were "almost unknown."[4] Moreover, he said, most perpetrators of crime victimized members of their own social class. For the 12,171 crimes reported in an average year, there were 11,097 arrests made. Of the arrested persons, 45.1 percent were reported to be drunk at the time of arrest, 61 percent were unemployed, and 83 percent were illiterate. This meant that in the vast bulk of criminal cases, at least three of the following four adjectives would apply to the accused, in the eyes of the authorities: unemployed, illiterate, drunk, disorderly. Macedo went further and said that, generally speaking, the lower one goes in the social classes, the more immorality one finds. "Crime among the lower classes has reached amazing proportions, which indicates an

infamously low state of moral development. Crime among the middle and upper classes is rare, and indicates a relatively highly developed state."[5]

This class bias in conceiving of the crime problem extended to the policeman on the beat as well, who according to many reports treated the social classes in drastically different ways. "The gendarmes were said to 'humbly incline themselves' before everyone who wore a frock coat and tie. Everyone else the gendarmes treated with 'haughtiness, brusqueness, and insults' . . . The gendarmes commonly accepted tips from the public and the inspectors general usually tolerated this custom."[6] The custom of tipping beat policemen, however much it may have prejudiced police forces, made sense at a time when the average gendarme earned one peso a day, and from this was deducted costs of uniforms and equipment, leaving a salary only slightly above the rate for manual laborers.

The poet and diplomat Amado Nervo reflected in a newspaper column that the low salary made the police inefficient, lacking in professional pride, and unwilling to risk their safety when a situation demanded it. They were like "rainbows, which come only after the storm." A more serious problem noted by Nervo, who was in most other respects a friend of the Díaz regime, was that the police were hated by the lower classes. "The common people are the enemy of the police. The gendarme represents for them repression, intimidation, and constraint, and therefore they hate them. If one commits a crime, and the police try to stop it, they will try to kill or disable the policeman, or at least wound him."[7]

The literacy rate of arrested persons is especially telling, because illiterate persons are less aware of what the laws say, and of what their legal rights are under them, than persons who can read and write. This partially accounted for the high conviction rate, and also made prosecution quite easy in most cases with the application of a little intimidation. When indicted, and confronted with the choice of signing a confession or hiring a lawyer, most defendants signed.

The broadsheets of Posada and Vanegas Arroyo naturally gravitated toward the more spectacular or unusual crimes or punishments, as these held the most interest for the buying public. Of the penalties suffered by convicts, the government was most secretive about the penalty of transportation, and this exaction was the subject of more than one print (fig. 13). In the text, a man who was convicted once too often of drinking and fighting, laments his fate : transportation to the Islas Marías, a group of three islands about 115 miles off the coast of San Blas in the Pacific. Early in the poem, he expresses regret for the style of life that resulted in his plight:

I guess it's not so pretty
To live by fighting and grousing
But I'd rather be in Mexico City
Drinking and carousing.

Tristísimas Lamentaciones de un Desterrado
PARA LAS
ISLAS MARIAS

Ya estamos en la estación
Toditos los desterrados,
En un maldito furgón
Como fieras encerrados.

Yo conseguí que llevaran
También mi pobre familia,
Para que me acompañaran
En mi destierro á las Islas.

Dicen que hay música y todo
Pa poderse divertir,
Me da igual que me afiguro
Que allá me voy á morir.

¡Ni onde me la iba á espantar
Lo que's es un destierro ingrato!
Crey'ba qu'era nomás
Llegar y besar el santo

Por querer hacer cariño
Con la maldita flojera.
Y nomás de puro riño....
¡Qué vida tan lisonjera!

Pero no era tan benéfico
Vivir del puro riñito....
¡Mejor estuviera en México
Dándole recio al pulquito!

Pero niguas valedor,
También era reabusivo....
Y resistí yo el rigor
Del Podér Ejecutivo.

Aquí empiezo á padecer
Por mis muchas fechorías
Me voy derecho á moler
Camino á las Tres Marías

Allá se van á moler
Y á golverse reteflacos.
Mi desgraciada mujer
Y hasta mis pobres chamacos.

Quién me lo manda por flojo
Y no querer trabajar,
Tener tanto vil antojo
Para llegar á robar.

Hora no tiene remedio
La de malas me tocó,
Por andar de muy ratero
Ya la ley me desterró.

He notes that the prisoners are loaded up like cattle in the train station for the trip to the coast. He was able to take his wife and children along with him, but he is sure that they will all waste away to thinness. He has heard that there are diversions there, but he "figures that he's going there to die." The four stanzas on the back of the sheet amount to an extended farewell:

Goodbye, beloved City of my dreams
Farewell, Pulque that I adore
I take my leave with tears and screams
My life is over; there's no more.

Posada's illustration clearly puts the story in the mouth of the peasant, who is also the protagonist and focus of attention here. At times the opposition press in the capital would denounce conditions of transported criminals, but here Posada places those words in the mouth of the actual victim. Presumably he has survived the ordeal of transportation and has returned to tell his story. He shouts to a crowd of people who are dressed in various ways that indicate urban lower classes; no one could be mistaken for a middle-class person. We see no policemen. The reality that he denounces is depicted in the cartouche at the right, a line of agricultural laborers toiling under a nearly cloudless sky.

This peasant was right to dread the prospect of transportation. The government began sending recalcitrant minor criminals to Islas Marías in 1906, and by 1910 over 1,000 convicts worked there in limestone mines, on henequen plantations, and harvesting lumber. The colony was poorly organized; some convicts literally worked themselves to death, others did very little. No pay was awarded for the work, whether one did much or little; record keeping was poor, forcing many to outstay their sentences; and living quarters were not segregated by gender. According to one report, "The colony comprised the worst of two worlds: it was a harsh prison and a community in anarchy."[8]

The capital's leading daily newspaper also reported, in tones very different from those of the broadsheet, on one nighttime departure of ninety-one prisoners from Belén on trains bound for the coast. It said, somewhat sympathetically, that the loading of the cars was accompanied by many "tears and candles: tears for those who will add to the population of the dreaded colony, and candles for the saints who protect the deported." Yet the tone of the article soon shifted to condescension. The prisoners, it said, are "examples of vice, laziness, and immorality, whose profiles may be sinister or contemptible, but all miserable and sordid. There are five or six that are said to be from good families. They try to hide themselves by strange dress, and with disguises to divert curiosity." The train whistle's lonely sound resembled a sad good-bye, a type of "*hasta la vista* which is a new note in the scale of the eternal wail of our common classes."[9]

The institution of transportation of convicts was created at the suggestion of businesspeople who needed labor, but was cloaked in a secrecy that makes finding hard facts about the practice difficult. The Mexican Constitution

prohibited forced labor of any kind, though an 1894 law tried to get around this by ambiguous wording. Intractable petty thieves and minor criminals, it said, would "suffer their punishment in the place that the executive designates, and they will dedicate themselves to the work that it determines." No records were kept of numbers of deportees in any official report of either the Justice or Interior Departments. Neither did President Díaz mention the practice in any message to Congress.[10]

So *Islas Marías* deals with a touchy subject and avoids controversy by treating the dread and anticipation of the convict rather than narrating actual conditions on the islands. A closer examination of this image reveals curious aspects that point to its derivation from an earlier plate that was created closer to the incipience of transportation. The plate on *Islas Marías* is oddly shaped at the top, with a sombrero cut off at the left, and nothing above the campesino's pointing arm. The plate is curved around the hat and arm of this worker and the oval inset. This image is in fact a cut down and remade version of a plate from a few years earlier which purports to tell the story of a deportee who was sent to the Valle Nacional (fig. 14). In this plate the scene varies only in minor details, such as the signature below the oval, the buildings in it, and the shading below the pointing arm.[11]

The subject of deportations to Valle Nacional was as delicate as the Islas Marías case. The valley is a remote and fertile canyon surrounded by thickly forested mountains in the province of Oaxaca, with only one road leading to it. The first convicts sent there in 1895 worked under contract on private tobacco farms for fourteen-hour days with a half day off on Sunday. The Valley also suffered problems of loose record keeping and inhumane working conditions, but in this location the workers were apparently much more closely guarded, and punished with the lash for rules infractions, avoidance of duty, or attempts to escape.[12] Transportation to Valle Nacional was condemned almost immediately in the opposition press as a cruel slavery, a fact that led the government to try to maintain secrecy. Deportations were apparently begun in response to a labor shortage, when growers approached the government, but by the time deportations to the Valley were stopped in 1900, the *patrones* had another system of coerced recruitment in effect. In the places where it was practiced, convict transportation shaded imperceptibly into the practice of *enganche*.

It is this latter method of labor procurement that the poetic text of the sheet denounces; this poem also served as a source for the text of the later Islas Marías sheet. Under the system of *enganche,* recruiters canvassed in urban lower-class neighborhoods promising free transportation to the job in a car, a relatively easy rural life in pleasant climates with a peso a day in wages, and the freedom to end the contract at will. The opening stanza alludes to this:

> I thought it was merely a matter
> Of arriving and kissing the saint.

But the worker quickly became disillusioned with the hard days of work,

heavily guarded conditions, debt peonage at the company store, and inability to escape. Like his comrade on the Islas Marías, the *enganchado* pines for the life left behind, for the pulque, for the women to flirt with, and for the lost sense of community. He concludes:

> Here's the end, my friends
> Of my lament for a life so sad;
> I'm a hopeless *enganchado*
> Who never had it so bad.

As might be expected, the capital's official newspapers saw this system as a perhaps regrettable necessity. An 1899 editorial, written sat the time that transportation was giving way to *enganche* in the valley, and transported convicts were beginning to be sent instead to the Yucatán to work installing a railroad, gives the official view. It was true, admitted *El Imparcial,* that there were abuses in the system, but these existed not in the treatment of the workers, but in the actions of their recruiters. These persons, whose zeal is partially explained by their payment per worker recruited, often enlisted persons "who lacked aptitude" for the work. It is difficult to imagine who may have had such aptitude, but moreover, the paper admitted, the recruiters often oversold the contract and its benefits, at times resorting to the sorts of outright deceits noted in the poem above. If a worker were illiterate, he would be unable to read the contract in any case. In the eyes of the editors, however, the need for labor with which to develop the economic base of that unexploited region outweighed most humanitarian considerations. The protection and furthering of capital interests was paramount. The real root of the problem, according to *El Imparcial,* lay in "the lack of workers for harvesting the agricultural riches of the region . . . In those hot lands, there are immense zones in whose exploitation vast sums have been invested, and whose development is not only useful but necessary."[13] If this meant that some had to endure harsh conditions, then the appropriate workers could be found; this work could provide the moral benefits of labor and a little pocket money for the lower sectors. However, from the sheets by Posada on the Islas Marías and the Valle Nacional it is obvious that the subject people not only failed to grasp the significance of these chances for their own improvement, but that they were also profoundly uninterested in the larger economic picture which supposedly necessitated such labor.

In fact, the Valle Nacional worker said that he would rather be in jail in Belén than farmed out to the Valley, and to anyone familiar with the literature on conditions in the capital's principal correctional facility, this is a shocking statement. The jail was regularly denounced as barbarous, unhealthy, discriminatory, disorganized, and offensive by persons in opposition to the Díaz regime, and occasionally, but less harshly, even by persons friendly to it. Here is how one opposition journalist, who allowed bitter anger to overcome the aptness of his animal metaphors, described the prison in a 1909 book that was published outside the country:

Belén is a superlative example of Mexican injustice and an expression of the fairness of Porfirio Díaz, the Just, the Upright, the Impartial. Belén is not a prison, nor a jail, nor a presidio; it is Gehenna, the hell of the Bible; an unmentionable sore on the body of Mexican justice; an immense sewer which has worms, filth, rotting flesh, diseases, contaminations, and deprivation; stuffed full of jailbirds like sardines in a can, and treated like cattle. It is an abomination on the face of the earth, a human cesspool, filthy and disgusting evidence of the benevolent interest which the old despot takes in whatever is shielded from the view of foreigners.[14]

This jeremiad is only slightly more forceful than copy that regularly appeared in opposition newspapers such as *Diario del Hogar* and more irregular sheets such as *El Hijo del Ahuizote*. But, as we shall see, the position taken on Belén in Posada's broadsheets is considerably milder, aligning itself neither with the regime nor the opposition. Some of the reticence about criticizing may be due to fears of censorship or prison, but not all of the evidence can be made to correspond to such fears, if they indeed existed.

Originally a convent, Belén had been secularized following the Wars of the Reform, and opened as a prison in 1863. Throughout the Díaz regime its inmate population grew steadily, from 1,017 in 1877 to 3,361 in 1896 to 4,414 in 1905.[15] The building was divided into administrative units whose conditions varied wildly. Occupying part of the top floor was a group of cells for upper-class inmates or others whose confinement was a sensitive matter. Incarceration in this deluxe section, referred to by the inmates as the Department of Distinction, came complete with a chest of drawers and a table, fresh linens every day, the best food, laundry service, and a daily newspaper. "It was like living in your own home," wrote one historian, "except that you could not go out to the street."[16] Some of these cells overlooked the patio in which executions took place. A section with its own courtyard, called "Los Pericos," The Parakeets, after a common affectionate name for children, held youthful offenders. The bulk of inmates inhabited cells on the ground floor and the floor above it that opened onto passageways overlooking one of two large courtyards. There was ostensibly piecework available and instruction in crafts, so that the inmates could pass their time productively, but this section was a common target of complaints about unsanitary conditions and discriminatory treatment from officials. The food was meager and of poor sanitary quality, so most inmates benefited from food brought in by relatives. The inmates slept on mats in cells originally designed for one person but which held up to twelve at a time. Many routine supervisory tasks were given to inmates, who were correspondingly assigned ranks such as Corporal, Captain, or Major. Rampant outbreaks of disease persisted, and in fact typhus, contracted in Belén, killed Jesús Martínez Carrión, one of Mexico's leading caricaturists. Outside the entrance an inscription on the wall read "Your entry here is in your hands; your exit in those of God."[17] This was not the only writing on the walls, as graffiti were relatively common. Women were allegedly kept in a separate section, but only a cloth

over the doors separated the two areas. In the basement were ninety-four solitary confinement cells used for punishment or other isolation purposes. They often flooded during the rainy season. The two cells farthest down were called "El Infierno y El Purgatorio," Hell and Purgatory. These cells had no windows, no sleeping mats, a hole for a latrine, and constant moisture. Many of the city's most notorious criminals spent time in one of them. Francisco Guerrero, for example, who was known as "El Chalequero," The Spoiler, was serving a life term for an 1888 rape and homicide after his death sentence was commuted. After spending a while in El Infierno he said he would rather be sent to the military prison of San Juan de Ulúa in Veracruz, which had a reputation at least as bad as that of Belén. Referring to Miguel Cabrera, a leading criminal detective who played a role in many celebrated crimes of that day, Guerrero said: "They say that San Juan de Ulúa is "The Inquisition;" I prefer that, and not this "Hell" which is slowly killing me. Tell Miguel Cabrera that since I have escaped the death sentence that they send me immediately to San Juan."[18]

Administrative problems, many of which were also common in prisons in more "advanced" industrializing nations, plagued the prison. Before photography was used for record keeping, a complicated method of head measurement was developed for inmate identification under the influence of Comtian "scientific" penology. Because of this method's inaccuracy, inmates were often misidentified and sometimes served the wrong sentence. Belén was guarded by about 150 conscripted soldiers, many of whom smuggled marijuana or alcohol to the inmates in exchange for payment. The highest administration of the jail was in constant flux during the Díaz regime. "Only three wardens lasted on the job for more than two years . . . Many wardens resigned from office, but at least one third were dismissed for negligence, embezzlement, or other causes.[19]

The difference between the Vanegas Arroyo broadsheets and the opposition press on the issue of conditions in Belén can be traced in the way both covered a 1910 violent incident in Belén which involved drugs. In October of that year, an inmate under the influence of marijuana went on a rampage with a knife, leaving one inmate dead and two others wounded. The broadsheet treated the incident like a sensational crime of passion in which human depravity found yet another outlet, but with the important difference that the moral of the story focused on the reestablishment of order (fig. 15). The text entered into a fairly minute description of the personal animosity that existed between the killer, Eligio Rodríguez Hernández, and one of his victims who was a Major. "These two inmates were paragons of vice. A few days ago they had a serious quarrel, and since then each has hated the other with profound passion." On the morning of the crime, Rodríguez smoked some marijuana, which put him in a state of "terrible nervous excitation." The Major was the first victim, who was stabbed so severely that "his intestines came out." The second was a guard who was seated at his desk; the third was another inmate who happened by. The guard was able despite his wounds to pull out his revolver and shoot Rodríguez three times, including once "through the left eye." The story concluded with

SANGRIENTO DRAMA

EN LA CARCEL DE BELEM.

Por efectos de la marihuana. Un presidiario hirió á un Celador un Corneta y otro recluso.

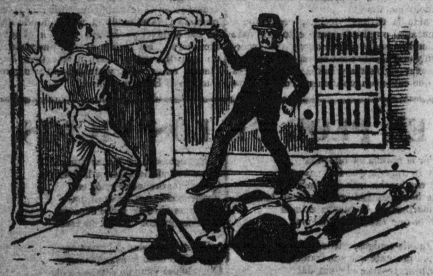

El 24 de Mayo del presente, ingresó á la cárcel de Belem, Eligio Rodríguez Hernández por haber agredido á la policía, por lo cual fué sentenciado á un año y veinte días de arresto, y tenía el cargo de Cabo de un departamento.

Albino Linares Escudero entró á la prisión el día 19 de Agosto de 1891 por homicidio, y, á últimas fechas desempeñaba el cargo de Mayor del departamento de Talleres.

Estos dos presos eran modelos de depravación. Hace pocos días, entre ellos surgió un serio disgusto y desde entonces ambos se odiaban con todas sus potencias.

Nunca se ha podido evitar que hasta los presos lleguen el vino y la marihuana, sin embargo de las enérgicas disposiciones dictadas para suprimir el comercio de esos dos tóxicos.

Ayer, desde muy temprano, Rodríguez comenzó á fumar la hierba, y ya poco después de la hora de la "caridad" se encontraba completamente loco de remate.

En ese estado de terrible excitación nerviosa, recordó las injurias que días antes le había dirigido Linares Escudero en ocasión de su disputa, y resolvió tomar cumplida venganza.

Albino Linares Escudero se encontraba muy ajeno de que en breve recibiría la agresión de su enemigo. Se dedicaba á ejecutar alguna faena, al mismo tiempo que vigilaba el orden de la prisión.

Intempestivamente se dejó oir una clamorosa gritería, y un millar de presos se aglomeró en torno del Mayor. Sobre éste se había arrojado el furioso Rodríguez Hernández, y sin provocarlo previamente sin recordarle siquiera el motivo de la agresión, por la espalda le dió dos heridas una que penetró profundamente en la región subclavicular derecha y otra en la región costal del mismo lado.

Inmediatamente, el Mayor, llevándose las manos hácia la segunda herida, por la

the assignment of the case to an investigating magistrate as the wounded were taken to a hospital. There followed on the back of the sheet a rare signed poem of eight stanzas, by Arturo Espinosa, which is meant to highlight the moral of the story, about the presumed dangers of marijuana smoking:

Your sufferings always become more acute;
Your feelings sharper, but less astute;
You see in such a way the world and time
That all is pain, and all is torment
Until, half crazy, comes the moment
When pure hate will drive you to crime.

Posada's illustration shows a climactic moment, but here it is the criminal's last moment of life rather than that of one of his victims. The wounded officer shoots the attacker in the head while another victim lies on the ground. The scene thus illustrates the beginning of the reestablishment of order, rather than the high tide of crime, a fact that helps to underline the moral of the story. In neither the illustration nor the text is there any denunciation of unsanitary or inhumane conditions. The text mentions the presence of marijuana in the jail obliquely and in the passive voice, glossing over the probable connivance of guards in its distribution. "Marijuana and wine have never been prevented from arriving in the hands of the inmates, despite energetic efforts to suppress traffic in these drugs." Posada's illustration supports this line as well, since the scene is shown clean and well swept.

Readers of the account of this incident in the opposition newspaper *Diario del Hogar* absorbed a different sense of the problem. The narration of facts paralleled that of the broadsheet quite closely, but without the sensational language and focus on shocking details. For this newspaper, the incident served to point out both the corrupt administration and insanitary conditions of the jail. "There is an active trade" in marijuana there, it said, which is "tolerated by the Majors." The reference is to inmate supervisors, from whose ranks came the first victim of the episode. Regarding this trade, the Majors "know perfectly well who sells it and who smokes it." Moreover, given the conditions of life in the jail, such smoking may even be an understandable attempt to escape pest infestations. "If the prisoners smoke marijuana, not all do so out of pure vice; some intoxicate themselves so as not to feel the bites of the bedbugs and other insects which attack them through the night."[20]

The broadsheets reticently depicted poor conditions in Belén, and when a new penitentiary opened in 1900, they waxed positively nostalgic about the place. Despite Belén's reputation for poor management, disease, and danger, it seemed far preferable to the brand new edifice, which represented an effort to adopt a more "scientific" approach to criminal reform.[21] The broadsheets seemed to be on the side of the ordinary prisoner, who had reasons for preferring life in Belén.

The Díaz government had planned to open a penitentiary as far back as the

late 1880s as part of its modernization plan. All of the "civilized nations," said a report, have such institutions, in which life is regimented but healthful, whose "great goal" is to "bring up, to educate, and to improve the morals of criminals."[22] The regimen adopted toward this end was a modified version of the Crofton system, which led inmates through stages of progress. The first stage was the harshest, in which prisoners would work alone at hard labor and spend most of their free time in solitary confinement. In the second stage they were allowed visitors, could begin to attend classes, and could work in workshops; as in the first stage, each inmate spent the night in a solitary cell. The final stage was a type of work release which might involve leaving the institution for short periods, always returning at night. The plan was to have inmates wear colored caps and numbered uniforms that would identify each by name and level, and promotion to the next level would depend on the inmate's behavior and apparent moral progress. The planners of the penitentiary thought that once the system was in place, with a capacity of about eight hundred prisoners, that crime would actually begin to decrease, meaning that the city would probably never need more than eight hundred spaces:

> Persons with wide administrative experience and a deep understanding of social sciences affirm that the rise in the number of criminals brought about by the rise in the population will come to a halt in the capital for various reasons, among them the following: the education of the public . . . the expansion of the economy which the new means of fast communication and transport have brought about . . . the reform of the Penal Code . . . and, finally, the penitentiary itself, which, reforming delinquents, will return to society useful men in place of lazy and corrupt ones.[23]

The opening ceremony took place on September 29, 1900, with General Díaz and most of his cabinet in attendance; the first prisoners were brought over the next day.

In contrast to the official hope and optimism, broadsheet texts dealing with the penitentiary looked on it with unabashed dread (figs. 16 and 17). Paramount among their objections was the threatened loss of community. Less visitation, no importation of food or clothing, and an emphasis on solitary confinement meant that

> There you will have no outlet;
> Gentlemen, everything is sad;
> Because in this new prison
> The silence will drive you mad.

While in Belén the prisoners wore whatever clothing they had on when captured, and accepted gifts of clothing from relatives. The new system of uniforms, colored caps, and limited visitation seemed oppressive:

CORRIDO
De la Penitenciaría de México

Señores tengan presente
Esta nueva triste historia
De los que ahora están pasando
Para la Penitenciaría.

Señores, ahora sí es cierto
De lo que enantes decían
Que en México se iba á hacer
Una Penitenciaría.

Allá sólo van los de años,
Señores, qué triste ha de ser
Que los que tengan sus padres
No los volverán á ver.

Allí no tienen alivio,
Señores; todo es llorar,
Porque en esa nueva Cárcel
Con nadie vuelven á hablar.

¡Año de mil novecientos!
Esto tendremos presente
Comenzaron á pasarlos
Por orden del Presidente.

Adiós, Cárcel de Belén,
Adiós, también los amigos,
Adiós porque ya nos llevan
Para ese nuevo presidio.

Allí están por separado,
Pues cada quién en su celda;
Allí no tienen amigos,
Allí solitos se alegran.

Cuando van para el wagón,
¡Ay! con sus ojos llorando......
¡Ah, qué suerte tan ingrata!
¡Sabe Dios ahora hasta cuando!

Rafael Buendia fué el primero
Y otros cuatro compañeros;
Ellos fueron á estrenarla
Y ellos fueron los primeros.

Buendía les puso un pretexto,
Diciendo que estaba loco;
Su pretexto no valió
Ni lo creyeron tampoco.

Señores; pero Buendía
Su pretexto no valió,
Lo sacaron entre cuatro
Cargando para el wagón.

El corazón se entristece,
De lo que enantes anunciaban;
Veintinueve de Setiembre
Era cuando se estrenaba.

Y al quitarles ya su ropa
Pá darles la del Gobierno,
Dicen todos á una voz:
Ya son penas del infierno.

Allí está por separado,
Cada quien en su cuartito,
Allí ni quien les visite,
Ni quien les dé un cigarrito.

52 Chapter Two

16. *Corrido on the Penitentiary of Mexico City.* Broadsheet with black-line illustration by Posada, 1900. Half Sheet. Tinker Collection, Ransom Research Center, University of Texas at Austin.

17. *Sad Departure of the Prisoners from Belén Who Are Now In the Penitentiary.* Broadsheet with black-line illustration by Posada, 1900. Half Sheet. Tinker Collection, Ransom Research Center, University of Texas at Austin.

They take away your clothes
And give you a uniform.
Everyone replies at once:
"To this hell we can't conform."

In addition, the ration of three cigarettes a day was not enough, and the custom of referring to inmates by number rather than name inferred that one's identity was lost. Several aspects of penitentiary life which were officially touted as advantages were also specifically rejected:

What do I care for this mattress?
I'd rather sleep on the floor.
I'm still a man of pride; besides,
I'm not sleepy here, just bored.
And why do we need electric light
That they've carefully installed?
If our souls are all in darkness
Then light is beyond the call.

In fact, inmates of Belén who were selected to inaugurate the penitentiary protested. Rafael Buendía, the first inmate to be brought over, feigned insanity and caused a disturbance in an effort to avoid transportation. The *corrido* noted this fact, pointing out that it took four guards to subdue him. In its report on

the opening, *El Imparcial,* in contrast, glossed over these details: "A great many of those who have the security of knowing that they will go over to the new Penitentiary complain sadly," it admitted, but "there are others whose transportation to the Penitentiary, they assure us themselves, will be an improvement in their conditions."[24] As for Rafael Buendía, it said, he was feigning paralysis rather than madness.

Posada based his illustration of a cell on a drawing that appeared with a newspaper article at the time of the opening (fig. 17). It depicts a solitary cell with plumbing fixtures, table and chair, and bed; all of these would have been luxuries in Belén. The perspective of the drawing—the rounded roof seems to press down—suggests a somber mood. The seated inmate, obviously despondent, seems not to notice anything in his self-absorbed solitude.

Although severe, the penitentiary paled in comparison to the ultimate penalty the state could mete out: capital punishment. Posada's sheets treated capital punishment in a manner similar to that of the mainstream newspapers. Both focused intently on the last hours of the condemned; both contained graphic pictures of the final act, and sometimes its preludes. It seems that the Vanegas Arroyo shop competed directly with newspapers in this type of story, as at times Posada borrowed directly from newspaper depictions of events for his own prints. Vanegas Arroyo hoped to sell vast quantities of sheets dealing with executions, and circulation figures of the major dailies went up on the days in which they treated of the subject. Sympathy for condemned men prevailed in the capital city, a fact made understandable when we note that the criminals with the biggest press were convicted of so-called "crimes of passion;" they were probably less dangerous to society than habitual street robbers, and none was what may be called a "career criminal." Still, the two media treat capital punishment differently. Broadsheet texts tend to be more sympathetic to the criminal, and sometimes offer slightly different and more personal information about the circumstances. Both media took advantage of a strong public curiosity about state-inflicted death.

Such intense general interest contradicted government policy, which had been characterized by grave reservations about the propriety of capital punishment since the mid-nineteenth century. The Constitution of 1857 stated that once the capital city had a penitentiary, constitutional authorization for capital punishment would lapse. The 1874 Penal Code ordered that the death penalty could be carried out only in a location away from public view, with only the minimum number of officials present as witnesses. These enactments indicated a desire on the part of the Constitution's framers to imitate "civilized nations," and avoid what may be construed as barbarous spectacles. Besides these constitutional restrictions, other customary restrictions remained in force throughout the Díaz period. Judges were reluctant to sentence criminals to death, and the ultimate penalty was actually carried out even less often, due to frequent commutations. For example, in 1896, only ninety-two persons were found guilty of murder, and of those only five were sentenced to death. In the eleven years ending in 1900, there were only three executions in the Federal District.[25] When the

penitentiary opened in September of 1900, a debate ensued about the need for capital punishment, since it was now technically unconstitutional. Death penalty advocates carried the day and amended the Constitution the following year, relying in part on racial arguments about the backwardness and intractability of Mexico's native peoples. Journalist Francisco G. Cosmes, for example, argued that for this reason abolishing capital punishment was impractical. "Indolent by nature, rebellious against all progress, refusing to send their children to school, and without aspirations of leaving the condition in which they find themselves by their own determination, they abandon themselves to robbery and murder, without even the death penalty being enough to intimidate them."[26] Amending the Constitution had no apparent effect on the slow pace of capital punishment, however. In 1906 there were 139 murder convictions and seventeen death sentences, but only two executions.[27]

One of those two people executed was Rosalío Millán, who was also the subject of a broadsheet. A mounted policeman, he had been convicted in June of the previous year of murdering his lover and wounding her mother. He resisted the death penalty, saying he did not think he deserved it. Carlos Roumagnac, a criminologist on the staff of Belén who was an official witness to this and many other executions, recalled him saying, "Since the President has chosen me to teach a lesson to criminals, I won't say anything. But I don't think I deserve the firing squad; worse criminals than I have had their sentences commuted."[28] Millán also attempted suicide by shooting himself. Press coverage in *El Imparcial* was less sensational than usual, since the paper agreed that Millán should not be executed. Whether the editors were moved by the social position of the offender, they never said. Rather, the incident was reported as a "crime of passion," in which the accused killed his wife out of jealousy because of her flirtatiousness. In addition, Millán was merely a "common criminal," not a serious threat to society.[29] Still, the story remained front page news for three days. The newspaper reported that on Millán's last day he was under a suicide watch; that for his last meal he ate coffee and biscuits; and that in his last confession he said "it is cowardly to kill a woman." His death throes before the firing squad were reported to have been unique because he insisted on meeting his maker with a cigar in his mouth. The circulation of the newspaper was well above normal on each of the three days:

March 7	94,797	Before the story broke
March 8	100,187	The prisoner's confession
March 9	115,273	His last day and the editorial
March 10	105,844	News of the execution
March 11	100,550	No news of Millán case[30]

Circulation returned to normal slowly because on the 11th another front page story broke about an American named John Madden arrested in Oaxaca for shooting to death an innocent person.

In contrast the broadsheets treated the Millán execution with empathy, and

¡El corrido más sensacional!

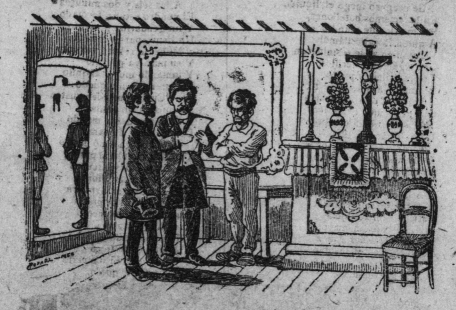

LAS ULTIMAS HORAS
Del fusilado Rosalío Millán.

Pues han de saber ustedes
Que el ocho del mes de Marzo
Del año que va corriendo
Fué Millán encapillado.
 ¡Qué impresión no sentiria
Al entrar en aquel sitio.
Cubierto con paños negros
Y en el fondo el Crucifijo!
 En todo ese triste día
Ya sintiose como muerto,
Sufrió penas muy terribles
Pero ya no había remedio.
 A las siete de la tarde
Del mismo funesto día
Llegó lento el Padre Araoz
A la lúgubre capilla.
 En pie se puso aquel reo
Estechándole la mano.
Y de asuntos diferentes
Aplaticar comenzaron.
 Rosalío á poco tiempo
Tomaba su desayuno:
Café con leche sabroso
Y muchos bizcochos, muchos.
 Después de tomar aquello
Se comenzó á preparar

Para morir santamente
Y empezaron á rezar.
 Desde estos serios momentos
Nadie hasta allí penetró
Y daba terror extraño
Aquel cuadro de dolor.
 Aquel lúgubre recinto
Se encontraba debilmente
Alumbrado desde luego
Con cuatro cirios enfrente.
 De la capilla en el fondo
Junto al altar enlutado,
En un sofá se miraban
Al Padre y al reo sentados.
 Dió lectura el sacerdote
A varios, á varios capitulos
De obras todas religiosas
Que preparan al patíbulo.
 Así Rosalío la noche
Pasó de lo más horrible,
Entre zozobras mayores
Y los tormentos á miles.
 De vez en cuando aquel reo
La hora que era preguntaba,
Pues la muerte inevitable
Ya próxima lo esperaba.

18. *The Most Sensational Corrido. The Last Hours of the Condemned Rosalío Millán*. Broadsheet with black-line illustration by Posada, 1906. Half Sheet. Tinker Collection, Ransom Research Center, University of Texas at Austin.

even expressed a friendliness toward the condemned man (fig. 18). His moods at various points during his last day are mentioned:

> Throughout the entire day
> He felt that he was already dead.

The poetic text agrees that he had biscuits for his last meal, though it asserts that he had "very, very many." When the priest arrived, the two sat down to talk about religious lessons, and they prayed together.

> And Rosalío spent
> His most horrible night
> Sometimes crying out
> In torment and in fright.

At midnight the condemned man asked that his water jugs be replenished. Among his numerous requests for someone to tell him the hour, he asked for some cigars. At four in the morning his defense attorney arrived. At five the priest came back for Millán's final communion, and the official witnesses made their presence known. At six he was marched out to the courtyard of Belén that was used for executions. He refused a blindfold, lit his cigar, and announced, "When you are ready, you may fire." Upon orders from the captain of the detachment, the troop fired and the condemned man fell. An attending doctor ordered a *coup de grâce,* a bullet to the head to finish the deed. His body was placed in a casket and turned over to his family, who, according to the sheet, wept loudly over it:

> It seemed as if they wanted
> To break the dead man's box.

A funeral procession then went to the city cemetery. The poem concludes simply, offering no moral:

> Here the story ends
> Of how it all occurred.
> Of the sad execution
> Of the felon Millán you've heard.

Posada's illustration imparts tenderness and compassion for the condemned. The print does not depict the firing squad, but rather the chapel in Belén where condemned prisoners spent the last twenty-four hours before their execution. Two soldiers stand guard at the door, which looks out to the courtyard where the last act will unfold. (Inmates referred to this place as "El Jardín," The Yard.) In a carefully drawn tableau with an altar and crucifix, Millán is depicted hearing the reading of his death warrant. The scene is rather sweetly rendered, with

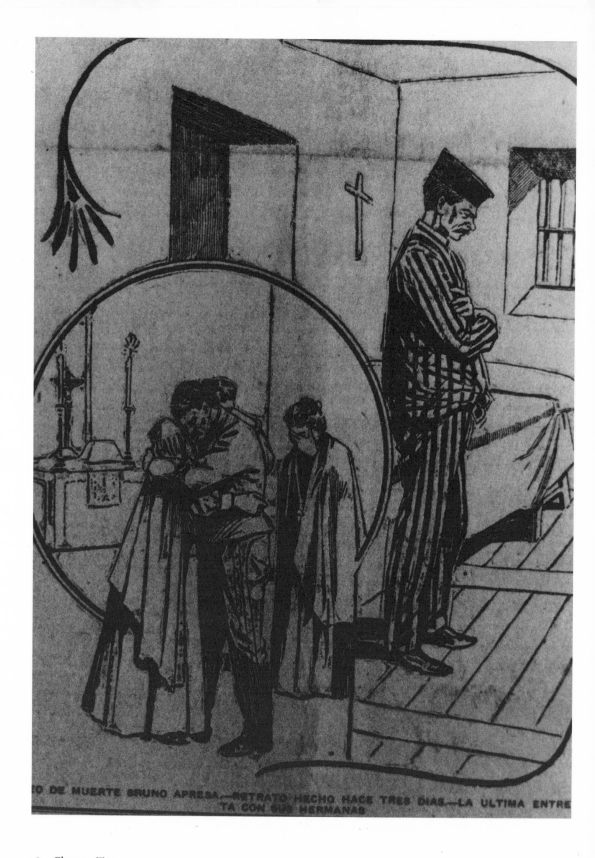

…O DE MUERTE BRUNO APRESA.—RETRATO HECHO HACE TRES DIAS.—LA ULTIMA ENTRE…
TA CON SUS HERMANAS

19. *The condemned criminal Bruno Apresa. Portrait made three days ago. The last meeting with his sisters.* Anonymous illustration in *El Imparcial*, 29 April 1904, page 1.

placid poses and dutiful gestures of the guards and officials (one of whom holds his hat respectfully in his hand), as they stand in the daylit doorway and cast shadows on the floor. Millán's facial expression and crossed arms betray anxiety and resignation. The violence of his crime, his suicide attempt, and his ultimate end are left out of this sympathetic rendering.

In the first decade of the twentieth century, newspapers and broadsheets featured military executions because so few instances of civilian capital punishment occurred. Military executions and the Belén executions shared tragic qualities, but the military executions had a somewhat different atmosphere: there was more ceremony attached to the fact, and sometimes the condemned man made a show of stoical bravery. Such was the case with Bruno Apresa, a career enlisted man who had spent nineteen of his thirty-eight years in the army. His story captured the attention of the capital's residents at the end of April 1904. The public favored his execution, and the newspapers and Posada's broadsheets seemed to fall over each other supplying information about the event. While both emphasized its tragic aspect, the broadsheets—a total of three—were more personally sympathetic to the condemned man. In this case also we see Posada borrowing from a newspaper illustration and altering it in extremely telling ways.

As in the Millán case, the story of Apresa's crime related a crime of passion. In January of 1902, Apresa and his sergeant both loved the same woman. On an occasion when the soldier saw his superior in her company, he snapped and resolved to preserve his dignity by killing his rival. (Broadsheets implied that the sergeant also hated Apresa and would have done the same to him if given the chance; newspaper accounts, which tend to side more with established authority, left this aspect out.) Apresa took advantage of a vulnerable moment to shoot the sergeant through the back; the bullet went on to wound a corporal who was standing nearby. The private was convicted of murder three months later by a military tribunal, and the death sentence went through the required appeals over the next two years. A final appeal for clemency to President Díaz was turned down.

The best explanation for this denial of clemency came from *El Imparcial,* which cited the need to maintain military discipline, including: "any soldier who shoots a superior should expect to pay with his own life," and continued, "The President of the Republic, always magnanimous with civilian criminals, must be inflexible, in the name of discipline, with soldiers sentenced to the ultimate penalty."[31]

The newspaper reported in great detail on how the condemned man spent his last day, and illustrated its stories with drawings made on the spot. The execution was scheduled to take place on the parade ground at the military base of Santiago del Tlatelolco, near the capital, and a temporary chapel was set up nearby in which Apresa spent his last twenty-four hours. Padre Araoz, the same chaplain who would visit Rosalío Millán, visited him there. A drawing on the front page of the newspaper illustrated this meeting, and another showed Apresa grieving in his cell and saying farewell to his family (fig. 19). Along with

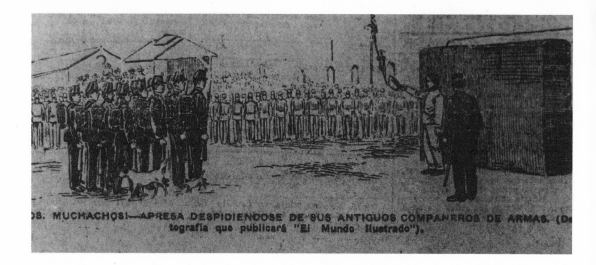

OS. MUCHACHOS!—APRESA DESPIDIENDOSE DE SUS ANTIGUOS COMPAÑEROS DE ARMAS. (De
tografía que publicará "El Mundo Ilustrado").

the usual reports about the last meal came notices about his condition: "The
prisoner shows signs of deep weariness, and he seemed to want to rest, but
sleep would not come; after turning over nervously for awhile, he got up . . .
He frequently asks what time it is." In addition to these detailed reports, the
newspaper offered other information not found in broadsheets, such as the fact
that Apresa had been involved in other fights with soldiers, and had received a
sword scar on his face. Perhaps more telling was the information that he was of
predominantly Indian blood: "Apresa's face has that sad aspect which marks the
members of our indigenous races."[32] Since we do not know the race of the mur-
dered sergeant or that of his and Apresa's mutual love interest, it is difficult to
know what role race played in this case. If either of them were of predominant-
ly European blood, it is possible that the race factor had a great deal to do with
both the death sentence and the lack of clemency. The broadsheet is silent on
these points as well.

News of the next day's actual execution included minute details: before tak-
ing his last march, Apresa asked for a cup of orange tea; in his last moments of
life, he behaved like "a true soldier," refusing a blindfold. The article gave the
dimensions of the wall he stood against. And then came the most dramatic
moment:

> Apresa raised his cap, and with a firm and robust voice shouted "*Adiós
> muchachos!*" He waved his cap twice and tossed it forcefully to his right before
> standing at attention, and thus he awaited death, the blood drained from his
> face, with that noble paleness of those who are strong in spirit, with fixed gaze,
> head held high, in a martial pose which moved the detachment to tears.[33]

The report included a rather grisly accounting of the five bullets that were
fired; three hit a target area in the chest of the condemned man, "enclosing an
equilateral triangle of about 20 square centimeters in area."

The story of the execution was accompanied by a drawing based on a photo-

20. *"Good-bye, Boys!"*
Apresa saying good-bye to his
former companions in arms.
Anonymous illustration
in *El Imparcial,* 30 April
1904, page 1.

21. *Execution of the Soldier*
Bruno Apresa. Broadsheet
with white-line illustra-
tion by Posada, 1904.
Half Sheet. Tinker
Collection, Ransom
Research Center,
University of Texas
at Austin.

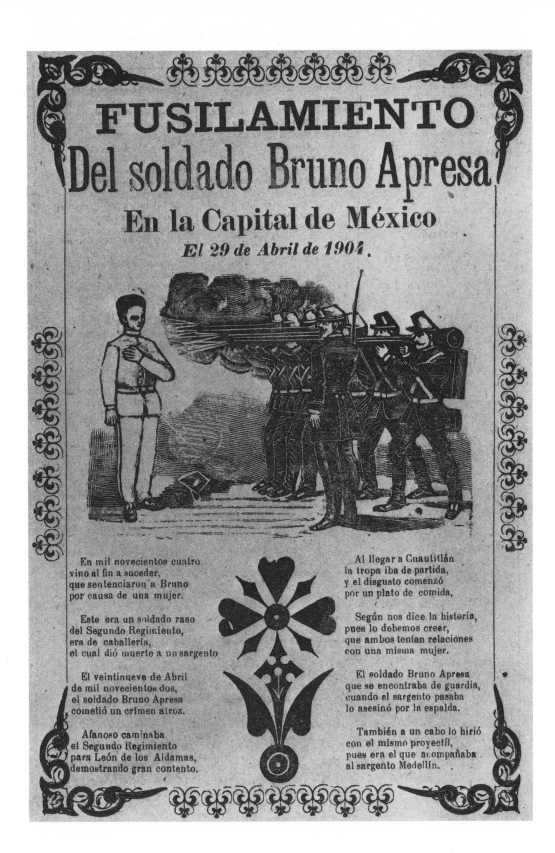

FUSILAMIENTO
Del soldado Bruno Apresa
En la Capital de México
El 29 de Abril de 1904.

En mil novecientos cuatro
vino al fin a suceder,
que sentenciaron a Bruno
por causa de una mujer.

Este era un soldado raso
del Segundo Regimiento,
era de caballería,
el cual dió muerte a un sargento

El veintinueve de Abril
de mil novecientos dos,
el soldado Bruno Apresa
cometió un crímen atroz.

Afanoso caminaba
el Segundo Regimiento
para León de los Aldamas,
demostrando gran contento.

Al llegar a Cuautitlán
la tropa iba de partida,
y el disgusto comenzó
por un plato de comida,

Según nos dice la historia,
pues lo debemos creer,
que ambos tenían relaciones
con una misma mujer.

El soldado Bruno Apresa
que se encontraba de guardia,
cuando el sargento pasaba
lo asesinó por la espalda.

También a un cabo lo hirió
con el mismo proyectíl,
pues era el que acompañaba
al sargento Medellín.

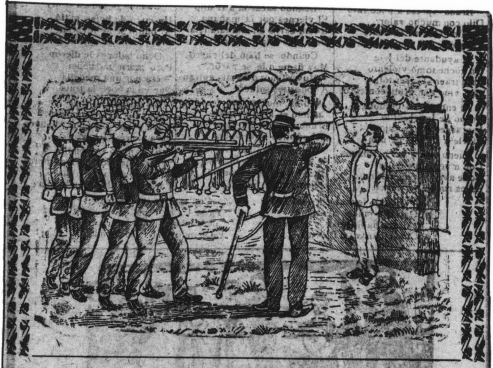

GRAN CORRIDO
DE
BRUNO APRESA.

El día ventinueve de Abril
Señores aconteció
Que fusilaron á Apresa,
Y una mujer lo causó

Este era un soldado raso
Del segundo regimiento;
Era de caballería,
El cual dió muerte á un sargento

El año mil novecientos dos
El Señor Don Bruno Apresa
Fué por los días los tentado,
Y un crímen cometió

Caminaban de Texcoco
El 2º Regimiento
Para León de las Aldamas,
Todos con mucho contento,

En el pueblo Cuautitlán
Estos iban de partida,
El enojo comenzó
Por un plato de comida.

Seguir nos dice la historia,
Y lo debemos de creer,
Que ambos tenían relaciones,
Los dos con una mujer

El Sr D Bruno Apresa
Se encontraba haciendo guardia
Y cuando el Sargento pasó
Le dio un balazo en la espalda

También á un cabo lo hirió
Con el mismo provectil,
Pues era el que acompañaba
Al Sargento Medellín

El Sr D Bruno Apresa
A Santiago lo llevaron
Y el veintisiete de Abril
Fué cuando lo encapillaron.

El Sr Manuel Orera
Un pretesto le inventó
Diciendo que estaba loco,
La autoridad no creyó.

Dos años duró en prisión
Haciéndole un gran jurado
Y el veintinueve de Abril
Fué cuando lo fusilaron

Entrando en la cartuchera
Lloraban sus dos hermanas,
Sus lágrimas que lloraban
Ya todas eran en vanas

Bruno le dijo á la guardia,
Pero con mucho valor
Dejen hablarle al Teniente
Para pedirle un favor

El Teniente se acercó.
—Bruno: ¿que es lo que deseaba?
—Pues ¿qué irán hacer conmigo?
—¡Quien sabe! Yo no se nada

Al ruido de los fusiles
Bruno se puso á exclamar
¡¡Ya están haciendo ejercicio
Los que me van á matar.

22. *Great Corrido of Bruno Apresa.* Broadsheet with black-line illustration by Posada, 1904. Half Sheet. Tinker Collection, Ransom Research Center, University of Texas at Austin.

graph by Agustin Casasola (fig. 20). Here we see the condemned man's last gesture of farewell as the firing squad stands at attention and the commander waits to give the fatal order. Due to the huge public interest in the case, hundreds of troops, some of whom are seen in the background, guarded the parade ground. The close attempt at fidelity to appearance is evidenced by the two stray dogs that are seen walking in the left foreground. As in the Millán case, *El Imparcial* rode a wave of public interest that rose quickly and subsided more slowly as interest faded. Since it was a morning paper, interest peaked on the day of the execution, April 29, when *El Imparcial* would be reporting events of the previous day. The tide of interest was reflected in its circulation figures, which were proudly posted on page one:

April 28	82,547	No news of Apresa
April 29	107,332	Apresa's last day reported
April 30	100,839	News of the execution
May 1	94,137	No news of Apresa
May 2	86,681	No news of Apresa

The Vanegas Arroyo shop participated in the commotion by issuing a total of three sheets on the execution, all illustrated by Posada. These sheets give less emphasis to the martial virtues of Apresa and make him both more human and more heroic; in addition, the broadsheet texts contain more folkloric elements. The first was similar to the newspaper account, except that it mentioned the animosity that the sergeant bore toward the soldier, and gave the names of the military judges who handed down the sentence of death.[34] Some details are sketchier; the sheet makes no mention of his last *adiós,* but says that it took three head shots to finally kill him after he fell, because he had a religious medal in his mouth which would be assumed to have protected him. This story was a rumor that persisted in the latter two sheets.

The second sheet carries an illustration that is the same as the first in every respect except that Apresa's uniform is white instead of black (fig. 21), a change apparently made in the interests of accuracy. Also added for the same reason is his cap on the ground, though it is placed on the wrong side. The text, in 50 four-verse stanzas, asserts that he begged his sisters not to tell their mother how he was going to die, and alleges that he cried upon confessing to the priest, and asked the firing squad not to shoot him in the face. There is also a rather curious account of how an American picked up the tossed cap and offered one hundred pesos for it, a request that the presiding officer denied. This story, which had the status of rumor, supported a common belief about the materialistic proclivities of most Americans living in Mexico. It also recalled the story of the crucifixion of Christ, in which soldiers gambled for his garments. This hinted equation between Apresa and Jesus was reinforced in the third stanza from the end, where it was pointed out that the condemned soldier was born in Salvatierra, a word that means "Savior of the Earth." These details, of course, heighten the tragedy of the event, just as the expressions of his sim-

ple religious faith (evidenced by the story of the medal in his mouth) aid in creating identification between the victim and the reader. In addition, the condemned man's race would also be a strong factor in creating sympathy for him, but the sheet does not dwell on this.

The poem in Posada's third sheet is edited down to thirty stanzas (fig. 22). It leaves out some details of his appeals and his mood the day before the execution, but includes the "*Adiós muchachos*" and the story about the medal. The most interesting change accompanying this sheet is the new illustration, which is clearly based on the newspaper drawing (see fig. 20). Although the new print was probably made in an effort to heighten accuracy, we see Posada's profound dramatic sense at work in his handling of detail. He probably began the drawing near the center, because the outer soldiers of the firing squad seem crowded in, especially their legs. He edited out the stray dogs, reduced the squad's numbers by eliminating ceremonial guards, and pulled the squad much closer to the victim, all of which add to the tension of the confrontation. Mexican firing squads respond to a set of commands very similar to their American counterparts ("ready—aim—fire"), and here the troop is about to fire, but Posada has combined that part of the sequence of events with the prisoner's farewell toss of the cap. We know both from the illustration and from the written newspaper account that they were separate occurrences, with one preceding the other, but by putting them in the same frame again, the artist increases the tension and drama of the event. As if to accent the cap, Posada silhouetted it against a guard tower, a feature missing from the newspaper drawing. There is another change in the soldiers that guarded the parade ground: In the newspaper they are regulars, with the French-influenced cap that Apresa also wore, but in Posada's print they are *rurales,* members of the citizens' militia that patrolled rural roads and highways. Their sombreros and ammunition belts betray this editorial change, which had the effect of placing the execution closer to average people.

For dramatic effect, Posada used his skill and artistic gifts to manipulate space and proportion in *Gran Corrido de Bruno Apresa.* The lateral extension of the scene is reduced and compressed; the soldiers in the far background closely crowd those in front of them; and the entire foreground scene is pulled closer to us. The collapsings provide the desired effect without congesting the composition. In addition, these spatial manipulations alter the scale of the figures in relation to the space of the composition they inhabit. This broadsheet shows Posada's excellent ability to scale and arrange the figures in dramatic composition while preserving the firing-squad format and the need to conform to fact. The figures are neither "larger than life" nor puny and somewhat distant, as in the newspaper. His characters move in a space that does not dwarf them or swallow them up, thereby contributing to the impression that they are purposeful people, each responsible for his own fate. Through subtle body postures, he endows each figure with its own sense of direction and energy, enabling it to acquire individuality. By these means he facilitates our ability to identify with the persons pictured, which is a crucial value if art is to have relevance in the

lives of viewers. Here, and in many other works, Posada shows an innate grasp of pictorial proportions which, by the standards of the Western tradition, is as good as that of many great artists. Beyond this, the effortless quality of the drawing adds greatly to its attractiveness.

Posada's prison and execution broadsheets sided with the accused or the condemned when the judicial system of Mexico functioned "normally," and also when that system malfunctioned. In the most celebrated case of judicial failure, Arnulfo Arroyo allegedly attacked President Díaz, but the populace did not believe official accounts of events. The case resulted in the sentencing of many higher police officials to imprisonment in Belén, and in the mysterious death of an inspector general of police. The two broadsheets on the scandal kept their focus on the lowliest figure in the plot, the accused Arroyo.

Reconstructing a believable account of the events in this case proves difficult because of the extensive bibliography that exists on the matter.[35] At its most basic level, the story unfolded something like this: As President Díaz was taking his usual Independence Day stroll to observe the ceremonies in the Alameda on 16 September 1897, an apparently intoxicated Arnulfo Arroyo lunged out of the crowd and struck him on the back of the neck with a stone he held in his hand. The President staggered but did not fall, and was unhurt. Security forces quickly subdued the assailant and took him to the police station, where he was put in a straitjacket. What happened next depends on whom you ask. The official story, which was disseminated by Inspector General Eduardo Velázquez, was that a gang of thugs broke into the station that night, overpowered the guards, and stabbed Arroyo to death; but this story would never hold. Too many people had seen another group enter and leave the station just before the alleged suspects. Moreover, most of the accused, members of the "gang of thugs," had never owned weapons of any kind. All the accused strongly protested their innocence, and some claimed they had actually been invited by police to enter the station to view the already-dead body of Arroyo, then were arrested for killing him. The scandal rocked the city for several days.

It seems that one of Don Porfirio's cabinet ministers, Francisco Z. Mena, went to visit the president and urged him to get to the bottom of the situation. Mena was an old friend of Díaz's from the days of their revolt against Lerdo de Tejada. He was also godfather to his son, so apparently Díaz listened.[36] A congressional investigation into Arroyo's death was ordered and soon began to bear fruit. The suspects who were held in the murder turned out to be innocent, and suspicion turned to the group that had entered and left the station just before that "gang of thugs." This group was made up of police officials in disguise, led by the well-known detective and head of Don Porfirio's secret police, Miguel Cabrera.[37] Velázquez and Cabrera were both from Puebla, and were, according to one account, longtime associates. Velázquez "knew that he [Cabrera] was useful for 'certain tasks'," such as leading the attack on Arroyo.[38] As these new suspects were taken into custody, Velázquez suddenly died in strange circumstances in his office on September 24. This death is generally regarded to be a suicide: the official report held that he had hired Arroyo

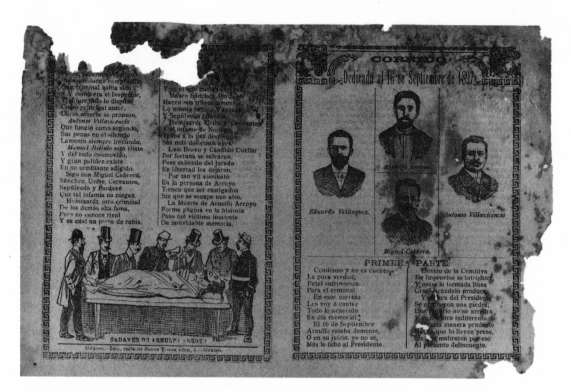

to attack Díaz in an effort to build his own reputation as the President's savior, and had sent Cabrera and his associates in to kill Arroyo when he began to fear that the latter would implicate him. As Cabrera's guilt began to be suspected, the story went, Velázquez had killed himself. Dissenters from this story have held that Velázquez was actually murdered, and that he was acting on higher orders from someone in the cabinet who hoped that Arroyo would kill Díaz and make way for a coup d'etat, the failure of which forced the decision to put Velázquez out of the way. That question has never been answered. For our purposes, it suffices to note that Cabrera and a few others were convicted of murdering Arroyo and sentenced to eight years in Belén. Although he inhabited the Department of Distinction, Cabrera, one of the Porfiriato's star detectives whose secret police connections involved him in many other important cases, served three years.[39] So did Police Captain Villavicencio, who returned to active duty in 1900.

The broadsheets do not oppose the most widely accepted line: that Velázquez hired Arroyo and committed suicide when he could no longer cover up his plot for self-aggrandizement. But the sheets do make Arroyo out to be a mere pawn, the ultimate victim of the machinations of higher-ups, and not a deranged or drunken lunatic. The first sheet was produced shortly after the events, and shows portraits of some of the principals, with Arroyo at the top center (fig. 23). These portraits are based on likenesses that appeared in newspaper accounts of the crimes; note that Arroyo's style of dress betrays his lower social standing. Police Captain Antonio Villavicencio, pictured at the right, was one of the city's most corrupt police officers with his own lengthy arrest record:

23. *Corrido Devoted to the 16th of September, 1897.* Broadsheet with black-line illustrations by Posada, 1897. Half Sheet, 1978.84. Amon Carter Museum.

24. *A Souvenir, My Friends, Of the One Who is Now a Skeleton.* Broadsheet with black-line and white-line illustrations by Posada, 1898. Half Sheet, 1985.22. Amon Carter Museum.

UN RECUERDO, MIS AMIGOS,
Del que ya es hoy calavera,
HÁBLEMOS DE ARNULFO ARROYO
QUE FUE MUERTO DE DEVERAS.

Un Padre Nuestro por él
Y que su alma en paz descanse,
Porque lo hizo calavera
Su buen amigo Velázquez.

Un responso también á éste
Pues después se arrepintié
Y se fué á alcanzar á Arroyo
Para pedirle perdón.

Va á hacer un año que Arnulfo
Al otro mundo marchó,
Por hacerse calavera
Velázquez lo sentenció.

Es cierto que cometió
Un delito criminal,
Pues le asestó al Presidente
Un golpe acaso mortal.

Borracho dicen que estaba
Con tequila y con chorrera,
No contaba con la huésped
De que sería calavera.

Pobre de Arnulfo, en verdad,
Pues cometió ese atentado;
Prisionero fué al momento
Y á Velázquez entregado.

Los dos eran muy amigos,
Y Arroyo nunca creyó
La red que le había tendido
De vileza y de traición.

Velázquez formó un complot
Con gendarmes disfrazados,
Y estos viles asesinos
En la noche lo mataron.

¡Ay que triste y que horroroso
Fué este crimen de deveras,
Sólo al estarlo contando
El cuerpo se escarapela.

Ya debían ser calaveras
Estos grandes criminales,
Donde dieron á probar
No ser más que unos cobardes.

Desinquieto debe estar
Arroyo allá en el Panteón,
Pidiendo que la justicia
Pronto los mande al zanjón.

Velázquez fué criminal,
Pero hay otros tres ó cuatro
Que por hacerle la barba
Con Arroyo se ensañaron.

El que con fierro matare
Con fierro debe morir
Y volverlos calaveras
Por su corazón tan vil.

Han de estar como teleles,
Siempre en la muerte pensando
Pues dicen que ya muy pronto
Vuelven á estar en jurado.

Que la ley sea muy pareja
Y la justicia severa,
Y que paguen su delito,
Volviéndolos calaveras.

La muerte anda en bicicleta
Y es de por sí muy matrera
Y á estos bravos asesinos
Ya huelen á calaveras.

Dicen que están todos tristes
Y aunque el crimen hace un año,
Les manda decir Arroyo:
Que los está ya esperando.

Han de estar arrepentidos
De su crimen tan fatal,
Perdieron á sus familias
De paso su libertad.

La cosa está de piquitos
Y de picotes está,
Pronto serán calaveras
De á medio y también de á real.

Este crimen se lo deben
Al Diablo que fué picudo,
Los empinó de cabeza
Y al infierno van seguro.

En fin, aunque esto ha pasado
A ninguno se le olvida,
Que la justicia sea recta
Y estos tengan el castigo.

Ya que Arnulfo se murió,
Y ahora que es calavera,
Recémosle una estación
Encendiéndole una vela.

IMPRENTA DE ANTONIO VANEGAS ARROYO, CALLE DE SANTA TERESA NÚM. 1.—MÉXICO.

in 1887 for drunkenness, 1890 for fighting, 1891 for assault and resisting arrest, and 1896 for counterfeiting and extortion.[40] Below the portraits, the corrido gives a brief account of the attack on Díaz, and Arroyo's capture. The author of the poem confesses not to know if Arroyo was deranged, drunk, or in his right mind when he committed the deed. The second part, which occupies the severely damaged left half of the sheet, runs down a list of conspirators, beginning with Velázquez and Villavicencio whom it regards as the masterminds. Cabrera and others are named briefly, and severe punishment is ordered for all. The poem concludes with a clear statement of sympathy for the victim:

> For such a vicious crime
> Against Arnulfo Arroyo
> The guilty must serve time
> Not one should escape.
> The Death of Arnulfo Arroyo
> Forms in history a page;
> He was the innocent victim
> Whom we'll remember from age to age.

The illustration below these verses depicts a rather solemn scene, unusual for Posada in broadsheets, in which Arroyo's body lies on a slab as some obviously upper-class persons look on in the company of two gendarmes. Since no pictures of this sort appeared in newspapers, this scene is Posada's own interpretation of an event that may or may not have happened. The top-hatted figures are from the highest level of Mexico City society, and probably represent the members of Congress or cabinet ministers who supervised the investigation. Though each seems to have a slightly different inner state, each figure's bearing is thoughtful, reserved, and respectful, except for the figure on the left, whose slightly stiffer posture resembles a fashion advertisement. It would have seemed ironic to the buyers of the sheet that in order to be the subject of such individual attention, members of the lower classes have to attack the President and die shortly afterward. The fact that Arroyo obtains such aristocratic attention, even in death, underlines his importance as the focal point of the story. A possible further explanation of the mood of the picture is that with the death of Arroyo, a great deal of important information was lost about the plot and who was behind it. We can see here that Posada was not handicapped in his ability to perceive upper-class people and their mannerisms, and that he was able to delineate moods that are more subtle than sensational. In this work, he was drawing on his previous experience as an illustrator of fashionable magazines, in which he frequently depicted such moods and types.

Vanegas Arroyo meant to honor the pledge not to forget Arroyo because a year later he released another sheet with that specific purpose (fig. 24). The poetic text calls for prayers for the repose of Arroyo, and also for Velázquez, who, it is claimed, repented of his evil and joined Arroyo in the world of the dead through his suicide "to ask for Arroyo's pardon." Mention is later made

of "another three or four" who were involved, meaning Cabrera and his associates. It would probably have been too risky to speculate on their fate by name, due to their association with secret police matters, but the text speculates on the guilt that they must be secretly harboring in their minds for their dark deeds. The accompanying illustration seems a parody of the previous one, as Arroyo lies, now a skeleton, face down on a tombstone. Other skeletons, from various social classes, contemplate him. This is a somber occasion also, as it is a tradition on the Day of the Dead to visit cemeteries in honor of deceased relatives or friends. So, though their leering countenances seem to deny it, these visitors are paying respect to the memory of Arroyo, fulfilling what the last stanzas of the poem call for, namely, memories, prayers, and ceremonies.

In all of these cases—the deportees, the first inhabitants of the penitentiary, the executed persons, and the Arnulfo Arroyo matter—the buyers of broadsheets were reading about people like themselves, with little education, of mixed or indigenous race, and subject to the machinations of the authorities. These criminals and victims entered public life by falling into the snares of the system in one way or another, rather than through some sort of achievement. The tenderness with which Posada and Vanegas Arroyo treated them is one of many ways in which they both affirmed the concerns and interests of their audience and refused to go along with upper-class prejudices.

EL VALIENTE DE GUADALAJARA

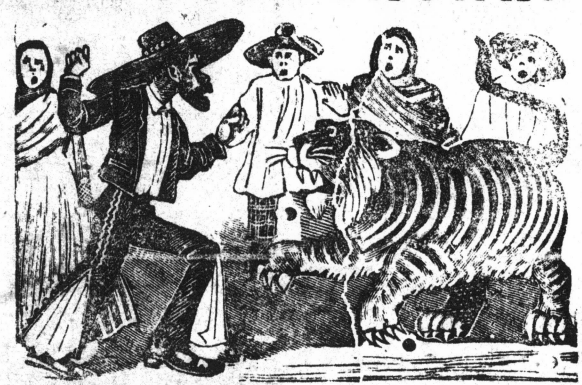

Entrenle al Gualajareño
ntes que se le haga tarde;
ire que no es un cobarde
sí el mentado Briseño.

No soy como el Potosi
Ni jamás he sido arreado
Soy del barrio de Santiag
Y no distingo padrino.

Si porque traigo pechera
guran que soy arriero,
ensan que soy un ranchero
orque porto calzonera.
unque vea yo a la pantera
unca se me arruga el cuero,
orque no conozco el miedo;
a tú lo has visto, Tagarno,
ue a ninguno le recelo
unque fuere Zamorano.

Por Jalisco me pasié
Y hasta les eché la pela,
Solito ya la brillé
Por el barrio «La Canela.»
Ya tú lo has visto, Manuela,
Que nunca soy dejado;
A Jesús Castro he encontrado
Que estaba abrazando a Panch
Me vió y me dijo enojado:
¿Qué no te calientas, plancha?

oOo

oOo

No tengo 1 modo tan feo

Una vida es la que tengo

FOLKLORIC SUBJECTS
AND RURAL HEROES

Some of the characters and situations Posada depicted had little or nothing to do with either city life or the criminal justice system, and belong more properly to the realm of rural folk stories. A few prints depict events on the farm, which probably stirred memories of rural life for many capital city residents. Several prints deal with *valientes,* brave ones, who proudly boast of a regional provenance and brute strength, and are known more by title than by name: The Valiente of Guanajuato, or the Bajío, or Oaxaca, for example. An outgrowth of the *valiente* tradition is another folk story hero that I call the Rural Hero. He shows some of the same characteristics of the Mexican valiente, such as a specific regional heritage and great bravery, but the rural hero differs because he is known by his name, often meets a violent death, and shows more noble personal characteristics. Macario Romero, the most well-known, appeared often in broadsheets. The rural hero is not a bandit, even though bandits, as we shall see, also embody many of these characteristics. The rural folk story, the valiente, and the rural hero all served to remind viewers of their own regional roots and historic past in the rapidly urbanizing capital city.

These prints address the differing cultures of city and country, and the struggle over which set of values would find wider adoption. Rural culture in Mexico was more paternalistic, tradition-oriented, agricultural, and barter-based. Urban culture was more impersonal, progressive, dependent on trades, and wage-driven. This urban/rural division also confronted novelists of the day, who approached the question from a higher-class viewpoint than Posada's broadsheets did. Early in Federico Gamboa's 1906 novel *Reconquista,* for example, the main character, an artist, contemplates modern city life, with its crowds, factories, and class oppression, and feels a strong pull toward rustic life, which

recurs like an "atavism," showing that longing for the simpler rural life is by no means confined to the working classes:

> His nostalgia for rural life urged him to flee the huge city and return to the limitless fields, to the plow and the furrow, to the seeded plain, to the crags and hills, under the summer sun that revives and brings growth to both the people and the grain, to return to the open air and the noble solitude . . .[1]

The artist never returns to the country, but over the course of the novel, his art evolves toward a conception of the "national soul" strongly based in rural realities. In a discussion with a writer friend about the proper subject for art, he reels off a list of characteristics of what he considers the "typical Mexican," characteristics shared by rural valientes:

> Do you want Mexicans? Mexicans you shall have: with leather chaps and decorated charro's sombrero; passionate about women, horses, and weapons; jealous of their independence and liberties; defenders of their home territory; a threat to invaders, who are amazed at their stoicism in the face of death . . .[2]

Gamboa obviously conceived of the "true Mexican" as a rural character, in part because what was traditionally Mexican was retained more purely outside the rapidly changing and Europeanizing cities.

In a 1919 novel, the cultural opposition between city and country was brought home in a different way when Carlos González Peña described a middle-class character of rural origin who was something of a laughingstock because he never adapted to urban manners even after living in the capital for quite some time:

> Beltrán was known as a provincial who had not shed that skin after years of city life. He blushed at almost anything. He became tongue-tied on receiving a compliment. And it was a sight to behold how the wrinkles stayed in the lapels of his jacket, a coarse and outsized cashmere thing, bought in the ready-made store. At least the wrinkles went with those in his necktie—which was usually of brilliant colors and knotted in any way whatsoever—and drew attention away from his shoes, which were generally dull with dirt.[3]

A significant portion of Mexico city residents were either born in the country themselves, or had relatives who maintained ties to it. The Posada prints dealing with country life and regional characters provided a way for the lower classes to remember a previous culture, rather than to help them adapt to a newer one. They continued to buy prints of valientes and rural heroes throughout the Díaz period, indicating that they resisted the pull of urban values.

The tale of *El Ranchero y el Gavilán* (The Rancher and the Hawk; fig. 25), with its many double meanings, captures the struggle between wild nature and cultivated nature, which is at the heart of rural life, in an entertaining way. The

25. *The Rancher and the Hawk*. Broadsheet with black-line illustration by Posada, 1913. Half Sheet. Amon Carter Museum. 1978.133

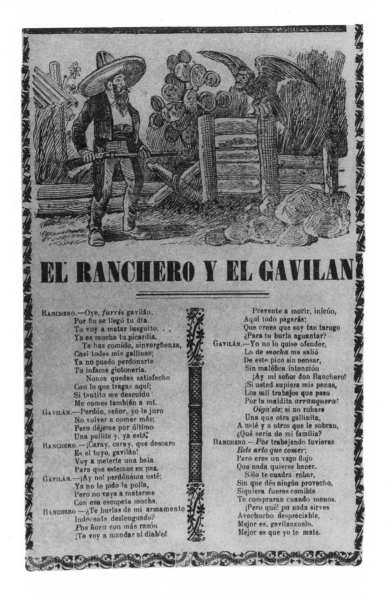

Mexican countryside before the revolution, according to a poet writing in 1939, was "an extension of Viceregal times. Unconnected, because of the lack of railroad transportation, to the rest of the republic, rural people remained unscathed even by the progress of the Enlightenment. There were islands of backwardness in the culture of the time." The poet thus described the rancher's life in this period: "A man of the country, who, beyond the narrowness of his horizons which obligated him to live always with his family, found his outlets in rural duties and in certain sports: rodeos, cockfights, bull-wrestling, hunting, horse racing. He was usually a good horseman and a good shot."[4] The broadsheet's story takes the form of a dialogue which begins when the rancher announces that he will kill the hawk for eating his baby chicks. The hawk, whom Posada pictured with a human face and an interested expression,

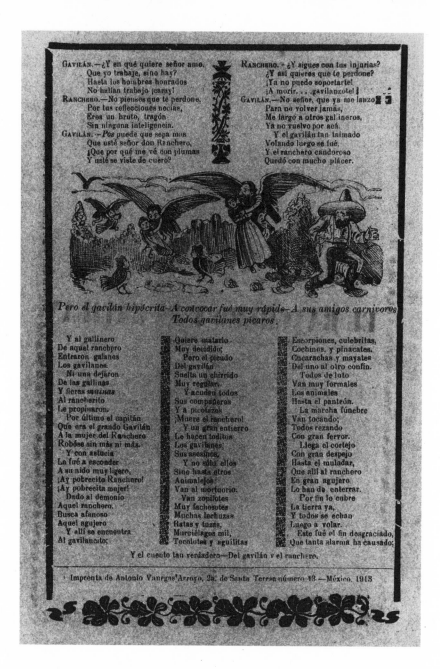

26. Back of the figure: broadsheet.

responds that he, too, has a family to support, and how can he work, since even good men have trouble finding work? The rancher at that point gets angry, so the hawk apparently gives in and flies away. But the back of the sheet (fig. 26) indicates that the hawk only went to rouse his friends, who returned with a vengeance to the farm and captured all of the "baby chicks," including the farmer's own wife (the word "gallina," chicken, serving double duty, as it can in English). The story continues in a verse section , as the farmer finds his wife in a nest, but the army of hawks overpowers the farmer, eventually killing him by pecking at him with their beaks. The story concludes with the farmer's funeral,

attended by well-dressed pests of various species, "praying with great fervor:" vultures, owls, bats, prairie dogs, snakes, scorpions, roaches, beetles, and lice.

Anyone who had lived on a farm remembered being preyed upon by one or more of these natural enemies. Whether or not to kill a hawk may have been a difficult decision, since reasons not to were numerous. One of these was futility, since hawks appeared to be in ample supply and their nests were in inaccessible places. In addition, hawks brought benefits as well, as they eat rodents and larger insects such as grasshoppers.

The two protagonists in the story weigh these points. The farmer complains that the hawk has stolen too many chicks. The hawk apologizes and says he will steal only one more, and begs him not to shoot him with that "ridiculous gun." The farmer takes offense at the hawk's offhand adjective, as applied to his firearm, and announces that he will shoot right now. The hawk then apologizes again, and claims that he must steal chickens in order to support his own family. The farmer urges him to get a regular job and quit the life of the *gavilán*. The hawk then complains that there is no work in the territory. The rancher says he still will not forgive him, at which the hawk, sensing danger, takes his leave. This dialogue's moral subtext reflects on the balance of nature, a crucial concept for farm life. As a vehicle for ethical contemplation. the dialogue form appeared in ancient European popular culture, and in prints, chapbooks, and broadsheets throughout the Middle Ages.[5] Julio Caro Baroja noticed the same characteristic in Spanish popular prints and chapbooks.[6]

The story takes on added significance if one considers that the word *gavilán* also referred to a small-time criminal who lived by his wits in a provincial city: "The poor person, without available diversions, without hope of realizing even his vaguely formed ambitions, (those signs of manhood), [yet] well endowed with energy, and bounding with will, often ended up as a "gavilán."[7] This character was the subject of Gutiérrez Nájera's book-length poem; he slept in abandoned buildings, stole once in a while, lived in and out of jail, took odd jobs when he had to, and had the vice of marijuana smoking. A character such as this might indeed be a threat to the rancher's life if he came to the country, not only because of his vicious ways, but because he came from elsewhere and was not rooted to the territory. To rural womenfolk such a figure may have been attractive. Posada's illustrations personify the feathered gavilán. The human face, the protest of lack of work, the "nest" of thieves, and the winning over of the ranch women all contribute to this story of rural catastrophe that enacts a multileveled cultural struggle.

The sheet titled *El Valiente de Guadalajara* (fig. 27), which was released in more than one edition, combines rural motifs with many regional recollections of Guadalajara, capital of the state of Jalisco. The valiente calls attention to his "typical" attire, and says that many people mistake him for an ox driver or a rancher. This marks him as a rural character, but his social class can be inferred more easily in other ways. The poet mentions Guadalajara and two of its neighborhoods, La Canela and Santiago and also speaks of basketry and leatherwork, two crafts of the region. The print shows him in traditional costume, with

EL VALIENTE DE GUADALAJARA

Entrenle al Gualajareño
Antes que se le haga tarde;
Mire que no es un cobarde
Y sí el mentado Briseño.

No soy como el Potosino
Ni jamás he sido arreado;
Soy del barrio de Santiago
Y no distingo padrino.

Si porque traigo pechera
Figuran que soy arriero,
Piensan que soy un ranchero
Porque porto calzonera.
Aunque vea yo a la pantera
Nunca se me arruga el cuero,
Porque no conozco el miedo;
Ya tú lo has visto, Tagarno,
Que a ninguno le recelo
Aunque fuere Zamorano.

oºo

No tengo el modo tan feo
Y me atoro en cualquier gancho,
Y por doquier que paseo
Donde quiera lavo y plancho.
No crean que bajé del rancho
Ni que me peleo en cuadrilla,
Vengo buscando a la *ardilla*
Porque no sabe plagiar;
Aunque es la fiebre amarilla
La contra le vengo a dar.

Por Jalisco me pasié
Y hasta les eché la pela,
Solito ya la brillé
Por el barrio «La Canela.»
Ya tú lo has visto, Manuela,
Que nunca soy dejado;
A Jesús Castro he encontrado
Que estaba abrazando a Pancha,
Me vió y me dijo enojado:
¿Qué no te calientas, plancha?

oºo

Una vida es la que tengo:
La misma que he de dejar,
Si creen que me ando durmiendo
Todos se han de equivocar.
Jamás me sé yo aplomar
Ni mucho menos me agüito,
Aunque me vean chaparrito
Mi alma nunca se cuartea;
Ya tú lo has visto, Irenea,
Que no le temo al prietito.

wide-brimmed sombrero, waistcoat, and bell-bottomed pants with inserts, as he
seems to taunt a tiger. The animal mentioned in the poem is in fact a panther,
but it appears that Posada favored a more ferocious tiger, showing its teeth and
raising one paw as if to strike. Panthers, of course, haunted rural regions of
Mexico, and a panther's presence in the poem is as strong a reminder of a
regional reality as is the valiente himself. Undaunted, the hero reports on the
back of the sheet that he ran out of challenges in his home territory and had to
search elsewhere:

> This whole country I've crissed and crossed
> In search of braggarts I can toss.[8]

In this work Posada heightens the dualism between observer and observed,
and valiente and enemy. He collapses three-dimensional space into two paper-
thin planes, one containing the main action, which includes only the two
opposed figures, and the other holding astonished bystanders, who apparently
witness the scene at some risk to their own safety. From the images of these
bystanders, Posada conveys his vision of the audience. They are meant to repre-
sent the urban peasantry who bought the sheets, and their clothing is typical of
that social station, with sandals, shawls, tunics, and sombreros. The valiente is
not only bolder, larger, and foregrounded, but much more colorfully dressed
than they. His motion appears to be forward, left to right, toward the animal,
whose posture and gesture seem defensive.

The valiente's boastfulness, taunting gestures, and use of slang mark him as a
member of the lower classes; a principal difference between Posada's characters
and those of the Spanish drama from which they descended. These Mexican
bravos are the offspring of the valientes of Spanish drama of the golden age.
Many plays used valientes as title and main character: Fernando de Zárate's *El
Valiente Campuzano* and Luis Vélez de Guevara's *El Valiente Toledano* are two of
the best-known examples. It is doubtful that the Spanish valientes would recog-
nize their progeny, however, because important differences between the two
forms point to the differing social setting of each. The Mexican rural valientes
are also quite distinct from characters that were referred to by the same name in
the capital city itself. These city valientes had higher-class pretensions and never
appeared in Posada prints.

The Spanish valiente's social status is always clear: while not of the highest
classes, he is always of "good blood," perhaps an "hidalgo," a word that is a
contraction of the phrase "hijo de algo," or "son of somebody." In Cristóbal de
Monroy y Silva's play *El Más Valiente Andaluz Anton Bravo,* for example, the title
character is described, in addition to having good blood, as "cuerdo y afable"
(genial and clear-headed), and admired throughout Spain for his bravery. In
fact, a maid points out that on tales of his courage young boys are weaned.[9]
Like most Spanish valientes, Anton Bravo's task in the play is to right a wrong,
in this case to protect a woman from a threatened kidnapping by a rejected suit-
or. In attempting to do this, Bravo—the name is far from coincidental—runs

NUEVOS Y DIVERTIDOS VERSOS
DE UN VALIENTE DEL BAJIO

A SUS VALEDORES.

Aquí estoy por que ya vine,
Por que quiero y por que sí,
Vengo á ver si encuentro uno
Que pueda igualarse á mí

Soy de Ranchería de Amoles
De la pura Sierra soy......
Y soy de lo más hombrote
Y á cualquiera parte voy.

Traigo mi caballo prieto;
Buena silla de montar;
Una rechulona cuarta
Y espuelas de apuntillar.

Suave reata, buen machete
Y mis pistolas de á par,
Mi jorongo potosino;
Mi charrito del Palmar.

Toquilla de *ciertopelo*,
Barbiquejo de juglar,
Ando forrado de cuero
Como charro caporal.

Porque me dá la real gana
Y á ningun cuerno le vá....
Con mis tacos de baqueta
Que á mí retebién me están.

Al pinto que no le cuadre
Que se vaya á rebuznar,
Y sabrá lo que es la leche
Que se toma en mi corral.

Yo he lidiado toros bravos
No gatos de garbanzal......
Nomás no regüelvan la agua
Porque así la han de tragar.

He bajado por el pueblo,
Porque los vengo á tantear;
Buscando á los jugadores
Que juegan tan bien billar.

Mi machetito es el taco,
Las ganas me han de sobrar;
La mesa el purito campo
Donde hemos de juguetear.

No le hace que sean grandotes
¡Si no los he de cargar!......
Y si se encuentran muy débiles
Gordas llevo en mi costal!

No crean que de hambre estoy flaco
Mis carnes así han de estar;
No por que me ven chaparro,
Crean que he de reventar....

La ley está en los chaparros
Y se los puedo probar.
Lo único que les encargo;
No se vayan á rajar......

Con ustedes me recreo
Y me los llevo á pasear,
No le hace que se amontonen;
A todos puedo tantear.

Traigan sus viejas si quieren,
Yo las puedo contentar....
Les mantendré á la familia,
Soy *peche* pá trabajar.

Y córrenle y no reculen
Que no los voy á tragar,
No se espanten con la sangre
Ni se vayan á llamar.

Soy su papacito, chulos,
A quien han de *respetar*....
No más no regüelvan la agua..
Porque así la han de tragar.

afoul of a local sheriff who remembers an old false charge against him in another city, but the valiente brushes him aside, holding to a higher standard of morality. In addition, he betrays his upper-class birth by speaking in suave tones, at times using Latin phrases with allusions to historic warriors of the past. He once referred to an enemy who seemed to be sent by the Roman god Mars, bearing "aquel empeño de Marte" (the war-god's burden).[10] Later in the same monologue, he compares himself with Alexander the Great, Xerxes, Hannibal, Mithridate, Pompey, and Scipio. Lest we confuse this with the boastfulness of the Valiente of Guadalajara, Bravo excuses himself in advance for "exceeding the decorum of modesty."

The Spanish valiente concerns himself with right and wrong, and even though he is at times outside the law, he prefers to be within it. When a chance arises later in the play to make a case for his innocence of the earlier false charge, he does so with some relief, so that when an official says he will plead with the governor for Bravo's innocence, the latter replies "I gratefully throw myself at your feet."

Against this backdrop, *El Valiente de Guadalajara* represents a lower-class appropriation of the traditional character. If the two share a fair measure of physical courage, the Mexican variant is both more and less than his predecessor. Less educated, and of a lower social status, he knows nothing of the subtleties of language and learning. Moreover, he shows little interest in moral distinctions, as he is willing to take on anyone, anytime. Indeed, as the print makes clear, his alleged domain extends to the animal kingdom. On the other hand, the Mexican valiente is more rooted in the local culture than his Spanish counterpart. The Mexican's clothing and the setting of the poem are both firmly attached to a specific region. Anton Bravo shows little of what is traditionally considered Andalusian. The urban lower classes of Mexico, in appropriating the Spanish valiente, took what met their needs for a connection to a regional culture, and left out the social class distinctions.

El Valiente del Bajío (fig. 28), shows different regional characteristics. The early stanzas of the broadsheet's poem reflect Mexico's "heartland," the high plains region where horse culture and cattle raising predominate, and describe a well-appointed *charro*. This valiente says that he has a black horse, with his own saddle, spurs, lariat, machete, pair of pistols, poncho, and leather chaps. Posada's illustration (which is signed just above the corner of the pool table) depicts a formally dressed charro, with decorated sombrero, jacket with epaulets, and sash about the waist; in his hands he holds a riding crop. This variance between verse and illustration serves to accent the difference between the valiente and his observers. He is restraining an apparently high-spirited dark horse, but, as in the previous print, *El Valiente de Guadalajara,* spatial ambiguities come into play, as the valiente and his horse cannot be inhabiting the same ground line. In similarly ambiguous location are the billiard players, who look up with some apprehension at the new arrival. Their nondescript dress looks appropriate for urban tradespeople or shopkeepers.

The boasts of this valiente are somewhat different from those of the one

from Guadalajara, though the Valiente from the Bajío also announces himself with a braggart's flourish:

> Here I am because I already came
> Because I want to and that's all.
> I'm looking to see if anyone's here
> Who alongside me can stand as tall.

He then proceeds to boast that he can dominate the billiard-playing urbanites at their own game, since he will use his machete as a cue stick. He also proposes to out-drink any of them, offering to down a quart of tequila and twelve glasses of beer. He has apparently arrived in town for a wedding (hence the formal attire), and claims that if he desires he can carry off the bride. His charro accoutrements, and other aspects, place his provenance explicitly at Ranchería de Amoles, a settlement in *pura sierra*, (the authentic highlands). He has eyes like an eagle, and has subdued the wildest bulls. The encounter between urban and rural cultures here is accompanied by some anxiety, as if the billiard players know that they have met their match.

The ability to manage horses conferred important social status in rural culture. The charro had a different set of skills from the landlocked farm laborer, and a greater mobility and larger investment in equipment. Owners of haciendas prided themselves on their stables of horses, and gave the job of caring for them to only the most trusted workers. This was illustrated in the 1919 novel *Fuertes y Débiles,* which depicts life in the city and country on the eve of the revolution, though again from a higher-class viewpoint. Bolaños, the patrón of the hacienda, gives the job of stable master to Chema, but the owner's seduction of Chema's wife leads the worker to retaliate against his boss in the one way he knows will harm Bolaños while still providing the hope of impunity for Chema: he poisons the patrón's prize steed, and when it begins to weaken and die, he pretends to attempt to cure it. The novel's theme exposes the apparent incompatibility of urban and rural values. On trips to his townhouse Bolaños shows that his impulsiveness and rural rough edges get him nowhere among the Europeanized upper classes of Mexico City. At one point Bolaños becomes involved in a tennis game, but is unable to restrain his temper and physically batters his opponent in the locker room at the game's unfavorable conclusion.[11]

In Mexico City the urban valiente was a creature of the upper classes who went about righting wrongs of an altogether different sort from the rural valientes. "Los valientes" were mockingly described in an 1899 Mexico City newspaper article as "generally persons of the leisure classes, who live from rents or by borrowing from friends and admirers; who pass the good life busying themselves only with maintaining a reputation as men of mettle." There follows a supposed diary entry from one such valiente, who noted on April 7: "I rearranged the face of an Englishman in the cantina 'La Mona.' He had brusquely pushed me aside while approaching the bar, so I let him have it with

my cocktail in his face, and followed it with my fist."[12] The author noted that sixteenth-century values of honor and chivalry live on in urban society, as these valientes, like those of old, never suffer a wrong.

A similar phenomenon was noted years later by an author who recalled the urban valientes of the Díaz period as "sons of illustrious families . . . well educated and gentlemanly in their outward bearing, attentive toward women, aloof and dandified in their appearance, but vaguely vicious in their more intimate customs." They have the habit, the author said, of "forming gangs of valientes who go about provoking fights in cantinas and salons," but these quarrels are usually short-lived (unlike that of Bolaños above), as the perpetrators "soon offer a friendly peace, and seal it by buying their victims a drink." The author concluded with a reflection on the varying customs of chivalry in that time and this, noting that while Mexico had been independent from Europe for some time, during the Díaz period, "it continued to be subject to the customs, habits, and traditions of centuries long dead."[13] As might be expected, this urban type of valiente had no utility for the lower classes, so it never figured in Posada's broadsheets.

The two Mexican valientes, from Guadalajara and Bajío, share a well-marked tendency toward a rather indiscriminate braggadocio, in contrast to their Spanish counterparts. The latter usually serve some sort of social good that is widely recognized: personal honor, a village's safety, or, in the case of Anton Bravo, the protection of a woman's virtue. The Mexican valientes perform no such social good, nor do their actions protest against society as presently constituted. Their regional identity provides the bare bones of their social setting, but, as in many other aspects of broadsheet culture, their connection to the dominant social order is tenuous; in this sense they are "free agents," even freer than the Spanish valiente. Their actions neither support nor oppose any political reality or structure beyond that of machismo. This freebooting may be a product of social frustrations, closed paths, or the result of lack of opportunity. The valientes are like loose cannons, bursting with barely focused energy.

The Spanish valiente Anton Bravo shares one further characteristic with many Mexican broadsheet heroes: he meets a tragic end. Tricked by some supposed friends, he dies of a sword wound on stage in the last scene. This tragic aspect permeates Mexican broadsheet culture, and some Mexican valientes also end this way. The most notable case is Macario Romero, a soldier who was celebrated in various editions of the same corrido (figs. 29 and 30).

As with other valientes, Romero stood for traditional values with roots in country life. According to what history can be reconstructed, Romero was a soldier in the *Cristero* revolts during the rule of President Sebastián Lerdo de Tejada. Following the death of President Benito Juárez in office in 1872, Lerdo, who was then presiding judge of the Supreme Court, succeeded him in office to fill his unexpired term, and was then elected president in 1876. (Later that same year, Porfirio Díaz, announcing a plan of "no re-election," seized power.) Lerdo was closely aligned with the secularizing program of Juárez, and both, inspired by Enlightenment ideas, crusaded to lessen the influence of the Roman

Catholic church over Mexican life. This struggle was characterized by outright conflict in the famous Wars of the Reform (1858–61), and the traditionalists, sensing weakness in the later rule of Lerdo in the 1870s, rose up in sporadic revolts dubbed Cristero, "devoted to Christ." Beyond a strengthening of the church's influence and a recovery of its expropriated properties, the Cristeros favored a tradition-bound, aristocratic society governed more by ancient custom than by the modern rationalism favored by Juárez and Lerdo.

Although the available corridos on Macario Romero do not mention his religious beliefs (except to note that he called for God's punishment of his betrayers), they do seem to agree that he was correct and chivalrous in his treatment of others. In this respect Romero resembles Anton Bravo more than do the Mexican regional valientes. *Verdaderos Versos de Macario Romero* (see fig. 29) states that Romero "was a friend to all men/ and loved them from the heart." Another claims that

> He had a good heart
> And good manners as well,
> Always a friend to men
> And a servant to women.
> He was everywhere admired
> For his nobility and gallantry.[14]

Romero was a true valiente, a brave man who merited the label.

A forbidden romance with the daughter of the Lerdista provincial governor of the state of Morelia, where Romero was active, caused his downfall. This governor, Vicente Llamas, sensed an opportunity to rid himself of a problematic enemy when his daughter wanted to invite Romero to a dance. Romero first

29. *True Verses About Macario Romero.* Broadsheet with white-line illustration by Posada, 1904. Half Sheet. Tinker Collection, Ransom Research Center, University of Texas at Austin.

30. *True Verses About Macario Romero.* Broadsheet with black-line illustration by Posada, not dated. Half Sheet. Amon Carter Museum. 1978.169

sought permission from his general, Abraham Plata, to visit his beloved, but Plata refused him, citing the danger of entering the heart of enemy territory. Romero, pulled by love and emboldened by self-confidence, went anyway and walked into a trap. Shot five (or perhaps six) times, he died slowly, only after bidding good-bye to his beloved and announcing that his brother would wreak vengeance. The tragic aspect of the corrido is heightened by the narrator's final leave-taking, where he threatens to break down:

> Now I'll say goodbye
> In order my tears to save
> About the story of the man
> Romero the valiente: the brave.[15]

Posada's illustrations appear to have little to do with the corrido on the sheet, and they include some important but historically questionable additions to the story, which suggests that Posada and his publisher were trying to be kind to President Díaz. One of Romero's descendants alleged that the valiente died in 1878,[16] during Díaz's first term in office. Whether by then General Plata's division of Cristeros had been disarmed remains unclear. If so, this would indicate that Governor Llamas could not bury the hatchet, an entirely plausible supposition. If not, then Romero could easily have been in arms against Díaz as he had been against Lerdo. Some allege that Romero willingly joined Díaz's army and served loyally,[17] but this seems improbable since Díaz had been an associate of Juárez, and had made no moves to placate the Cristeros by the time of Romero's alleged death. Díaz's military coup of 1876 was in fact accompanied by much disorder, and Díaz dealt harshly with captured Lerdo supporters, ordering the cold-blooded murder of several of them. Both the text and the illustration completely bypass these questions by making Romero's enemies not the Lerdistas or Díaz, but Indians. In both prints, Romero is shown trampling or frightening natives in feathered headdresses, and the first eight lines of text allude to Yaquis and Apaches. It is quite implausible that Romero could have fought these groups, however, since Díaz did not begin campaigns against them until much later. The style of the eight-line introduction to the corrido differs considerably from the rest of the poem as well, as it is a vicious first-person boast about vanquishing

> Numbers of Yaquis in guaraches
> And how many cursed Apaches . . .

A more usual corrido opening, which harmonizes with the poem's conclusion, follows:

> I'm going to sing these verses
> With my heart's true affection
> About Macario Romero
> to bring his deeds to reflection.

This suggests that the eight-line introduction was a later addition. Most corrido collections that include the rest of the poem indeed omit this boastful opening. The effect of Posada's illustration and the appended opening is to remove the story from its murky historical context. It may have been an effort to highlight Romero's identity as a valiente, since by the time these prints were made in the 1890s, campaigns against indigenous peoples were in full swing, and it is easy to imagine those campaigns as situations calling for bravery and courage. If that was the motivation, then it had the effect of aligning Romero with the Díaz government. At least the change has the effect of partially de-fanging Romero as even a potential enemy of Juárez and Díaz.

Posada places Romero on horseback in both broadsheets. This move, while it is not out of accord with aspects of known corridos about Romero, adds to his

social status, but the iconography of the equestrian figure, especially the rearing one from the Amon Carter collection (see fig. 30), does more: it borrows from a long heritage of such honorific images that were known to even the lowliest Mexico City dweller. Placing Romero in a heroic equestrian posture amounts to an appropriation of a positively hoary visual tradition dating back to the equestrian monument to Marcus Aurelius. In medieval manuscripts, the Three Magi are often seen approaching Bethlehem on horseback. The iconography of the medieval knight almost always includes equestrian accoutrements, conveying the sense of an important person on a heroic mission. Popular prints throughout Europe traditionally depicted mercenaries, knights, kings, avengers, and crusaders in this way. Mexicans might have seen examples of this tradition in Spanish popular prints imported to Mexico, and most of the residents of the capital were familiar with Manuel Tolsá's 1808 large equestrian bronze of Spain's King Charles IV. The Romero corrido suggested that he be depicted in this way, as the hero's beloved says that she can recognize him "at a distance of a league/ on his ash-colored steed."[18] Depictions of heroes on rearing mounts are far less common in outdoor monuments because of the inherent instability, but Diego Velázquez painted portraits of members of the Spanish royal family on rearing horses, and Posada may have seen prints of these works. In any case, he borrowed the accumulated heritage of centuries of equestrian imagery in depicting Romero in this sort of pose. Posada also depicted bandits in this way, a fact that points out similarities between the myth of Romero and that of the outlaw.

Whether the Europeanized city or the rural life represented the "real Mexico" was a question brought home forcefully by the time of the Revolution. Rural people filled the armies of the regional warlords Villa, Zapata, and Obregón, and determined the outcome of the conflict as they struggled against the Europeanized old regime. José Vasconcelos, at the outset of the violent upheaval, wondered in his autobiography if perhaps the rural type was truer to Mexico's identity. His apparent scorn for them added oddly to his credibility:

> I felt strange among these people who wore tight pants, the ropers and cowboys who spoke mostly of cockfights, bets, and bull-wrestling. And, with astonishment but without sympathy for that kind of life, I asked myself: Could this be the true Mexico, this and not the European courtesies that we maintained in the cities? At least the long "Porfirian Peace" had relegated these vulgar types to their places.[19]

Even Vasconcelos, who after the revolution instigated the mural painting program that employed Diego Rivera, José Clemente Orozco, and others, seems somewhat surprised by the vitality of rural cultural life, to the extent that he hesitates to cultivate them as allies in the struggle to overthrow Díaz. Clearly Posada and Vanegas Arroyo played a role in the preservation of just such values.

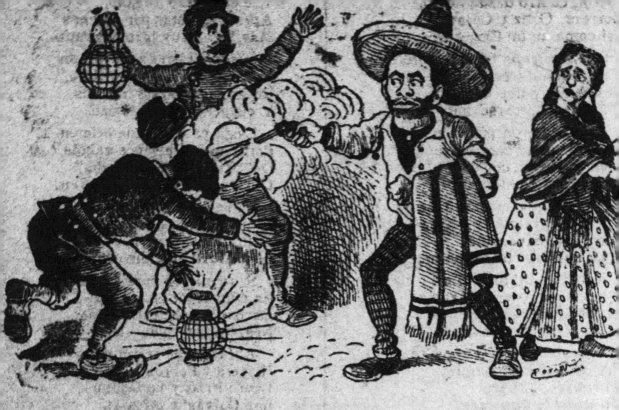

LA VIDA DE UN BANDOLERO
LOS CRIMENES MAS NOTABLES DE
JESUS NEGRETE
(a) El "Tigre de Santa Julia."
(APREHENSION DE SUS COMPLICES.)

Vamos á narrar los crímenes
Mas notables de Negrete.
Los cuales se han descubierto
En México últimamente

El Coronel Felix Díaz
Trabajando sin descanso
Ha conseguido hacer esto
Sin tropiezos ni retraso.

Los cómplices del bandido
Tambien fueron descubiertos
Y en poder la Justicia
Todos se encuentran ya presos.

A referir comencemos
Los formidables delitos
Del "Tigre de Santa Julia,"
Con sus detalles precisos.

La noche del día 15

De Negrete fueron complices
Un Hernandez y un Martinez;
Otro llamado Galván
Con instintos tambien viles.

Los muertos en una zanja
Fueron por allí arrojados
Y los bandidos huyeron
Para no ser apresados.

Despues de esto al poco tiempo,
Aquí ya en la Capital,
A un gendarme dió un balazo
Con vileza singular.

Su cómplice fué en este crímen
Su querida la "Cabrera"
El gendarme lo llevaba
Por escándalos que alteran.

Huyeron los criminales

BROADSHEET BANDITS AND PUBLIC OPINION

Broadsheet tradition closely relates the characters of the valiente and the bandit. Both types show great bravery or physical courage, operate mostly in rural areas, and sometimes meet a tragic end, although this denouement characterizes bandits more often than valientes. The most important difference between them, of course, is that bandits operate outside the law, a fact that does not prevent them from having desirable characteristics and enjoying considerable public renown. In Mexico, as in the cultures of many other countries, persons who defy authorities by committing bold crimes, attempting frequent escapes, and by displaying a defiant attitude have been celebrated by the lower classes who do not enjoy the benefits of the dominant economic or cultural structure. Although these bandits' victories are often short-lived, criminal-heroes embody the wish for a social inversion that will favor those less fortunate. Seeing virtue in criminals, even when this requires stretching the truth or creating myths, has the effect of undercutting a promise that the social contract often offers: virtue will be rewarded. As we have seen, the belief that virtue resides more in upper-class persons than in others was widespread in Mexico. Hence, as Eric Hobsbawm argued, the cult of bandits is "an extremely primitive form of social protest. . . . That is why Robin Hood cannot die, and why he is invented even when he does not really exist. Poor men have need of him, for he represents justice, without which, as St. Augustine observed, kingdoms are nothing but great robbery."[1]

Most bandits who are the subject of popular stories end up having not one but two lives: the one they actually lived, and the one that is told in tales, poems, novels, or myths. The stories that are told about a bandit frequently enter the lore of that person as surely as the better-attested historical "facts," and both take their place in forming the popular conception of the figure.

When considering the bandits Posada pictured, some of whom enjoyed much renown, they will be placed in a matrix that includes historical bandits in Spain, their counterparts in Spanish literature, and bandits in Mexican literature. As we examine the evidence, we will see that the phenomenon of banditry as pictured by Posada and Vanegas Arroyo was a matter negotiated between them as producers of broadsheets, and the urban lower classes as consumers of broadsheets. Some of the consumers of broadsheets had great curiosity about, and even admiration for, such career criminals, while others saw in crime stories a vehicle for moral exhortation. At times the producers drew moral lessons from information about bandits; at others they merely related the deeds without editorial comment; and, at still other times they apparently joined in adulation of such heroic criminals. There was some risk in the latter course, however, since publicizing the deeds of malefactors was cause for imprisonment during the Díaz period. We will see that the sheets walk a fine line between meeting the public's curiosity and disseminating anti-establishment information.

The principal way these bandits differ from other types of criminals is that their crimes are brazen and numerous; bandits pose a much bigger threat to society than the more incidental "non-professional" criminal. Yet a ready market for information, poetry, and pictures of bandits existed. Posada and Vanegas Arroyo operated in this matrix. In historical terms, the banditry they constructed is a relatively complex phenomenon that does not exactly correspond to any of its cultural neighbors. There are, for example, important differences between Posada/Vanegas Arroyo bandits and those portrayed in Mexican literature, differences having to do with the class viewpoint of the authors and their degree of closeness to official culture. The Mexican broadsheet bandits are probably closer to their Spanish counterparts, though in both cases it is difficult to separate the "historical facts" about the outlaws from their mythification in literature and legend. In fact, both the later Mexican bandits and their official persecutors often operated with knowledge of the stereotypes involved, so that they were aware of how they were modifying or extending certain legendary scripts about themselves. Since these scripts were developed largely in Spain, it will be necessary to begin the discussion there.

The cult of the bandit in Spain—as an object of fascination, interest, and even admiration, rather than opprobrium or fear—dates to early seventeenth century Catalonia.[2] Roque Guinart, who was born near Vich in 1582, may be the earliest celebrated Spanish bandit. A former military officer, he led a gang that numbered two hundred at one time, and such was his renown that Miguel de Cervantes arranged for Don Quixote and Sancho Panza to meet him. They happened upon his hiding place in their travels near Barcelona, and found him to be "aged 34 years, robust, of larger than average build, of grave mien and somewhat dark complexion. He appeared riding a muscular horse, dressed in a mail-suit, with four pistols—which in that land were called shortmuskets—at his sides." During their three days with Guinart, they saw him in situations that excited their admiration. When robbing from parties that traveled through his

territory, Guinart rarely took all that his victims possessed, and seldom more than he and his troupe needed for their own survival. He always divided the booty with rigorous equality. When he was approached by a woman who had been wronged and sought help for revenge, Guinart shed a tear upon hearing her story. He later described his own situation to Don Quixote and Sancho Panza in terms that convinced them he had become a bandit almost by accident:

> My nature is to be compassionate and to keep good intentions; but, as I have said, my need to avenge an affront that was once done to me got the better of these inclinations, and has caused me to continue in this present state, in spite of what I might desire. Just as deep calls unto deep and one crime leads to another, these counterstrikes have mounted up so that I now take on not only my causes but those of others.

Such was Don Quixote's respect for Guinart that he invited him on the spot to take up with him the life of a knight-errant. Guinart, who "discerned that don Quixote's sickness lay more in madness than in excess of bravery," declined. In fact, he was eventually pardoned by the king and given a military commission in 1611, which he was exercising in Naples when Cervantes wrote him into the novel.[3]

Guinart's contemporary Juan Serrallonga, who died in 1633, devoted himself to smuggling in the Pyrenees Mountains. He was the subject of popular plays written by Antonio Coello, Francisco de Rojas, and Luis Vélez de Guevara. Indeed, the *bandolero* is almost as common a character as the *valiente* in Spanish Golden Age drama; his (or her) deeds can be appreciated in *El Bandolero Más Honrado* ("The Most Honorable Bandit") by Gabriel Suárez; *La Condesa Bandolera* ("The Bandit Countess") by Tirso de Molina, and the anonymous plays *El Bandolero de Flandes* ("The Flemish Bandit") and *El Dichoso Bandolero* ("The Happy Bandit"). These characters closely overlap the *valiente* type. Courteous to women and children and generous with the poor, they attack only when necessary and kill only in self-defense, characteristics supplemented by excellent horsemanship and knowledge of human nature.

The Roque Guinart legend tempted Lope de Vega to write bandits into his plays as well. He is the alleged author of an unlocated play named *Roque Guinart,* but more certainly attributed to him is *Antonio Roca.*[4] As the play opens, the protagonist, whose name may purposely recall that of Roque Guinart, has just been ordained a priest when he learns that a Baron who tried to seduce his mother has killed his father. Roca knows that justice will never prevail when charging someone of noble rank, so he avenges the deed himself by entering the prison and murdering the Baron. In the process of escape he kills eight more people, a fact which leads local bandit gangs to unite in seeking him out and appointing him their leader. Roca accepts this commission, justifying it with an interesting historical precedent:

As for Alexander the Great,
How did he his empire form?
With his squadrons, did he not
Take the world like a storm?
And the monarchy of Rome
Was begun with two thieves' might
Who with their arms and weapons
Took everything in sight.[5]

Lest we think that Roca is going to become merely a raider and plunderer, he announces that from henceforth his gang will treat everyone well, not kill except in self-defense, and will take only what they need. The part of the drama that Vega wrote concludes with Roca and his companions heading for the hills.

Diego Corrientes, probably the best known Spanish bandit in history, lived closer to Posada's own time. Corrientes' operating theater was Andalucía, his trade primarily smuggling, and his hiding place the remote zones of the Sierra Morena. Hung for his crimes in Sevilla on 30 March 1781, his legend lived on when he became the subject of many novels and plays in the nineteenth century. José María Gutiérrez de Alba wrote a play named for Corrientes, and Manuel Fernández y González wrote two highly popular serial novels about him in the 1860s: *Diego Corrientes: Historia de un Bandido Celebre* (*Diego Corrientes: The Story of a Famous Bandit*) and *Nueva Historia de Diego Corrientes y sus Amores con Consuelo Domínguez* (*New History of Diego Corrientes and his Love Affair with Consuelo Domínguez*). The Mexican author Luis G. Inclán transplanted the character of Corrientes across the Atlantic in *Astucia,* an 1865 novel whose main character, Lencho, is based on the Spanish smuggler. Indifferent to socially constructed morals, Lencho's virtues are made up as he goes along. His enemies are not only the authorities but a rival gang made up of less noble types, and the novel depicts him struggling against both while maintaining nobility and generosity with those less fortunate. Unlike Mexican bandits in novels of the Díaz period, Lencho is actually a hero:

The fact that Lencho lives outside the law has nothing at all to do with questions of right and wrong. These questions are decided on the basis of obligations to self and to one's friends, with no awareness of the welfare of society. The attitude is the direct opposite of the common sense that nineteenth-century intellectuals desired; and though similar attitudes are seen in some other fictional characters, I know of no other novel in which the author approves of them.[6]

The middle years of the nineteenth century amount to a golden age both of Spanish and Mexican banditry, because central authority in each country was weak at that time. Since this period coincided with literary Romanticism and its cult of the outsider, bandits, some of them reportedly as noble as Diego

Corrientes, flourished both in Andalucía and in literature. Juan Delgado thought of himself as a chivalrous knight, and was lauded in popular songs. The gang known as The Seven Kids from Écija (Los Siete Niños de Écija) was the subject of a novel by Fernández y González. Bandit José María Hinojosa, nicknamed "El Tempranillo," began his outlaw career in 1823, at a time when the government, desperate to re-establish some semblance of order in rural areas, began a campaign to rehabilitate bandits by making them policemen and giving them responsibility for "guarding" roads through especially dangerous areas. They were actually deputized and authorized to solicit protection money from travelers. El Tempranillo's career took this turn when he was captured and pardoned in 1831, but ironically, his career ended when he was killed by bandits in 1833. The moral twists of this story were not lost on Fernández y González, who wrote a novel on El Tempranillo in 1875, *El Rey de la Sierra Morena* (The King of Sierra Morena). This character took on a new life as the model for Don José in the novel and opera *Carmen*. El Tempranillo's second in command, Luis Borrego, was also pardoned and went on to become vice mayor of the Cordoban town of Benamejí.

In contrast to the frequently sympathetic portrayals of bandits in Spanish literature, the two major Mexican bandit novels from the Díaz period paint them in far darker tones. The lead character in Ignacio Altamirano's *El Zarco* (Blue Eyes), for example, is entirely distasteful. In this novel, which was written in the 1880s but not published until 1901, the main character takes up the bandit life because gambling debts are getting the better of him. His gang kills needlessly and with apparent pleasure. In one episode they capture a French businessman, and, after despoiling him of all his possessions, torture him by holding him chained, beating him and feeding him one tortilla every other day, until he reveals where the rest of his money is.

The principal plot of the story hinges on El Zarco's seduction of Manuela, a well-guarded young woman of good family from the town of Yautepec. He visits her by night, riding up to the wall of her house on his horse, where they chat and flirt. El Zarco's outfit is studded with silver taken from his many robberies, but on his person it forms a gaudy display that Altamirano characterizes as "unseemly, cynical, and tasteless." After several meetings in which he plies her with stolen jewels, he resolves to have her for his own, in part for the thrill of possessing a well-bred woman. Such feelings of desire, even if perverted by lust for conquest, are new to him:

He had never loved anyone, but rather, had hated everyone: the rich landowner with his fine horses; the laborer who received his living wage each week; the freeholder, with his fertile fields and commodious home; local businessmen with their well-stocked stores; and even the servants, who had earned more in salary than he ever had. It was mere greed mixed with envy, the latter powerful and despicable, which created this singular hate and this fierce desire to steal everything he could, no matter what the risk.[7]

Manuela finally consents to ride off with El Zarco, in part, says Altamirano, because she has read too many romances of the outlaw life. El Zarco takes her to his hideout, where soon the gang is celebrating a successful raid with what amounts to a drunken orgy. The scene includes much dancing, drinking, shouting, and fighting, and at the climax one of El Zarco's lieutenants, El Tigre (The Tiger) tries to take Manuela for himself. She is revolted and horrified. Before he consummates the deed, though, the party is interrupted by a danger call. El Zarco is eventually captured and shot by a firing squad, which he faces trembling. Manuela swoons and dies of sheer terror minutes later.

Mexican authors of "official" literature were reluctant to portray bandits as favorably as had their Spanish counterparts because of the wide belief that Mexico was already lawless enough. Such reticence characterizes the other principal bandit novel of this period, Manuel Payno's *Los Bandidos de Río Frío.* While writing it in the late 1880s, Payno was a consular officer in Madrid, and the novel shows strongly the formal influence of the serial novels of Fernández y González. The principal character, Evaristo, is somewhat more complex than El Zarco, but still not worth emulating. A poor woodcarver at the story's outset, Evaristo lives with Casilda but tires of her when he meets another more attractive servant. One night in a drunken rage, he kills Casilda and flees to the mountains; thus begins his outlaw life.

Evaristo recruits a gang of Indians, and he and his gang devote themselves to holding up travelers and stagecoaches on the road between Mexico City and Veracruz. In this most "colorful" part of the novel Evaristo most resembles his Spanish forebears in outlawry. Evaristo never reaches the moral stature of Roque Guinart or Diego Corrientes, though, for two reasons. First, he mistreats women. If they refuse his advances, he threatens or hits them; he also murdered Casilda. Second, when the government attempts to solve the bandit problem by creating the *rurales,* the rural militia, Evaristo plays both sides. He receives a commission, and accepts praise as a local hero, while still functioning as a bandit. His ruse is discovered, though, and he is sentenced to die. He faces his penalty in a cowardly fashion:

> Evaristo wanted to try one more thing. On hearing the sentence pronounced, he laughed uproariously, jumped, danced, and said a thousand crazy things, acting like he was insane. But no one believed him. The prison doctor examined him and said he was faking. Then Evaristo became furious and hurled blasphemies about Relumbrón, Cecilia, and Lamparilla, so that he was threatened with muzzling. Changing tactics, he humbly begged forgiveness and said that he had important information to reveal. No one paid attention.[8]

Because the novel's action takes place before the Díaz regime, the penalty is carried out by garroting. These fictitious depictions of banditry influenced Posada and Vanegas Arroyo as they attempted to cater to public curiosity without bringing undue risk on themselves.

31. *Verses About Valentín Mancera Brought from the State of Guanajuato.* Broadsheet with blackline illustration by Posada, not dated. Half Sheet. Tinker Collection, Ransom Research Center, University of Texas at Austin.

Versos de Valentín Mancera

TRAIDOS DEL ESTADO DE GUANAJUATO

AÑO DE MIL OCHOCIENTOS OCHENTA Y DOS MUY PRESENTE

MURIO

VALENTIN MANCERA

MURIO EL ESPADA VALIENTE

¡Ay! qué dolor
lleva en su corazón
de ver que nadie
le tiene compasión.
Se repite al fin de cada cuarteta

El diez y nueve de Marzo
a las cuatro de la mañana,
se ha dirigido al oficio
la de-graciada San Juana.

Muy buenos días mi señor
don Dionisio Catalán
ahí le tengo su prenda
la que busca de San Juan.

Lo sacaron entre cuatro
con mucho gusto y afán
lo llevaron que lo viera
don Dionisio Catalán.

Le empezaron a tocar
al compás de la guitarra,
las agonías de la muerte
porque lo vendió San Juana.

A este Valentín Mancera
¡ah qué suerte le tocó!
lo mataron a balazos....
el gobierno lo mandó.

Respondió la pobre madre:
señores, ¿que harán favor?
que este Valentín Mancera
no muera sin confesión.

Los gachupines decían:
a nadie le hagan favor,
que a ese Valentín Mancera
ya le tenemos horror.

Este Valentín Mancera
¡ah qué suerte le ha tocado!
lo mataron a balazos
sin haberse confesado.

Este Valentín Mancera
era un hombre chaparrito,
no era alto, no era grueso....
era un poco delgadito.

De México lo pedía
todo el Ayuntamiento,
y el Presidente decía:
«a Valentín yo lo siento.»

Todos los gachupines
se vistieron de galón,
y estaban tomando copas
en la tienda del «Vapor.»

Historical records about Valentín Mancera are difficult to come by, but understanding why this bandit would be a broadsheet hero proves easy. Mancera served as a mouthpiece for the indigenous lower classes of the capital; he voiced their frustrations about the dominant positions many Spaniards held in Mexican society. Killed by police on 19 March 1882, by (according to some reports) a total of twenty-one bullets, Mancera, a bandit from Guanajuato, seems to have victimized only persons of Spanish descent. The corrido on the broadsheet *Versos de Valentín Mancera* points out that when Mancera died the Spaniards all went to the local bar and had a toast out of sheer relief, because Mancera had at one point offered the insultingly low reward of three cents for the head of each Spaniard brought to him. When Mancera's mother urged that her son not be allowed to die unconfessed, the Spaniards opposed even that:

The gachupines then said
Don't do him any favors,
In front of this guy Mancera
We are horrified and quaver.

His victims are referred to in the poem as *gachupines,* a pejorative term that persons of mixed descent used to designate Spaniards. The origin of the word is cloudy; it may come from the Portuguese *cachopo,* or child, but it may also be derived from two Aztec words, *cactli* and *tzopini,* that combine to mean "spur-wearer."[9] The latter usage refers to the fact that it was Spaniards who first brought horses to the New World, and thus the wearing of spurs was a mark of foreign descent.

Use of the word *gachupin* indicates that resentment against Spaniards was widespread among urban lower classes, primarily because of the positions they occupied in the economic structure. The Mexican upper classes encouraged immigration and investment partly for racist reasons, believing that Europeans were more fit for economic progress than native peoples. In Mexico City, Spaniards were heavily represented in businesses such as bakeries, grocery stores, and pawn shops.[10] Most urbanites had to buy bread and food, of course, on nearly a daily basis, but the Spanish domination of pawn shops would have been especially galling to persons on the economic margins, who made frequent recourse to them in time of need. Before Evaristo became a bandit, for example, he and Casilda would place possessions in hock at times of economic distress. This involved taking one's possessions to the shop and having an authority figure look them over and offer an amount of money usually lower than what was expected or desired. Hence Valentín Mancera became a vehicle for symbolic revenge against some of those who benefited from personal economic crises.

Mancera's capture typified Mexican tragic heroes: he was caught by trickery rather than outright physical confrontation. No bandit or valiente died by being outshot or outfought or outsmarted. More commonly they were betrayed by women, as in Mancera's case when a woman was paid two hundred pesos

(about a years' worth of working-class wages) to lure him into her room. Another Mancera corrido asserts that she served him a drink laced with opium.[11] This ignominious fate has befallen many heroes in the mythology of Western culture as far back as Sampson in the Bible, but it is especially common among Mexican bandits and valientes. The romantic needs of men are seen as their weak point. Romantic problems were also the downfall of Bruno Apresa and Rosalío Millán, who were led by romantic passion to commit grievous crimes. Macario Romero was led into a trap by his love for a woman. All of these stories contain the subtext of the woman as betrayer, or at least as master of this side of men's nature. The first stanza of the corrido about Apresa, (see fig. 21), stated it plainly: "A woman was the cause." Women are almost never heroes in broadsheets, and, as we have seen, they are portrayed as fiendish killers in broadsheets more often than in life. Thus their role is closely circumscribed and often quite negative.

The corrido *Versos de Valentín Mancera* was issued and reissued several times, and Posada made two different plates for it, using similar compositions but different techniques. The black-line version (fig. 31) shows him in captivity, but several steps are taken to minimize the pain of this fact. The prisoner wears a clean set of charro clothing, with shiny riding boots, necktie, vest, double-breasted jacket, and sombrero, with a serape over his shoulder. Most buyers of broadsheets associated this type of outfit with being very well-dressed; also, this mode of attire owes almost nothing to the Europeanized fashions of the urban upper classes. Mancera's stride is more purposeful and decisive than that of his captors, an impression supported by his scowling face and swelling chest. The fact that he is enjoying a cigar also lessens the gravity of his situation. He could be their commander. In any case, this is hardly the drugged and murderous outlaw that the gachupines would have imagined. As he is led away, a young boy strums a guitar and sings, presumably a corrido about our hero. Thus again does Posada collapse events to intensify characterizations. It is as if Mancera's fateful deeds and their popular celebration in song happened at the same time, a proposition that is possible but unverifiable. It is easy to imagine this corrido ringing in everyone's ears even as the criminal is being shot by the firing squad. Certainly this illustration represents every criminal's dream: to be serenaded with songs about your heroism as you are led off.

Beyond a reckless hatred of gachupines, the available corridos about Mancera reveal few personal characteristics, but this situation is reversed with the more famous character Heraclio Bernal. If a bandit could fill the role of "noble robber" like his Spanish forebears, it was he. Although some idealization has entered into the accounts of his life, Bernal was more than a mere freebooter.[12] He came from a politically active family from the province of Sinaloa whose members were firm partisans of Benito Juárez and Lerdo de Tejada, and were opposed to Porfirio Díaz from the beginning. As a teenager Bernal went to work in the silver mines and experienced firsthand the hard labor and oppressive conditions laid down by the foreign (mostly American) owners. Legend has it that he began his career of illegalities by accident: Some enemies

got him drunk, put him in the presence of some stolen silver ingots, and denounced him to the authorities. He joined an abortive revolt against Díaz under Jesús Ramírez Terán, who, in 1880, took over the city of Mazatlán, holding it only briefly. When Ramírez lost interest in opposing Díaz, Bernal earnestly began his own outlaw career, and during the next six years made sport of civil authorities and mine owners in a series of lightning raids on towns and garrisons that earned him the nickname "Thunderbolt of Sinaloa." During this time his troupe, which numbered up to about 150, sustained itself by stealing silver from foreign-owned mines and selling it to smugglers along the coast; arms and ammunition came from raids on army camps.

Bernal's reputation for generosity toward the poor has never been seriously challenged, neither has the truth of certain daring deeds that made him a hero to these people. Twice in his career, for example, he escaped from captivity. He also reportedly took pride in the fact that the government mobilized an artillery division just for him, and that General Bernardo Reyes owed his last promotion to the campaign to retake Mazatlán. On one occasion Bernal took over the entire town of Quilá and, as was his custom, threw a vast party, complete with music, dancing, and free tequila. At the height of the festivities he decided that the guest list was incomplete, and in a few minutes the following telegram was received in the state capital: "General don Francisco Cañedo, Governor of the State, Culiacán, Sinaloa: Citizens of Quilá and friends of mine invite you to attend a dance as guest of honor. With kind regards, Heraclio Bernal."[13]

A literate outlaw, he knew what was expected of him as a bandit and popular hero. Once, in a moment of disillusionment, he penned some confessional verses that read as though they could have come from the back of a Vanegas Arroyo crime sheet. They also betray a slightly different goal from that which his followers and fans expected:

Fed up with this world
I'm going to hide myself away;
It to me, nor I to it am indebted
Any thanks for bringing me, nay,
Into a world so noisy and overrated.
Dangerous, without understanding,
To society I have been;
But I have only always wanted
To truly belong to it from within;
Instead I have been only hunted.[14]

Some historians have taken this to mean that, rather than a criminal, he was at bottom a frustrated politician who would rather work to change society into something he could belong to, than rail destructively against it. There is good evidence for this view in his political activities. If this formulation is accepted, his elevation as the "perfect bandit" becomes somewhat ironic because it is

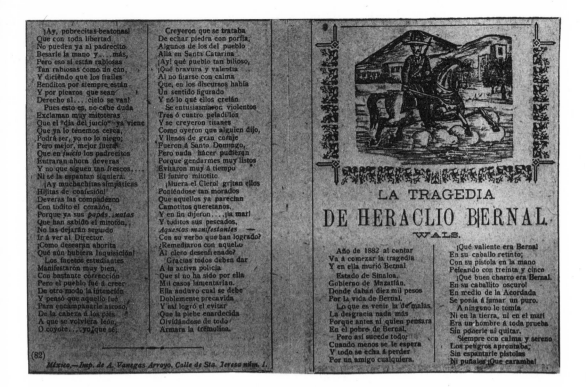

32. *The Tragedy of Heraclio Bernal.* Broadsheet with white-line illustration by Manuel Manilla, not dated. Half Sheet. Tinker Collection, Ransom Research Center, University of Texas at Austin.

based in part on a misinterpretation of his motives and personality. But this idealization also shows that the sometimes urgent need of people for a hero overrides subtler analysis.

Bernal's fortunes began to change when his two brothers, trusted seconds, were captured and murdered in January of 1886. In the fall of that year Bernal helped plan an anti-Díaz revolt with Trinidad García de la Cadena, a revolt that ended before it started when García de la Cadena was assassinated that November. Bernal aspired to political leadership more than he did to being a mere robber, and issued political manifestos on several occasions, but the power of Díaz was too strong. Governor Cañedo offered a reward of ten thousand pesos for Bernal's capture in October of 1887, and the reward was paid in February of the next year after Crispín García discovered by trickery Bernal's hideout and shot him in the back.

The first Vanegas Arroyo broadsheet on Bernal, which was reissued several times, was illustrated by Posada's predecessor Manuel Manilla; it may have been created shortly after Bernal's death, at a time when Posada was just getting established in Mexico City. The sheet participates fully in the apotheosis of the bandit (fig. 32), enacting appropriations of cultural forms meant for aristocrats and kings. The highly laudatory corrido rhapsodically evokes a Superman in stanzas that vary the color of the horse along with the trait to be extolled:

ECHO GARRA AL MALVADO IGNACIO PARRA

YA LA AUTORIDAD

> YA CON SU VIDA PAGÓ
> EL MENTADO IGNACIO PARRA
> LA JUSTICIA AL FIN TRIUNFÓ
> LA SOCIEDAD ESTA VENGADA.

Ahora si fué de deveras,
Mataron á Ignacio Parra
Pues la Justicia logró
Que sus crímines pagará,

 Era un bandido de cuenta,
Pues mandaba una cuadrilla,
Con que asolaba á Durango;
Pues tenía muchas guaridas.

 A mucha gente robó
Sin piedad ni compasión,
Y á veces aún los mataba;
Pues fué de mal corazón.

 La cuadrilla era compuesta
De ladrones muy mentados:
Como Federico Arriola,
También Refugio Alvarado.

Este era pues, su segundo,
Era su dedo chiquito;
Pero á éste, antes lo mataron
Pagando así sus delitos.

 La tragedia de éste fué
En la Cueva de los Lobos,
Donde Don Felipe López
Trató de acabar con todos.

 Con la muerte de Alvarado
Empezó á estar Parra de malas,
Ya no pudo alzar cabeza,
El diablo quería ya su alma.

 Don Octaviano Merás,
Jefe bueno de Acordada,
Lo comenzó á perseguir
Por la buena y por la mala.

33. *The Authorities Have Finally Grabbed the Bad Guy Ignacio Parra.* Broadsheet with black-line illustration by Posada, after 1911. Half Sheet. Amon Carter Museum. 1978.180

How brave was our Bernal
On his horse the color of wine
With his pistol in his hand
He could take on thirty-nine.

And what a great charro he was
On the back of his very dark horse;
In the middle of a furious battle
He could light a cigar, of course

How fearless was our Bernal
On his horse the color of honey
He never stole from the poor
But rather gave them money.

The first half of the 28-stanza text consists mostly of lofty praises for his bravery, horsemanship, and coolness under pressure. The style of this part of the corrido resembles the panegyric, a traditional form characterized by "impressionistic evocation of the hero's exploits rather than a chronological account of successive episodes."[15]

The corrido mentions Bernal's generosity in a case in which he gave a poor mountain family four hundred pesos. It also credits him with killing ten Spaniards (gachupines) and making their skin into boots for his feet. The text dwells for six stanzas on his betrayal and murder, calling Crispín García money-hungry, in obvious contrast to the charity of Bernal. Among the usual leave-takings at the end of the corrido is a good-bye to "gringos," who will now be able to stroll safely.

Manilla's print fully supports this encomium by placing Bernal on a spirited horse in a solemn demeanor derived from heroic equestrian monuments. The mount kicks up a little dust as the noble and erect hero gallops through a rural village setting backed by the mountains in which Bernal presumably hid out. The hero's face is composed and dignified. He goes well armed with rifle and long sword, holding the reins of the rapidly galloping horse lightly in the other hand. The Spanish word for gentleman is *caballero,* horseman, and this is how Manilla depicts him. (The legs of a horse never do in gallop what the artist pictures, but neither Manilla nor Posada was apparently aware of the contemporary pioneering photographs of Eadweard Muybridge, which revealed once and for all the truth.) Manilla is not as good at pictorial composition as Posada, as the unfortunate coincidence of sombrero and hilltop shows. Nor can he define masses in space as well. The strokes of the burin on the forequarters of the horse seem to lose their way, and the leaves on the tree at the right similarly dissolve into autonomous patterns. These defects do not detract from the clear sense of the artist's commitment to the subject, however. And since this plate is probably the first instance in a broadsheet of the use of the equestrian mode to glorify a bandit or valiente, Manilla must be credited with the idea of inversion

of social codes that such a usage implies. Since Bernal was a menace to established authority, this print and the various corridos would be the only monument that Bernal would enjoy during the Díaz period.[16] The title of the sheet, *The Tragedy of Heraclio Bernal,* completes the picture of a rare and honorable man meeting a cruel and implacable fate.[17]

Using the equestrian mode may be a way to extol social outsiders and overturn social codes, but in Posada's print of the bandit Ignacio Parra, the treatment clashes with the known character of the subject, who was not as exalted as Bernal (fig. 33). Parra had been a member of Bernal's band, and on Bernal's arrest claimed the province of Durango as his operating theater, where he focused primarily on cattle rustling. The corrido text of this sheet emphasizes the evil nature of the bandit:

> He stole from many people
> With no compassion on his part;
> And at times he even killed them;
> Inside he had a bad heart.

Apparently the authorities dispatched Parra by chipping away at the hierarchy of his band, since the text mentions that first Parra lost Refugio Alvarado, his second in command. The corrido praises Octaviano Meraz, the leader of the posse that finally defeated Parra in an 1892 battle near the village of Camotlán. At times the text praises Parra's bravery and his valiant last stand, but overall makes him a bad example:

> May the Eternal forgive him
> In peace may he ever rest.
> May those who are tempted to follow
> See how the bad ones meet death.

Posada did not apparently agree with this negative characterization of Parra. His illustration depicts the bandit astride a galloping horse holding a sword, a weapon of far greater symbolic than practical significance. The black-line technique allows for fairly clear detailing of Parra's embroidered vest and saddle blanket. In the far distance we see other horsemen charging in the same direction. Parra's fine clothing and improbably light armament—he is not even wearing a pistol—take this image out of the heat of battle. This cannot be an attempt to realistically depict an engagement between Parra and an enemy, because the hero is obviously not anticipating much danger. The composition, with the central figure foregrounded and everything else minimized, supports this; the others in the background are carrying banners or spears and seem similarly unprepared to do real battle, though they are difficult to read. The image becomes an interpretation of the man's spirit as recollected by the artist at some distance in time and space. The earliest sheet dealing with this subject is dated

1903, many years after Parra died, and Posada's use of black line also supports such a later date for this composition. In any case, Posada depicted him like an avenger, a knight-errant. Other corridos extol Parra's generosity toward the poor and his supposed crusade against the rich, more in the tradition of the social bandit.[18] This image in Posada's, broadsheet, corresponds more closely to the social bandit reality than to the vandal.

Parra's actual character is difficult to determine, but this sheet was popular; in fact, it was reissued at least four times.[19] The text's negative image of Parra did not affect sales, an apparent anomaly with two possible explanations: Parra could be fitting the mold of the tragic hero who meets death, even if he deserved it, courageously. This interpretation would align this story with that of Rosalío Millán or Bruno Apresa. It is also possible that this sheet was bought more for the illustration than for the text. Writers on Posada have traditionally emphasized the semi-literate nature of his audience, and if a buyer knew that it was the bandit Ignacio Parra in the print, maybe that was all they wanted to know. This particular image, with its fine draftsmanship and very Mexican subject, is attractive on its own, and can be appreciated without knowledge of exactly who is depicted. This sheet and many others were possibly bought because they had pictures by Posada that looked interesting or beautiful or finely crafted, not because of what the text said about them. In any case, one further fact about Parra of historical relevance which buyers would not have known this: the young Francisco Villa rode with Parra's band.

After the death of Parra, however, few rural bandits captured the public fancy in Mexico. This was due in large part to certain aspects of the Díaz modernization program that made brazen lawbreaking difficult. The extension of telegraph and railroad lines made communication and travel much easier. The efforts of business interests to exploit mineral and agricultural potential in unexplored zones led to the inclusion of many new areas into the market economy. In addition, the work of the *rurales* began to take hold. This rural citizens' militia had been created in the days of Benito Juárez in an attempt to stanch rural marauding; patterned after the Spanish *Guardia Civil,* in its early days Juárez recruited bandits for its ranks, as the Spanish had done. By the early 1890s the rurales' increasing professionalization and effectiveness had made a difference in the climate of many rural areas of Mexico so that, according to one chronicler, "brigands could no longer make demands on authority as in their heyday."[20]

The government attempted to make an official cult of the rurales, having them march in parades and perform feats of horsemanship at civic functions. Each Independence Day, for example, rurales paraded through the streets of the capital, and performed feats of marksmanship and *charrería.* Amado Nervo commented enthusiastically on one such parade:

The rural policeman is Mexico: under his sombrero is our Country, our swarthy Country of the dark eyes and tawny complexion. The rural policeman is

Mexico: in the colors of his bright bandana course the blood colors of our flag. His leather vest is strong and rough. . . . When we see them pass, we think, "That is our country going by."[21]

Rurales were sent by the government to worlds' fairs in Paris and St. Louis, as symbols both of Mexico's desire to progress and of its rootedness in the distinctive culture of horsemanship.

Vanegas Arroyo collaborated in the effort to glorify the rurales and produced a larger-than-usual sheet about them that was reissued each Independence Day for several years (fig. 34). On the back of a sheet that had a portrait of independence hero Manuel Hidalgo in an oval (visible through the paper), were several paragraphs expressing admiration for the horsemanship and military skills of the rurales: "The risks that passengers ran in days past is well known, since travelers could not be secure, neither in their lives nor their possessions. Today one can travel without risk because of their efficiency and effort in the pursuit of malefactors. . . . Robberies in rural areas are now uncommon." Posada's illustration on the sheet captures the lively prance and bustling activity of the ranks of the well-dressed horsemen. Some riders wear their sombreros jauntily, and one blows on a trumpet. All carry the sword. The type of banditry that the rurales suppressed was of smaller scope than the more politically potent type that was the subject of corridos and broadsheets. None of the most famous outlaws was brought down by the rurales. In addition, information about the dubious backgrounds of many members of the rurales and their sometimes overzealous tactics was rigidly censored. Filomeno Mata, for example, editor and publisher of *Diario del Hogar,* spent a month in Belén in 1888 because he criticized in print the rurales' lack of respect for constitutional rights.[22] This did not stop Posada, however, from participating in their cult.

Rural social banditry had one last hurrah near the onset of the revolution, in the life and deeds of Santana Rodríguez Palafox, known as Santanón. Both he and Heraclio Bernal embody the spirit of the social bandit, and Santanón, along with Bernal, was celebrated (somewhat ambivalently) in broadsheets. Since his career was much shorter, though, and since the onset of the revolution brought another set of heroes to the public mind, his celebration was less intense.[23] As with other social bandits, fact is difficult to separate from myth and idealization.

A mulatto born in the state of Veracruz, Santanón seemed to have been forced into banditry by oppressive economic conditions, much as Heraclio Bernal had been. According to one story, a German sugar planter for whom he worked lusted after Santanón's wife, and used his aristocratic privileges to have Santanón jailed on trumped-up charges in 1906. After his release from jail, he was drafted into the military and sent to the province of Oaxaca, where he served with a unit that was practically a private army serving the interests of wealthy foreign growers there. He allegedly deserted in 1908 vowing to oppose foreign capitalists by any means at his disposal. Another account ignores the seduction of his wife story, and has him return from the army to find that his

GLORIAS DEL 15 Y 16 DE SEPTIEMBRE

SITUACION DE LA REPUBLICA MEXICAI

dulce armonía se oye esta fecha en el pueblo mexi-
el esplendido palacio hasta la humilde aldea se sien-
na, y emocionados de júbilo desde antes que se lle-
es preparamos entusiasmados a celebrar la indepen-
os vivas del alma arrancados del libro del corazón.
lia 15 en la noche se reunen en la plaza los habitan-
pital y mucha gente que de varias partes de la Re-
e á celebrar la fiesta; hombres, mujeres y niños por
pitulan. Los comercios abiertos y los ambulantes

luciendo monogramas del costoso sombrero, espuelas de Amo-
zoc, estribos de arte y gracia, frenos y fornituras, que no tienen
que pedirse más. Siguen los elegantes que sujetándose á la mo-
da, unas veces de levita con cola "de palo," otras cruzadas, otras
jackeré, otras rabona ó larga, y en fin, según el pedir de la mo-
da parisién, toman sus coches ó se sientan en sillas que forman
la valla mientras viene la Comitiva Oficial, que constituye el
Sr. Presidente, Ministros de Estado, Corporación Municipal y
empleados de alta gerarquia. Al pasar, todos los siguen para el

El Ayuntamiento de aquí, los de los pueblos y l
ticulares, en este memorable dia, inauguran cam
calles, calzadas, edificios, fuentes y planteles, com
á nuestro padre Hidalgo.
Y como hemos entrado en una época de paz y
ha dado por origen el desarrollo progresivo de l
industria y del comercio, los negocios públicos e
acentúan.
Fue tiempo de luchas festivas a los que con corazon

34. *Glories of the 15th and 16th of September and of the Mexican Republic.* Portion of a broadsheet with white-line illustration by Posada, not dated. Double Sheet. Vanegas Arroyo Family Collection.

mother has been murdered by the patrón's subordinates, a fact which forces Santanón to swear to exact vengeance. In any case, his first crime to achieve national attention was an unprecedented amphibious raid on a cargo boat plying the Papalopán River in March of 1910. This was followed by the politically explosive murder of a German planter two months later, a fact which the Mexico City German community, small but highly influential, protested to President Díaz in an audience attended by the German ambassador. In June Santanón's bandits raided a sugar plantation near San Andrés Tuxtla and killed its owner, the American Norman Lawer. The governor of the state, who apparently hoped to be a vice presidential candidate in that year's elections, appointed an army of five hundred to search for the outlaw.

Santanón exploited the weaknesses of the Veracruz political structure, and joined the national Anti-Reelection Society and the Liberal Party, both strongly anti-Díaz. The stakes became higher on June 18, when Veracruz deputy Salvador Díaz Mirón stood up in an open session of the Mexican Congress and asked for a commission and an army to pursue Santanón, whom he knowingly referred to as the "Mexican Diego Corrientes." Díaz Mirón's credentials for making such historico-literary allusions were beyond doubt, since he was, in addition to being a congressional deputy from his home province of Veracruz, one of Mexico's leading writers of poetry. He was probably at that time already

CORRIDO DE LA VIDA DE SANTANON.

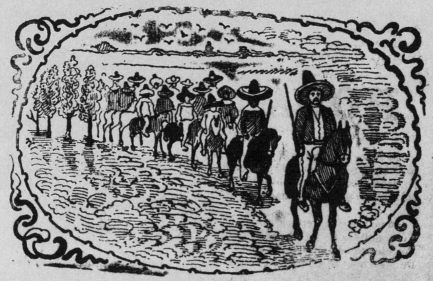

Santanón, terrible bandido,
Por sus robos criminales,
En Yuzutlán fué batido.
Por los valientes rurales.

De Octubre, día diecisiete
Como á las once tuvieron
Un encuentro. En el rindieron
Al Santanón tan valiente.

Aquello fué muy atroz;
Se acabó la valentía,
Del bandido tan feroz,
Que á todos acometía.

El grupo quedó deshecho
Y á Santanón costó caro
Por un certero disparo
Que le tocó por el pecho.

Al suelo se desplomó,
La sangre manchó su silla
¡Ya Santanón terminó!
Solo queda la gavilla.

Viéndose ya perdida
La gavilla del ladrón,
Se dispersó la partida
Por falta de Santanón.

Esa fuerza de rurales
Con su jefe inteligente,
Se batió con criminales,
Disparando frente á frente.

En Veracruz se internó
Ese bandido famoso,
Ricos y pobres robó
Y en todo fué peligroso.

Y cinco pesos en dinero
Que llevaba á su destino,
Un rebozo que era fino,
La cobija y un sombrero.

En Veracruz fué el terror,
Se alarmaron los vecinos,
Todos le tenían temor
Al bandido en los caminos.

Este bandido andaba
Dando á todos mucha guerra
Su refugio fué la sierra,
En linderos de Orizaba.

También en Córdoba llegó
A ocasionar muchos males
Con mucha crueldad robó
Santana y sus criminales.

Decían que era imposible
A ese bandido atacar......
Que era feroz y temible
Y muy valiente al pelear.

En un encuentro que tuvo
Santana y sus criminales
Por más listo que este anduvo
Le ganaron los rurales.

Propiedad Particular

at work on the ode for the dedication of the Independence Monument. Díaz Mirón's only qualification for the enterprise of pursuing Santanón was his ability as a duelist; he had challenged several persons in the past for personal affronts, and had been wounded before. The irony of this situation was not lost on one of the capital's humor magazines, which observed: "To die at the hands of Victor Hugo would have been, fifty years ago, the ideal dream of many Spaniards and almost all Frenchmen. To fall with one's head bored through by a bullet fired from the same hand that had bored through so many hearts by writing poetic verses, is almost like dying on the throne of celebrity."[24] Once the poet was armed, the chase was on. Díaz Mirón's militia, desperate for information about Santanón's whereabouts, rounded up entire villages and interrogated everyone in them. Santanón continued his provocative acts, terrorizing primarily foreign-born sugar planters. He recruited workers who had been subject to *enganche* and ethnic minority Yaqui Indians who had been deported from the north for his forces. He aligned himself over time more firmly with the Liberal party, which was the most radical (though not the most popular) organized opposition to President Díaz. The party's exiled leader Ricardo Flores Magón appointed him a regional commander.

Other daring acts less well-attested contributed to the mystique of the shadowy jungle warrior. Santanón was reported to have confronted a judge in his chambers in the state capital. One story had it that he was serving, in disguise, as a guide to Díaz Mirón's troops. Another said that he had actually met the poet incognito and given him two cigars. Such was the quality of the cigars that Díaz Mirón is supposed to have compared their perfume and flavor to the verse of a leading Symbolist poet of the day: "My cigars compared with these are like verses of Vanegas Arroyo next to a sonnet of Heredia."[25] For every rumor of a Santanón heroic deed, the authorities circulated one about a major advance against the bandit. In the struggle for public opinion about Santanón, *El Imparcial* used the vocabulary of moral opprobrium that it usually applied to most sorts of criminals. In their eyes, he simply did not want to work at a job appropriate for someone of his social station, and moreover, he did not even come up with the idea of the famous amphibious raid: "He was a man of dark history and doubtful bravery. . . . His extraordinary laziness caused him to quit his job at the Laureles hacienda and dedicate himself to thievery, which he did without achieving notoriety until he was led by a local peasant to commit his first bloody act."[26]

This raid on the boat was carried out when its owner was asleep anyway, and Santanón had merely murdered him in cold blood. Among this tide of myth and disinformation, *Diario del Hogar* alone complained about the lack of accuracy in news reports. Careful not to name names, it lamented, "We can be assured that all, absolutely all, that is published by certain newspapers, interviewers, and correspondents is entirely false. . . . Very little have they relied on the press in the province of Veracruz."[27]

By August 2, Díaz Mirón gave up the fight, leaving the struggle to more professional authorities. He returned to the capital city and resumed his legislative

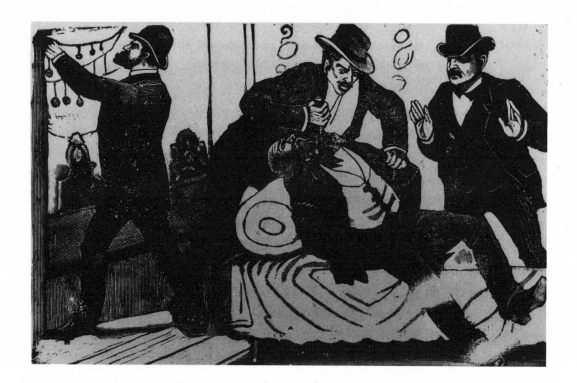

and poetic duties. Santanón caught malaria in early October, and was finally gunned down on the seventeenth of that month. It is unclear who actually shot him, since both rurales and regular army units were involved in the final battle. Lieutenant of Rurales Francisco Cárdenas (who would later murder President Francisco Madero) took credit for the kill.

Against this background the Vanegas Arroyo broadsheet performed a balancing act, trying to satisfy the curiosity of its public while keeping the good graces of the establishment (fig. 35). The text is devoted mostly to his capture, and it attributes the murder of Santanón to the "brave rurales" under their "intelligent chief." It claims that the bandit "robbed both rich and poor" and says that he was feared by the entire province of Veracruz. It completely ignores the social aspects of his banditry. In a more laudatory vein, the sheet asserts that Santanón was "very brave" (*tan valiente*), "astute," and "famous."

> They say it was quite impossible
> On this bandit to alight;
> That he was ferocious and fearsome
> And dauntless in a fight.

The similarly neutral illustration depicts a ragged line of peasants led by a large-bodied figure, all of them on horseback traveling a nondescript terrain. There is no sign of danger or opposition as the horses walk toward the lower right. The figure of Santanón is recognizable by its size—he was said to be a

36. *The La Profesa Robber*. Restrike of a white-line illustration by Posada, 1891. Half Sheet. Amon Carter Museum. 1978.384.3

large man—and by the white halo around it, which the artist achieved by leaving out background lines.

This was the only sheet on Santanón, however, because his cult was short-lived. Even though his career flared as brilliantly as that of any other bandit in Mexican history, his glory was brought to an abrupt end after only a few months. By the time of his death the social tensions that would lead to the revolution were already at a fever pitch. Once those violent forces were unleashed, several other leaders of lawless bands competed for attention in corridos. The earlier fame of Bernal and Parra, in contrast, lasted through a period in which they had few other provincial rivals.

Two other criminals embodied the social bandit type in their deeds and reputations, even though neither worked in rural areas but instead plagued the Federal District. The crimes of Jesús Bruno Martínez and Jesús Negrete had less obvious political relevance than those of Santanón or Heraclio Bernal, but they were such objects of fascination to the city's common people that Vanegas Arroyo and Posada produced numerous sheets on both men.

Jesús Bruno Martínez committed only one holdup, but it was so brazen that it had an impact on the future organization of the city's police forces. In February 1891 he and four companions broke into a large jewelry store after it closed and robbed it at gunpoint, killing owner Tomás Hernández Aguirre and escaping with uncounted jewels, cash, and silver. Since the store was located on what is now Madero Street across from the Temple of La Profesa, the robbery was dubbed the La Profesa robbery. According to one writer, this deed "marked a new era in the history of crime in Mexico for its audacious and bold character, for the way in which the owner was killed, and for the enormous quantity of jewels that the robbers got."[28] It is easy to see why the crime was so shocking; it differed in many ways from what Miguel Macedo claimed were the characteristics of the vast majority of crimes in the capital. It was well-planned, and had to be carried out in cold sobriety rather than in a heat of passion. In fact, emotion or anger would have harmed the execution of the deed. A team, rather than an individual, committed the crime. It was a transgressive crime, crossing class boundaries in a bold and audacious way. It was later discovered that the robbers were aided in their efforts to enter the store by their well-dressed appearance. To hold up a jewelry store is not only to steal from the wealthiest classes but to steal their luxuries, a crime certainly beyond the reach of the vast preponderance of Mexico City criminals up to that time. In response to Martinez's crime, the institution of the Secret Police in the capital was strengthened.

In fact, the La Profesa robbery was one of a series of bold thefts that were reportedly carried out in the city by a new gang of urban bandits who worked "in the European style." In the wee hours of the morning after the La Profesa robbery, two Frenchmen were reported to be among a group making a disturbance in a bar, drinking to excess and speaking in heavily accented Spanish. The Secret Police followed them.[29] Within a few days, a detachment headed by

EL JURADO

DE LOS ASESINOS

DEL SR. TOMAS HERNANDEZ AGUIRRE.

Defensa de los reos. La sentencia. Actitud de los CRIMINALES.

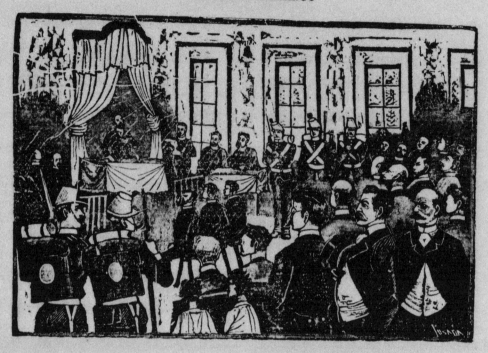

La sangrienta tragedia de la calle de la Profesa, toca á su desenlace.

Bien conocidos son ya del público todos los pormenores, todos los detalles del terrible asesinato del honrado comerciante Don Tomás Hernández Aguirre, verificado la tarde del 20 de Febrero del presente año, con circunstancias que lo hacen verdaderamente espantoso, causando justísima alarma en todas las clases de la sociedad.

Tal vez ningún proceso haya caminado con la velocidad que el presente, pues apenas hace dos meses de la consumación del delito, y ya el jurado del pueblo ha pronunciado su fallo sobre tan ruidoso suceso. ¡ hubiera sido mucho más rápida la marcha de este asunto, si la aprehensión de Nevraumont hubiera sido al propio tiempo que la de sus cómplices; pero como se sabe, á este último no se le capturó sino un mes después y como era natural, su declara-

raciones, que pusieron en claro todos los acontecimientos de la noche fatal del homicidio, determinaron una nueva marcha en el proceso y las consiguientes averiguaciones de diversas diligencias practicadas ya y que hubo que efectuar de nuevo; pues los primeros reos, contando con que tal vez Nevraumont escaparía de las manos de la justicia, habían procurado hacer recaer sobre él toda la responsabilidad del suceso. La asiduidad del Sr. Lic. Salvador Medina y Ormaechea, Juez de la causa, es digna de todo elogio, y la sociedad entera debe estarle agradecida por su empeño en dar á la vindicta pública la satisfacción que reclamaba por tan atroz atentado.

Los acusados han ocupado los banquillos de los criminales y el pueblo, representado por los jurados, ha pronunciado el fallo que condena á los responsables del crimen de la calle de la Profesa.

¡Cuánto darían esos desgraciados por poder borrar esa sangrienta página de su pasado, que hoy los pone bajo el inexorable brazo de la justicia humana!

Triste celebridad la que han alcanzado á costa de un castigo que no se hizo esperar mucho por cierto. Cuando para alguno de ellos debía abrirse un porvenir risueño, quizá feliz, ven tan sólo un abismo que le es ya imposible evitar.

Pasemos á dar cuenta de los principales incidentes de este célebre jurado, cuyos pormenores hemos tomado en el salón mismo donde se verificó.

La aglomeración de gente era tal, que había por lo menos cinco gentes para el sitio que debiera ocupar solo una. Leída la voluminosa causa por el Secretario del juzgado, se pasó á los debates, tomando la palabra el Representante de la sociedad.

37. *The Trial of the Murderers of Mr. Tomás Hernández Aguirre.* Broadsheet with white-line illustration by Posada, 1891. Full Sheet. Fondo Editorial de la Plástica Mexicana.

Miguel Cabrera had arrested all of the perpetrators but one. The four, who all blamed the missing man for planning the deed and murdering the jeweler, were held incommunicado while the fifth member was hunted; one month after the robbery, he too was brought into custody, and the trial began. The roster of suspects provides evidence of foreign influence on the crime, and shows that by welcoming French influence into some areas of Mexican life, Mexicans also admitted French traits that were less desirable. Besides the Mexicans Jesús Bruno Martínez and Aurelio Caballero, the others were Nicolas Treffiel, Gerard Nevraumont, and Anton Sousa. The Vanegas Arroyo shop released as many as ten broadsheets about the crime and its aftermath; over their course two trends are noticeable: The coverage becomes more sympathetic toward the criminals, and their focus gradually narrows to Jesús Bruno Martínez, who, besides being the most clearly "Mexican" of the gang, was the one convicted of murdering the jeweler.

At the outset, the crime was treated like one of the more usual crimes of passion with the notable exception that the perpetrators were dressed in European-style clothing (fig. 36). In this image we see Martínez viciously stabbing Hernández in the chest as another robber removes some crudely suggested baubles of jewelry from the wall. A third criminal has found it impossible to carry out his assignment in the presence of such carnage, and he looks on in shock at the right. The tension in the body of Martínez is palpable; he bends over stiffly and his arms grasp the knife and his victim. His eyes are aflame under the furrowed brows. The victim, whose arms are tied behind his back, apparently met death with his eyes wide open as blood began to flow from the wound in his chest. The style of this white-line print, in the body postures and in the way Posada has suggested the volume of the figures, resembles the images of Guadalupe Bejarano, which were created within a few months of this one. The overall ensemble of the figures is quite interesting, as they are in various degrees of exertion. The jagged diagonals and implied energy of the outlines of their black clothing is made richer, though not quite balanced, by the horizontal and vertical of the couch and the wall pillar at the left center. The plate has sustained some damage in the leg of the jeweler.

This image survived without a text, but we can get some idea of how it might have read from the second sheet released on the subject, which dealt with the trial (fig. 37). Below an illustration of a crowded courtroom we read an account in prose with a sense of moral outrage which parallels that of the most sensational crimes: "By now well known to the public are all of the facts and details of the terrible murder of Don Tomás Hernández Aguirre, which took place in the evening of the 20th of February of this year in truly shocking circumstances which have caused the most justified alarm among all social classes." The text later praises the speed of the trial and the diligence of the investigating magistrate, Salvador Medina y Ormaechea, whom it calls "worthy of all praise and thanks from the entire society." After pausing for a moment to wonder if the criminals regret their bloody deeds, it concludes by noting that the courtroom could not accommodate the press of spectators, who

Los autores del crimen de la Profesa en Veracruz con dirección á San Júan de Ulúa.

El día 26 del mes de Mayo de 1891, Nevraumont, Treffel, Caballero y Sousa, fueron sacados de Belen y conducidos á Veracruz, para de ahí ser pasados á S. Júan de Ulúa donde cumplirán su condena por el robo verificado en la calle de la Profesa.

Los cuatro fueron pelados y rasurados completamente, vistiendo el uniforme del presidio, consistente en saco y pantalón de dril blanco con vivos azules y un letrero que dice: «*Presidio de San Juan de Ulúa*;» sombrero de petate y huaraches.

Este golpe los ha de haber desmoralizado por completo, pues hay mucha diferencia entre la cárcel de Belen y el terrible presidio de Ulúa, de donde muy pocos vuelven.

Tristes quejas de dolor de Nevramont, Treffel, Sousa y Caballero, en S. Júan de Ulúa.

De la luna á los reflejos
Que sobre la mar flutúa,
Se ve de S. Júan de Ulúa
La negra sombra á lo lejos.

Allí en profunda aflicción
Bien justificada á fé,
Se encuentran Sousa y Trefé,
Caballero y Nevraumont.

Y aunque aparentan frescura,
Tras esa fingida calma,
Lleva cada uno en el alma
Una infinita amargura.

¡Cómo desearían ahora
Poder borrar el pasado!
¡Cómo querían ver borrado
El extravio de una hora!

Y así exclama dolorido
Nevraumont, el más osado,
Al contemplar el olvido
A que hoy se ve sentenciado;

«En esta horrible prisión
«Se irá mi mejor edad,
«Y en tan profunda aflicción
«Llegaré á la ancianidad.

«Lejos de mi patria amada
«Sin amigos ni parientes,
«Tendré una vida augustiada
«En estos climas ardientes.

«Ya de mi madre querida
«No gozaré las caricias,
«Que de mi pasada vida
«Formaban, ¡ay! mis delicias.

«¡Mis mano» no cerrarán
«Por última vez sus ojos,
«Que ya en la tierra estarán
«Descansando sus despojos.

«Y cuando llegue á salir
«Me hallaré solo en el mundo,
«Si no llego á sucumbir
«En este encierro profundo.»

También Nicolás Trefé
Lamenta sus tristes penas,
Al sentir bajo su pie
El peso de las cadenas.

«En extranjera nación
«Hoy me miro sentenciado,
«Y de todos despreciado
«Por una perversa acción.

«En este presidio horrible
«Sufriendo mil desengaños.
«Pasaré diez y seis años
«De una existencia terrible.

«Ya no veré más el suelo
«Donde ví la luz primera,
«Ni tendré en mi hora prostera
«De mi familia el consuelo.

«Adios, patria idolatrada,
«Mi vista á verte no alcanza,
«Y ni aún tengo la esperanza,
«De volver á mi morada.

El infeliz Caballero
Su triste suerte llorando,
Va sus penas lamentando
Con acento lastimero.

«Triste de mí que olvidé
«En un momento de horror,
«De la prisión el dolor
«Y al delito me entregué.

«¡Cómo olvidar un momento
Pudo y aunque esto me asombre,
Que habia dado muerte á un hombre
Por un fútil sentimiento?

«Y sufrí amarga prisión
«Que necio pude olvidar,
«Para volverme á entregar
«A otra criminal acción.

«Tardíos es mi arrepentimiento
«Pues de aquí saldré un anciano,
«Sin encontrar una mano
«Que calme mi sufrimiento.

Sumido en hondo terror
Sousa lágrimas derrama,
Y entre sollozos exclama
Con un profundo dolor:

«Olvidé la educación
«Que en mi niñez recibí,
«Y en la tentación caí
«De hacer una mala acción.

«Mi familia siempre honrada
«Por mí manchada se vió,
«Y así me vine á ver yo
«En situación angustiada.

«Aquí en horrible tristeza
«Lloraré diez y seis años
«Los terribles desengaños
«Que me buscó mi pereza.

«Adios, familia querida
«Adios, mi Concha adorada,
«En mi solitaria vida
«Ya no puedo esperar nada.»

Así sus penas lamentan
Esos cuatro desgraciados
Que hoy en sus desdichas cuentan
El mirarse sentenciados.

¡Méjico.—Imprenta de Antonio Vanegas Arroyo, calle de Santa Teresa núm. 1.

38. *Those Responsible for the Crime of La Profesa in Veracruz, On Their Way to San Juan de Ulúa.* Broadsheet with white-line illustration by Posada, 1891. Full Sheet. Colorado Springs Fine Arts Center.

outnumbered the available seats by five to one. The verdict of the magistrate was that Martínez had committed the murder and should be sentenced to death; the same penalty was decreed for Nevraumont, who was considered the master-mind of the crime; the others received sixteen-year sentences, but to make an example of them, they had to serve at hard labor in San Juan de Ulúa, the military prison in Veracruz. Within a few weeks, Nevraumont's death sentence was overturned on the grounds that he had not killed anyone, and he too was sent to Ulúa for a twenty-year sentence.

At this point, with the alleged danger to society past and the responsible parties in custody, the treatment of the criminals in the broadsheets began to shift toward sympathy, though a strong moralizing tone was retained. A sheet which must have been released in early June of 1891 dealt with the fate of those sentenced to prison in Veracruz (fig. 38). The brief text describes them wearing the white prisoners' uniform, straw hats, sandals, with heads shaved. It makes the claim that "These shocks must have completely demoralized them, because there is a great difference between the prison of Belén and the terrible presidio of Ulúa, from which few return." There follows a series of "sad laments" in verse, in which each of the prisoners complains about his fate and expresses regret for his deeds. Nevraumont, for example, pines for his home country, says that he will lose his youth in prison, bids farewell to his mother. Treffiel also casts a longing eye toward France and sighs sadly as he looks on the walls that would hold him. Caballero regrets participating in the crime, saying that he threw his life away with one hasty decision. Sousa's principal regret is staining his family's reputation. All of these choruses are spoken in first person, as if the inmates are actually saying them. Except for the rhyming, they speak in a style of utterance appropriate to conversation among friends, putting the spectator in a position of seeming intimacy with them. Despite the nature of their deeds, they invite sympathy and identification from the audience.[30]

Posada's illustration is one of his least successful works, indicating perhaps that he could not sympathize with the burst of moralistic lamentation of the verse text. The illustration's rather matter-of-fact composition is stylistically similar to figure 37. The symmetry of the black-clad soldiers is obvious; the parallel verticals they form and the strong high horizon combine to constrain the composition. The prison in the background seascape is rendered in the crudest way possible; in the foreground, the prisoners seem casually jumbled together in the boat, without any sense of composition or the inner energy typical of Posada's subjects. One prisoner is not even delineated clearly, and seems about to vanish into thin air. In a sense this type of picture is appropriate to a depressing scene of captivity; there is little action and certainly no violence or vigor. At the same time, this is one of the few assignments in which it seems that Posada found nothing to identify with, no life-movement, no *élan vital* whose energy he could feel, harness, and redirect. Posada's art depends for a large measure of its success on such sympathetic intuition of energy and state of being; we have seen in other works that he did not make moral distinctions between various types of such energy. The galloping rurales, the police

commissioners examining a cadaver, the man chewing his children, and the criminal standing to hear his death warrant read: all, even when not in vigorous motion, are imbued with vigor. Even when his composition is based on a newspaper picture, Posada adjusts things so that power surges through the protagonist. Not here. In the distance between this work and other better ones, we can see again some of the factors that account for Posada's skill and efficiency as an artist.

Other sheets dealt with the fate of these prisoners; the Mexico City public could not forget about them. One sheet reported that Nevraumont became ill shortly after arrival, and that the rest were working in the quarries that line the shore of Veracruz, hauling rocks out of the water. The text continued, "Perhaps they were hoping to be sentenced to Belén, where the work that the prisoners do is not unbearable, and one can plan on the comfort of family visits."[31] Another sheet informed the public that Caballero had died vomiting. Yet another brought news that Nevraumont broke under the strain of the Ulúa regime and committed suicide by throwing himself into the sea. In fact, only Treffiel survived his sentence.

Jesús Bruno Martínez received the most sustained attention; not only was he regarded by the authorities as the worst of the lot, but he was imprisoned in

39. *Jesús Bruno Martínez in Jail in Belén.* Restrike of white-line illustration by Posada, 1891. From a full sheet. Fondo Editorial de la Plástica Mexicana

40. *Flight of Jesús Bruno Martínez from the Belén Prison.* Broadsheet with white-line illustration by Posada, 1891. Full Sheet. Photograph © The Art Institute of Chicago. William McCallin McKee Memorial Collection. 1944.926

LA FUGA DE Jesús Bruno Martínez DE La Cárcel DE BELEN.

El miercoles 7 de Julio del presente año, el célebre criminal Jesús Bruno Martínez se fugó de la prisión de Belen.

Demasiado conocido es este sentenciado y bastante fresco está aún el recuerdo del asesinato perpetrado en la persona del anciano joyero de la Profesa D. Tomás Hernández, para que demos pormenores que de sobra conoce el público. Trátase ahora de la fuga de Martínez sobre cuya cabeza pesaba una sentencia de muerte.

Los compañeros de Martínez fueron llevados á San Juán de Ulúa y sólo él fue sentenciado á la última pena.

Sin duda el fusilamiento de Manuel García verificado el día 2 del presente Julio, hizo comprender á Martínez que tal vez estaba cercana la hora en que él sería fusilado y esta consideración lo hizo intentar un desesperado recurso para sustraerse del terrible fin que le aguardaba. Resuelto á fugarse hizo sus preparativos proveyéndose de una larga y fuerte cuerda con sus correspondientes nudos.

El punto en que se fijó para consumar la evación fue la tapia del patio del Jardín que da para el camino de fierro del ferrocarril Cerdan.

Después de escalar esta tapia por la parte interior se pasó al lado de afuera descolgándose con toda felicidad, llegando al suelo perfectamente sano y salvo.

Ya emprendía su camino aparentemente tranquilo, contando quizá con haber recobrado para siempre su libertad, cuando fue detenido por un guarda vía del citado ferrocarril Cerdan que había visto perfectamente la fuga de Martínez, y que sin miramiento alguno lo condujo á la comisaría respectiva. En esta Oficina dijo llamarse Antonio Díaz, negando tenazmente lo de la fuga y todos los pormenores que dió el guarda vía; pero por desgracia para Martínez

mientras estos acontecimientos pasaban, en la prisión se había notado su ausencia y adquiridas las pruebas evidentes de su fuga, los empleados de Belen habían ocurrido á la inspección para pedir auxilio á fin de capturar al prófugo y al presentarse en la Inspección vieron á Martínez el cual no pudo ya negar nada, siendo llevado á Belen con todas las precauciones necesaria para evitar una nueva intentona.

Profundamente abatido iba el desgraciado Martínez considerando sin duda que su situación se ha agravado muchísimo con esta circunstancia y que esto sea tal vez motivo para violentar el triste fin que le aguarda.

Si alguna esperanza abrigaba de obtener el indulto con cuyo objeto se decía que algunas señoras se acercarían al C. Presidente de la República, con este rasgo de audacia es evidente que ha destruido las intenciones que algunos tuvieron de favorecerle y aun en el caso de que esto no fuera así, lo que si es casi seguro, es que no obtendrá la gracia que en su favor se solicite.

El tormento de este desgraciado debe ahora ser más insoportable que nunca.

La fatalidad se ha puesto á su frente y el único recurso que en su mano estaba intentar, le salió mal, no quedándole ya más que la conformidad y la resignación con su negra fortuna.

Cuantos pormenores podamos obtener respecto á este suceso, nos apresuraremos á ponerlos en conocimiento del público, ya que se trata de un personaje que se ha célebre con una tristísima celebridad.

Según oimos decir á última hora, la fuga se verificó á las dos de la tarde, hora sumamente peligrosa para llevar á cabo empresas tan arriesgadas como la fuga de una prisión.

M.M

Méjico.--Imprenta de Antonio Vanegas Arroyo, calle de Santa Teresa núm. 1.--Méjico.

Belén in the capital, awaiting execution. The sheet known as *Jesús Bruno Martínez en las Bartolinas de Belén* (fig. 39) bears an obvious resemblance to the similarly titled sheet on Guadalupe Bejarano (see fig. 8), and they are dated less than a year apart. The text that accompanies figure 39 contains a health report on the other robbers and news of the recovery of some of the stolen jewels, a feat achieved by trailing the girlfriend of Treffiel, who was trying to sell them. The poetic text is Martínez's alleged leave-taking, and it is truly a sad lament:

41. *Execution of Jesús Bruno Martínez.* Restrike of a white-line illustration by Posada, 1892. Dimensions unknown. Instituto Cultural de Aguascalientes, Mexico.

What happened to those old times
When I was poor but respectable
And my conscience was clean; not yet
Tainted with crime despicable?

In agony interminable
I watch the hours drag
When nothing, I know, can save me
My spirit as limp as a rag.

My hopes, they all have all fled
I'm resigned to take my last breath
And await the fate that's due me
The implacable sentence of death.

Posada's illustration captures this mood, but also depicts emotions that
are more complex than the depressed resignation of which the poem speaks.
Martínez leans against the table in his cell, head in hand, but his back is straight
and he stares at us intently through slightly furrowed brows. His lips are parted
as if in speech, and the hand gesture is one of a person who wants to make a
point. It is not a gesture of resignation. There is complaint, but not sullen
complaint; this is not a picture of a beaten man.

Posada probably knew of the problems that the Belén authorities were having
with Martínez. Rebellious in his cell, he railed against his fate. At one point he
wrote an angry inscription on a wall in which he threatened the famous detec-
tive who had arrested him: "Soon they are going to kill me, but I don't care. I
will kill Cabrera."[32] A knife blade was found in his cell. He still hoped to have
his death sentence commuted, and these hopes were not completely vain,
because a group of women, including the daughter and niece of the murdered
man, joined in requesting clemency. When his final appeals were denied near
the beginning of July, he compounded his fate (and his celebrity) by escaping
from Belén, an event that was also illustrated in a broadsheet (fig. 40). He
climbed up to the roof at two in the afternoon on the seventh of July and let
himself down with a rope onto some railroad tracks. He was spotted immedi-
ately by a security guard of the railroad company and taken to a nearby police
station, where he denied everything and told them his name was Antonio Díaz.
At that moment guards from the prison entered saying that Martínez had just
escaped. Foiled, he was returned to custody, this time to "El Infierno."

Martínez had one last trick up his sleeve. When his execution date finally
arrived and he was being led away to the firing squad, he tried to make good
on his threat to kill Cabrera, who, as the arresting officer, was entitled to be a
witness to his execution. Using yet another smuggled knife blade, he lunged
at him, wounding him in the neck.[33] Posada made an illustration of the confu-
sion surrounding this scene (fig. 41). At the far left Martínez stands defiantly,
head held high. The figure closest to him may be Cabrera, as a comparison
with an 1897 depiction of him shows something of the same high forehead and
mustache (see fig. 23). He is obviously of higher rank than the soldiers in atten-
dance, as was true in life, but the different printing technique and the relative
crudity of figure 41 compared with figure 23 make this comparison difficult.
Invisible is the left hand of Martínez, which would have held the knife; perhaps
he has brandished the blade and is about to attack. Two soldiers seem to be
moving toward Martínez to subdue him. Complicating our interpretation of
this print is the fact that it survived without a text, but it is at least clear that
the criminal died arrogantly. He literally went down swinging.

In the development of the story of the La Profesa criminals in these broad-sheets, we can see that at various times, Posada and Vanegas Arroyo shifted the frames that they used in presenting and interpreting the events and characters. At the beginning, the story was conceived as a sensational and shocking crime perpetrated against a seemingly innocent victim. The tone shifts to moralizing with the sad laments of the prisoners at hard labor in San Juan de Ulúa, a line that Posada did not adapt well to, though he tried. This moralizing mode was tried in the first poetic text about Martínez, but that frame would not fit the mercurial and rebellious temperament of the criminal. Posada saw this, and made an illustration that departed from it in subtle but important ways. The sheer number of sheets and illustrations produced—there are still others that I have not discussed here—indicate that the common people were intensely curi-ous about this crime in general and about Martínez in particular. It is difficult to imagine a moralizing interest being sustained over such a period. Once we perceive a story's moral, our interest is exhausted if that is all we are looking for. So it was with the vast majority of sensational crimes in the broadsheets; they merited one sheet apiece. The case of Guadalupe Bejarano is in some ways an exception, but the public seemed to remain shocked about her deeds, as evi-denced by the rock throwing incident as she was led off. Her victims, after all, were children. In the case of La Profesa, it was rather the criminals' open defiance of authority that caught the fancy of broadsheet buyers. The original act was daring and provocative, and over the course of time it became obvious that it was Martínez who most retained these characteristics.

Of course, Martínez did not approach the true social bandit type as closely as had Heraclio Bernal and Santanón; though literate, Martínez did not work on the vulnerable points of the socioeconomic structure, and did not apparent-ly ally himself with any organized oppositional political movement. Nor did he share his wealth with the poor. Other differences between Martínez and Bernal and Santanón included their operational environments. For Bernal and Santanón, building up a criminal track record was easy because the countryside provided them with ways of escape. Knowing the territory well, and navigating it on horseback, also added to the glamour of the rural bandits. An urban social bandit would have to develop alternatives to these forms and styles, and Martínez did not, partly because his career was cut short. But he does have in common with them a sustained, arrogant, and seemingly fearless defiance of dominant powers, and the public showed that they appreciated this attitude by buying a succession of sheets about him.

For all of the public interest in the deeds of Martínez, his one robbery pales in comparison with the list of crimes allegedly committed by Jesús Negrete, "The Tiger of Santa Julia." *El Imparcial* helpfully provided a list:

15 August 1900	Robbery of the Hacienda de Aragón with woundings
13 September 1902	Murder of the gendarme Arnulfo Sánchez
19 June 1903	Robbery of the Valdés factory
4 July 1904	Murder of Marcelino Molina

12 July 1904	Murder of the gendarme Rafael Bejarano
8 November 1904	Robbery of the post office in La Piedad
15 October 1904	Murder of Lauro Frías, Leocadio Enríquez, Regino Aguilar of the Rurales; wounding of two others[34]

When his trial began in 1908, the newspaper reported that his lengthy criminal career and the impending hearing had turned him into a hero in the poor neighborhoods, a fact that created unique problems in the courthouse: "The trial has succeeded in attracting public attention in a most powerful way, and naturally these people, deserting their *barrios,* have ended up polluting the air in the massive hall with the foul odors of sordid poverty and rampant crime. They could not get into the courtroom, but they did not leave the hall." On being informed at the outset of the case that he was charged with five capital offenses, Negrete growled: "Five death sentences! I'm not guilty, and besides, I'm not a cat."[35] As in the case of Martínez, the Vanegas Arroyo shop gladly ministered to public curiosity about this most famous of the capital's urban criminals, producing once again a series of broadsheets about his life and deeds. The coverage of the Negrete case also shows some of the hesitancy that characterized the coverage of Martínez; they were at times willing to help turn El Tigre into a folk hero, while at others they took a more authoritarian line.

Negrete did not begin his criminal career exactly by accident, but he was in part a product of the tight economic situation of the Mexican lower classes in that period.[36] At age eighteen, still illiterate, he signed up as an *enganchado* for a two-year contract to work as a laborer on a hacienda. At the end of his term he was informed that he had an unpaid debt at the company store, and he would have to continue working to pay it off. This all-too-typical fate led him into a flight from this debt —his first crime. A stint in the army followed a series of odd jobs. When he could not afford to buy his military promotions he deserted the army in 1898 and settled in the district of Santa Julia, one of the capital's more remote and dangerous suburbs.

The Santa Julia choice probably influenced Negrete's future career. The urban growth of Mexico City during the Díaz period was not spectacular in terms of population, but was highly irregular. According to one source, between the years 1858 and 1910, the city's population grew 2.3 times while its geographic expanse multiplied nearly fivefold.[37] The core of the city, near government buildings and in wealthier neighborhoods along Paseo de la Reforma, had most of the usual amenities, such as street lights, sidewalks, sewer systems, pavement, and, after 1900, electric trolley cars. Paseo de la Reforma was styled after a French boulevard, with civic monuments and a lush growth of trees shading its stately promenade from the Alameda Central to Chapultepec Park. These luxuries did not extend very far out, however. Even some upper-class neighborhoods lacked a sewer system, a fact that Posada once noted in a cartoon. In the more remote suburbs, animals roamed on the unpaved streets that separated crude dwellings of sun-dried brick. Police rarely visited. In the constellation of suburbs Santa Julia had probably the worst reputation. Located

LA VIDA DE UN BANDOLERO
LOS CRIMENES MAS NOTABLES DE
JESUS NEGRETE
(a) El "Tigre de Santa Julia."
(APREHENSION DE SUS COMPLICES.)

Vamos á narrar los crímenes
Mas notables de Negrete,
Los cuales se han descubierto
En México últimamente

El Coronel Felix Díaz
Trabajando sin descanso
Ha conseguido hacer esto
Sin tropiezos ni retraso.

Los cómplices del bandido
Tambien fueron descubiertos
Y en poder la Justicia
Todos se encuentran ya presos.

A referir comencemos
Los formidables delitos
Del 'Tigre de Santa Julia,"
Con sus detalles precisos.

La noche del día 15
De mil novecientos tres
De Vallejo en la Garita
Un robo y asalto fué

Dos arrieros que llevaban
Animales, con carbón
Fueron ¡ay!, asesinados
Por robarlos á los dos.

De Negrete fueron complices
Un Hernandez y un Martínez;
Otro llamado Galván
Con instintos tambien viles.

Los muertos en una zanja
Fueron por allí arrojados
Y los bandidos huyeron
Para no ser apresados.

Despues de esto al poco tiempo,
Aquí ya en la Capital,
A un gendarme dió un balazo
Con vileza singular.

Su cómplice fué en este crimen
Su querida la "Cabrera"
El gendarme lo llevaba
Por escándalos que alteran.

Huyeron los criminales
Sin que pudieran prenderlos
Y al pronto quedando impune
Este delito tan fiero.

Despúes en el Molino
Llamado de Valdéz
Asaltaron una noche
Con mucha avilantez:

42. *The Life of a Bandit:
The Most Famous Crimes
of Jesús Negrete.* Broad-
sheet with black-line
illustration by Posada,
1906. Half Sheet.
Colorado Springs
Fine Arts Center.

but rather a dependency of the incorporated city of Tacuba. The only problem
was that Santa Julia was twice Tacuba's size, and police presence was minimal.
It was "a neighborhood that today would be called a *ciudad perdida* [irredeemable
city] . . . infamous as a sanctuary of pickpockets, robbers, and sneak thieves."[38]
This was where El Tigre took up residence. His first crime to come to the
attention of the authorities took place in 1900, but he established himself before
that as a pickpocket and mugger, victimizing upper-class people in Chapultepec
Park and taking refuge in the barrio at night.

Not content to do such small jobs, he soon began committing crimes that
had an element of revenge against the rich. When he held up the Hacienda
Aragón in 1900, he and four others went straight for the company store, where
they got some cash and tools which they sold to a fence. Less well-corroborated
sources say that he would rob the employers of his neighbors in the barrio if the
latter complained about foul treatment. In one case, he attacked an allegedly
greedy store operator in Santa Julia, and stripped him of his clothes. The store
operator then wandered to the police station naked. Though Negrete was never
charged with most of these crimes, from such deeds must have come his reputa-
tion in the barrio. He apparently developed a network of safe houses for
himself with the cooperation of local residents. At the time of his capture in
October 1904, he was planning another attack on the Hacienda Aragón. A
friend of the administrator, Vicente Godines, had earlier offered to join the
Negrete band, but as the date of the planned attack approached he was getting
cold feet. Negrete began to fear that Godines might tell the authorities or the
owners, and one of his gang shot Godines during a planning meeting in a
cantina. This brought police, and a general gunfight ensued. The rurales were
called in as reinforcements, and with this added power the police were able to
subdue Negrete and several others, who were all taken to Belén.

Near the time of his capture the first broadsheet on Negrete was released
(fig. 42). The poetic text is of poorer quality than usual, for two reasons. It is
based rather closely on the newspaper accounts of the crimes with which he was
charged; there seems to be a strong interest in getting the supposed facts down
in print in a chronological narration. The author of the text also wants to
include the names of as many accomplices as possible, and this results in
strange rhymes and odd meters in many places. Still, the overall tone of the
poem is by no means negative. Nowhere is Negrete called a bad man, though
at one point his accomplices are credited with "vile instincts." The text says that
he murdered a man in Tacuba "with great aplomb." His crimes are described
with such adjectives as "sensational," "singular," "notable," and "formidable."
The poem finally credits police Inspector General Félix Díaz (Don Porfirio's
nephew) with hard work.

Posada thus had a wide choice of crimes to choose from for the illustration,
but he selected the murder of a policeman. It is difficult to tell which case this
is, but the most plausible is the murder of Rafael Bejarano, which occurred as
the police broke up a robbery of a bakery. Negrete allegedly shot the policeman

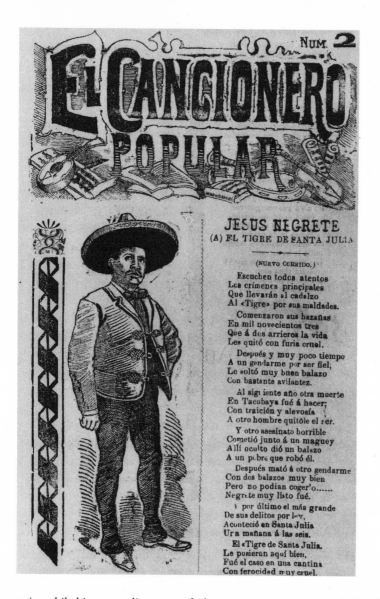

43. *The Popular Songster No. 2.* Broadsheet with black-line illustrations by Posada, 1909. Half Sheet. Amon Carter Museum. 1978.63

44. Photograph of Jesús Negrete. *El Heraldo de México,* 12 May 1909, page 1.

twice while his accomplices, one of whom was a woman, escaped. Posada seems to have made a fortuitous choice, because the impact of this illustration would have been drastically different depending on the social class of the viewer. If the upper classes viewed the police as guardians of order, and supported them with tips and payoffs in addition to their salaries, they would naturally tend to see Negrete in this print as a menace. The lower classes, many of whom had no reason to trust the police, would view this act with far less moral condemnation, and for some it might seem that Negrete was a deliverer.

The authorities may have thought they had him, but that was not to be. Investigators took nearly a year to draw up the indictment against Negrete, which in its final form resembled very closely the list published in *El Imparcial* noted previously. During that time he was held in various places in Belén, including El Infierno and El Purgatorio. On 29 November 1905, in the

company of four others, he escaped. This fact was the subject of another broadsheet, but it gave no special attention to El Tigre. The text was a recitation of available facts drawn mostly from newspaper accounts, and for an illustration the broadsheet producers used the same plate as for the escape of Jesús Bruno Martínez except that the part depicting the railroad track was cut off.[39] From it we learn that the escapees bored a hole through the wall of a cell and let themselves out onto the roof, from which they lowered themselves with a rope. All of them except Negrete stole a car and drove in it to the house of a friend, where they were caught the next day. Several staff members of Belén were arrested for aiding the escapees, including, according to the sheet, "several" employees, five gendarmes, four inmate Corporals, and thirteen soldiers.

Negrete returned to Santa Julia and hid successfully for four months. He was recaptured when a woman who was sheltering him betrayed him to the police. The arrangement between the woman and the police required her to signal them when Negrete went out to the back yard to relieve himself.[40] This time the police took him to the more secure Penitentiary, where he was held for another two years awaiting trial. It was there that he learned to read and write.

The trial was surprisingly brief, from June 1 to 12, 1908, but was front-page news every day. The press of people in the courthouse, noted previously, was remarkable given that El Tigre had committed his last crime four years earlier. The defendant claimed that if he had learned to read and write earlier in life, he would not be in such problems today. His responses to the charges against him corresponded closely to that of the traditional valiente code of honor. He denied participating in any robberies, saying, "I have killed, but I have not robbed. I am a man, not a *ratero* (petty thief)." He admitted to two murders, but said that one was in self-defense and the other was committed in order to escape unfair capture. A third victim was shot in the back, but Negrete's retort was that he would never do such a thing. "I only shoot people who are facing me," he said.[41] His defense lawyers protested that the trial had been unfair because the defendant had been held incommunicado during most of the pretrial period, so that they could not have the access to him that they needed. Moreover, Negrete did not fit the current scientific definition of a "born criminal." In their final statement his lawyers argued that his criminal career had been a perverse pursuit of excellence: "Why has Negrete acted thus? He wanted to be unique, to go from sergeant to captain of bandits. Thus he became the ultimate in energy, in bravery, in virility, in steadfastness; so that no one could better him, and that he might obtain from posterity the victor's medal on his chest and the laurel wreath on his tomb."[42] The verdict was announced almost immediately. He was found guilty of the two murders to which he had admitted, and was sentenced to death.

Another corrido sheet was issued during Negrete's appeals process which shows a new influence on Posada (fig. 43). The ambivalent text calls Negrete "smart" and "brave" but also "vile" and "unruly:"

EL FUSILAMIENTO
DE JESUS NEGRETE

(á) "El Tigre de Santa Julia"

El 22 de Diciembre de 1910, á las 6 y 25 de la mañana
En el Patio del Jardín de la Cárcel de Belem.

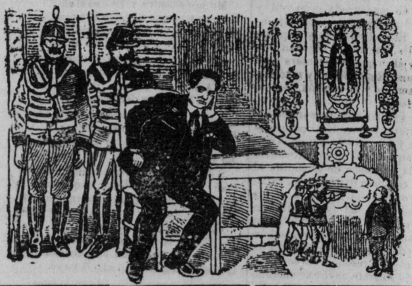

ULTIMOS DETALLES

Habiéndose verificado la entrega del reo, que se hallaba confinado en la bartolina Nº 67, la misma en que pasó tantos años en Belén, antes de ser transladado á la Penitenciaría, hubo de procederse á el encapillamiento, para lo cual se designó la pieza que sirve de descanzo á los celadores, y en ella se levantó el altar, donde fué colocada en la parte superior una Virgen de Guadalupe y á sus pies un crucifijo y candeleros de latón con su respectivas ceras.

Había en el interior de la capilla dos camas: una para "El Tigre" y la otra para el presbítero Padre Julián Villaláin, que le acompañó hasta el último momento.

Había también dos mesas con sus sillas y demás útiles indispensables, por lo que Negrete veía complacido y con curiosidad todas estas cosas que le rodeaban.

Quizo vestirse de negro y el Sr. Alcaide le obsequió un traje de charro de este color y un sombrero de pelo también negro, todo lo cual recibió Negrete muy agradecido, y para celebrar el estreno de su indumentaria, brindó con una copa de cognac, manifestando la verdadera serenidad de los hombres valientes.

Durante buena parte de la noche se la pasó platicando con los sentinelas y otras personas que lo acompañaban, como su defensor el Lic. Justo San Pedro, el padre Villaláin y otras, que le daban conversación.

In 1903
His deeds had their start
When he killed those two muledrivers
With cruel fury in his heart.

The print by Posada shows that he had been looking at newspapers, as it is very close to a photograph by Casasola which appeared in several editions (fig. 44). During the decade prior to the revolution, Mexican newspapers gradually acquired the technology to reproduce photographs, and during the last few years of Posada's career he was strongly influenced by them on many occasions. The example in figure 43 is of the "portrait" type, the principal goal of which is to convey factual information about the appearance of the subject, leaving at a minimum interpretations of his temperament, and editorializing even less. Though Posada was content in this case to keep the same general approach as the newspaper photograph, he has reinterpreted Negrete after his own methods of drawing the figure. While the details of Negrete's dress are close to identical, and both figures seem to bear their weight comfortably, the bodily proportions vary in subtle but telling ways. Posada's version is much more squat in the hips and chest. The body seems more compact and the midsection rounder. The hanging arm is shorter and more curved, and the hand more visible. The left elbow protrudes further, adding to the lateral expanse of the silhouette. These changes take away the hint of elegance that exists in the more elongated and relaxed-looking Negrete of the photo; rather we get a body that seems to push outward against its skin; it seems more poised for some kind of lateral motion. Posada's figure of El Tigre is more dense with potential energy. We know that he had the ability to draw more suave types; it is also clear that he did not see Negrete as suave. His Negrete is more like the "energetic, brave, virile" figure that his defense lawyers described.

Exhausted all of his appeals, there remained only the final act, the death sentence that was carried out in December 1910 accompanied by intense publicity and two more broadsheets. Newspapers reported that Negrete was aware of the impending fury of the revolution. The battle at the house of Aquiles Serdán had taken place in Puebla the previous month; the armies of Francisco Villa and Francisco Madero were organizing in Ciudad Juárez. Negrete pronounced himself in favor of the revolutionaries, and wished he could be among them: "What a pity that I am locked up! If I were free, I could have had my own party with lots of men behind me; knowing that I was their leader, they would have fought with all their might."[43] He was taken to Belén for the last time on December 21. A reporter who witnessed the transfer described the condemned man: "It was the same Tiger of Santa Julia, the one of the shocking and bloody deeds, only he was a little heavier. The same attitude, the same mildly disrespectful smile that stamps itself on his lips whenever he finds himself face to face with the majesty of the law."[44] The broadsheets on his last hours take divergent points of view on the criminal. The first, dealing primarily with his last night alive, was quite favorably disposed toward him (fig. 45). The text says that

JESUS NEGRETE
(á) el Tigre de Santa Julia.
FUSILADO
En la Cárcel de Belem.
El 22 de Diciembre de 1910.

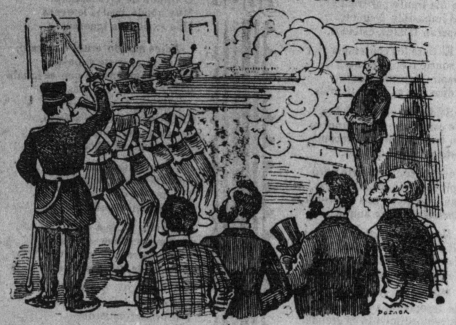

Ya es conocida la tenebrosa historia de este temido criminal. Esta larga cadena de crímenes que cometió Negrete en compañia de sus camaradas que formaban su «pandilla» esa interminable serie de robos, asesinatos, riñas, escándalos y otros atentados, ahora toca á su fin, la cadena muestra su último eslabón. El tigre de Santa Julia fué fusilado el Jueves 22 á las 6 de la mañana en el Jardín de Belém.

Fué trasladado la tarde del martes 20 de la Penitenciaría á Belem y entregado al Sr. alcalde de ésta última prisión, encapillado el Miércoles 21 á las 6 a. m. en la sala de descanso de los Celadores, donde se puso la Capilla y donde pasó las últimas 24 horas de su existencia en fervorosa plática cristiana con el sacerdote padre Durán, que lo dispuso católicamente á recibir el castigo de sus culpas en este mundo y á pedir el perdón de ellas allá en el otro, donde habrá de presentarse á un nuevo jurado, no menos severo que el de los hombres.

¡Oh, mis lectores amados! figuraos cuan terribles serán los momentos que duró ese infeliz esperando la muerte, pensad en todos los tormentos que enloquecerán su alma, y haced el firme propósito de huir del camino del mal para seguir por la senda del bien y de la virtud.

46. *Jesús Negrete, alias the Tiger of Santa Julia, Executed at Belem [sic] Prison*. Broadsheet with black-line illustration by Posada, 1910. Half Sheet. Colorado Springs Fine Arts Center.

they brought him a new suit and set him up in a chapel off the courtyard, as was traditionally done with condemned prisoners. The text points out that he greeted the arrival of the suit with "a toast of a shot of cognac, showing the true serenity of brave men." He refused the rite of last confession, a defiant gesture, and spent most of the night quietly chatting with his lawyer and the priest. Like Heraclio Bernal before him, he understood the obligation of famous criminals to write a final farewell in verse, so he produced eleven four-line stanzas. The back of the sheet reproduces the entire poem, together with an introduction that acknowledges the veritable cult that had grown up around him: "In order to properly satisfy our readers, we duplicate below the poem of El Tigre de Santa Julia without any correction or change, so that the public may possess the true verses." The poem is a remarkable document from one so recently literate. After asking for attention, Negrete describes himself and his fate:

I was a man of pleasure, I cannot deny it;
And I gave free rein to all of my passions.
But the ungrateful world which has rejected me
Has made me a toy of all its illusions.

The dominant note of the poem is pessimism and a profound sense of the transitoriness of life, expressed through certain obvious metaphors that Negrete is coming to as if for the first time:

All the world is false and a trick:
Our youth, and our strength, and our vigor;
Our hopes and our dreams will all pass away;
Our eternal reality is that we suffer.

Let me continue: a human being
Resembles in history the course of certain flowers.
He is born, he shows color, and distinctive aroma;
But fades with the march of the sun's powers.[45]

Posada's print emphasizes this embittered and brooding Negrete more than the brave man drinking cognac with his lawyer. Wearing the new suit, he is shown at the table in the makeshift chapel tensely leaning on his elbow and casting sidelong glances at his guards. The pose of the condemned man contrasts markedly with the bland dutifulness of these soldiers. They seem to have just wandered in for a momentary look around prior to resuming their positions outside. The absence of the lawyer and the priest heightens the alone-ness of Negrete, and emphasizes the confrontation between him and the auth-orities. Below the altar, with its candles and figure of the Virgin of Guadalupe, a bubble depicts the execution that will follow the next morning. The principal direction of the composition, indicated by the repeated rhythm of the human

figures with booted or bent legs, is a downward, left-to-right diagonal that bypasses this altar, a fact that in graphic language supports Negrete's refusal to confess. The interpretation of the criminal offered here is of life force converted by captivity and fate into mere restlessness or nervous energy. Sitting very lightly on the chair, he appears sullen, but listless rather than depressed. He seems to be entertaining thoughts of jumping up and tackling the guards in an effort to escape, but we know from the bubble in the corner that this cannot happen. Readers of the broadsheet would have elicited from the poem a sense that Negrete fully understood his fate; from the illustration they would have recognized that he rebelled against it, if only in his mind, to the end.

The tone of the final sheet, which emphasizes the execution, is quite different and much more supportive of the dominant morality (fig. 46). The text glosses over Negrete's refusal to confess, saying rather that he spent "the last 24 hours of his life in fervent Christian conversation with the priest." His crimes are described as an "endless list of robberies, murders, quarrels, scandals, and other assaults." It ends with a moralistic exhortation out of keeping with the spirit of the criminal of the previous sheet: "O beloved readers! Think of how terrible were the hours that this miserable man spent awaiting death; recall the torments that will soon twist his soul, and resolve firmly to flee from the path of evil and follow rather the trail of good and virtue." The back of the sheet contains the "Last Words of Jesús Negrete," completely false, in the form of the typical poetic repentance of the criminal, in which he expresses sorrow for all his crimes, begs forgiveness of his victims, and bids a tearful farewell to friends and family. For an illustration, the shop recycled an execution print made two years earlier for the case of Arnulfo Villegas, an unemployed butcher who had murdered his fiancee. As he had done with the case of Bruno Apresa, in this illustration Posada pulled the firing squad and the victim close together, and collapsed the sequence of events, as the squad seems to be firing before the captain has dropped the sword and given the order to shoot. In the foreground are the official witnesses, who are depicted none too flatteringly, especially the squinting, balding figure at the far right. The overall tone of this sheet is far more palatable to the religious and secular authorities, and, like the sheets dealing with spectacular crimes, meets the needs of those who see in crime and punishment a vindication of dominant morality. In the many prints about bandits, Vanegas Arroyo trod a fine line between sympathy and condemnation, between hailing the revenge of the social bandit and expressing relief at the final resumption of social peace that accompanied his demise. With these two sheets on the Negrete execution the two tendencies—sympathy and condemnation—are split, with each audience getting a sheet more to its liking.

The best description of Negrete's last moments, published in the newspaper *El País,* came from an entirely unexpected source: Salvador Díaz Mirón, who found himself locked up in Belén at that moment awaiting trial for assaulting a fellow member of Congress. The poet and sometime persecutor of Santanón was occupying a cell in the Department of Distinction that overlooked the patio of executions. Converted somehow into a foe of capital punishment,

the duelist wrote a poignant two-page account of how Negrete appeared, handcuffed but serene, on the fateful morning. Standing against the wall, he said "*Adiós, todos*" and waited for the fatal commands, staring at the ground rather than the guns. After the shots rang out, he slumped, but was still alive. The director of Belén called for a *coup de grâce,* and a total of three were given. Continues Díaz Miron: "Only one of these bullets meets the mark, finishing the criminal turned martyr. Blood, and not a little. Attendants of the prison take away on a stretcher his purpled remains. And from the morning sky an immense, tragic sadness descends on the gloomy yard."[46]

ANTONIO MONTES

MATADOR DE TOROS, MUERTO EN MEXICO EN 1907.

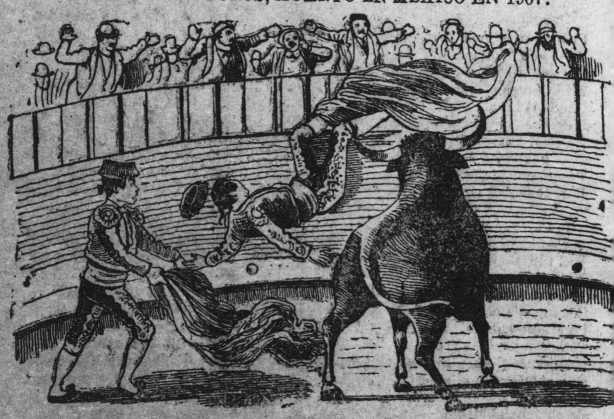

¡Desgraciado Antonio Montes!
La *malhora* le ha llegado,
Que aquí en nuestra plaza "México"
Un toro lo ha despachado.

Cuando á 1.ó de Sevilla
Grandes lágrimas lloró,
Y ya er la escala del buque
De España se cespidió.

El trece del mes de Enero
Que era domingo en la tarde,
Le cogió á Antonio Montes
El toro para matarle.

Médicos no le faltaron
A Montes junto á su lecho
Pero ro pudo vivir
Pues el mal ya estaba hecho.

En su breve testamento
Antonio les encargó
Que se llevaran su cuerpo
Para Sevilla veloz.

Al saber su pobre madre
El accidente tan cruel,
Lloró lágrimas amargas

Parece que sobre Montes
Había alguna maldición,
Pues que su cuerpo ha quedado
Toditito hecho carbón.

Cuatro cirios alumbraban
El féretro á medio arder,
Encontrándose distantes
Del catafalco muy bien.

A las seis de la mañana
Del veintitrés de este Enero,
El señor Pedro Gutiérrez
Avisó por el teléfono.

También al Presidente
De Beneficencia Hispaña,
Comunicó la noticia
Del fuego con grande alarma.

La autoridad acudió
Para el hecho esclarecer,
Y horrorizados quedaron
De lo que pudieron ver.

Las llamas consumido habían
La mesa y el buen cajon,
Y sobre el suelo mirábase

POSADA AND THE CULTURAL POLITICS OF BULLFIGHTING

The Díaz period in Mexico City corresponded to a time in which the acceptance of bullfighting increased dramatically. During the Juárez and Lerdo years, the sport had been prohibited in the capital city due to the Enlightenment-oriented views of Juárez, who saw the bullfight as a barbarian spectacle. During this prohibition, which lasted well into the rule of President Díaz, bullfights were held in some provincial cities and in rural areas, though these were not bullfights in the Spanish sense of the term, because most of them were done from the back of a horse in a Mexican variation known as *rejoneo.* Although the bulls sometimes had their horns covered, the *rejoneadores* had to be accomplished horsemen, and rejoneo was seen as a branch of *charrería,* the arts of the charro. The prohibition on bullfighting in the capital was lifted in 1886, but the authorities were slow to embrace what they regarded as its more unsavory aspects. It was prohibited again from 1890 to 1894 because unruly crowds, dissatisfied with the quality of the bulls or of the bullfighters, had vandalized bull rings and injured participants by throwing debris.

Keeping the sport alive was an uphill battle until the middle 1890s, but after that time bullfighting grew quickly. For the rest of the Díaz period, there were from four to six bull rings in the capital at which both Mexican and Spanish matadors plied the trade during the fall and winter each Sunday afternoon. A wide social spectrum attended, from urban workers who paid less than a peso for a seat high up on the sunny side of the ring, to the middle and upper class persons who sat nearer the action in choice seats in the shade for which they had paid perhaps ten pesos (see fig. 3). Bullfighters were popular cultural heroes, though various social classes and ethnic groups often had divergent preferences. Upper class persons and fans of Spanish descent liked the Spaniard Luis Mazzantini or the Mexican Vicente Segura, for example; the lower classes

idolized Antonio Montes and especially Rodolfo Gaona, though the latter was also preferred by some upper class people. This adulation took place in spite of the fact that bullfighters supposedly led immoral or questionable personal lives devoted to drinking and womanizing. A matador character called El Jarameño in the 1903 novel *Santa* by Federico Gamboa is in some respects a representative example of popular attitudes toward the bullfighter's life: he drinks heavily and lives with a prostitute. Still, there were magazines and newspapers devoted to coverage and commentary on the sport, which its most fervent devotees thought of as an art form on a par with painting and sculpture. Amado Nervo wrote about the spirit of devotion, comparing the aesthetic of the bullfight to Oscar Wilde's beliefs about the "uselessness of art" and describing by analogy the bullfighter's special status: "If in a balance we were to place on one side the brain of an illustrious man, and a matador's sword on the other, God . . . could not keep the sword from weighing more, because the matador risks his life, than the brain of the great man.[1]

The bullfight was also an important subject for the broadsheet business of Vanegas Arroyo and Posada. They participated fully in the cult of bullfighting, promoting favored matadors, giving news about gorings, and illuminating scandalous events. Their intervention in the scene, however, equaled their treatment of other aspects of Mexican life: they heavily favored Mexican bullfighters over Spanish bullfighters, and among Mexican matadors those from the lower classes or indigenous ethnic groups were the most favored of all. Vanegas Arroyo and Posada's treatment of certain matadors was as adulatory as the informal press censorship of the time permitted. They seem to have been aware that the bullfight was one endeavor in which someone with Indian blood or a provincial background or from the lower classes could excel and gain wide recognition, thereby inverting the class structure at least occasionally.

If we consider for a moment the traits of the successful bullfighter, we will see the importance of this class reversal. A matador is expected to show stoical courage in the face of danger. He is supposed to be indifferent to wounds and gorings. He is expected to be athletic and even graceful in his movements in the presence of the animal which wants to harm him. He will be less than successful if he flinches or hesitates, especially at the time of the kill, the final act of the drama and its most dangerous moment. As Julio Caro Baroja noted, these traits are aristocratic in origin, and also characterize the heroes of medieval romances such as El Cid and Bernardo del Carpio: "The bullfighter as such, no matter how plebeian his background, is inheritor of the prestige of ancient heroes, who always appeared, even on horseback, as matadors."[2] Hence the cult of the bullfighter served as a vehicle of hope for the lower classes, who could see their fellows in the ring acting like legendary aristocrats of old and earning the praise of thousands. If for the upper classes the bullfight was a more aesthetic spectacle, for many persons on the lower levels of society it showed that traditional virtues were not the aristocrats' exclusive property. In their treatment of the bullfight, Posada and Vanegas Arroyo cherished this belief and ministered to that hope.

A parlor game that Posada etched in 1898 illustrates the various stages of the Spanish-style bullfight as practiced in Mexico near the turn of the century (fig. 47). The center of the composition shows the crowds arriving for the spectacle. Posada was careful to include persons from varying social classes: urban workers in sombrero and cotton tunic share the space with more well-heeled types in top hat or corset. In cell 1 they are all seated. In cell 2 the various actors in the drama enter in stately procession; this entrance was often accompanied by trumpet or band music. Each matador had his own *cuadrilla,* his troupe consisting of subalterns who performed in the acts preliminary to the final dispatching of the bull. Cells 3 through 9 depict the first act, in which the picador on horseback, using a long pole, pierces the neck muscles of the bull to lower the head and weaken it slightly. These piercings alternated with capework by lesser members of the troupe as they distracted the bull away from the horse, and with acrobatic feats such as the leaping over the bull seen in cell 5. At times the bull would unhorse the picador, or knock the cape performer to the ground, problems seen in cells 7 and 9 respectively. At cells 10 and 11, the matador himself enters for capework, which also at times alternated with acrobatic leaps by subalterns like the one seen in 12.

Cells 13 through 22 depict the stage of the *banderillas,* in which specially trained performers insert barbed sticks into the area of the shoulder blades of the bull. Sometimes the banderillas were placed with the *banderillero* seated in a chair, seen in cell 17. Capework was also used at this stage to distract the bull if danger arose, or to position it for the next placement of the sticks. Some banderilleros achieved fame in their own right for exceptionally daring or acrobatic work, and some matadors placed banderillas themselves on occasion.

The final act of the drama, which culminates in the kill, begins in cell 23, in which the matador enters and dedicates the bull. The dedication usually honored a beloved friend, a dignitary in the audience, or perhaps a lover. The matador stood in front of the dedicatee and lifted his hat, sometimes announcing the dedication in rhymed couplets.[3] In this stage, the matador uses a much lighter cape which conceals the sword he will use to dispatch the animal. This part of the corrida is the most dangerous, as the bull may be wiser now and the smaller cape less distracting. Note that in cell 27 the matador has had to leap over the barricade to escape danger; most woundings of matadors took place during this stage. In cell 28 he brandishes the sword, and in 29 he plunges it in up to the hilt, intending to sever the bull's aorta. This was generally accomplished by letting the bull approach and stabbing it at the proper moment; the technical term for this is to kill *recibiendo,* or "receiving." If the sword thrust is not immediately effective, an assistant enters with a dagger and delivers the *coup de grâce* to the brain of the bull (cell 31), and the dead animal is dragged away. An afternoon's performance usually called for two matadors, each with his respective troupe, to kill three bulls each, or three matadors to kill two each.

The earliest bullfighter Posada illustrated was Lino Zamora, who was active through the period of prohibition and who met an untimely death over a romantic matter. The sheet was created shortly after Posada's arrival in Mexico

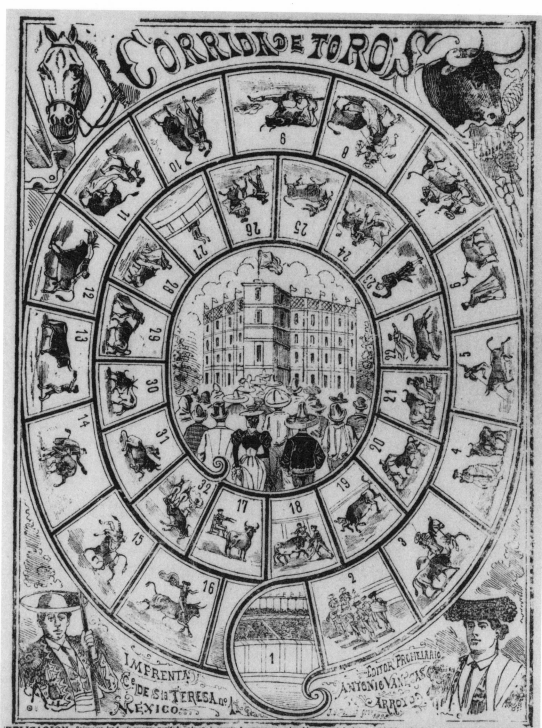

City, and was repeatedly reissued until as late as 1911 (fig. 48). The accompanying corrido is a tragic story of Zamora's death, which did not come at the horns of a bull, but rather from a jealous rival in love.[4] It seems that Zamora and his leading banderillero were rivals for the company of one Presciliana Granado, and on 14 August 1886, the jealous banderillero shot Zamora to death in the city of Zacatecas. The poem is full of praise for Zamora's qualities, first among which is devotion to the members of his troupe, whom he "treated like friends and companions." The sheet claims that Zamora bid his public good-bye as he lay dying, and that his mother and the rest of the troupe wept bitterly at the news.

Posada's illustration depicts Zamora not in the guise of matador, but as a banderillero, a skill at which he enjoyed considerable renown. Daring banderilleros often used short sticks to heighten the danger to themselves, and Zamora is reported to have had them as short as three inches, though Posada illustrates him using wrapped sticks of middle length. The bull, who is branded with the number 12, has already been pierced with one pair and stands alertly with tongue extended and tail switching. Posada's depictions of bulls are generally excellent in proportions, pose, and vivacity, and this one, though it is early in his Mexico City career, is no exception.[5] The artist's use of the burin is less assured than later works, however. The strokes here lack Posada's usual freedom, and there are too many of them in the body of the bull. The plate was probably influenced by the work of Manuel Manilla, who was still working for Vanegas Arroyo when Posada arrived on the scene.

Despite his valor in the ring, Zamora conformed to the popular image of the bullfighter as playboy who led an unruly personal life, and Vanegas Arroyo supported this stereotype by publishing a chapbook as part of his series of skits for children.[6] The plot, which may have been influenced by the story of Zamora, involves a rivalry between a matador and a banderillero for the love of a woman. Roberto, the matador, is beloved of Luisa, but the banderillero Luis also loves Luisa, besides being jealous of Roberto's success in the ring. On the way to a corrida, Luis meets Luisa by chance and proclaims his love, which Luisa rejects, claiming that she belongs to Roberto. Luis swears vengeance. Luisa worries about Luis, and confides in her friend Juana before the bullfight. Juana gives Luisa a revolver, which she hides on her person.

The climax of the story occurs as Roberto kills the last bull, which he had dedicated to Luisa using courtly language:

Before you and this beloved throng;
Here myself I humbly render
With true emotion in my heart
To you, this bull I now do tender

When the bull is killed, the crowd erupts into "boundless enthusiasm," throwing their hats at the feet of the matador in a rare but typical gesture of high enthusiasm. In the midst of the applause, Luis approaches, announces to

LEGITIMOS VERSOS

DE LINO ZAMORA.

Traídos del Real de Zacatecas.

¡Pobre de Lino Zamora!
¡An que suerte le ha tocado!
Que en el Real de Zacatecas
Un torero lo ha matado.
 Rosa, Rosita, Rosa Romero,
Ya murió Lino Zamora,
¿Que haremos de otro torero?
 Al salir de Guanajuato
Cuatro suspiros tiró,
En aquel Cerro trozado
Si corazón le avisó.
 Rosa, Rosita, Rosa Peruana
Ya murió Lino Zamora;
La causa fué Presciliana.

Y Lino le dijo á Braulio
Que se fuera hasta Jeréz,
Que fuera á hacer el contrato
Y que volviera otra vez.
 Rosa, Rosita, Rosa alelía,
Ya murió Lino Zamora,
Pues así le convendría.
 Cuando volvió de Jeréz.
El Jueves por la mañana,
Le dijo Martín su hermano:
Lino está con Presciliana.
 Rosa, Rosita, Rosa Peruana
Ya murió Lino Zamora
Por una mala tanteada.

Roberto that they are enemies from henceforth, and takes out his knife to stab him. Luisa, from her seat in the front row, then saves the day by quickly shooting Luis, who expires on the sand begging God's pardon for his jealousy. That this skit was written to be performed by children shows the prevalence of the stereotype of the torero who gets involved in romantic scrapes.

Besides inspiring the chapbook story, Lino Zamora's bullfighting skills were an important inspiration to the career of Ponciano Díaz, Mexico's most famous matador prior to the turn of the century and the subject of several broadsheets. Díaz's fame, though, contained nary a whiff of scandal, a fact which probably made it easier to produce these extremely laudatory sheets.

Ponciano, as he was generally called, was practically born into bullfighting. Raised on the Atenco farm, which was at that time one of the country's leading bull-breeding farms, he grew up practicing rejoneo, the Mexican form of bullfighting on horseback.[7] He knew and admired Lino Zamora, and some sources report that he worked in Zamora's troupe in 1878. An important mentor in Ponciano's early career was Cuban-born Bernardo Gaviño, who had been practicing the bullfighter's art in Mexico from 1835 through the period of prohibition. Ponciano worked for Gaviño, and in fact received his promotion to full matador from Gaviño in Puebla in 1879. (This ceremony, called *la alternativa,* can be performed when a matador feels ready to take on his own troupe and can find another who has had the promotion and is willing to confer it on him. Any alternativa must be re-enacted in Madrid, or "confirmed," to be valid.) Ponciano fought in the provinces until the prohibition was lifted in the capital in 1886. In that year, his mentor Gaviño was fatally gored while fighting a bull at the incredible age of 73; Ponciano quickly mounted a benefit corrida to help pay the impoverished matador's funeral expenses.

For the next several years, Ponciano was the leading Mexican matador, and he excelled both at rejoneo and at the more typical sort of ceremony which Posada pictured in the game board described earlier (see fig. 47). As a result of the prohibition, the Mexican corrida had developed along somewhat different lines from that practiced in Spain. Across the Atlantic, there were fewer tricks and acrobatics, and the matadors were more reserved and dignified, controlling the bull with cape movements rather than foot and body motion as was done in Mexico. Like Gaviño and Zamora, Ponciano knew little of this Spanish style:

> Ponciano had no concept of Spanish-style bullfighting, since he had never seen it done, and he had only the example and teachings of Bernardo Gaviño, who had been persevering in Mexico through all kinds of interruptions and revolutions. In the bullfight on horseback and its Mexican variants, Ponciano was a master, but as for bullfighting on foot in a style vaguely similar to the Spanish, one could say that he practically had to invent it himself.[8]

The arrival of the Spanish bullfighter Luis Mazzantini shortly after the prohibition was lifted in 1886 set off a rivalry between the two that divided the Mexican bullfight public along tellingly cultural lines. Mazzantini, who was

GLORIOSO EXITO DE PONCIANO DIAZ Y DE SUS Valientes Charros EN LAS PLAZAS DE MADRID

Ponciano Diaz en Sevilla
Nuevos triunfos alcanzó.
Cuando el público lo vió
Poniendo sus banderillas.

PONCIANO DIAZ EN LISBOA.

El presente grabado, representa á Ponciano Díaz en el acto de banderillear en la plaza de Lisboa el día 8 del actual, al toro «Venadito,» valiéndole la arrogante suerte, la más grandiosa ovación que se ha visto en Portugal; participando de ella Celso Gonzalez que gineteó otro toro con la maestría que todos conocemos.

Los dos picadores mexicanos Celso Gonzalez y Agustin Oropeza, fueron aplaudidos frenéticamente en la corrida celebrada en el Puerto de Santa María el día 18 de Agosto último en que se lidiáron toros de Ibarra. Concluida la corrida, nuestros valientes paisanos fueron obsequiados con una magnífica cena, á la que concurrieron varios aficionados inteligentes, elogiando todos el valor de nuestros charros y su incomparable maestría como ginetes consumados.

Décimas dedicadas
A
LOS DIESTROS MEXICANOS EN MADRID.

Pronto será conocido
Ponciano en las dos Castillas,
Por su gracia y su maestría
Para poner banderillas.
Para las suertes lucidas
De gineteo y de mangana,
Es la gente mexicana
La que no tiene rival,
Pues hasta hoy nadie les gana
Para echar bien un buen pial.

Ya en la plaza de Sevilla
Trabajó también Ponciano,
Entusiasmando á todito
El público sevillano.
Nuestro valiente paisano
Probó suficientemente,
Que es un charro inteligente
A todas horas dispuesto,
A dejar siempre bien puesto
Su nombre como valiente.

Sus valientes picadores
Gonzalez y Oropeza
Probaron que valen más
Que muchos que tienen trenza.
Tienen valor y vergüenza
Como se ha podido ver,
Dándose siempre á querer
En todas las ocasiones,
Pues no se hacen remolones
Cumpliendo con su deber.

Por eso Ponciano Díaz
En llevarlos tuvo empeño,
Y así lo dijo en Madrid
«Es la muestra lo que enseño.»
Y aunque les parezca un sueño
Arrojo tan singular,
Aquí es muy fácil hallar
Sin trabajo y sin desvelo,
Charros que pican en pelo
Como se debe picar.

Allí están Arcadio Reyes,
Mercado, alias «Cantaritos,»
El valiente José Mota
Y el simpático «Güerito»
Con un valor inaudito

Y sin temor á la muerte,
La más peligrosa suerte
Consuman con arrogancia,
Y no hay toro que sea fuerte
De su brazo á la pujanza.

Ya muy pronto Lagartijo
El torero sin igual,
A Ponciano allá en Madrid
La alternativa dará.
Nuestro paisano será
Ya matador de cartel,
Y no habrá otro como él
Que á las más feroces reses
Dé muerte en el redondel.

En cualquier plaza del mundo
Será un primer matador,
Que ha de dejar asombrados
A todos por su valor.
Es justicia y no favor
A su mérito probado,
Pues bastante ha demostrado
Que en la suerte de matar,
Nadie ha podido llegar
Donde Ponciano ha llegado.

En la plaza de Lisboa
Tuvo gran aceptación
Y á París irá á las fiestas
De la gran Exposición.
Causando la admiración
Del público en general,
Va este diestro sin igual
Más agrandando su fama,
Y por eso se le llama
El soberbio caporal.

Muy contento debe estar
El simpático Ponciano
Que tantos triunfos adquiere
En medio del pueblo hispano.
El modesto mexicano
Enseñó con su maestría,
Que en saber y valentía
Pocos se le han de igualar;
Por eso causa alegría
Mirarlo siempre triunfar.

En la próxima hoja aparecerá la «Alternativa de Ponciano Díaz en la plaza de Sevilla».

México.—Imprenta de Antonio Vanegas Arroyo. Calle de Santa Teresa núm. 1. y Encarnación 9.—México.

49. *The Glorious Success of Ponciano Díaz and His Brave Charros in the Bull Rings of Madrid.* Broadsheet with white-line illustration by Posada, 1889. Full sheet. Photograph © The Art Institute of Chicago. William McCallin McKee Memorial Collection. 1944.1020

already a success in his home country, came to Mexico for the seasons 1886–87 and 1887–88, and showed the public of the capital city the more elegant and reserved Spanish style. The Mexican upper classes, and persons of Spanish descent, naturally took to the more sober and traditional Spanish way of the corrida, and began to look down on Ponciano's provincialisms. For example, Ponciano killed the bull *recibiendo,* while Mazzantini used the more dangerous *volapié,* or "flying feet," in which the matador lunges at the bull head on from a distance of several yards to plunge the sword in between the shoulder blades. Mazzantini was called "The King of Volapié," and a Mexico City bar even took that name. The Spanish matador came from a wealthy family, moved in cosmopolitan circles, and was an occasional companion of the actress Sarah Bernhardt. During his stay in Mexico he was regularly feted at banquets.

All of this naturally made Ponciano look like a bumpkin in some people's eyes. He wore a mustache in the charro style, while Mazzantini, like apparently all other Spanish matadors, went clean-shaven. The two were unfailingly generous with one another in public, complimenting each other for the newspapers, and occasionally dedicating a bull to the other if he were in the audience; but the followers of each were far more partisan. Mazzantini's fans derided Ponciano's movements, and pointed out that the Mexican's alternativa had never been confirmed. Ponciano's followers, meanwhile, occasionally resorted to throwing things into the ring or chanting at the wrong times when Mazzantini was fighting. In March of 1877, a rock-throwing mob vandalized the King of Volapié bar. Mazzantini's hotel was similarly pelted in an incident that resulted in eighteen arrests. Ponciano's followers said, according to one account, "Whoever is not behind Ponciano is not a true Mexican but a *gachupín* who disrespects his country."[9] This division thus reflects some of the cultural tensions that were also manifest in other areas of Mexican society.

There was room, however, for both to be extremely successful. Ponciano became wealthy enough to open his own bull ring in the capital in January 1888, where he dedicated the first bull to "my country and my mother." The Mexican balloonist Joaquin de la Cantoya y Rico made a spectacular landing during intermission. The following Friday there was a festival of charrería to which Mazzantini was invited. Juan A. Mateos wrote the libretto for a zarzuela, a musical drama, (now, alas, lost) called *Mazzantini y Ponciano* which premiered the night before the bull ring opened.[10] General Miguel Negrete, a hero of the war against the French intervention, formed the Ponciano Díaz Society. Journalist Porfirio Parra highlighted Ponciano's fame by commenting on some coincidental similarities of names: "Rest assured, in Mexico today there are two extraordinary Porfirios: the President and I. People pay more attention to him than to me. That's natural. But I still have my satisfaction. It's that there are also two famous Díazes: Ponciano and don Porfirio, and the people applaud and admire Ponciano more than don Porfirio."[11]

In the transatlantic rivalry, Posada and Vanegas Arroyo weighed in firmly on the side of Ponciano. They apparently produced no sheets about Mazzantini, and did not even mention him in any that have come to light. Their first

surviving sheet on Ponciano was produced in 1889 when the torero made a trip
to Spain, and it depicts him in a rejoneo, placing the banderillas from the back
of a galloping horse (fig. 49). Ponciano may have felt a certain inferiority about
doing his usual cape maneuvers in the Spanish bull ring; before he left he
announced that he would fight bulls in Spain only on horseback. General
Negrete, intending that Ponciano have the best mounts possible, presented
him with two of his own before the matador's departure. The text of the sheet
describes great successes in his early engagements in Lisbon and Sevilla, earn-
ing him in the former city "the greatest ovations ever heard in Portugal." The
poem continues the praises, and includes names of his seconds, among whom
is Arcadio Reyes, probably Ponciano's only rival at that time in the arts of rejo-
neo. The tour was obviously intended to show the Spaniards Mexican rejoneo at
its best. The poem mentions that Ponciano will have his alternativa confirmed,
but leaves the details for another sheet.

The print by Posada is full of action. The mount gallops convincingly, mane
waving and dust flying, as Ponciano leans out far to his right, supporting him-
self on one leg in the stirrup. The bull comes on apace from the left, and has
lowered his head in the expectation of spearing the horse and rider. A good
banderillero can pass quite closely if he calculates his speed and angle properly
to the charging bull, and this is apparently what horse and rider have accom-
plished here. Posada has depicted what would be the climax of this pass, as
Ponciano is at the closest point in the encounter of the two galloping animals.
The banderillas appear to be perfectly placed in the neck muscles of the bull,
and Ponciano seems to be executing the feat almost effortlessly, as his body
shows little tension and his face is perfectly composed.

Since Posada did not go to Spain, the Ponciano Díaz sheet seems to have
been inspired by a series of popular prints of the stages of a bullfight that were
first created in Madrid in 1790 and were widely distributed throughout Spanish
America , rather than by direct observation. The print by Antonio Carnicero
(fig. 50), depicts a picador rather than a banderillero, but otherwise the relative
positions of horse, rider, and bull are quite similar to Posada's scene. The im-
portant difference lies in the relative lack of tension present in the Carnicero
print. The picador grasps the reins lightly, and an assistant at the right makes a
picturesque gesture. The work seems imbued with the spirit of the Rococo, a
mood which is entirely foreign to Posada.

Another sheet issued shortly after the figure 49 sheet dealt in a similarly
enthusiastic manner with Ponciano's fortunes in Madrid.[12] The poetic text men-
tions that he dedicated the first bull there to his mother and his country, and
the second to Mazzantini and to Spain. It was often Ponciano's custom to dedi-
cate bulls to his mother, and the poetic text points out that she was "always first
in his memory." In fact, Ponciano's dedication to his mother may have kept
him from some of the usual pitfalls of the bullfighter's personal life; his was
held to be spotless. He did not drink, he never married, and was never seen
romantically attached to a woman. This unique feature of Ponciano no doubt
increased his appeal in many quarters. The high point of his trip to Spain, how-

LIII

50. *Antonio Carnicero*, plate from the series "The Principal Maneuvers of a Bullfight," 1790. Etching and aquatint. Biblioteca Nacional de Madrid.

ever, was the alternativa, which was confirmed 28 July 1889 at the hands of the matador Frascuelo. Ponciano was the first Mexican to be so honored. The text of the sheet resembles an accolade:

When Ponciano appeared
In the Plaza of Madrid
The audience applauded
They cheered with frenzy.
In the land of El Cid
All have observed
The merits unchained
Of a torero so famed
That now he deserves
To be praised with such verve.

Back home in Mexico the bullfight landscape was changing. Shortly after his return, the Governor of the Federal District instituted another ban on bullfights, this one for four years, due to public disturbances at ringside. Ponciano reorganized his troupe and toured in the provinces. It was still possible for Mexico City audiences to see bullfights, but they had to take a train ride to Puebla or Tlalnepantla to do it, and working-class people, who formed the backbone of his support in the capital, rarely made the journey. When the sea-

son opened in the capital again in 1894, the public taste had begun to shift more decisively away from Ponciano's Mexican style of capework, with its dancing motions and busy footwork, toward the more graceful, elegant, and dangerous Spanish way. Mazzantini made a lengthy return trip in the 1896–97 season, and younger Mexican matadors such as Cuatro Dedos ("Four Fingers") and Vicente Segura schooled themselves on his example. Ponciano's best biographer described the situation this way: "On the reauthorization of bullfights in 1894, Ponciano devoted himself to running his bull ring, and he became more of an impresario. Since he could not satisfy the new aficionados who, egged on by Hispanophile critics who wanted the corridas in Mexico to be celebrated with the same seriousness, protocol, and order as in Spain, every week Ponciano was subject to acrimonious censure."[13] At a fight in his ring in the fall of 1895, a riot broke out because the bulls were allegedly bad. The police were called, and a warrant was issued for Ponciano's arrest. This would be his last fight in the capital. He began drinking, and was frequently seen in bars in the company of the famous clown Ricardo Bell. His tragedies were compounded by the death of his mother in April 1898.

When Ponciano died almost exactly a year later, Vanegas Arroyo issued two sheets, only one of which has survived (fig. 51). The illustration uses the same plate that Posada created for the sheet honoring Ponciano's alternativa. The matador has the sword and the *muleta,* the thin cape stiffened with a rod that is used in the last act of the corrida, in hand. He stands with an air of serene dignity, cap off, in the posture of dedication. This moment pictured is not the most dramatic of the corrida, but it is surely one of the most sentimental, as most matadors used it to express tender feelings for someone in the audience, and to offer themselves and their talents for that person. The plainly nostalgic text makes no mention of the matador's fall from grace, but says that he died "covered in glory." The poem recounts a brief summary of his life, from his birth on the farm to his first bullfight at age fourteen, to his alternativa and creation of his own ring, and to the death of his mother and its effect on him. At various points the poem waxes philosophical:

Our life is only lent to us
And death is a reality;
Ponciano is no longer with us
He rests in his eternity.
May these short verses serve
To keep our affection alive
So that we may never forget
The one whom we know has died.

To remember Ponciano thus is to once again elevate what is Mexican and popular in seeming opposition to what is foreign and favored of the upper classes. Both the Manuel Horta biography, and the Armando de María y Campos biography hold that the man died almost unmourned; his funeral was

51. *Here is the Second Part of the Verses about Ponciano.* Broadsheet with white-line illustration by Posada, 1899. Full Sheet. Amon Carter Museum. 1978.195

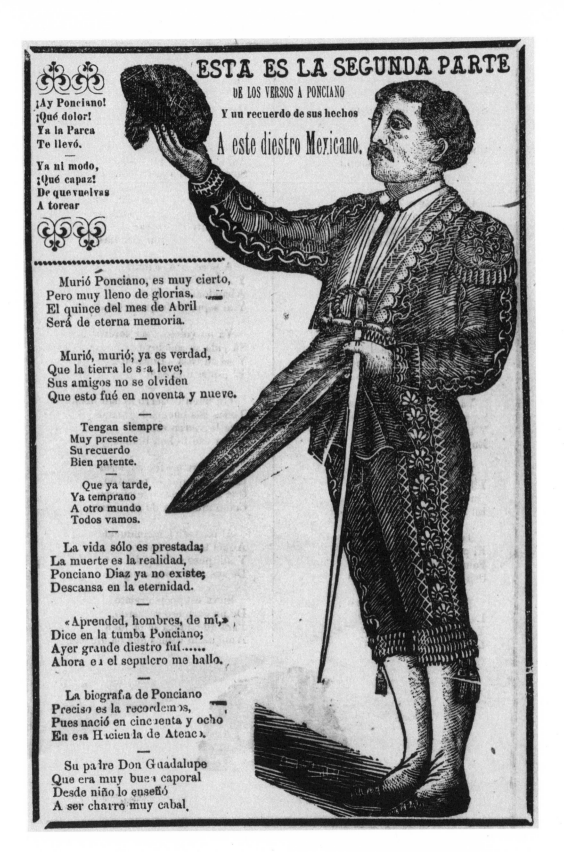

ESTA ES LA SEGUNDA PARTE
DE LOS VERSOS A PONCIANO
Y un recuerdo de sus hechos
A este diestro Mexicano.

¡Ay Ponciano!
¡Qué dolor!
Ya la Parca
Te llevó.
—
Ya ni modo,
¡Qué capaz!
De que vuelvas
A torear

Murió Ponciano, es muy cierto,
Pero muy lleno de glorias,
El quince del mes de Abril
Será de eterna memoria.
—
Murió, murió; ya es verdad,
Que la tierra le sea leve;
Sus amigos no se olviden
Que esto fué en noventa y nueve.
—
Tengan siempre
Muy presente
Su recuerdo
Bien patente.
—
Que ya tarde,
Ya temprano
A otro mundo
Todos vamos.
—
La vida sólo es prestada;
La muerte es la realidad,
Ponciano Diaz ya no existe;
Descansa en la eternidad.
—
«Aprended, hombres, de mí,»
Dice en la tumba Ponciano;
Ayer grande diestro fuí......
Ahora en el sepulcro me hallo.
—
La biografía de Ponciano
Preciso es la recordemos,
Pues nació en cincuenta y ocho
En esa Hacienda de Atenco.
—
Su padre Don Guadalupe
Que era muy buen caporal
Desde niño lo enseñó
A ser charro muy cabal.

LA SENSACIÓNAL COGIDA Y MUERTE
DEL FAMOSO TORERO ESPAÑOL
ANTONIO MONTES

El trece del mes de Enero
De mil novecientos siete
Un toro tepeyahualco
A Montes le dió la muerte.
 Sucedió en la plaza «México»
Esta tremenda desgracia
El trece del mes de Enero
De las fechas la más mala.
 La plaza estaba repleta
Y comenzó la corrida
A las horas de costumbre
Con formalidad debida.
 Fué el primer toro jugado
Sin niguna novedad,
Y Montes al descabello
Le clavó sin vacilar.
 Llega ya el segundo toro
Muy renegro y muy abierto,
Tres verónicas d'ó Montes
Y al último dos galleos,
 Aquí principió de malas
Pues el toro le cogió
Y en los aires fué lanzado
Pero nada le pasó

Los picadores bien le pican
Al toro tepeyahualco
Y escuchan bastantes palmas
Llenándolos de entusiasmo.
 Blanquito le pone luego
De banderillas un par
Y entra Montes al segundo
Comenzándole á torear.
 Pero lo encuentra acostado
Puesto del lado derecho
Y ya se teme un percance
Y todos ven con acecho.
 El toro en momento dado
Da la cogida mortal
Pues á Montes lo derriba
Y lo recoge brutal.
 Lo balancea en las astas
Y Montes vuelve á caer
Pasando á la enfermeria
Sin poderse ya valer.
 Y continuó la corrida
Según costumbre, lo mismo,
Como si nada pasara
Ni hubiese ningún herido.

not reported in any newspaper. Vanegas Arroyo apparently took it upon himself to see that this hero from the heartland, the consummate charro and apparently noble bullfighter, did not disappear without a trace.

The Vanegas Arroyo shop was generally selective in the bullfight news it dealt with. Sheets on the world of crime, for example, outnumber those on the corrida by probably six or eight to one. The shop adopted the cause of only a very few matadors, and completely ignored the careers of others who were at least as well known. The case of Mazzantini and Ponciano is only one such example of class and ethnic favoritism. After the turn of the century, the Mexican Vicente Segura rose to prominence, and was even called in some quarters "the successor of Ponciano," but he never appeared as the subject of a sheet. This is probably because he was from a wealthy family as Mazzantini had been. In Spain, where he went for his alternativa, he was called "El Torero Millonario," a reference to the fact that he often refused his share of the gate.[14] In 1904 a major rivalry between two Spanish fighters, Antonio Montes and Rafael González ("Machaquito") flared up and the Mexico City public again seemed to divide along class lines, with those in the cheaper sunny seats favoring Montes and those on the shady side favoring Machaquito.[15] Although the rivalry led to blows among the partisans, and fruit and bottles thrown into the ring, Vanegas Arroyo and Posada took little interest. A sheet on Machaquito survives, but it is dated 1907, after the rivalry had subsided. The text deals more with the pageantry of bullfights in general than with Machaquito's alleged virtues, and the print image is from a rather generic plate of a matador acknowledging applause that Manuel Manilla had done years earlier.[16] This selective treatment of the bullfight in broadsheets probably reflects the fact that the urban sheet-buying public did not regularly attend bullfights, which, after all, demanded disposable personal income that few of them may have had.

A spectacular goring of a Spanish matador in 1907 was the subject of three sheets, but the goring's appeal as a sensational story of death and tragedy far outweighs its interest to bullfight aficionados. Its primary attraction for us lies in the skillful renditions of bullfight poses and actions in the plates by Posada. During a fight in the Plaza México in January 1907, Antonio Montes was executing some capework when the bull tossed him into the air. The audience gasped, but he was unhurt. Later in the same fight, as Montes was killing the bull, it gauged its horn thrust more accurately, and broke the matador's tail bone, then scraped the inside of his pelvis. The bull died, but Montes had to be carried out. He seemed to be improving over the next few days, but by the following Thursday an infection apparently set in, and his fever began to rise. On Friday morning he dictated a will and underwent confessional rites, and that evening he died despite the ministrations of several doctors. The first sheet on the event deals with the story up to Montes's death (fig. 52). The text points out that many in the crowd thought that it had been one of the best fights of the season, with Montes going against his fellow Spaniard Antonio Fuentes. We also learn that in his will he left three thousand pesos to his beloved, a woman

El cadáver de
ANTONIO MONTES
CONVERTIDO EN CARBON
En el Depósito del Panteón Español de la Capital de México

MONTES ANTES DE LA CORRIDA DEL DIA 13 Y DESPUES DE CARBONIZADO.

Parece que sobre Montes
Había alguna maldición
Pues que su cuerpo ha quedado
Todito hecho carbón.

En el fondo de la huerta
Del buen Panteón Español,
Por un muro separado
El Depósito está hoy.

Depósito de cadáveres
En forma de una capilla
Con un altar y su retablo
De maderas esculpidas.

Un Crucifijo se encuentra
Dominando aquel altar
Un Crucifijo muy grande
De escultura singular

Al centro de esta Capilla
Grande mesa se miraba
Y allí estaba colocado
El cadáver en su caja.

Cuatro cirios alumbraban
El féretro á medio arder,
Encontrándose distantes
Del catáfalco muy bien.

A las seis de la mañana,
Del veintitrés de este Enero
El señor Pedro Gutiérrez
Avisó por el teléfono

Este señor es de allí
Tiempo hace Administrador
Y dió aviso del percance
A General Inspección.

También al Presidente
De Beneficencia Hispana
Comunicó la noticia
Del fuego con grande alarma.

La autoridad acudió
Para el hecho esclarecer
Y horrorizados quedaron
De lo que pudieron ver.

from Chicago named Grace, and that he wanted his body sent back to Spain for burial in the event of his death.

The illustration is extremely lifelike, but may not be exactly accurate in all respects. Montes killed *volapié,* and so we see the huge animal firmly planted on four slightly spread legs as the matador approaches with the sword. There are three banderillas visible at the base of the bull's neck. The animal seems awesomely powerful, and is in the process of raising his massive head. The color of the horns goes from white to black, probably for easier readability. It is this head movement of the bull that is apparently causing problems for the matador, because at appears that his sword thrust has struck bone at the base of the bull's skull or spine, rather than cleanly entering between the shoulder blades. The muleta flies uselessly at the right, and the matador's face and body posture betray the fact that something has gone terribly wrong. Posada compressed the space between the matador and the audience in the ring, and even made the ring smaller. Normally less of the circle's arc would be visible in a view of this angle. This compression parallels his strategy in other plates, and serves to contain the action within a narrower space, concentrating its dramatic force. The fact that the audience has not yet reacted to the situation indicates that the artist may have been influenced by photography, which by that time was commonly used in the better bullfight magazines. A snapshot will capture the instant of a blow before it has registered with the crowd, if taken at the right moment, and that seems to be what has happened here. Given Posada's tendency to collapse moments of time, it is difficult to imagine that he would not have included the reaction of the audience, which would have happened only a split second later. According to the available accounts of the event, the sword thrust of Montes was successful, a fact that is not reflected in this illustration. Perhaps Posada referred to a photograph of a similar event in a magazine. One author stated that this illustration was actually created for the goring and death of Timoteo Rodríguez, which took place in Durango in 1895, and was thus re-used for Antonio Montes.[17] This is possible, but in 1895 the white-line technique still predominated in Posada's output over the present black-line. So the sources of this print and its level of correspondence with known facts remain somewhat mysterious.

Such questions do not cling to the second sheet on the Montes matter, which was issued about a week after the first (fig. 53). Montes's body was lying in a chapel at the Spanish Cemetery awaiting transportation when on the night of January 23 a fire broke out. The body was partially burned and cemetery attendants were questioned by police after they admitted to having fallen asleep on the job. The sheet speculates about the cause of the fire, concluding that one of the many candles fell over and burned a cloth hanging, which in turn ignited the casket. As is typical in such sensational stories, the text informs us of several rather grisly details: Most of the victim's face was burnt, and his eyes were merely holes, but his hands were still intact. The illustration seems quite accurate regarding the reported condition of the head, and Posada has obligingly composed the sheet so that the head is both close to the picture surface and

exposed to view. This composition probably amounted to artistic license in the service of sensationalism, since the heads of most dead persons are usually covered along with their bodies, but this is again a typical strategy of the artist. He might have shown the chapel in flames, a more dramatic scene, but that would have made the rendition of these horrible remains more difficult. Several blackened wreaths surround the body, and in a cartouche Posada includes a portrait of the victim in matador costume.

The text of both the second and third sheets speculates on the evil influence of the number 13, which recurred suspiciously in the Montes disaster: The original goring took place on the 13th of January; there are 13 letters in Montes's name; his saint's day falls on the 13th; and the train that took his now-burned body to the seaport of Veracruz for shipment to Spain was number 13. These and other folkloric elements figure more prominently in the text of the third sheet, which is a general summary of the disaster (fig. 54). This sheet, produced after the ship left for Spain, probably responded to intense curiosity and to the good sales of the previous two. It points out that the bull's horn "pierced him like a melon," and informs us that his mother wept bitterly on hearing the news. How the authors of the sheet could have known this latter fact is an open question, since Montes's mother lived in Sevilla and this news would have had to travel the Atlantic twice. The sheet omits mention of the fact that the ship nearly ran aground in the Guadalquivir River, near its home port, and that when it finally started to unload its cargo, the casket dropped from the derrick, broke open, and nearly fell into the water.[18] That item of news from the Spanish end would have certainly accompanied any information about the reaction of Montes's mother, so it seems safe to conclude that the news about the mother's reaction was included more for reasons of corrido form than for fact. We also find out that the matador in his last night dreamed that he ate steak, but the significance of this is left unclear; perhaps this is a reflection on the bull which was in effect "eating" him.

The illustration is more closely tied to the events of the goring, but other differences link it also to Posada's typical style. Dominating the center of the composition is the monstrous bull, this time foreshortened more radically, and quite skillfully. It looks like the same bull as was illustrated in the first Montes sheet. As in figure 52, the animal is not moving but is rather tossing its head with results that could prove dangerous to the matador. This illustration refers to the first time in the fight that Montes was thrown, when he was not harmed. In the center of the picture he flies in midair with his cape around his legs as the bull lifts its horns high. Since this is an earlier stage of the fight, there are no banderillas yet. In this illustration we see two time compressions. First, there is another matador posed nearby, using a cape to distract the bull and help insure his colleague's safety. He has arrived much more quickly than would likely be the case. Seconds and subalterns rarely remain that close to the main action in a ring, but his presence here helps to indicate that this is an emergency. Second, and unlike the earlier work, in this print we see the crowd reacting at almost the same instant as the event. They are already on their feet, gesturing

TRISTISIMOS RECUERDOS

DE

ANTONIO MONTES

MATADOR DE TOROS, MUERTO EN MEXICO EN 1907.

¡Desgraciado Antonio Montes!
La *malhora* le ha llegado,
Que aquí en nuestra plaza "México"
Un toro lo ha despachado.

Cuando a 1.6 de Sevilla
Grandes lágrimas lloró,
Y ya er la escala del buque
De España se cespidió.

El trece del mes de Enero
Que era domingo en la tarde,
Le cogió á Antonio Montes
El toro para matarle.

Médicos no le faltaron
A Montes junto á su lecho
Pero no pudo vivir
Pues el mal ya estaba hecho.

En su breve testamento
Antonio les encargó
Que se llevaran su cuerpo
Para Sevilla veloz.

Al saber su pobre madre
El accidente tan cruel,
Lloró lágrimas amargas
Tan amargas como hiel.

Le hicieron sus funerales
En el Panteón Español,
Y hartas coronas tenía
Y de ceras un montón

Parece que sobre Montes
Había alguna maldición,
Pues que su cuerpo ha quedado
Toditito hecho carbón.

Cuatro cirios alumbraban
El féretro á medio arder,
Encontrándose distantes
Del catafalco muy bien.

A las seis de la mañana
Del veintitrés de este Enero,
El señor Pedro Gutiérrez
Avisó por el teléfono.

También al Presidente
De Beneficencia Hispaña,
Comunicó la noticia
Del fuego con grande alarma.

La autoridad acudió
Para el hecho esclarecer,
Y horrorizados quedaron
De lo que pudieron ver.

Las llamas consumido habían
La mesa y el buen cajon,
Y sobre el suelo mirábase
Informe y denso montón.

El mismo señor Gutiérrez
Provisto de regadera,
Trata de apagar violento
Aquel rescoldo que humea.

and shouting. These differences combine to make this second print on the fight a more dramatic evocation than the first one, which uses relatively simple means. It is also worth noting in this print that three or four contour lines in the wall of the ring at the far left are missing. This indicates that Posada often worked quickly, or even carelessly, but also with no obvious loss of vigor in the finished work.

By the time Montes died, the most famous bullfighter of Posada's time, and probably one of the greatest in Mexican history, had already started his career. If sheer numbers of sheets produced are any indication of the popularity of a figure with the urban lower classes, then Rodolfo Gaona was by far the most popular bullfighter of his time. His fame outpaced that of criminals, with the possible exception of Jesús Bruno Martínez. Many of the sheets about Gaona deal with one 1909 incident, in which he was strongly suspected of rape in the case of a young German woman's suicide. But both before and after that watershed, he was the subject of adulatory attention. A brief examination of his background will show that issues of race and class were closely intertwined with discussions about Gaona's quality as a bullfighter. Not only was he from a very modest background, but he was of predominantly Indian blood, and his abilities in the ring, which most observers admit were of a rare order, allowed him to enact on an unprecedented scale the reversal of social classes that is part of the potential of the sport. More than any other bullfighter of the Díaz period, Gaona was to the urban lower classes "one of their own." And when controversies raged in late 1909 about his possible involvement in the suicide case, Vanegas Arroyo and Posada saw an opportunity to defend him.

Gaona was born in 1888 in León de las Aldamas, a village in the central highland district; as a teenager he worked not in the paternalistic and extractive fields of agriculture or mining, but in an altogether more capitalistic shoe factory.[19] He hung around bull rings, occasionally using the cape himself, until at the age of sixteen he was discovered by Saturnino Frutos, who was known as "Ojitos" (Squinty-eyes). Ojitos had been a well-known banderillero in his day, working in the troupes of the Spanish fighters Cayetano Sanz and Salvador Sánchez y Povedano "Frascuelo." In addition, he toured with Ponciano after the latter's return from his alternativa trip to Spain. After his retirement, Ojitos established a bullfighting school, hoping to nurture local talent and then manage it; he approached Gaona and received an eager affirmative to the question of whether the young man wanted to be a matador. As the boy's consent was not sufficient to enter into a business agreement, Ojitos sought the permission of Gaona's mother.

The way that Ojitos presented the plan to Mrs. Gaona indicates that he wanted to operate against certain prevalent stereotypes, and also that he thought the craft of bullfighting could benefit from some rational control. Gaona recalled Ojitos addressing his mother: "Madam, bullfighters can be decent people and well regarded in society. It is a career like any other. I promise you that I will educate your son and I will see that he does not give himself over to vice."[20] The consent was given, of course, and in the summer and fall of 1904, Ojitos

took Gaona and a few other fighters on a tour of bull rings in the center of the country. For the next seven years, Ojitos was Gaona's manager and something of a father figure. According to the matador's recollection, Ojitos took seriously his vow to keep Gaona away from "vice:" "Ojitos, as everyone knows, kept a close eye on me. Closer than if I had been his son. As if I were always a child."[21] The routine of touring small rings in the season and practicing during the off months lasted until 1907, when Gaona made his first appearance in Mexico City. His performances there were so noteworthy that he was offered an alternativa, but Ojitos had higher hopes. He took Gaona to Spain in the spring of 1908 hoping to repeat his Mexican success and get the alternativa in Madrid first.

After a series of performances in rented rings, he was noticed enough to get the alternativa from Manuel Lara "Jerezano" on 31 May 1908. Gaona thus joined the rare company of Mexican matadors with Spanish credentials, which at that time included only Ponciano and Vicente Segura. His first big success came that July 5 at the Plaza Madrid in a sellout performance which many commentators raved about: "If this kid has a defect, it is that for a twenty-year-old he knows too much. The crowd carried him off on their shoulders."[22] Also in the audience was the poet and diplomat Amado Nervo, who was sending back to *El Imparcial* regular newspaper columns which offered his usual witty and somewhat world-weary commentary on modern life. The way Gaona recalled it, Nervo thought that Gaona's race had everything to do with his apparent stoicism in the face of danger, and even Nervo compared him to the last Aztec king. Gaona remembered him saying: "He praised my valor and poise in the ring, which had been the cause of admiration also for the Madrid public. And he explained that, if in moments of danger "Bombita" had turned as pale as the sand, and "Machaquito" became red and nervous, I remained impassive. It was my Indian blood, which never courses any faster even as one approaches death. He said that Cuauhtémoc showed the same serenity while he was being tortured."[23] The notion that Indians are indifferent to life and death was a common racial attitude at the time, and in other circumstances helped to justify various kinds of mistreatment. Here the attitude seems a logical fallacy: if it were true, there would probably be many more Indians with alternativa, and the question of how non-Indians achieve such stoicism is left open. But Nervo obviously meant it (and it was apparently taken) as a compliment.

On this first trip to Spain Gaona apparently began to chafe under the restrictive personal regime of Ojitos. A woman reportedly twice his age, who was married to an important banker and later Finance Minister, tempted him to have an affair, but he refused, perhaps in part due to the influence of Ojitos.[24] Gaona later recalled that when he would push at the limits Ojitos imposed, his mentor would become angry and call him ungrateful: "Ojitos said that lacking his support and vigilance, I would have thrown myself into partying, bad company, and vice, and I would have been washed up in no time."[25]

That fall Gaona returned to Mexico as one of the country's leading matadors. He built a rivalry with Vicente Segura which filled rings and won much acclaim

Cogida de Rodolfo Gaona

En la Plaza de toros de Puebla, el 13 de Diciembre de 1908.

Veinte centímetros penetró en el cuerpo del diestro el cuerno del toro.

AMARGAS LAMENTACIONES
DE LA AFICION MEXICANA.
Efectos del numero 13.

¿No han de ser supersticiosos
Mirando lo que ha pasado?
Lo que es hoy....ojos llorosos
Traerán los aficionados!

—

Será que el diablo le ayuda
O "de malas," si os parece,
Más por lo visto no hay duda
Que es número malo el 13;
Pues en una misma tarde,
Bueyes mansos, pero arteros,

Con la maña del cobarde,
A los tres buenos toreros
Con que México á contado,
El día trece..... (mala suerte,)
De Diciembre se han mirado
A las puertas de la muerte,
En Celaya, muy ufano,
Luciendo su habilidad
El Reverte Mexicano
Torea con felicidad;
Pero el día 13 llegó
Por obra del mismo pingo,
La de malas que calló
En el merito domingo.

55. *Goring of Rodolfo Gaona
in the Bullring at Puebla.*
Broadsheet with black-
line illustration by
Posada, 1908. Half Sheet.
Amon Carter Museum.
1978.74

for both, though Gaona usually received the louder applause. A brand of cigars
was named after him. In May 1909 a Mexico City daily instituted a somewhat
unscientific public opinion poll on who was the greatest bullfighter of the
moment. One could vote by sending in a coupon clipped from the newspaper,
a system which did not, of course, prevent multiple votes. But of the thirty-
seven named matadors, Gaona won first place by an unbelievably wide margin.
He was followed by three Spanish toreros, with Segura in fifth place:

Rodolfo Gaona	9199
José Claro "Pepete"	5995
"Machaquito"	4634
Manolete	3022
Vicente Segura	2506[26]

By 1909 Gaona had already begun to be celebrated with panegyrics in broad-
sheets. The first was apparently issued shortly after his return from Spain, and
it begins by informing the reader that if he has not yet heard of Gaona then he
must be an idiot.[27] It tells the story of the meeting between Ojitos and the
future matador, which according to legend took place in a pool hall. His social
advancement is lauded, as the poem notes that he wants to buy the house in
which he grew up. Gaona is celebrated as the successor of Ponciano, and his
fame is compared with that of Jesus Christ himself:

So, reader, you must have seen
His likeness everyplace
Like the story of Christ the King
And we all know that face.

The form of the panegyric, which originated as praise for kings and mytho-
logical figures, does not generally dwell on details or on specific events. It is
not based on a minute knowledge of the deeds of the hero but rather on a
warm enthusiasm that finds expression by recalling important moments, which
take on mythological significance, and by spinning praises from various angles.
As with traditional panegyrics, the idea is not to recite the great deeds in an
effort to convince hearers/readers, but to appeal to the emotions and to a basic
need to feel the presence of such a hero. The style of utterance is decidedly
"upward"; that is, from those "below" who know little of the hero, yet are filled
with praise and trust for the one "above" who has special knowledge, skills, or
personal characteristics.

When Gaona was gored in Puebla in late 1908, the poetic text took an entire-
ly different and more informative tack (fig. 55). The subtitle *Effects of the Number
13* indicates what was thought to be a principal cause of the wounding. The
text points out that the matador Reverte Mexicano was gored on a 13th day of
the month, and also that Vicente Segura had recently been wounded in
Guadalajara, though no mention is made of the date of that event. Hovering

over all must have been the death just under two years before of Antonio Montes, also a victim of unfortunate numerology. The poem narrates closely the details of Gaona's misfortune, describing the color of the bull and its name ("Criminal") before telling of how the right horn penetrated 20 centimeters into his right hip, leaving an opening 5 cm wide. The event happened in Puebla, near the capital, and Gaona was taken in a car to a hospital there where doctors Urrutia and Moya operated. Near the conclusion, before a lament over the poor quality of bulls in Puebla, the poem waxes melancholy:

> All of Mexico mourns
> Because if Gaona dies
> Our lives will then be shorn
> Of this, his special prize;
> Which a few toreros display
> When adversity does test them
> On some fateful day
> With danger to distress them.

Posada's illustration is a careful response to a delicate situation, and it is worth comparing to the prints he made on the wounding and death of Antonio Montes (see figs. 52 and 54). Obviously Posada did not want to depict Gaona in the same undignified positions, at the mercy of an animal, having lost control of the situation. That would simply not accord with the image of cool mastery of danger that Gaona commonly displayed and that was the basis for his fame. So Posada pictured him in a business suit, centered and staring back in a manner reminiscent of a photographic portrait of a political leader. There may be a practical reason for the print appearing this way: The wound was serious enough to have killed him, and if so, this picture may have had to serve as a funeral image later. Surrounding him are various implements of the corrida arranged in a style that owes a great deal to bullfight posters. Clockwise from the left, there is the cape, picadors' lances, the killing sword, banderillas, the head of a bull, and the muleta. At the bottom of the composition is a huge horn, disrupting with its robust literalness what would otherwise have been a somewhat tasteful array; it is the only reference to the recent tragic event.

Of all the compositional elements here, however, the two circles at the center have the most ambiguous meaning. Behind the wounded matador is one circle that on a basic level represents the bull ring. Yet other symbolic interpretations are possible: the setting sun, the orb of the cosmos. Perhaps Gaona is a religious icon in a medallion. Religious connotations are more clearly suggested with the hat that the hero is wearing at an impossibly jaunty angle, because its placement certainly gives it the aura of a halo. Such symbolic overtones, as we have seen, are quite rare in Posada's work; the best example is the depiction of Guadalupe Bejarano made rather early in his Mexico City career (see fig. 8). Posada would much rather focus on the energy of a moment than on its cosmic significance or its allegorical resonances. But in this event he was denied (or

denied to himself) the possibility of depicting the dramatic moment of a hero in danger. This deviation from his usual working method led him to create this image, which takes the subject far from the painful and dangerous incident that caused its creation; rather, it reads like San Rodolfo, the patron saint of toreros. This illustration was re-used when the matador was wounded again in Spain in July 1909.[28]

These sheets take a clear position in the cultural tug-of-war that was then occurring over the significance of Gaona as a modest man from the provinces who had gained international renown. Certain members of Mexico City's upper crust were very uncomfortable with him occupying such an exalted position. Gaona recalled in his autobiography that he was jeered at many fights by patrons—we might call them dandies, or urban valientes—sitting in expensive seats: "Near the screen would sit lots of guys who hung out on Plateros Street, spending the day watching the girls, who thought they were aristocrats. They called me 'Indio Bolero' [Indian Bootblack]; they would shout this at me every Sunday afternoon in an effort to bother me, which, in effect, it did."[29] This verbal abuse is highly significant. In two words it reminds Gaona and everyone else of what were held to be the two unsavory aspects of his past: his race and his work in the shoe factory. The dandies were trying to demystify Gaona, and more importantly, to upend the class reversal that accompanied his celebrity. To call him an Indian bootblack is an attempt to put him "back in his place," to refuse to accept his social ascent. The hecklers knew that the bullfighter functions in a world radically different from the everyday one of most spectators. He faces danger or death in the ring with a specially bred animal; for an urban population, such connections to the animal kingdom and the basically rural culture that nurtures it are often a dim memory. As if to emphasize the detached and unique nature of the bullfighter's trade, he wears in the ring a special costume, the *traje de luces* or suit of lights, which has no counterpart in the practical attire of either city or country life. It is based rather on the medieval mail-suit, another allusion to the rural and aristocratic origins of the sport. Putting on the suit of lights and entering the ring, the bullfighter becomes a creature on another plane, rather similar to a character in grand opera, set in a distant time and place, but with the very real difference that the matador faces actual danger. To call him "Indio Bolero" is thus to attempt to snap him back into the real world, to undercut both his aura and his permission to enter the glamorous and risky world of the ring.

The opposition of the dandies in the front row, however, was as nothing compared with the campaign that leading newspapers mounted when Gaona was suspected of rape in the 1909 suicide case. Both *El Imparcial* and the Roman Catholic *El País,* while pretending fairness, jumped on every suspicious contradiction in the case in an effort to get Gaona to either confess or to be found guilty. They gloated on his incommunicado stay in Belén, and groaned when he was finally released after twenty-one days. Gaona recalled that the case made him a "sacrificial lamb" in a battle between the official press and the opposition, and that for years thereafter, when "someone wanted to upset me, they would

confront me with that ghost."[30] Among the few defenders of Gaona in print was the Vanegas Arroyo shop, which issued several sheets on the matter. Their tone, while cautious out of fear of censorship, avoided speculation and calumny; and Posada's prints continued the laudatory tenor established before.

The facts of the case which were not under dispute might lead one to suspect Gaona's involvement. María Luisa Noeker was accustomed to buying eggs from a market vendor who knew Gaona. Noeker was a fan of the matador's, as evidenced by the fact that she wore a locket around her neck with his picture, and kept another on her nightstand at home. The vendor, Cirilio Pérez, told Noeker that there would be a dance at his house one Thursday night, 2 December 1909, at which Gaona and several other toreros would be present, and that he could introduce her to him. She agreed and appeared at the party, where according to available evidence, she drank to excess. Taken home in the early hours of the next morning, she shot herself in the head; an autopsy revealed that she had been sexually assaulted sometime that evening. The case soon became an embarrassment to official Mexico City, because the young woman was descended from a prosperous German family, and her father was an employee of an American-owned railroad company. A group of citizens from the city of Aguascalientes, where she had lived until shortly before the fatal

56. Front Page of *El Imparcial* with headline "Rodolfo Gaona Sent to Prison" and photograph of the suicide María Luisa Noeker. 12 December 1909.

evening, wrote to President Díaz firmly asserting her "innocence." The German consul involved himself in the case on behalf of the family, and many expatriate women wrote to newspapers or other authorities demanding justice.

Gaona was the likeliest suspect, of course, and *El Imparcial* led the charge against him.[31] The newspaper trod delicately around the subject of the rape in print, referring instead to the "crime against the person" or the "offense against the honor" of the woman. The victim's maid said that she had told her that evening that she had been to Rodolfo Gaona's house, and that it was "very nice." So the newspaper printed a plan of the house where Gaona lived with Ojitos, showing the locations of the various bedrooms, and speculated on who could have seen or heard the couple. The investigating magistrate asserted that Cirilio Pérez could not have committed the rape. Gaona's brother Enrique admitted to the deed, but medical examinations somehow eliminated him from suspicion. Two domestic servants in the Noeker house alleged that they had seen Rodolfo accompany the victim home a few hours before she committed suicide. There were other, more minor inconsistencies in the depositions collected. For example, Rodolfo alleged that he told Enrique in person that he would not be at the party, while his brother said that he heard it over the telephone. *El Imparcial* dutifully reported all of this information, even though the collection of evidence is supposed to be a confidential process, and when the matador was taken to Belén on December 10, this fact was the lead story, together with a photo of the deceased woman (fig. 56).

The newspaper claimed to be acting under only the most disinterested moral authority, pursuing only justice. It set out its official viewpoint in a front-page editorial titled "Our Position on the Gaona Matter."[32] Scornfully mocking Ojitos by confusing his nickname with words meaning "little fleas" and "little curls," it claimed that it only sought the punishment of the guilty: "What do we care if the guilty party is Rodolfo Gaona, Enrique Gaona, "Ojitos," "Piojitos," "Ricitos" or some other zoophyte toreador of those that prowl about the streets?" Yet the same editorial wondered incredulously if it was conceivable that "the virgin who loved Gaona could have given herself into the arms of another." No, the real motivation of *El Imparcial* was justice on behalf of the weaker sex. Sounding perhaps more than slightly puffed up, the editorial solemnly intoned: "For several years now, very many!, we have maintained, firmly and persistently, a long campaign on behalf of scorned women, and women who have been wronged. . . . Thus, we have involved ourselves in this matter, and from its ramparts we expose to view the intrigues, the machinations, the false leads, and the tricks with which some would try to falsify justice." In another front-page article after he had been incarcerated for several days, the newspaper seemed to gloat over his changed appearance: "Rodolfo Gaona languishes. The prison and the lack of contacts are having their effect, and the matador seems very depressed in both his spirit and his faculties, giving him a very different appearance. A beard is starting to grow on his dark face."[33] Other newspapers also strongly suspected Gaona. *El Heraldo de México,* for example, as early as two days after the event, speculated, "as time passes and

LA PRISION DE RODOLFO GAONA Y SUICIDIO DE LA SRITA. MARIA LUISA NOEKER.

El sensacional acontecimiento que en la actualidad se comenta en esta Capital es el que sigue y cuya historia comenzó á descubrirse el viernes 3 del pt°. mes de Dbre. de 1909. Fué el caso que la policia de la 6a. Demarcación en ese día tuvo noticia de que en una casa de la calle de Nuevo México de esta Ciudad se hallaba el cadaver de una joven que se llamó Maria Luisa Noeker, cuya familia estaba fuera de esta Capital. Llevaron el cadáver al hospital para la autopsia y comenzaron á esclarecerse los hechos.

Resultó ser una suicida María y que se había arrebatado la vida por estar deshonrada vilmente. Se notó como al autor del crimen de honra al torero Rodolfo Gaona quién fué detenido en la Comisaría, más momentos despues presentose allí el hermano del diestro llamado Enrique diciendo que él era el único culpable del atentado y por esto fué puesto en libertad Rodolfo y detenido su hermano; continuaron las investigaciones y resultó como interventor directo de aquel hecho el huevero Cirilo Perez, quién fué detenido inmediatamente en la Comisaría citada. Aclaróse el suceso y se supo que en la plaza de San Juan vendía huevos en un puesto Cirilo Perez que era muy afecto á toreros y corridas. Tenía en sus marchantes á Maria Luisa la suicida que iba allí á comprar con su criada Guadalupe González. Se hizo Maria de amistad con Cirilo y este le habló de toros y de Gaona. María comunicóle al huevero que ella amaba á Rodolfo sin conocerlo y entonces Cirilo dijo que él era íntimo amigo del diestro citado. El jueves 2 de Dbre. actual se verificaría una fiesta en la casa num. 26 de la calle de Victoria. Se trataba de comelitón y baile. Cirilo avisó de esto á María, diciéndole que él iba á concurrir, lo mismo que Rodolfo y que esta era buena ocasión para que lo conociera llevándola á ella á dicha casa. María se resistió un poco á concurrir á una casa extraña para ella, pero al cabo accedió á instancias de su criada y además porque idolatraba ya en silencio á Rodolfo. Conviniéronse pues en la hora en que Cirilo había de llevarsela. Llegó el juéves y María con el huevero se presentaron en el festejo, Cirilo la presentó con la familia y con muchos toreros amigos que allí había, pero Rodolfo no estaba; por lo que ella se disgustó. Cirilo le dijo que no tubiera cuidado pues Rodolfo iría en la noche de seguro al baile que se daba allí. María comió con los toreros y Cirilo. Despues se salieron de allí para regresar en la noche.

the investigation proceeds, it is constantly said that Rodolfo Gaona had a very direct involvement in the matter." Eleven days later, they practically pronounced him guilty: "The way things stand, the most serious presumptions point to one single individual: Rodolfo Gaona. If he does not end up confessing, he will be proven guilty. This is the prevailing opinion in the halls of Belén."[34] The Roman Catholic daily *El País* laid the beginning of the controversy to "lack of religious beliefs, reading of romantic novels, and the yellow press which feeds on scandals and suicides." But later it worried that if Gaona were freed it would amount to a "travesty of justice."[35]

In this torrent of calumnies, the surviving broadsheets seem at first glance to be "objective," merely reciting known facts, but the texts take his side in the fine print, while the images are variations on the highly favorable picturing noted previously. It was probably risky to take Gaona's side strongly in the matter; *Diario del Hogar,* for example, completely avoided comment. But the first sheet contains only a simple, rather factual headline (fig. 57). The text admits that the woman was at a party in the company of a large number of toreros, drank too much, and was "dishonored," but it names no suspects. It also alleges that Rodolfo was absent: "María and Cirilio arrived at the house. The dance was in full swing, but Rodolfo was not there. The liquor had its way, and María was the subject of several toreros' seductive intentions. By 11 that night, Rodolfo had still not arrived. . . . In the early hours of the morning, Enrique took her to her home on Nuevo México Street, where she lived with her uncle. He scolded her for staying out so late, but she responded that nothing had happened. But María was already dishonored, and decided to kill herself, which she did." The account leaves out the earlier suspicions of Enrique, and the interventions of María's maid. It continues with the imprisonment of Rodolfo, and quotes him as asserting his innocence in the strongest possible terms: "If I am not telling the truth, may a bull kill me." As if to balance this apparent partisanship on behalf of the matador, below the text a twenty-eight-line poem titled "Sad Reflections of Rodolfo Gaona," in which he laments his fate and his ruined reputation, reads:

> Here I am in prison,
> In this very dark cell
> For a horrible crime
> Which a judge will investigate with skill.
> I seem to be the culprit,
> The author of her dishonor.
> And here I am lamenting
> The loss of my own honor.
> I was the idol of the crowd
> Which now sees me with dread;
> No matter how good I was
> I'll never again be applauded.

The illustration was cut from the previous plate which dealt with his goring, and it too contains, because of its quality of quotation, a subtle laudatory connotation (see fig. 55). We see again the matador in a business suit with the halolike hat on his head. The removal of the surrounding material substantially reduces the honorific quality of the original, and brings it far closer to the style of the news portrait. But avid fans of Gaona who had bought the previous broadsheets on him would have already seen the "complete" version twice before, most recently about five months previous. For them, this image is not as objective as it seems, since it refers back to its earlier, more acclamatory incarnation.

Support for Rodolfo Gaona in the broadsheets did not, however, imply sympathy for the victim. If there was a moral to be derived from the story, according to Vanegas Arroyo and Posada, it had nothing to do with Rodolfo Gaona and everything to do with a woman who paid a price for incautious behavior (fig. 58). This sheet, called *Sufferings, Reflections, and Advice from the Suicide María Luisa Noeker From the Other World,* does not even mention Gaona but rather blames the woman for putting herself in harm's way. The poetic text points out that she shot herself first in the hip, and when family members entered her room and tried to wrest the gun from her, she threatened to shoot them just before she put the weapon to her own head and pulled the trigger. The text, allegedly the dead woman's lament, drips with regret:

I killed myself for my honor
Which I lost in a single night.
Because I was with some toreros
Who would not treat me right.
Together we drank some liquor
And I let myself go too far.
Cirilio brought me to a party
Which was more than I bargained for.

After explaining that it was because of her tender age—she was apparently fifteen years old, though newspaper photos make her look much older—she urges young women everywhere not to go to parties where they do not know the others who are invited. She also advises parents to exercise vigilance over their children, and to teach them right from wrong. The sad lament concludes with a request for prayers for the repose of her soul. Posada's illustrations for this sheet are plainly sensational, and support the viewpoint that the woman was more at fault than the actual men who raped her. Above, a portrait of María Luisa is surrounded by a funeral wreath. This likeness comes from a photograph, with its bright eyes that return our gaze and *gioconda* half-smile on the face. Below we see an imagined re-creation of the moment of her suicide, as she delivers the fatal shot while the maid shrieks and runs away. The implication is that what she did to herself is far more important than what others did to her.

The evidence against Gaona never proved convincing enough. In his own

58. *Sufferings, Reflections, and Advice from the Suicide María Luisa Noeker.* Broadsheet with blackline illustrations by Posada, 1909. Half Sheet. Amon Carter Museum. 1978.141

Sufrimientos, Reflexiones y Consejos de la Suicida

MARIA LUISA NOEKER:
EN LA OTRA VIDA.

¡Ay! qué horrible sufrimiento
Tengo en aqueste lugar,
Me figuro que estoy viva,
Que no me pude matar.

Sin embargo que la bala
Certera fué á destrozar
A mi cerebro aturdido
Yo no me sentí acabar.

Aquí me encuentro clavada
En mi cuarto ¡que dolor!
Con la pistola en la mano
Sin saber si vivo ó nó.

Dos heridas me he causado;
Y me mana sangre de ellas:
En la cadera una se halla
Y la otra en la cabeza.

El arma querian quitarme
Pero yo les dije fiera:
Le pego un tiro en el acto
Al que quitarmela quiera!

Me suicidé por la honra,
Que en una noche perdí
Por estar con los toreros,
Que se burlaron de mí.

Juntos tomamos licores
Y gozamos sin medida;
Cirilo Perez llevóme
A esa fiesta maldecida;

Yo estaba apasionada,
De Rodolfo el gran torero
Y por conocerlo he ido
Ignorando el plan artero.

Sufro aquí terribles penas
Pues creí con el suicidio
Quitarme padecimientos
Pero al contrario ha salido.

La Libertad caucional
DEL FAMOSO DIESTRO
RODOLFO GAONA.

El más bonito "Año Nuevo"
Que Rodolfo recibió
Fué el salir bajo de fianza
De bartolina y prisión.

Rodolfo Gaona el diestro mexicano que tanta fama ha alcanzado, como recordarán nuestros lectores fué marcado como el presunto responsable del crímen registrado en la honra de la joven María Luisa Noecker.

El huevero Pérez como dicen vulgarmente, "encampanó" á María para ir al baile á donde según él debía asistir Rodolfo. Allí había muchos toreros y María Luisa estuvo en dicho festín. Enrique Gaona se la llevó de la casa del baile. Los toreros disputábanse á María Luisa. Resultó al último ésta deshonrada y al verse así ella, se suicidó con una pistola de su tio. Aprehendidos fueron Enrique, Cirilo y otros sospechosos y con especialidad Rodolfo.

La justicia le halló mérito para la prisión porque ella estaba prendada del torero Rodolfo, teniendo retrato de él en su tocador.

Rodolfo entró á Belén el 8 de Diciembre del año de 1909, y hasta hoy dicen que aun no confiesa ser el que deshonrara á María Luisa. Veintiun días duró en la prisión Rodolfo porque el 30 del mismo mes de Diciembre á la 1 ½ de la tarde quedó en libertad bajo caución de cinco mil pesos. Es decir, entró á Belén á principios del mes último del año para salir el día penúltimo, dos días antes del año nuevo.

El día 30 de Diciembre
De la tarde al ser la una
Rodolfo dejó la Cárcel
Con muchísima fortuna.

Cinco mil duros costóle
Y aunque fuera mucho más,
El caso era de Belén
Los muros abandonar.

No es la libertad completa
Pues está bajo caución,
Pero al menos ya en la calle
Podrá arreglarse mejor.

59. *The Famous Matador Rodolfo Gaona Free on Bail.* Broadsheet with black-line illustrations by Posada, 1909. Half Sheet. Colorado Springs Fine Arts Center.

defense, he said that on the fatal evening he had been to the opera house to see a zarzuela that contained a character based on him (also, alas, lost), and that he had returned home at about midnight. Witnesses corroborated both claims; in addition, no one who had been at the dance would say that they saw Gaona there. The domestic workers who alleged to have seen the woman in his company, when confronted with the real person, changed their story; no, this was not the man who accompanied the victim home. Presumably he was also subjected to the same medical examinations that had earlier cleared his brother. Also weighing heavily in the matador's favor was the long-standing policy of Ojitos that prohibited his protégé from attending social functions that could lead to trouble. Ojitos hired lawyers who lined up witnesses to testify to the constant limitations on the matador's personal life. This parade of witnesses, together with the silence on the part of the partygoers, was what led the newspapers to fear a travesty of justice. Thus the strictures Gaona had earlier protested may have helped save him. There was other public pressure brought to bear on his behalf as well. A rally was staged on December 19, in the form of a bullfight with free admission. The guest of honor was Francisco Chávez, a prefect of police who believed in Gaona's innocence. At another bullfight just before his release, when the crowd discovered that Luis Reyes Spíndola, son of the publisher of *El Imparcial,* was in the audience, they jeered him lustily and threw cushions at him.[36] When it was finally decided that there was insufficient evidence for further detention, his release on bail of five thousand pesos was announced for 3:00 P.M. December 30. In an effort to avoid a spectacle, the Belén authorities let him out at 1:30, but even by then a large crowd had gathered. Two thousand people waited at the gateway of the prison, giving him an ovation which years later he described as "unforgettable; among the ones for which I am the most grateful."[37]

Upon his freedom Vanegas Arroyo and Posada produced another sheet (fig. 59). The cautious text avoids mention of Gaona's claim not to have been at the party, saying only that "he never admitted to dishonoring María Luisa." The verse leaves it unclear whether he would be allowed to practice his trade, and says that he immediately left in the presence of Ojitos to a celebration at his home. Posada's illustration is a close continuation of previous prints dealing with his woundings. There is the same haloed face, but the lines are far less assured. It looks as if Posada was intending to copy his previous work, thus reuniting in this new plate the portrait with the bullfight materials. Below the face are more implements of the corrida, again arranged in a style that is based on bullfight posters. If the print lacks a certain originality, its approach serves the needs of the sheet and of Gaona's reputation by making no reference to the dishonored woman or to the prison. Rather, it places him back in his element.

Years later in his autobiography, Gaona told of what he thought was the political motivation of those affiliated with *El Imparcial* who sought to taint him with the crime of rape. He performed most frequently in the plaza called El Toreo, which was owned by publisher and businessman Víctor Garcés. In mid-1909, Garcés decided to fund an anti-Díaz magazine which came to be called

Actualidades, and which could not turn a profit without some transference of funds from the bullfights at El Toreo, where Gaona and others worked to great success. So when the Noeker scandal came along, *El Imparcial* editors saw an opportunity to indirectly attack an enemy by attempting to ruin the reputation of one of the most productive matadors who fought in that ring. When the newspaper's chief bullfight correspondent, Riverita de la Torre, refused to go along, he was fired, and the attack began.

The story is probably unverifiable with our present resources, but it is true that de la Torre was let go from *El Imparcial* at that time. In addition, as the novel *Pacotillas* shows, powerful interests regularly used the press in the Díaz period to further their own economic interests, acting behind the scenes with subsidies, and clothing themselves in loftier goals.[38] *El Imparcial* benefited from a government subsidy of its own, and hostility between its publisher Rafael Reyes Spíndola and Garcés is entirely plausible. Surely the official newspaper had other reasons for attacking Gaona, among them the high social status he enjoyed for someone of his race, and the fact that the dishonored woman was the offspring of the economically vital European expatriate business community. But something of its wounded pride, if not its economic motives, at the eventual outcome of the case can be gleaned from an editorial published ten days before Gaona's release under the long title "We Are Beaten! Mr. Rodolfo Gaona Should Be Returned to the Bosom of the Society Which Adores Him": "We give up! And we are sorry for thinking that this crime, which has so aroused public opinion, would be resolved in courts, when the facts show that it is not under the auspices of the serenity of the law that the innocence or guilt of the accused will be judged, but in the bull ring. . . . The moral level of *El Imparcial* is too high for it to involve itself in such moral disgrace."[39]

When Gaona did return to the ring on January 9, the shop released a sheet on the event, which shows several signs of hasty production (fig. 60). These seemingly careless features support the widespread belief that the authorities would ban Gaona from the ring for some period of time after his release. In the second line of the heading, the word *Diestro* ("Master") uses more than one type style. The final *O* is larger, and was placed on its side to keep it from extending too far beyond its neighbors. Below, the name of the matador also uses two different styles, one solid and one decorated. In the heading's third line, the capital *T* in Toros is larger than the other capital letters in that line. It is possible that the sheet was made in such haste that Posada could not provide an illustration, for the present one is by Manuel Manilla, and had been used previously by the shop. Its subject is entirely appropriate, though, as it depicts a matador standing next to the dead bull receiving the applause and tossed hats of the crowd. It is an old plate, though, evidenced by the long crack through the bull's hindquarters which extends through the body of the matador. The text makes no mention of the hero's recent legal difficulties, focusing rather on the festivities at the ring and the joy of the crowd at the star's return to action:

60. *Reappearance of the Famous Matador Rodolfo Gaona in the Bullring "El Toreo" in 1910.* Broadsheet with re-used white-line illustration by Manuel Manilla, 1909. Half Sheet. Amon Carter Museum. 1978.214

Reaparición

DEL DIESTRO MATADOR DE TOROS

RODOLFO GAONA

en la Plaza de Toros "EL TOREO" en 1910

Domingo nueve de Enero
Gaona fué ya á torear,
Y la plebe se previno
Para ese acto vitorear.
 En la Plaza de "El Toreo"
De esta culta Capital,
Su reaparición famosa
Tuvo en la tarde lugar.
 Y seis toros españoles
Traidos de Peñalver,
Entraron en buena lidia
Y fueron dignos de ver.
 Castor Ibarra, el espada
Fué á Rodolfo acompañar
Con "Cochero de Bilbao"
Que es de fama singular.
 La corrida estuvo magna
Como pocas en verdad,
Y Gaona entusiasmado,
Como nunca se verá.

Ya se acababa, de fijo,
Por salir al redondel
Que es de vocación torero,
No solo por interés. .
 Qué ovaciones se le hicieron!
¡Qué rumbosa recepción!
La Plaza veníase abajo
De palmas por mayor.
 Manifestacion ruidosa
En "El Toreo" se miró,
Y Rodolfo contentísimo
Como ninguno, gozó.
 Grande concurrencia tuvo
Esa corrida ¡caray!
Porque fué de las mejores,
Que se han visto por acá
 Saludemos pues, contentos,
Al torero sin rival,
¡Viva Rodolfo Gaona!
¡Viva México! y no hay más.

IMP. DE ANTONIO VANEGAS ARROYO, 2a de Sta. Teresa núm. 43 México

The corrida was magnificent
Like very few truly are;
And Gaona was enthusiastic
Like he's never been before.
What ovations he received!
And what a lusty reception!
The plaza nearly collapsed
From all the noise and commotion.
We greet him, then, content;
Of matadors he's the head.
Viva Rodolfo Gaona!
Viva Mexico! Enough said.

El Imparcial's condemnation of Gaona reflected some behind-the-scenes machinations and political jealousies, and the broadsheet's text referred to this by mentioning—a total of three times, twice in the text and once in the heading—the fact that Gaona reappeared in El Toreo, the ring owned by the anti-Díaz publisher.

Gaona said in his autobiography that he preferred not to get involved in politics, and that he saw his vocation as essentially apolitical. Indeed, his recounting of the controversy between Reyes Spíndola and Garcés was present-ed as something that had been later "told to him," rather than a matter that he deduced for himself. But, as the Garcés controversy demonstrates, this did not keep others from seeing political opportunity in an association with him. President Díaz, for example, who very rarely went to the corrida because he wanted to maintain a detachment from its inflamed partisanships, attended two of Gaona's performances during his first year after the alternativa. Francisco Madero, who was elected President after Díaz abandoned the office in May 1911, went further. When Gaona was gored again in Spain in May 1912, Madero sent him a telegram wishing him well.[40] The previous January, Madero had appeared at one of Gaona's bullfights, and invited him up to his seat at its conclusion and allowed photographs to be taken (fig. 61). Gaona later recalled that Madero had been severely criticized for doing this, "as if he had sullied himself for embrac-ing a fellow compatriot." For his part, Madero defended himself carefully: "I attend this event because I judge it to be a duty of mine to give importance with my presence to an occasion which glorifies an artist who is honoring his country." Through it all, Gaona professed ignorance of the political significan-ce of their meeting, and, by implication, his own significance in the important cultural struggles of the late Díaz years: "I was practically unaware of who he was and of what event had made him President."[41]

61. Photograph of
Rodolfo Gaona with
President Francisco
Madero, 1912. Appeared
in Lauro Treviño, *Rodolfo
Gaona: Gloria Nacional*
(Mexico D. F.: SEI,
1975).

LA BICICLETA

lerta, alerta, manario! | *Como tren extraord*
un lado la maleta, | *Subiéndose á la ba.*
hay viene la Bicicleta | *Como se sube al ca*

Hay te va la Bicicleta,
Todos dicen por la calle
A andar como en carretela,
Vamos á hacer un ensaye.
Aunque me rompa una pierna;
Un papelero que es poeta,
Conquistó mi corazón.
Montado en su Bicicleta,
Salió de la Redacción
Dando vueltas cual ruleta.

Como es la moda del día,
Todos estamos entrando
Y nos andamos paseando
Con gusto y con alegría.
Ya el coche de fantasía
También perdió los papeles,
Porque ya hasta las mujeres
Corren á la descubierta,
Gozando de sus placeres
Montadas en Bicicleta.

BROADSHEET VIEWS
OF URBAN MODERNITY

As we have seen, Vanegas Arroyo and Posada rarely positioned their broadsheets in overt opposition to official laws or policies. The cases of the Islas Marías deportees, Rodolfo Gaona, and Jesús Negrete demonstrate, for example, that Vanegas Arroyo saw his mission as speaking, within the limitations of press censorship of the times, for lower-class concerns and cultural values in a way that most often distanced itself equally from both the establishment and its declared opponents. In narrating controversial events, the sheets often stuck to "facts," and the voices of praise for criminals and bandits were frequently muted though not completely silenced. The broadsheet is no *Diario del Hogar,* and even less an *Hijo del Ahuizote.*

Yet there was material in the sheets that Díaz government officials would have preferred not to see in print. The references to *gachupines,* for example, are all derogatory. The picture of the jewel thief and murderer Jesús Bruno Martínez, defiantly taunting his executioners, could hardly be expected to give peace to the authorities who captured him. And Vanegas Arroyo's refusal to condemn Rodolfo Gaona effectively aligned him against the regime on at least that point. Notwithstanding the threat hanging over the heads of all journalists, the broadsheet as instrument for the articulation of lower-class concerns could hardly be expected to make its voice always harmonize with the official chorus led by the upper echelons of the Díaz government.

For certain times and issues the broadsheets expressed opposition more explicitly than usual, and used satire and irony with greater than normal sharpness. When the targets were aspects of the Díaz modernization of Mexico City, or the Europeanizing trend of middle- and upper-class lifestyles, or the habits of rich individuals, a polemical or oppositional tone in the sheets is most apparent. On these issues, a decidedly anti-aristocratic tone cannot be mistaken or

camouflaged. To be sure, these attacks and satires were often muted in at least two ways. For example, when rich persons were named in prints, they were never well-known individuals, any more than, say, spectacular criminals were. Government officials and other prominent Mexico City upper class persons were never attacked by name. Moreover, the cloak of humor also served to shield the broadsheet producers from official counterattack. One could escape charges of fomenting discord by claiming a desire merely to be funny. The opposition in the sheets is more cultural than political, in the sense that the targets are often rather vaguely and broadly sketched. But for all that, if it was not clear exactly *who* was being referred to, it was always clear what *type* of person was being lampooned, and in this sort of satire Vanegas Arroyo and Posada apparently took great pleasure. If numbers of plates produced are any indication of popularity, then it is also clear that the broadsheet buying public was similarly amused, stimulated, or relieved at seeing its class enemies, and some of their habits and cultural products, somewhat roughly treated.

As we look at the way broadsheets dealt with these subjects, we will see that they most often show evidence of a certain bafflement about the subjects they were lampooning. The sheets give very little indication that their creators understand the life of the upper and middle classes, much less sympathize with it. But then the purpose of the sheets is not to broaden social understanding. The social types who are the subjects of this decidedly jaundiced attention are portrayed as either shiftless, lazy, self-absorbed, fatuous, or socially inept, despite their fashion-driven exteriors. We will see also that the issue of race rarely seems to matter to the creators of the sheets. The hostilities, social antagonisms, and cultural divides are portrayed here much more as a product of class than race.

In terms of raw numbers, the middle and upper classes represented a distinct minority of the population of Mexico. According to a survey that was based on census figures for 1895, of the urban population of the country (counting not only the capital but all other cities), 68.6 percent were characterized as lower class. The middle classes accounted for 29.5 percent of the total, and upper class persons were only 1.9 percent. When considering the population of the country as a whole, 90.8 percent were deemed to be lower class, 7.8 percent were held to belong to the middle classes, and 1.4 percent were counted as upper class.[1] The survey also exposed a strong racial weight to the class structure, as most lower-class persons were of indigenous descent, just as most at the other end of the scale were of predominantly European blood. For example, of the 116,527 foreign-born persons residing in Mexico in 1910, only 9 percent were agriculture workers, and the vast bulk of the latter group was Chinese.[2] The relatively low number of immigrants in the population is somewhat deceptive, however, because the lighter-skinned ethnic groups tended to socialize and marry within their nationalities, propagating foreign colonies in major cities over generations. Moreover, these middle and upper class persons, no matter what their ethnicity, were held to be Mexico's hope for the future, because they

largely adhered to a bourgeois ideal imported from "civilized" European nations.

The rich appear in broadsheets with about the same degree of frequency as they did in real life (that is, not often), and when Posada pictured them it was almost never in a favorable light. They were portrayed as profoundly lacking in moral virtue and leadership abilities, and as regularly caving in to temptations such as greed and envy. These sheets often have an overtly religious message that parallels traditional Roman Catholic teachings, and they indicate the relatively high position that priests usually enjoy in this medium. Like most of the sheets on sensational crimes, the major goal of the sheets depicting rich people seems to be moral teaching. Beyond that, the sheets also deal with a class reversal of a different sort, in the form of an upper class person brought low.

The case of the Avaricious Rich Man Juan Pérez, headlined "Horrible and Singular Example," demonstrates most of these characteristics (fig. 62). It seems that Mr. Pérez was greedy and covetous, and according to the text he especially victimized poor persons, "lending them money at usurious rates or hocking their belongings." Thus the broadsheet links the subject with the hated pawnshop business. He suddenly contracted a serious illness, and his family began to urge him to confess to a priest and dictate a will. A priest was called, but Pérez abused him and sent him away. When the notary came to take down the sick man's will, he began dictating: "Let's get to the heart of the matter. First, I want my soul to go to the devil for my bad behavior." When the notary asked him if he were crazy, he denied it and then added that he wanted the devil also to take the souls of all of his family members as well, and do it soon, so that they could not enjoy his riches. The notary, says the sheet, then began to merely move his pen over the paper without writing down anything because he had never heard of such a will. As the sick man continued dictating horrors and blasphemies against everyone he knew or was related to, his appearance began to take on a frightening aspect: "His eyes were bloodshot to such a degree that they seemed to be on fire; his hair was standing on end; his tongue was sticking out, and he gave off a foul odor that could not be tolerated even at a long distance." He remained this way for three days, and when he finally died a pall of smoke hung over his house. The authorities took his body and buried it far away in an unconsecrated place. His wife's health was soon broken and she died shortly thereafter.

As if the moral of the story were not plain enough, it is hammered home in a poetic text on the back of the sheet in the form of *décimas,* ten-line stanzas often used for moral exhortation:

This miserable and greedy man
Though covered with his wealth
Never helped the poor
To maintain their lives or health.
Since he devoted all his thoughts

Horrible y Singular Ejemplo,

Tomado de una Plática Religiosa y cuyo asunto se refiere
AL RICO AVARIENTO JUAN PEREZ.
Util para todos aquellos que tienen el abominable vicio de la avaricia.
Sus fatales consecuencias.

La avaricia y la codicia, son dos cosas abominables ante Su Divina Majestad. Juan Pérez, protagonista de, este relato, fué sumamente avariento y codicioso, al extremo de no dejar oportunidad alguna. Cualquier negocio que hacía era de muy mala ley, gravando los inteses de los pobres, ó ya prestándoles dinero con inmensa usura, ó ya hipotecándoles sus bienes, que á pocas fechas ya estaban perdidos por falta de recursos.

Así es como vivió Juan Pérez, siendo un despótico rey para cuantos le ocupaban en sus amargas necesidades; y así también llegó á obtener inmensos caudales que vinieron á ser el fruto de su indudable condenación. Este infortunado avariento es sorprendido por una violenta enfermedad que le ataca al corazón y que lo pone en la necesidad de administrarse, pero era en lo que menos pensaba. Sin embargo, á las muchas exhortaciones que le hizo su familia para que se confesara y su alma quedara limpia de culpa y pena, condescendió Juan Pérez, aunque con demasiada repugnancia, pues aún no llegaba el confesor cuando ya estaba enfurecido, hecho un veneno por la entrevista que iba á tener con el Ministro de la Iglesia Católica, pues de una buena confesión resultaba que tenía que dejar el dinero á su familia; cosa que no quería por su imponderable ambición al tesoro, y porque no creía en su próxima muerte. Por fin, llega á su lecho un sacerdote, lo ve impaciente y demudado y con cariño sin límites, le dice: "Sosiego, hermano mío, tranquilízate, que ya está tu alma próxima á partir para la eternidad. Confiésate contritamente de todos tus pecados, para que pueda yo darte la absolución. Estos son los mejores momentos en que sin duda puedo salvarte." El enfermo Juan Pérez, no hizo aprecio de las exhortaciones del confesor, pues al contrario, lo maltrató demasiado; entónces el sacerdote mirando su resistencia se retiró lleno de consternación.

La esposa de Pérez se le acercó y le dijo:
—Oye, Juan, dispón tu testamento, para que todo quede arreglado.
—¡Bueno! exclamó Juan con sarcástica sonrisa; conque quieres que haga testamento? magnífico: vas á ver que complacida te dejo, lo mismo que á mis hijos: que venga el Notario.

Acto contínuo se presentó el Notario, á quien después de saludarlo, le dijo con imperiosa voz: "Oiga con mucha atención lo que le voy á dictar y escríbalo al pie de la letra."
—De muy buena gana, le contestó el Notario.

To nothing but greed and lies
In order to improve his prospects
With fraud in moral guise.
So he seemed to pass his days
With smiles, and never with cries.
But when he died, the picture was quite different:
At his side a very large troupe
Of snakes and wild beasts
Of ghosts and panthers fierce
Tormented him; they never ceased.
With all of these cruel tortures
He entered into hell
And of course he never left;
A dragon still guards his cell.
From all of this it's very clear
That his greed has cost him very dear.

The illustration presents the moment when the priest has just been dismissed. He leaves at the right, in quiet conversation with an associate. Their stride seems slow and measured, underlining their solemn mood. At the left the notary sits at the ready, the picture of dutiful attention, with his head attentively inclined, pen in hand above a still-blank piece of paper. The rich man has only just begun to speak, but his wife is already expressing shock with her open mouth and hand gestures. The elongated bed fills the entire frame in a long diagonal, and the subject of the story has most of the crazed features that the text claims. His emaciated body leaves the mattress quite flat, a fact brought out by Posada with a well-drawn series of parallel lines. Probably most Mexicans would immediately recognize the scene even if they could not read, since it was fairly common for very sick persons to be visited by a priest and then to dictate a will (this was what the matador Antonio Montes did). The lack of action in the scene places the burden of demonstrating that something is terribly wrong on the woman and the monsters that surround the bed. These three monsters combine features of bats, dragons, and reptiles. Posada compresses both space and time in this print, as it seems doubtful that the notary would already be in his seat before the priest was even out of the room. The cleric and his assistant are also quite close to the bed, but a little below it; their location is dictated as much by the desire to collapse space and time as a need to show them as secondary to the principal figures in the scene, the rich man and his wife. Posada's illustration intervenes less decisively in this story than usual, in part because it is difficult to picture a dying man in anything resembling vigorous motion, but it succeeds in giving the sense of a wealthy person with attendants surrounding him, and some sense of the danger through the monsters and the gestures of the wife.

The sheet titled *Ejemplar y Ciertísimo Suceso* presents an even less favorable image of a rich person (fig. 63). Although it has a better ending than the previ-

EJEMPLAR
Y CIERTISIMO SUCESO

Que pasó en una Hacienda cercana á esta Capital.
¡Patente castigo de Dios
á un propietario que se burló de la Santa Iglesia!

En una Hacienda situada á poca distancia de esta Capital, vivía el dueño de ella, el cual era enemigo acérrimo de la Religión católica y de todos sus ministros. Pocos días hace que el Sr. Cura de un pueblo, á cuyo dominio religioso pertenece dicha Hacienda, mandó pedirle al incrédulo propietario los diezmos y primicias que ordena la Iglesia. El hacendado en vez de remitirle algunas producciones de sus terrenos tan abundantes y ricos, le envió con un mozo las astas de un toro muerto en días pasados. Se rió grandemente de pensar en el coraje que haría el Señor Cura al recibir las astas, y contó esto con mucha mofa á todos los de la Hacienda. Ya verán muchachos, les decía, qué coraje va á llevar este monigote hipócrita cuando reciba mis diezmos y primicias tan elegantes. Cuando nos lo cuente Mateo, (así se llamaba el enviado) vamos á reirnos mucho y á tener un rato bien divertido. Y soltaba una chocante y estrepitosa carcajada burlesca. Los trabajadores que lo oían, no se lo aprobaron dentro de sí, claro está, pero disimularon bastante, riéndose también aunque forzadamente. Temían que su patrón se enojara con ellos si no aprobaban su idea. Después de algunas horas regresó el enviado diciéndole al hacendado que con mucho gusto había tomado el Cura las astas del toro.

—¡Ah qué fraile tan imbécil! exclamó el desnaturalizado propietario y continuó riéndose del Señor Cura, quien verdaderamente recibió sin enfado aquellos cuernos.

A la hora de la Misa mayor los colocó en el altar como se colocan todas las ofrendas. Luego subió al púlpito y explicó á los fieles oyentes la razón de haber puesto en el altar las astas, por haber sido remitidos del dueño de aquella hacienda como primicias y diezmos. Allí expresó que la humildad es antes que todo, y si aquel propietario se burlaba de la Iglesia, debía ser esta burla recibida sin enojo ni soberbia. Pasaron luego nueve días y al cabo de los cuales, comenzó á sentir el castigo justísimo á su insolencia aquel rico hacendado. Todos los magueyes, milpas, trigos, etc., principiaron á secarse, por más riegos que se les daba; los ganados de toros y borregos fueron atacados de una peste extraña y fueron acabando todos como por arte de mágia. Preguntó el hacendado á los due-

ous example, this story provides interesting information about class behavior. Here Posada has again taken more than usual liberties with the story line, in a way that makes the rich man seem worse than he perhaps was. The subject of this sheet is an unnamed owner of a hacienda "near the capital" who was the "bitter enemy of the Catholic religion and all of its ministers." When the priest sent a messenger to the establishment in search of tithes and offerings for the year, the owner gave him only the horns of a bull who had recently died. What was worse, he was proud of having committed this insult and "let loose a shocking and resounding guffaw." The workers who heard this outburst apparently had better moral sense than the owner, because "within themselves they did not approve, of course, but they hid their reaction, laughing along with him, though forcedly. They were afraid that the patrón would get angry with them if they showed disapproval." The response of the priest showed that he knew what to do. He sent the messenger back to the patrón to tell him that the gift was gratefully accepted, and the next Sunday he placed the horns on the altar along with all of the other tithes and offerings. In the sermon that week he said that the church accepts all offerings even if they come with calumnies, and he referred to the gift of the horns as an example.

The owner's troubles were just beginning. His crops dried up and would not produce, "no matter how much water they were given." His herds were attacked with a mysterious disease that killed them all, and rotted their hides so quickly that they could not be tanned. Vultures even refused to fly overhead. All of the other haciendas in the area were having a good year, but this particular owner was suffering the judgment of God. The story has a happy ending, however. The owner apparently repented of his defiant attitude, confessed, and "was completely converted." He returned to work and now, "with a thousand tasks and at a price of incalculable sacrifices he is beginning to recover his exorbitant losses."

Posada depicted the low moment of the story, but in a way that accents the evil character of the hero. He is seen seated at a table in an expensive charro outfit, his fat paunch obvious. Under the table are bags of money which, though hardly a common domestic accoutrement, hammer home the class level of the protagonist. A decorated chest fills the right corner, but does not extend below the level of the table top. Its skewed angle and uncertain extent may mean that it was an afterthought, inserted into the composition to hold the plate off the paper. The rich man's gesture is disdainful, and his head is thrown back haughtily as he sends away the church's representatives. It looks as if he is filling their ears with insults even as they leave the premises. According to the story, the priest never actually visited the patrón, but he is there in the center of the group of three, with his long cloak, hat, and staff. They walk away slowly, heads downcast. The presence of the priest together with the barely hidden bags of money and the patrón's attitude greatly sharpen the sense of confrontation between the church and the wealthy man.

The directionality of this work is from right to left; it is significant that this is the opposite of the arrangement of the majority of Posada prints. Among

works that display a strong sense of direction in the composition, sheets that deal with spectacular crimes generally have the action moving from left to right. The deeds of Guadalupe Bejarano and Norberta Reyes were carried out in this orientation (see figs. 6 and 10). In addition, the bandits Santanón and Ignacio Parra are depicted moving in the same direction (see figs. 33 and 35), as is Macario Romero (see fig. 30). The orientation of these deeds in a left-to-right format, an eye movement which is more natural since it is also used in reading, facilitates an interpretation of these scenes as depicting free and spontaneous individuals, the illegality of some of their deeds notwithstanding. Execution prints, which also show a strong directionality, divide about evenly between one orientation and the other, making it more difficult to draw conclusions about this type of scene.

A partial exception to this scheme is Jesús Negrete killing the policeman, which moves from right to left, but he killed while trying to escape, and he is obviously about to continue his path toward the right (see fig. 42). Moreover, other scenes that involve the authorities have their motion primarily in this direction, though they are outnumbered by about two to one in comparison to scenes with the opposite orientation. See for example the shooting of the marijuana smoker in Belén (fig. 15) or Valentín Mancera in captivity (fig. 31). To generalize, passionate or impulsive deeds or persons in Posada prints move from left to right, an orientation which is more natural to the eye for Western readers, and right-to-left motion characterizes deeds that are halting or "complicated." Whether Posada intended this, and what bearing it may have on the necessity of working backward when making prints, since the plate has the opposite orientation from the printed image, is impossible to determine. Most printmakers, especially prolific ones such as Posada, become accustomed to visualizing compositions in reverse. It certainly is plausible that this is a purposeful strategy of the artist, because the orientation of the composition contributes to its mood in so many cases, the present one, figure 63, included. After reading the story of the rich landowner's rejection of the church, we know that the deed pictured is not the decisive event in the story, as it is, for example, with the spectacular crimes of Guadalupe Bejarano and Norberta Reyes. The orientation of this print contributes to our feeling, together with the laborers who uneasily laughed along with their master, a sense of dread about coming events that is far more remote from stories of the blinding flashes of fury displayed by Reyes and Bejarano, and from the larger-than-life exploits of Macario Romero, Ignacio Parra, and Santanón.

The Roman Catholic church lurks behind both of these stories, more or less explicitly; the headline for the first case, figure 62, says that it was taken from a religious sermon, and the headline in the second story, figure 63, castigates the landowner for scorning the Holy Church. At a time in which the church was the principal purveyor of moral teachings, this link to the broadsheets makes sense, but there is more to the story than that. The sheets very rarely portray the church in anything other than a favorable light, and they cannot be generally termed anti-clerical. While there was an occasional sheet about miracles or

64. *Shocking and Terrible Occurrence in the City of Silao in the First Days of the Twentieth Century: Suicide of a Greedy Rich Man.* Broadsheet with white-line illustration by Posada, 1900. Half Sheet. Amon Carter Museum. 1978.88

ESPANTOSISIMO
— Y —
TERRIBLE ACONTECIMIENTO
EN LA CIUDAD DE SILAO EN LOS PRIMEROS DIAS DEL SIGLO XX
¡SUICIDIO DE UN RICO ENVIDIOSO!

En la ciudad de Silao, perteneciente al Estado de Guanajuato, vivía un hombre extremadamente rico, tan rico como muy pocos habrá en el mundo. Se llamaba Bardomiano Urrizalde. La exorbitante fortuna de que gozaba, la debía únicamente á la cuantiosa herencia de sus padres y á la desordenada usura que practicó después; ayudado además con todos los medios ilegales y hasta infames que se pusieron á su alcance. Su carácter era digno de censurarse por todos.

Bardomiano no tenía ninguna religión; era materialista y ateo; estas ideas tan arraigadas en su alma trajeron funestas consecuencias, y la envidia fué una de las pasiones más dominantes que tuvo; de este vicio resultaron la avaricia, la gula, la soberbia, la lujuria, la ira y por último, la pereza.

Así pues, los siete vicios rodeaban á este desgraciado y formaron profundas raíces en él.

Por mucho tiempo á Bardomiano no se le negó nada de cuanto deseaba, pues como tenía dinero, éste le facilitaba todo; él mismo salía en busca de personas á quien prestarles dinero con un exagerado premio dejándoles de cobrar por mucho tiempo, y después les cargaba los réditos pretestando que ellos eran los que no le querían pagar y de esta manera les abría juicio y les embargaba sus intereses, quedándose dueño de ellos y dejándolos en la miseria más grande del mundo.

Tenía el vicio de cortejar á las mujeres, engañándolas y, después de conseguir sus infernales deseos, las abandonaba dejandolas en deplorable estado de pobreza.

La mayor parte de las noches se ocupaba de jugar en su casa, para lo cual tenía ciertos individuos amigos suyos, que le servían de convidadores y paleros, quienes les llevaban jóvenes de buenas familias y allí los desplumaban en un abrir y cerrar de ojos.

Al rayar al día para celebrar sus triunfos en el juego, formaba banquetes con sus compañeros de vicio, bebiendo y brindando con ellos y muchas mujeres de mal vivir que estos mismos le conseguían, con todo lo cual se daba por bien satisfecho. Cuando algún mendigo le pedía limosna,

other strange occurrences in churches, the bulk of Vanegas Arroyo's production on a religious theme consists of devotional prints for the home with depictions of saints, holy places, and Christ crucified. Besides meeting the needs of a popular market, and thereby providing him with a great deal of business, there is evidence that these religious prints also reflected the values of the Vanegas Arroyo family in those days. One writer claimed that the reason the family left Puebla in 1867, where the founder of the shop was born, was because the anticlerical liberals took over that city: "His father was a conservative. He was fifteen years old when the liberals ejected the conservatives and took possession of the city of Puebla."[3] After he established the printing business in Mexico City in 1880, the first several broadsheets that Antonio Vanegas Arroyo produced were devotional in nature, illustrated by Manuel Manilla. Antonio's son Blas Vanegas Arroyo always claimed that Antonio was a liberal, but the sheets do not prove this. The attitude toward religious authority in the sheets is overwhelmingly positive and supportive of popular faith.

Similarly correct from a religious point of view, but embodying a much larger class reversal, was a sheet dealing with the suicide of a rich man in the province of Guanajuato (fig. 64). This man, with the unlikely name of Bardomiano Urrizalde, was given to vice from an early age, because he inherited his wealth: "The huge fortune that he enjoyed, he owed exclusively to the bequest of his parents, and to the outlandish interest rates that he charged when lending it, in addition to whatever tactics, legal or illegal, that he could muster. His character was reprehensible to everyone." Beyond this, he was irreligious, a "materialist and atheist," and subject to all of the seven vices: greed, luxury, sloth, anger, gluttony, pride, and envy. He spent most of his time gambling, and he regularly took advantage of women. At some point, however, and for reasons not entirely understood, it seems that he began to suffer financial reversals. People stopped borrowing from him; a bank where he had large deposits failed. A servant stole a large sum of cash from him. Also, women began to shun his company, his food began to seem bland, and he lost the ability to sleep and began "turning over all night in desperation and making himself miserable." When his finances were exhausted, he did not know what to do, since he never learned to work and save like everyone else. He sunk so low that he had to give up his home and rent a shack from, of all people, an Indian.

He resolved to commit suicide, but had difficulty carrying out even this plan. The local store refused to sell him strychnine, and no one trusted him enough to sell him a gun and ammunition. So he bought a bag of matches, boiled the heads in water to extract the phosphorous, and poisoned himself by drinking the brew. The death was neither pleasant nor sweet: "He had horrible cramps, with sharp, unbearable pain in his stomach; his despair grew so that he lay on the floor and began to whip and bite himself. . . . His hut filled with infernal demons, among them the seven vices which had first led him to suicide."

The illustration, while true to the basic thrust of the story, takes several perhaps understandable liberties. A death by poisoning, after all, involves rather little action, as we already saw with the story of the man who poisoned his par-

ents (see fig. 11). In addition, because he had been brought so low, at the time of his death Mr. Urrizalde was probably not recognizable as a rich person. So Posada avoided depicting the suicide as it might have actually happened in favor of a different moment when he still had his energy, and the demons could still be in full force. The monsters are seven in number, and each is helpfully labeled according to a particular Christian vice, but their attack is not located in space or time, and, since the victim appears well-dressed, could not have occurred in the dirty hut in which the man allegedly died. Posada has pictured an earlier moment in the entanglement of the subject, when he still enjoyed the benefits of wealth. Neither is there a hint in the picture of how he met his end.

This print approaches the iconography of a temptation scene, a subject that has a lengthy pedigree in European graphic arts, rather than a suicide; Posada's treatment of the temptation theme demonstrates key aspects of his style without slavishly following all of its conventions. The demons, for example, closely resemble one another. They seem to be from the same family, with variations primarily in their foreheads: some have horns, some pointed ears, and some have tufts of hair. More than anything else, they resemble a winged pack of noisily barking dogs. Their action is relatively limited as well, as they merely bark and snap, rather than tempt with blandishments or tear at the subject's body. Perhaps to make up for this lack of variety, they are all labeled, each with its own sin. "Avarice," in the upper left, is misspelled—it should be *avaricia* rather than *abaricia*—but the error is of a very common sort, since the two spellings sound nearly identical in spoken Spanish. The relative lack of imagination in conception of the demons parallels the simplicity of the composition, in which they are all arranged in profile, each occupying its own cell of flat space. The composition is roughly symmetrical, but the symmetry is not of the sort that suggests the majesty and stability of a religious subject. This should not surprise us, but on the other hand, the conception of the present scene seems completely lacking in metaphysical meanings. This is not a titanic struggle of good and evil but a worthless rich man beleaguered by a passel of wild canines. Posada's lack of interest in symbolism, remarked on before in other connections, reveals itself here as evidencing a profounder distrust of philosophical speculation or moralizing. Rather than presenting a vehicle for our reflection on temptations, ethical dilemmas, and the inner substance of persons, Posada presents us with a cracklingly energetic scene which, in order to establish its distance from a "Dog Bites Man" story, must resort to labeling the protagonists for easy identification.

The subject of the temptations is similarly stripped of such metaphysical baggage. His dress betrays his upper-class provenance, and his attitude differs widely from that of traditional temptation scenes. The saints who were the subject of such prints—St. Jerome and St. Anthony being the most popular, not to mention Christ himself—most commonly endured their demonic sieges with a stolid and unruffled demeanor that spoke of inner resolve and deep spiritual tranquility. To be sure, this is a picture of a man who lacks such traits and is hence reduced to barking back and waving his arms, but he is not evil

personified. Rather, he is weak, a reed shaken by the wind. The strong desire for class reversal that Posada seems to have shared with his audience keeps him from endowing the rich man with virtues, but neither is the rich man the source of the evil that befalls him; he merely lacks spiritual substance, perhaps due to the fact of his inheritance.

In broadsheets, Posada seldom engaged in caricature as traditionally conceived. That is, he hardly ever exaggerated the physical characteristics of his subjects to a degree that provoked mirth. He often portrayed them with intense facial expressions or highly dynamic body postures, but his figures rarely are "carriers," (from the Latin *carricare,* which is the source of the word) and thus they are rarely "loaded" in the sense that, say, Daumier once fattened the King's face into a pear shape. But when Posada did approach caricature, he was depicting members of the upper classes (fig. 65). Here we see five of them standing in front of a rigidly symmetrical classical portico. The man at the left lifts his hat, apparently in salutation of the woman, but he is staring rather fixedly into it, as if he has seen a louse or a fly. The woman stares at him with a blank hauteur created by the lack of a mouth and the perfectly flat hat she wears. Her pose, with one hand on the hip and the chest thrown out, is airily stuffy, but she and her companion are far less caricatured than the other three figures in the print. The fellow in the center is impossibly skinny, with oversized feet and a handle-bar mustache that is almost as wide as his shoulders. His eyes are buggy, with huge pupils. The unfortunate next to him has the opposite ocular problem, as his eyes are blank. If the man in the middle is too thin, this one is too fat, and he exaggerates his own condition by putting hands on hips and pulling his coat back to reveal his loud striped pants. All of the men in the print wear buttoned collars in accord with European fashions of the day, but the man at the far right must have his shirts specially made, as his neck is long and cylindrical.

The print was made as the cover of a songbook called *Los Lagartijos,* a term which was in common use as a pejorative to describe the idle rich of Mexico City. Like the individuals who jeered Rodolfo Gaona in the bull ring, these characters generally enjoyed promenades along Plateros Street (now Madero Street), did their drinking at private clubs rather than bars, and lived from some hidden source of income. A joke that originated at this time tells of how one *lagartijo* was surprised to meet another drinking in a bar, and remarked on the fact. The first replied that his club had recently burned to the ground in a fire. Upon being asked why the fire department was not called, the first replied, "Of course we called them; but we couldn't let them in, because they were not dressed correctly." The term *lagartijo* is derived from the word for lizard, *lagarto,* and it refers to their alleged habit of sitting idle for hours at a time, like an iguana in the sun. Journalist Enrique Chávarri, writing under the telling pseudonym Juvenal, described lagartijos satirically in a newspaper column near the turn of the century:

All they do is sit in the sun. They have no knowledge of the struggle for exis-
tence. They get up at eleven or twelve o'clock. . . . Sometimes we may note

65. *The Fops.* Cover of a chapbook with white-line illustration by Posada, not dated. 4 1/2 in. x 2 1/2 in. Photograph © The Art Institute of Chicago. Anonymous gift. 1942.725

them sad or even withdrawn, and this is because their best friend's horse has taken sick, or because the tailor left a wrinkle in their new jacket, or their barber failed to stiffen their mustache enough.[4]

The dandified pettiness of this character resembles both Posada's figures in the print and the urban valiente, described in an earlier chapter.

An even stronger bit of social venom is loosed in both the print and the sheet titled *Repelito de Catrines* ("Hand-me-downs of the Dandies;" fig. 66). Here

REPELITO DE CATRINES
QUE LES GUSTA ENAMORAR
Y FIGURAN MIL JARDINES,
SIN HALLAR EN SUS CONFINES
NI UN CIGARRO QUE FUMAR

¡Vaya que me causa risa
Ese que me va siguiendo;
Ya parece que estoy viendo
Que no tiene ni camisa,
Pero eso sí, se va riendo!

Hay muchos de esos rotitos
Que no más andan vagando
Y también enamorando
A las de los piés bonitos;
¿Pero con pesetas?.... ¡cuando?

Los domingos van á misa,
Con alto cuello postizo,
Aunque de mugre cenizo,
Cantándole á Juana ó Luisa,
Ó á la que mejor le quiso.

Y van con guante y varita
Con el fondillo rasgado;
Eso sí, disimulado,
Pues lo cubre la levita
Que del empeño ha sacado.

Si siguen á una catrina
Y se le pega el dulcero,
Ahí es donde verlos quiero,
Pues no llevan su propina
En sus bolsillos de cuero.

—Escúche Ud., señorita,
Nos dicen saliendo al paso
Reciba usté esa esquelita,
Porque de fuego me abraso
Al mirarla tan bonita.

En estas sigue el dulcero
Al rotiro camelando
Cual si le fuera cobrando
Al estilo de usurero;
Y el roto va renegando,

—Hombre, yo dulces no quiero,
Si me impacientas te arranco
La lengua por altanero;
Yo traigo mucho dinero
Pero en billetes de Banco.

—Conque ande usted, señorita,
Reciba usted mi papel
E impóngase usted de él;
Ruego por su mamacita
Que no sea usted tan cruel.

—Vaya usted por su camino;
Contesta ella con rubor;
No me moleste señor,
Creo no tiene ni un comino
Y ya pretende mi amor.

66. *Hand-me-downs of the Dandies*. Broadsheet with white-line illustration by Posada, ca. 1890–1913. Half Sheet. Amon Carter Museum. 1978.136

the dandy is referred to not as a *lagartijo* but as a *catrín,* a similarly pejorative word that was first used by the popular novelist José Joaquín Fernández de Lizardi (1776–1827), who wrote the picaresque novel *Don Catrín de la Fachenda* under the pseudonym El Pensador Mexicano (The Mexican Thinker). The title character of the book might best be described as a flimflam man, a fop who believes that the world owes him a living, and who invents numerous schemes to obtain money without doing work. This is the source of the term that is used in this sheet, and its meaning is slightly different from the term *lagartijo.* While both types pretend to inhabit the upper strata of society, and adopt European manners and fashions, the major distinction between them lies in the relative lack of money possessed by the *catrín.* The lengthy text of the present broadsheet, in thirty five-line stanzas, describes in some detail the outfit of the boulevardiers of the day—top hat, frock coat, high button collar, imported shoes— but asserts that their clothing is always frayed and worn; hence the title of the poem. It further claims that the *catrines* wear shoes with holes in them, and that they frequently put their long overcoats in hock when they are a little short of cash. Moreover, when they go out to a restaurant with their friends, they always let someone else pay, and they even refuse to wear underwear, if the sheet is to be believed. Their lack of underclothing is only a metaphor for the wide gap between what they aspire to be and the reality of their allegedly shifty existence.

Posada's illustration places the scene of the class struggle in the location where much of it actually occurred, in the street. At that time, the principal way in which one could distinguish social classes was by dress, and frequently members of the lower orders who were even slightly "out of line" in public were reported to the authorities. These class tensions were evident in an incident described in *Los Bandidos Del Río Frío.* Before Evaristo became a bandit, he lived by attempting to sell his woodcarvings on the street. He was particularly proud of one piece, but he was having trouble selling it, and his money was getting low, and the day was nearing its end. When he attempted to show the piece to a passing aristocrat, he was probably a little more insistent than usual, because the man treated him with contempt, grabbing him by the lapel and hitting him with his umbrella. The aristocrat hauled Evaristo to the nearest police station, complaining to the magistrate on duty: " 'If these insolent lepers aren't punished severely,' the rich man said through clenched teeth, 'they will eat us all alive.' " Luckily the magistrate was a rare liberal, who held Evaristo only a few hours before letting him go.[5] The aristocrat in this scene was only acting on the common beliefs of much of Mexico's upper and middle classes about the alleged moral failings of the lower classes, a belief well documented in studies of crime.

Mexico's upper classes were scornful of the mixed blood and lack of moral character of those below them on the social scale, so the purpose of this sheet seems to be to return some of that acrimony. Posada places in stark opposition in the print two catrines and one laborer in a way that clearly favors the latter. The situation is rivalry for the attention of the woman who is seen on her balcony at the upper center of the picture; this was a principal way in which

women signaled availability. The catrines at the left lurk in the darkness. Probably they have discussed between themselves what they might do, but they have not taken any action beyond casting furtive glances around the corner. Their facial features are ridiculous, with exaggerated noses and thick lips. Their clothing is frayed at the edges, most noticeably in the knee and elbow of the figure at the center. Posada helpfully placed these body parts in the white section of the composition so that we can more easily make them out. Their gestures and attitudes are simian, in marked contrast to the hero figure at the right. He is larger, and is dressed in much more typical Mexican attire of the working classes: sombrero, serape over the shoulder, sash about the waist. He strides forward purposefully, looking directly at the woman on the balcony, who seems to return his gaze. He is obviously more socially self-assured than the poor dandies in the shadows, and he seems to be reaping his advantage in the attention of the woman. The splendidly smoked cigar refers directly to the headline of the sheet, which points out that the catrines want to flirt, but they don't have even a cigar. The "moral" of this sheet comes at the end of the poem, in the form of advice addressed to women:

> To all you women of honor
> If you want to have a good end
> Don't believe the dandy or *catrín*
> Who send you verses well penned
> Even if they seem like seraphim.

The principal point of attack in this sheet, the gap between Europeanized appearance and aspiration on the one side and a hollow reality on the other, was also underlined by post-revolutionary observers who recalled life in Mexico City at this time. They noticed an aura of unreality in the attempt by the upper classes to appropriate foreign manners and customs. José Vasconcelos, for example, remembering the years of his university studies in the capital, wrote that the darkness and moral confusion of Dostoyevsky's novel *Crime and Punishment* seemed much more adequate to describe Mexico's social situation than the Darwinist fulminations and reformist zeal of the Comtian positivists and French novelists:

> The environment in the poor neighborhoods, the odor of despotism, the complacency of the authorities in the face of all manner of exploitable vices, the maltreatment of "fallen" women, the emotional turbulence in all our souls: this was all so perfectly Dostoyevskian that it was no wonder that the Russian's books moved us so much. And nobody, after reading him, bothered to remember neither Zola nor Daudet nor Anatole France.

Later, he energetically attacked the seeming amorality of the city's upper classes, saying in English that their credo was "Try to make money honestly, but if you can't, then make money." He further pointed out in a highly

ironic voice that this belief was imported directly from "the northern super-civilization of the apt and genetically select, the biological aristocracy proclaimed by the Darwinists, the last word in scientific knowledge. . . . It was said of our capital city that it was a little Paris, but this was only because we copied its vices."[6]

Another writer in the 1940s plainly pointed out an air of unreality in the official culture of the Díaz period: "Mexico City had, in the rhythms of Porfirian society, a great degree of artificiality, similar to the impression that at times a doll house can give." It was true, he said, that near the turn of the century much of the world lived for pleasures, but in the Mexican capital these characteristics were "magnified:" "The laziness of our upper classes, along with the alleged laziness of the lower ones, seriously affected public morality, to say nothing of the economy and the culture."[7]

The well-known broadsheet *El Mosquito Americano* (fig. 67) seems to directly attack foreign influence in the country. In the illustration, persons of various social classes and ages are fleeing persecution by a swarm of large insects above their heads. Each moves away from the center of the composition, and each forms a diagonal with torso or scurrying legs. As in many other white-line prints by Posada, space is created by overlapping of figures rather than perspective lines. The well-dressed gentleman in the center overlaps all the others, his hat occupying a void in the center of the plate. If everyone in the composition continued moving, the scene would soon be empty except for the mosquitoes; this may imply that they are about to take over.

The text, in twelve ten-line stanzas, purports to be a recounting of verbal reports from several parts of the country telling of the damage inflicted by these "American" pests. Since the pest is reported as entering the country from Laredo, Texas, there can be no doubt that the "Americano" in the title refers not to "The Americas" but to the United States. Like the print, the text presents most of the social classes as victimized: In Guanajuato, the pest bit a soldier in the behind; in San Juan de los Lagos, a swarm trapped a surgeon and a doctor in a doorway; the pest ate the ears and tail off of burro in Aguascalientes, according to the *campesino* who owned the animal. At the conclusion, the mosquito has not reached Veracruz yet, but is attacking the capital city, where it first bit a newsboy before invading all of the major outdoor market places.

While one cannot say with certainty exactly what this American plague is, probably because a more direct attack would run the risk of retribution from the authorities, it seems clear that the American Mosquito amounts to the American capital, expertise, and customs which the Díaz regime and the upper classes welcomed into the country. Americans were heavily represented in rail-road, mining, and utility companies, among others, and their activity could be likened to a spreading swarm as it penetrated most of Mexico in search of economic opportunity. The bite of a mosquito also seems a worthy analogy for such activity, as it tends to rearrange the landscape and extract "blood" from it in the form of money or natural wealth.

EL MOSQUITO AMERICANO

 El Mosquito Americano
Ahora acaba de llegar;
Dicen se vino á pasear
A este suelo mexicano.

Dizque el domingo embarcó
Allá en Laredo de Texas,
Y que al Saltillo llegó
Picándoles las orejas,
En la Estación á unas viejas
Que bien las hizo marchar,
Hasta las hizo sudar
Este animal inhumano;
Luego empiezan á gritar:
El Mosquito americano.

A Guanajuato marchó,
Esto es cosa de reir;
Él al centro no llegó,
Pero si estuvo en Marfil.
Ya no podrán sufrir
Tan malcriado y altanero,
Pues le picó en el trasero
A un militar veterano,
Porque es mucho, muy grosero
El Mosquito americano.

Tomó el rumbo de Irapuato
Y por Pénjamo pasó;
De allí luego regresó
Por el pueblo de Uriangato,
La hacienda de Villachato
La dejó muy derrotada;
Toda la gente asustada
La encontró el vale Mariano,
Nana Emeteria gritaba:
El Mosquito americano.

Por la puerta de San Juan
Piedra Gorda y la Sandía,
Una viejecita decía:
¡Jesús, qué fiero animal!
Dígame usted Don Pascual
¿No le ha llegado el Mosquito?
Dicen que es muy chiquitite,
Y también muy inhumaho;
¿Qué dice tata Pachito
El Mosquito americano?

José Vasconcelos would have agreed with the claims of this sheet, and in his autobiography he noted with some specificity the deleterious effects of American-style capitalism in sugar and fruit plantations in the area of the Isthmus of Tehuantepec. When he made a trip to that region to organize resistance to Díaz, he saw two radically different styles of capitalism at work. The Spanish-owned companies used relatively simple means of production and harvest, and had little overhead, using methods that he described as "primitive, but proven." The Americans, on the other hand, "installed enormous machines which required office help, experts, and chiefs, all with their respective cars. The new Yankee colonists looked with scorn on their Spanish counterparts, who continued to mill their sugar harvests in the old ways." He noted that under the impulse of the foreign capital, vast new tracts were brought under cultivation, making new orchards and sugar fields spread toward the horizon. The houses the Americans built for visiting investors contained showers, electric refrigerators, and even mosquito nets. Yet, after about four years, said Vasconcelos, "came the crisis. The huge administrative expenses tried the patience of the American investors, and soon the sources of new capital dried up; work was suspended and the properties had to be auctioned off. At that point the Spaniard, who generally had money in the bank, presented himself to buy." Vasconcelos took this to mean that the "northern races" were not necessarily the most apt for business ventures, and concluded that it was not lack of competence that kept Mexico from developing, but "repeated betrayals by politicians" who welcomed foreigners too indiscriminately.[8] His own vision for the Americas was an amalgamation of Native and Spanish ways, giving rise by Hegelian synthesis to a new race.

Vasconcelos never used analogies to describe this invasion of American ways and capital, but Federico Gamboa did in his novel *Reconquista*. The protagonist, artist Salvador Arteaga, laments near the end of the story in a lengthy soliloquy:

> the Yankee invasion; slow, heartless, corrupting; today one zone, tomorrow another, and another, and finally, everywhere! More than an invasion, we should call it a flood, which gradually rises higher and higher because nobody, I mean nobody—this is the sad part—dares to resist it.

For Gamboa the problem lay in the hardheaded practicality and lack of tradition which Americans flaunted as virtues. This invasion, he says, is in some ways more dangerous than the original Spanish one, because at least the Spanish colonists came as conquerors in open warfare. The present flood is insidious because its effects are harder to discern. He lamented with deep irony:

> So we open the way for it; we dig canals so it can froth and flow, even though it floods our humble ancient seeds, though it drowns and ruins our ancestral heritage, though it undermines and inundates the walls of our poor sun-dried houses.[9]

To be sure, the broadsheet *El Mosquito Americano* lacks both the focus and the passion of these two thinkers. It presents the Yankee invasion as all metaphor and no fact, all fun and no direct social critique. The emotion of shock and surprise provoked by the alleged invasion is not converted into the moral denunciation and high rhetoric of Vasconcelos and Gamboa; the sheet betrays no concern for any wider cause such as spiritual decline, conservation of tradition, or even efficiency. But then these utterances come from persons of higher class standing in both cases. Vasconcelos wrote years after the fact, and Gamboa, though he wrote the novel in 1903, was already a leading literary figure at that time. His passions could be considered pardonable patriotism. The sheet speaks from a position apart from both the regime's supporters and its detractors. It takes as standing room whatever narrow ledge it is given by the power structure, and in Díaz's Mexico that ledge included permission to use humor on occasion. It is easy to imagine Vanegas Arroyo thinking of this sheet when he reportedly told General Díaz, "From time to time one has to let the people have some fun." So the sense of shock and surprise in the face of the alleged Yankee invasion is converted into a rather outrageous nursery rhyme:

> When the mosquito finally got
> To the great City of León
> The hand it bit and caught
> Of the daughter of Don Simeón.
>
> And it also ate quite a jot
> Of an old lady, all alone;
> Her ear, they say, is almost gone . . .
> "My! He's a tyrant one can't veto!"
> Said a one-eyed crone
> Of this American Mosquito.

If we consider other ways in which broadsheets elevated what was generally Mexican and traditional and popular against what was foreign and positivist and from the authorities, we see that this sheet takes its place alongside the evocations of rural bandits and valientes over police forces, Belén over the Penitentiary, Ponciano over Mazzantini. In the present sheet, however, the punches are pulled because the subject was so dear to the heart of the Díaz administration.

Posada and Vanegas Arroyo felt freer to satirize the Francophile fad of bicycle riding, which was growing quickly in Mexico City over the years surrounding the turn of the century. The cult of bicycle riding was heavily promoted among Mexico City's Europeanized upper classes for reasons of both health and practicality. A woman wrote to Amado Nervo in 1895 about the trend:

> Who, these days, does not ride a bicycle? . . . Even Europe's most responsible
> and serious-minded men: senators, judges, generals, all love this sport, because

it has all the advantages of calisthenics with none of the attendant difficulties; it is much more economical than horseback riding, less demanding than fencing, and it gives both coordination and agility.[10]

Four years later, there were over four thousand bicycles registered with the authorities in the capital, and several clubs devoted to social activities attending bicycle trips. Nervo confessed that he loved bicycling, and with only slight poetic exaggeration he wrote:

> Given a wide road, open horizon, lots of sky, plenty of air, one possesses the whirlwind, and a feeling of pleasure that is exceptional. . . . Strengthening and fortifying, cycling will recreate in us the curvaceous beauties of the ancient Olympic champions, and promote among us a rebirth of athleticism.[11]

The broadsheet called *La Bicicleta* gives a good indication of the response of Posada and Vanegas Arroyo (fig. 68). A member of the urban lower classes has commandeered a bicycle and is causing havoc in the streets, chasing away some people and knocking down others. As in many crime sheets, Posada has arranged the motion here from left to right, though the diagonals are not as pronounced as in other prints that depict similar vigorous motion. A man giving a gesture of surprise anchors the composition at the left. The text refers to a newsboy using a bicycle to make his rounds, and also to recreational use of the machine for outdoor promenades. The fourth stanza, though, expresses what must have been the crux of the lower-class response to the vogue:

> It's crucial, my friends
> That we all set to fasting;
> And into the bank
> Our money start casting,
> To buy a nice horse
> For the times we'll be passing.

If the sheets were unenthusiastic about bicycling, they were equally doubtful about the new electric trolley system. However, because of the official civic pride about this form of transportation, suspicions expressed in the sheets were quite muted, and can be seen much more in Posada's illustrations than in the accompanying texts. Like the Penitentiary, the electric railway was widely regarded among the upper classes as a sign of progress for Mexico and for the capital city. Moreover, it also signified closer linkage with foreigners, as the system was funded chiefly with British money. The London firm of Wernher and Bait, who also owned the capital's horse-drawn municipal carriages, applied for permission in 1897 to install electric cars on their tracks. The government negotiated a charter which granted to the company rights to the system for ninety-nine years, and work installing overhead electric lines began. The inauguration, which took place on 15 January 1900, was a civic celebration. President Díaz was

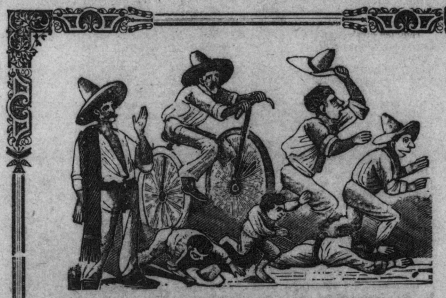

LA BICICLETA.

¡Alerta, alerta, manario! | *Como tren extraordinario,*
Haz un lado la maleta, | *Subiéndose á la banqueta*
Que hay viene la Bicicleta | *Como se sube al calvario.*

Hay te va la Bicicleta,
Todos dicen por la calle
A andar como en carretela,
Vamos á hacer un ensaye.
Aunque me rompa una pierna;
Un papelero que es poeta,
Conquistó mi corazón.
Montado en su Bicicleta,
Salió de la Redacción
Dando vueltas cual ruleta.

Como es la moda del día,
Todos estamos entrando
Y nos andamos paseando
Con gusto y con alegría.
Ya el coche de fantasía
También perdió los papeles,
Porque ya hasta las mujeres
Corren á la descubierta,
Gozando de sus placeres
Montadas en Bicicleta.

Corre más que un andarín
Por donde quiera que va,
Y á cada paso que da
Toda la gente lo mira.
Que por donde quiera gira;
Vámonos á dar la vuelta,
A bañarnos á la Alberca,
Yo el consejo les daré:
Si no quieren ir á pié:
Compren una Bicicleta.

Es muy preciso, señores,
Que vayamos ayunando,
Y que vayamos juntando
Y á comprar nuevo caballo.
Para correr como rayo
Y salir á dar la vuelta,
Solo buscando la puerta
Con gusto en el corazón,
Yendo á cualquiera función
Montados en Bicicleta.

represented by his Foreign Minister along with the Minister of Communications. The governor of the Federal District was in attendance, along with municipal officials and company executives. These dignitaries piled into the lead car to take the first ride. The following Sunday, Amado Nervo raved in a newspaper column: "The trolleys are beautiful to look at; it is marvelous to see the docility of the invisible colossus that powers them, which shows itself only with sparks and crackles, as the charge passes softly like a tightrope walker through the wispy cord. . . . It transports the cars with all the tenderness and suavity of a mother carrying a baby in its arms."[12]

The broadsheet issued near the time of the inauguration presents a decidedly mixed viewpoint on the innovation (fig. 69). The text generally supports the atmosphere of festivity:

At last we have the trolleys
That run electrically, yes, sire!
This, we know, has never been seen;
Now they're here for us all to admire.

It alleges that Díaz himself was present at the ceremonies (this cannot be independently confirmed), describes the course of the first trolley line, mentions the photographers that recorded the day for posterity, and alleged that everyone present was "filled with enthusiasm." But Posada's illustration gave voice to several doubts about the system that were apparently harbored by the urban lower classes. For example, since the cars had no obvious power source, and ran almost silently, many in the city refused to ride them because they believed that they were powered by dark forces, if not by the devil himself. The illustration alludes to these powers by making visible the energy in the form of lightning bolts that radiate from the roof of the car. When the trains traveled the streets at night, sparks were frequently visible where the trolley contacted the overhead wire. The resemblance of these sparks to lightning, also popularly thought to be satanic in origin, was enough to cement the belief. President Díaz acknowledged these fears by signing a law shortly before the inauguration that prohibited the new trolleys from carrying funeral processions or coffins: "There was no lack of persons who would have considered it impious for cadavers of Christians to be carried off to their final rest pulled along by an occult force. . . . They were pulled by the devil, according to popular belief."[13] In addition, there was the matter of danger to pedestrians. The trains were subject to power surges at unexpected times because of variability in line voltage, and when one of these surges reached a car, it would suddenly speed up, again without warning and without making a sound.[14] One author estimated that in their first year of operation, the trains injured or ran over no less than one thousand persons.[15] Such capricious performance would only support grave suspicions of the conveyances, and Posada acknowledged this phenomenon as well by picturing the car running over three pedestrians and chasing a fourth.

69. *The Electric Trolley Cars*. Broadsheet with black-line illustration by Posada, 1900. Half Sheet. Fondo Editorial de la Plástica Mexicana.

70. *The Great Electric Skeleton*. Broadsheet with black-line illustration by Posada, 1903. Half Sheet. Instituto Cultural de Aguascalientes, Mexico.

Such traditional beliefs lost out, however, because in 1903 the law was repealed, and a new trolley line was planned to pass the city's largest cemetery, Dolores, which also contained paupers' graves. In November of that year, in honor of the Day of the Dead, a new sheet was issued which takes extremely ironic note of this new way of going to the cemetery (fig. 70). The poetic text points out that now all of the spirits of the dead will be brought to life through electricity, including the lagartijos from Plateros Street and the famous bandit of the early 1880s, Chucho el Roto. Normally, graveside ceremonies for the Day of the Dead are rather solemn, but with the benefit of electricity, visitors will arrive to find the place jumping with life, and the spirits full of fun. The party at the cemetery will be lit by electric lights, the musicians will play electric

Gran Calavera Eléctrica
—QUE SE LES VA A REGALAR—
CALAVERA MUY FACHOSA DE PURA ELECTRICIDAD.

El primero de Noviembre,
Como diablos correrán

Los eléctricos vagones
Que á Dolores llegarán.

instruments, and the pulque will be stronger so that everyone will get drunk. The police will then come and haul everyone off to jail in the new electric cars. In the illustration, an electric car bearing skeletons has entered the cemetery where other skulls and skeletons are preparing to celebrate. This political defeat for traditional beliefs in the face of modernization is thus "laughed off."

Some of the most pointed cultural satire in the broadsheets, however, was directed neither at the governing classes nor their modernizing ideas. Rather, the most consistent and pointed ridicule in the sheets is directed at urban middle class persons of the sort that we might consider "white collar:" office workers, lawyers, middle government officials, accountants, and the like. The evidence of the broadsheets suggests that they were regarded as a complete mystery by the members of the urban proletariat. Their ways and fashions are presented in uniformly ridiculous ways, and they are never made to look good or effective. More specifically, at various times they are shown to be socially clumsy or inferior to persons whose culture was more rooted in "traditional" Mexico. If members of the white collar middle classes make their living by navigating the system in some way, this is seen in the sheets as a distasteful or useless trait.

An example of this is provided in the Vanegas Arroyo chapbook called "A Lawyer's Disappointments" ("Los Chascos de un Licenciado").[16] In the form of a short dramatic skit, the piece portrays the lawyer, who is never named, as practically insane. He tells his assistant at one point to bring him a cup of hot chocolate; when it is brought, he tells the assistant to drink it, and later he gets angry at him for doing so. When the assistant pulls the lawyer's chair back in

response to another request, this too is met with insults and abuse. He also orders the assistant Nicomedia (the only character who is named in the play) to get a stick and beat him with it. At one point the lawyer soliloquizes on his cruel fate in a way that exemplifies the seeming air of unreality and precariousness that surrounded middle-class work, at least in the eyes of those lower on the social ladder who worked with their hands and bodies:

Oh, what terrible luck! In the six years that I have spent practicing law, I haven't been able to win a single case. The scorn and bad faith of my associates has ruined my practice. Dark Fortune! If I had only been an honorable artisan, earning my living with the sweat of my brow!

As if that were not enough, he also laments his failure to attract women, who only, he says, "make fun of him." This would also be a serious failing among the Mexican urban lower classes, whose sense of male identity and power over women was strong.

The principal action in the chapbook comes when he gets a mysterious letter from a woman who claims to possess "beauty and no lack of money" professes to love him from afar. The missive is a request for an interview, with the condition that it be completely private. The attorney becomes agitated at this, plunging into some of the irrational behavior noted above. A police captain enters the office, and the lawyer thinks that he is the woman. He says to the officer in a sweet voice, "So late, my angel?" At this point the woman, who has been hiding behind a couch, reveals herself and says in a loud voice, "You have not met the conditions that I set out in the letter; you have lost your chance." She runs out the door, and the attorney tackles the policeman and tells Nicomedia to get the stick and beat the both of them with it.

Posada's most consistent ridicule of middle class persons comes in the series of prints devoted to the fictional character Don Chepito Mariguano Charrasca y Rascarrabias. This comic figure, the butt of rather rough humor in about a dozen prints, was created by Posada, and he and Vanegas Arroyo used it to attack several characteristics of the urban culture of the time. Don Chepito's ethnicity is unclear, but he does not look like a *gachupín;* rather, he could be a descendent of immigrants or even a Europeanized mestizo. He almost never appears in the upper-class attire of long coat and top hat; most often he wears the jacket, vest, and high collar of the more bourgeois types noted above. His name is a satire on the custom of using long names to show family pedigree; in his case that lineage is of a highly dubious nature, and indicates that he is an *arriviste,* someone who formerly occupied the lower rungs. "Don" is a mild honorific which could be applied, depending on the situation, to almost anyone who is not on the lowest social rank. Sometimes, for example, older men are referred to as *Don* no matter what their economic status. The term is not as elevating as the knightly Sir, but it is the closest thing in Spanish to that title. "Chepito" is a diminutive Chepe, a derivative of Pepe, which in turn is a nick-

name for José (Joseph). It is a very casual usage, indicating the utmost familiarity, and it was often used as a child's nickname. President Díaz's father was called Chepe, but that may not be relevant here, because he died well before his son took office. No matter whom it may refer to, the casualness of Chepito clashes in a mildly ridiculous way with the elevating Don.

"Mariguano" has a more complex set of meanings. It refers to the drug, of course, but in its masculine form, with the *O* at the end, the word means a habitual smoker of marijuana, or even someone who is actually intoxicated. According to available evidence, the drug was available at the Volador open-air vegetable market, and at times it was smoked mixed with tobacco.[17] Among the Mexican urban working classes, a marijuana smoker would be generally regarded as someone who had been brought very low. To smoke marijuana was most often regarded as a rather desperate act, done primarily by persons who had little left to lose in life. One opposition journalist reported that the drug was regularly used as payment for sodomy in jail at Belén.[18] A 1939 poem about life in the Porfiriato, for example, told the story of one Jesús, a migrant rural laborer who lost job after job until he finally joined the army. He was soon provoked into a fight which led to his expulsion, and then he became, in the author's words, a "mariguano." This led him to shun human company, including that of his beloved:

> Jesús has no use for parties;
> That bustle he held in reserve
> In order to enjoy, all by himself,
> The pleasures of The Herb.[19]

The story about the pot smoker in Belén who went on the killing rampage (see fig. 15) is another example of some of the aversion felt toward use of the drug. Among the lower classes, pulque was by far preferred, but these classes were not the only ones to indulge in pot smoking on occasion. According to more fragmentary evidence, the drug was also used by a few leisure class persons in the Díaz period who may have taken their readings of certain French poets a little too seriously. One folklorist reported that it was smoked by persons from the "better classes" who wanted to escape from life, and may have preferred, along with Charles Baudelaire, the monsters of their imagination to the triteness of actuality.[20] Don Chepito's name may also allude to this type of person, though it is difficult to say if most lower-class Mexicans of the time would have grasped the reference. In any case, when he appears in broadsheets, Don Chepito almost always has the enlarged eyes which allegedly indicate a *mariguano*.

His other two names, which are not always used in the sheets, refer most clearly to his lower-class provenance. "Charrasca" is a knife, but more specifically it is a blade carried as a concealed weapon by a poor person. "Rascarrabias" is a nearly untranslatable compound that refers to a person

of a foul temper who gets upset easily. Hence, if we string the names together, the result is something like Sir Joey Pothead Switchblade Sourpussed; hardly a candidate for admiration in any social class.

The ancestry of Sir Joey is probably traceable to Honoré Daumier's figure called Robert Macaire, another modern urbanite figure created by a printmaker to satirize certain current customs. He was a businessman who got involved in ventures of various kinds; in fact, Macaire did practically anything to make money. Medicine, architecture, matchmaking, dentistry, and even hypnotism, are only a few of the careers Macaire attempted in his never-ending quest to fleece the public. His guiding philosophy, according to a Daumier scholar, was simple: "a blend of Vanderbilt's famous 'The public be damned' and W. C. Fields's 'Never give a sucker an even break.' Take what you can get by any means you need—but take it."[21] Macaire was a vehicle for lampooning the rising business classes in Paris. He was invented in part because of the September Laws, which made it a crime to criticize government officials directly. Daumier's series was highly popular, and went through three editions in Paris before being pirated in Belgium. The first edition of Daumier's series to be published in Mexico was released in 1860, and it was from this that Posada probably knew him.[22] In comparison, Don Chepito is a more well-rounded figure. He is seen in many more different guises and situations than Macaire, such as civic functions and recreational activities. Moreover, the audience for Don Chepito was quite different. If through Robert Macaire the French middle classes of the 1830s and 1840s were laughing, in part, at themselves, Don Chepito exists to parody somebody else, a member of social class that was

71. *The Great Disappointment that Hit Don Chepito Mariguana.* Broadsheet with black-line illustration by Posada (right) and white-line illustration by Manuel Manilla (left), not dated. Tinker Collection, Ransom Research Center, University of Texas at Austin.

72. Back of the sheet illustrated in Figure 71. Black-line illustrations by Posada.

much higher than the buyers of the sheets themselves. Don Chepito was not the first such generic vehicle of satire that Posada created; in the early 1890s, while he was still working for the publishing house of Ireneo Paz, he added to the popular *Almanaque del Padre Cobos* the figure of Doña Caralampia Mondongo (Lady Lanternface Potbelly), a portly, fanged matron whose inscrutable but self-satisfied gaze often livened the back cover of the almanac.[23]

In these prints, Don Chepito appears most often in some kind of conspicuously inept way. For example, Posada etched three plates for a broadsheet story about Don Chepito's attempt to have an affair with a married woman (figs. 71 and 72). The poetic text relates a story that is similar in some respects to the traditional "lament of the criminal," who regrets his actions and proceeds to warn others not to follow the same path:

> Because I loved a housewife
> I'm locked up paying penance;
> I pray to God to give me
> Strength to endure my sentence.

The narrator tells the story of professing love for a woman and being invited to her home for dinner, only to find that the husband arrives and gives him a thrashing before calling the police. In the illustration below the heading, which is actually the second in sequence, we see the wife happily embracing her husband, seemingly delighted to be rid of the interloper. Don Chepito sits on the floor, with rumpled clothing and a quizzical expression on his face. The plate is

in bad condition, with cracks and a section missing at the upper right. The second plate represents the earliest moment of the story, as Don Chepito, hat in hand and bowing inelegantly, presents the woman with a bunch of flowers. She looks coquettishly over her shoulder, while her husband prepares to hit him. The scene as pictured does not exist in the poem; the text has it that she led him on, saying that her husband was away. The final plate, which depicts the police leading Don Chepito off, also has inconsistencies with the text. In the poem, the narrator says that he is being sent to "El Castillo," or the prison of San Juan de Ulúa in Veracruz. There is an allusion to that in the boats that bob on the horizon at the right in the frame. But the woman and her husband are also there at the dockside, a highly unlikely scenario. (San Juan de Ulúa would also be a most implausible destination for such a slight crime, but here it only poetically highlights the forlornness of the narrator.) Don Chepito accepts his fate only with complaints, as he gestures and remonstrates with the policeman.

As it stands, the poem could be narrated by almost any man; it uses only pronouns to refer to the characters, and there is no mention of the economic or social status of any of them. Posada's illustrations thus greatly alter the tenor of the fable, making it a scene in the social struggle of Mexican and foreign ways. Don Chepito, the Europeanized bourgeois, is seen in every frame as weak, ungraceful, or complaining. His rival is dressed in much more typical Mexican attire, with sombrero, waistcoat, vest, and short tie. Moreover, he strongly and robustly defends his rights, claiming a clear victory over the more "modern" figure of Chepito. Of the three characters, the woman is the most duplicitous, having led on the suitor and then expressing relief at having been rescued from him, and this is not atypical of these sheets, which often depict women as temptresses.

The cultural ironies of this story are many, and Posada's illustrations are responsible for the presence of most of them. The middle classes, who adopted European dress and pastimes, took on office work for foreign-owned companies, and sometimes adopted European names, had reason to hope that this would result in their social advancement, since that was the path that the country's leaders had chosen for Mexico's "progress." Novelist José López Portillo y Rojas also memorably described and condemned such arrivistes. On one occasion, describing the spectators at a tennis match just prior to the Madero presidency—tennis, of course, being also an importation—he ran down a list of such characters, and expressed impatience with their dissimulation of their true roots. Here their adoption of English nicknames seems especially galling:

Coming with her were Netty, Lilly, Raoul, and Thomas, our old friends, various other young women, and a half dozen fops of the most delicate sort, who had been subtly passed through the alembic of our new urban aristocracy, such as Jack (who should be called *Jacobito,* which comes from Jacques, but which actually means *Juanito* in English), Dick (*Ricardito*), Ellick (*Alejandrito*), Hal (*Enriquito*), Peg (*Margarita*), Lulu (*Luisita*), and Patty (*Martita*); all of them Mexicans, and some of them even half Indian; but, having crossed over the

73. *Don Chepito the Bullfighter.* Restrike of a white-line plate by Posada, not dated. Fondo Editorial de la Plástica Mexicana.

United States or England like migrating birds, had adopted these absurd and extravagant names in order to seem foreign. . . . They did this in order to get more attention and stature in the eyes of those above them, who were also frivolous, brainless, and idolatrous toward anything imported or exotic.[24]

Adopting such foreign ways was supposed to help one to rise on the social scale and earn a place in the new system, but Posada's illustrations here do not address that issue with the same directness as the novelist, who was writing with hindsight just after the fall of Díaz. Posada's attack is on the cultural front, saying that even though the dandies may occupy the offices, the true Mexican cannot let certain domestic barriers be crossed. The Mexican figure in the plates may pay a social price for his maintenance of some traditional ways, but at home or on the street he will yield to no one.

The consequence of this strategy of critique is that there is no direct challenge to the social or political role of the Europeanized bourgeoisie. The Don Chepito prints basically leave him ensconced in his social place, while making fun of his personal or cultural ineptitudes. This makes the cultural battle in the prints a rear guard kind of action, but that was what the authorities and the publisher allowed.

Don Chepito is unlucky in love and at the bullfight, as shown in a print that has been widely reproduced (fig. 73). The huge bull charges vigorously from the right, hooking Don Chepito's shirt and raising him off the ground as it tramples his hat and umbrella. It is not uncommon for bulls to toss matadors, hitting the torero's body with their foreheads so that the horns do not reach flesh, and throwing the victim without otherwise injuring him; that seems to be what has happened here. The expression on Don Chepito's face betrays shock and anger; his swollen eyes and dilated pupils show, in addition, his reputed

"DON CHEPITO MARIHUANO"

74. *Don Chepito the Pothead.* Restrike of a white-line plate by Posada, not dated. Dimensions unknown. Instituto Cultural de Aguascalientes, Mexico.

75. *Corrido on Don Chepito the Pothead.* Restrike of a white-line plate by Posada, not dated. Dimensions unknown. Instituto Cultural de Aguascalientes, Mexico.

Corrido "DON CHEPITO MARIHUANO"

marijuana habit. Obviously Don Chepito is not a professional matador, but has rather jumped from the crowd into the ring to work the bull as an *espontáneo,* a phenomenon that happens relatively rarely and is in some jurisdictions a criminal act. Overcome by the enthusiasm of the moment and using his umbrella as a cape, he probably hoped to impress the public, the goal of most other *espontáneos* who may wish to become professional matadors themselves.

The effect of this man-bull encounter has been carefully calibrated. Don Chepito is not actually injured, as can be seen from the horns on either side of his torso. One could also reasonably expect that once this tossing happened, the professionals in the ring would quickly move to divert the bull's attention away from the fallen man. To show Don Chepito actually injured would not be appropriate from a political point of view, because that might arouse sympathy in viewers for this middle class character. Rather, the story seems to fall into place in this way: Don Chepito, unable to control his enthusiasm for some performance he witnessed in the bull ring, and emboldened by smoking marijuana, jumped in and attempted to cape the bull himself, but was quickly given his comeuppance and had to be rescued by the real toreros present. He thus merits derisive laughter for his lack of self-control and his ineptitude at a craft best left to persons who have the courage and grace under pressure to carry it off successfully.

The print of Don Chepito as bullfighter survived without a text, a factor it unfortunately shares with the majority of Don Chepito prints. Comparing the dates of other works by Posada for which text is unknown suggests that these Chepito works were made before the turn of the century. Such a date rings true for the print of Don Chepito and his bicycle, for which a date prior to 1900 would coincide with the peak of the fad (fig. 74). Here we see the hero in the foreground, standing awkwardly next to his cycle. His middle-class accoutrements are obvious here, especially his leather briefcase. We also see very clearly the bulging eyes of the alleged pot smoker. His ungainly posture contrasts markedly with that of the much more relaxed urban peasants in the background, who wear clothing typical of the lower classes.

Don Chepito wears the same clothing in the print that depicts him at a boxing match (fig. 75). Here we see him applauding wildly at an interracial bout while the rest of the crowd expresses shock. As William Beezley has shown, this print probably refers to a famous exhibition match that took place in the bullring of the city of Pachuca, a short train ride north of the capital, on 24 November 1895. The two pugilists were Billy Smith, the heavyweight champion of Texas, and Billy Clarke, the champion of Central America. Boxing was in its infancy in Mexico in those years, and was promoted chiefly by foreigners, in this case the American James Carroll, who also owned the Mexican National Athletic Club. Carroll hired a train to take some five hundred spectators from Mexico City to the venue of the fight, which Smith won by knockout.

Since the sport was a foreign importation, Posada pictures Don Chepito reacting in a manner completely different from that of his fellow spectators, who are all dressed in more typical Mexican attire. Don Chepito, wearing white to further set him apart, drapes a leg over the rail and applauds wildly, apparently in an effort to show that he appreciates this new fad from north of the border. The expressions of shock by the other spectators are most likely a response to the seeming barbarism of the match itself, rather than its interracial aspect. The sport gained relatively few adherents during the Díaz period, but, as Beezley said, "During the Porfirian years it demonstrated only the influence

of foreigners, the imitative quality of the Mexican elite, and the desire for excitement in a comfortable, secure society.[25]

A datable sheet from a few years later contains more pointed critiques of government officials, but is subject to varying readings (fig. 76). The sheet deals with the creation in 1902 of Army Reserve units in the capital under the command of General Bernardo Reyes. In January of that year, they paraded before an audience of about six thousand persons from the capital who came out to see their friends and relatives. The front of the sheet depicts clearly the crowd, the paraders, and the official reviewing stand, and the accompanying laudatory text hails the patriotism and good order of the event:

When the enthusiastic crowd
Cheered the soldiers' marching feet,
A very ardent joy
In their hearts would beat.
There is no higher honor
Than that of the military man;
And he who defends his country
Will revere it all he can.

The back of the sheet contains a highly satirical account of Don Chepito's response to the swelling emotions of the event. Apparently he also attended the parade, and later, he spontaneously delivered—from the back of his horse in the neighborhood of Lecumberri (which is near the Penitentiary), in a voice

76. *The Unequaled Lecture by the Playful Don Chepe About Our Country's Army Reservists.* Broadsheet with blackline illustration by Posada, 1902. Half Sheet. Tinker Collection, Ransom Research Center, University of Texas at Austin.

described as "boozed up" (*aguardentosa*)—an address to the crowd in the following manner: "Citizens! I come only with the aim of awakening in you and rekindling in your jugged souls the most highly sacred flame of the most highly ardent patriotism. May my chemical gestures, full of horizontal eloquence, serve as a bellows to inflame your pure oven of marvelous headswelling for your saintly Mother, which is your Country." The discourse is difficult to translate, as it contains locutions which have no real counterpart in English. For example, when Don Chepito says that his only aim is to awaken patriotism, the word for "only" is a special one that refers to God's "only" son, Jesus. He continued: "I, proletarian, tributarian, consuetudinarian, originary and proprietary, am most thoroughly inflamed by the icy valor shown in the battle against the Mayan Boers; hence our Great and Noble Reservists." He is referring here to some famous military engagements that took place two years previous in Yucatan in which soldiers from the 28th Battalion inflicted a defeat in armed battle against a group of rebellious indigens. This incident had been the subject of a broadsheet which praised the action of the soldiers.[26] Don Chepito then mentions his own heroic bravery: "I have always been a brave military man myself, and such a hero that I have defeated valiant battalions of bugs, fleas, and lice on the field of my bed. Citizens! Long live the homeland of Periquillo Sarnoso!" This last is a reference to *Periquillo Sarniento,* the serial novel by Joaquín Fernández de Lizardi which was widely used in schools to teach reading and deportment; it was probably as well known was McGuffey's Readers were in the United States. Chepito botches the title so that the name Sarniento becomes an adjective meaning "rude" or "mangy." Clearly, no one who loved Mexico as much as he claimed that he did would make such a mistake. The discourse concludes with more *Viva!*s for Mexico, the Reservists, and, finally, for Don Chepito Mariguano Charrasca y Rascarrabias.

The text says that he then patiently waited for the applause of the crowd, but was rewarded instead with pelting stones. This is what Posada pictures in the small print that accompanies the text. His gesture resembles the oratorical flourishes of Roman emperors etched in marble; this was apparently the concluding phrase of his elocution. But the stones that are already flying from the crowd visible in the background decisively negate any dignity or nobility of this equestrian moment. According to the text, Don Chepito was hauled off by police for his own protection.

This rather obvious satire on speeches by dignitaries at official occasions could function in two ways, depending on the attitude of the audience. If readers were kindly disposed to those in authority, they might identify with the rock-throwing mob, which rejected Chepito as an interloper who spoiled with his drunken perorations the good feelings aroused by the Reservists' parade. Or, if the reader were fed up with the seemingly constant happy talk by their leaders and their insistence on Mexican "progress," then Don Chepito becomes the focus of attention as he banters on in the style of a dignitary, using big words that have no real meaning. In either case, however, Don Chepito is the obvious target; the urbanized middle class is the butt of the humor.


```
ringa
mo!
menzó
mo.
arece,
...
es gusta
.
ualquiera
apata!
e gusta
ebata.
ullosos
ballos,
unos
gallos.
borazos...
ateado:
les
neado,
n los ricos,
defensa,
onto
piensa.
se juntan
y bandidos
ciencia.
idos.
re gente!
pera,
bando
nuera.

der
busca.
uido
rano
atista
no
```


```
¡Amigo, amig
Con Emiliano Z
Que el Estado d
Por poco ya no
   Al principio
Por ser antipor
Pero se ha con
En un monstrú
   Los zapatista
Hacerlo dueño
De aquellos pue
En donde son e
   Son como fie
Cuando no hace
Roban y matan
Y amantes son
   Que triste es
Lo que hacen lo
Que no tienen c
De niños ni señ
   ¡Pobre Estad
Cuanto ahora h
Con esos cuant
Que maldición
   En los peque
Haciendas y ra
Han hecho derr
Con todas sus fe
   Han incendia
Y los campos de
Honras y vida y
Cuanto han pod
   Más, la justic
Y todos esos ba
Acabarán con s
Jefe de los forag
   Ya la Nación
Que siga ese ba
Y no lo dudes, a
```

THE COMING OF
THE REVOLUTION

The tensions that led to the Mexican revolution can occasionally be noted in Posada's works. The bandit Santanón, for example, was in sympathy with the anti-Díaz Liberal Party of the Flores Magón brothers; President Francisco Madero posed for a picture with Rodolfo Gaona; Jesús Negrete lamented the fact that he had been born too early to be a revolutionary leader. In addition, some sheets by Posada probably stoked opposition to the Díaz regime, chiefly through glorification of outlaws and criticism of the Europeanized elites.

Yet a body of work by Posada exists that deals more directly with the prelude and early phases of the Revolution of 1910–17. The Vanegas Arroyo shop continued functioning throughout the conflict, and regularly issued sheets that dealt with military engagements or the personal characteristics of the various *caudillos* who led warring factions. For two important reasons, however, Posada's part in this drama was quite limited. First, he died on the 20th of January, 1913, during the presidency of Madero, but before the so-called Ten Tragic Days that resulted in the fall and assassination of the ill-fated president and vice president. Thus the printmaker never saw the most turbulent phase of the conflict, neither did he see the flowering of the careers of the most interesting revolutionaries such as Emiliano Zapata and Francisco Villa. Posada had very little chance to develop his own interpretation of these or other figures. Second, during this phase of his work, Posada was more heavily influenced by photography than previously, and this influence was not salutary for his style. The increasing availability of newspaper photographs surely made his work easier, but it also lent a certain pedestrian quality to many of his illustrations. A great deal of his work from this period consists of portraits derived from such newspaper sources, with little of the editorialization or subtle alteration that we have

LOS SANGRIENTOS SUCESOS

En la Ciudad de Puebla.
La muerte del Jefe de Policía
MIGUEL CABRERA.

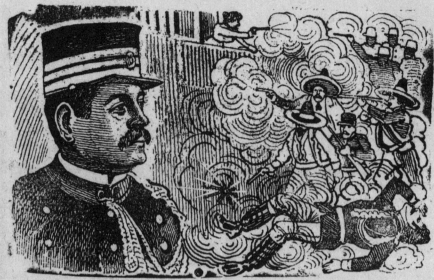

El viernes 18 del presente Noviem-
bre por la madrugada en una casa de
la calle de Santa Clara; en la ciudad
de Puebla. muy cerca del centro y de
la Plaza de Armas de esa ciudad,
donde vive el antirreeleccionista Aqui-
les Cerdán, aparecieron á las 5 de la
mañana varios individuos que grita-
ban y disparaban armas de fuego.

La policía se presentó para catear
la casa, con el jefe de seguridades el
Sr. Miguel Cabrera á la cabeza y
quizo penetrar en ella, pero fueron re-
cibidos á balazos. siendo muerto en
el acto el Sr. Cabrera y gran núme-
ro de policías.

Se dió aviso al Cuartel y al Bata-
llón "Zaragoza", acudió en su ayuda
y se trabó un formidable combate que
duró tres horas y del que resultaron
cerca de cien muertos y heridos.

Al fin fué tomada la casa por asal-
to y aprehendidas varias personas y
recogido el cadáver del Sr. Cabrera

que yacía tirado en el zaguán de la
casa.

La Ciudad se halla consternada.
El comercio todo está cerrado, y las
familias huyen en busca de lugares
seguros, pues la revolución es terrible
y la matanza espantosa.

La calle de Sta. Clara está desierta
y sus aceras manchadas de sangre.
En el interior de la casa de Aquiles
Cerdán, se encontraron como 200 fu-
ciles y muchos explosivos, planos de
ataque y muchos proyectiles y bom-
bas de dinamita, de las cuales varias
fueron arrojadas sobre las fuerzas fe-
derales, en compañía de una verdade-
ra lluvia de balas. La alarma es muy
grande pues se teme una general re-
volución antirreeleccionista.

Entre los heridos se cuenta el ca-
pitán 1º del batallón "Zaragoza" D.
Francisco Aguilar, que como el coro-
nel Mauro Huerta, peleó valientemen-
te contra los antirreeleccionistas; el

observed before. It is as if Posada's creative energies flagged with his increasing age and the rising tide of photomechanically produced images.

As we examine the work from the early days of the revolution, though, three main themes merit attention: The shop's treatment of urban violence in Puebla in late 1910 allows us to see in some detail both the political tightrope the shop walked, and also to reconstruct with great precision the timetable under which the shop operated in creating a sheet on a breaking story. The attitude of Vanegas Arroyo toward General Díaz, as the dictator fell from power and went into exile, becomes clearly apparent. Finally, the shop begins to experiment with different and more technologically sophisticated methods of image creation, experimentation that may have helped to hasten the departure of Posada from the scene.

Occasionally, comments arise regarding the seeming carefulness of the Vanegas Arroyo shop in the face of threatened press censorship and imprisonment of journalists. But the fine line the enterprise trod can be traced clearly in the way it dealt with events often referred to as the "opening shots of the Revolution." This was the battle at the house of the Serdán family in Puebla in November 1910 in which the anti-Díaz rebel Aquiles Serdán and several of his family members lost their lives (fig. 77). The event is usually referred to as the beginning of the revolution because it represented the first armed conflict that had the overt goal of ending the Díaz presidency, and it coincided closely with the date that Francisco Madero had set for the onset of armed resistance to the Díaz regime. The background to this melee can be traced in Madero's activities over the previous several months.

In the spring of 1908, President Díaz had been quoted in an interview with an American journalist saying that he felt that it was time in Mexico for an organized opposition party to form, in the manner of the more advanced democracies of the world. Moreover, since he himself was getting on in years, he would like wider democracy to be part of his legacy.[1] This interview caused political ferment in Mexico as soon as it was translated and published, and it raised the hopes of all others who eyed the presidential chair. Some of these figures, such as General Bernardo Reyes and Treasury Minister José Ives Limantour, differed little in their positions from Díaz, but the candidacy of the patrician and idealistic Francisco Madero captured the sentiments of large segments of the public. Madero took Díaz at his word, and in preparation for the 1910 presidential elections, traveled about the country organizing clubs and newspapers under the auspices of a new Anti-Reelection Party. He drew large crowds, numbering in the tens of thousands, in many cities where he gave public speeches. Not only was he by far the most successful anti-Díaz politician of the entire Porfiriato, founding more than one hundred anti-reelection clubs, but by the middle of that year, he was, according to one historian, "probably more widely known through personal contact than any other man in Mexico."[2] Among the largest gatherings he had drawn was in Puebla, where thirty thousand reportedly turned out, and where the Serdán family formed the backbone of a strong Anti-Reelection Club.[3] However, at the end of June of that year,

authorities in Monterrey arrested Madero on trumped-up charges having to do with creating public disturbances, and put him in prison in San Luis Potosí in an effort to snuff out his increasingly credible challenge to the continued presidency of Díaz.

Madero remained in captivity through the elections, and when the electoral college results were announced in October—Díaz re-elected by a comfortable margin—no one believed them. Madero escaped from prison early that month and fled across the Río Grande to San Antonio to plot more decisive action. After a series of meetings with other rebels over the next several weeks, in which members of the Serdán family participated, in early November he issued the Plan of San Luis, in which he proclaimed Díaz a usurper of the people's power and called for action to overthrow him. He set the date of November 20 for the start of organized resistance, and said that he would cross the border at an undisclosed location in time to lead the struggle.

In Puebla, meanwhile, the local authorities kept a close watch on the Serdán household.[4] They recruited two neighbors to serve as spies and report any suspicious events such as meetings or transfers of weapons in or out of the building, which was a large townhouse near the center of the city. Police regularly searched the premises, and on two occasions this was done under the leadership of the local chief himself. This chief was none other than the notorious Miguel Cabrera, captor of Jesús Bruno Martínez, tormentor of El Chalequero, and most importantly, assassin of Arnulfo Arroyo. (Upon completing about a third of his sentence in Belén for his part in that crime, Cabrera had been vetted to Puebla, his native city, where he continued to zealously guard civil peace in his new capacity.) According to an account written shortly after the house raid, Cabrera was "generally hated in Puebla. . . . He usually dealt with criminals by capturing them and torturing them, according to popular murmurings."[5]

The climax of events came on the morning of November 18. The spies had been allowed to spend the night elsewhere, and Cabrera and four associates knocked on the door of Serdán's house at 7:30 in the morning. No doubt they were intending to capture the arms that were reportedly cached for the announced revolt of two days hence. But in the doorway of the house, the group was met by a hail of bullets from within that killed Cabrera and one other instantly. As the rest fell back and sent for reinforcements, other members of the Serdán family climbed up to the roof and began lighting sticks of dynamite and tossing them onto the street below in an effort to rouse the populace. Soon the house was surrounded by hundreds of members of the army and police, and an open gunfight ensued. The siege continued all day, as the house was indeed well stocked with rifles and ammunition, and all of the house's two dozen occupants wielded arms at one time or another. The police clamped down on other possible sources of support for the Serdán family in the city, arresting known anti-reelectionists, and closing factories so that workers could not meet. Partly for this reason, the popular support that the Serdán family hoped for did not materialize, and it was only a matter of time before the hopelessly outnumbered occupants of the house began to fall victim to withering fire. By nightfall, the

place was secure enough to enter, because, it seemed, everyone inside had either surrendered or been killed.

Aquiles Serdán, the leader of the group, was the only one unaccounted for in the initial search of the house, but he soon revealed himself. At about two in the morning, probably thinking the danger over, he emerged from the basement through a trap door into a room where a captain happened to be standing, and the revolutionist was killed immediately with a bullet to the head. At daybreak, the authorities put his body on display at the military head-quarters, and news of the bloodshed spread quickly.

The account of these events in the broadsheet, figure 77, gives evidence of a rather edgy neutrality, in which a desire to avoid persecution competes with the felt need to give the people something to cheer about in the death of Cabrera. First, it contains halting favorable mention of the authorities. The text gives names of wounded soldiers, who, it says, "fought valiantly against the anti-reelectionists." It points out that Puebla was practically closed down, with "doors shut, citizens hidden in their houses, and all commerce suspended." The first half of the text says that Aquiles was "still at large," but later this is corrected with a brief description of his emergence from the basement and his murder. There follows a fairly long list of twenty-six persons in four other nearby cities who were rounded up as suspected revolutionaries, and concludes: "The government has taken all necessary measures to define the guilt of the entire group, as well as the degree of responsibility of each detained person." At the bottom of the back of the sheet is a poem that laments in more objective terms the loss of peace:

Oh Peace, Oh beautiful Peace!
Why do you abandon your sons?
Without you, all is lost;
There is no hope, only cost;
Why do you abandon us,
Oh Peace, Oh beautiful Peace?

In the treatment of the death of the police chief, some subtle double mean-ing could be hinted at, though it is not at all obvious. Cabrera is mentioned prominently in the headline and pictured in the left half of the print, as if it was presumed that readers would know who he was. Given the fact of his earlier illustrious career in the capital, it was likely that he was still widely remembered, but not, of course, in the honorific way he is named and pictured here. Posada even included him lying on his back in the right foreground, in his typical not-quite-dead style, with one arm raised and a hint of life in the legs. After such visual build-up, one might expect in the text some mention of Cabrera's service to the public, or of his innocent death while carrying out his duties, but nothing good is said of him. Rather, the event is treated only cursorily: "Among the dead are, in the first place, the police chief Mr. Miguel Cabrera, and Máximo Serdán, who was a leader of the revolutionary movement

and brother of the owner of the house; the soldier Angel Durán, Second Sergeant Manuel Sánchez, and two women who were passing by the house when combat broke out." This lack of comment on Cabrera contrasts somewhat tellingly with the prominent place given him in the headline and the illustration, and contributes to possible multiple readings of the sheet: to the authorities, the sheet would appear above suspicion, as the death of a police chief in a gunfight might certainly be considered newsworthy. If a reader were indifferent to Cabrera, the attractiveness of the sheet would come from the headline "Bloody Deeds in the City of Puebla" and the tumultuous battle scene in the print. But to a member of the lower classes who knew of Cabrera's grimy reputation, this would be good news, prominently featured. The fact that there is nothing favorable about him in the text amounts to a negative reinforcement of this view.

It seems indeed that some important information about public attitudes in Puebla toward the police chief was purposely left out of the text of this sheet. For example, there began to circulate on the streets of Puebla almost immediately a handbill in the form of a "funeral announcement" that commented highly satirically on the death of Cabrera. On it was depicted a cross draped with flowers; below, in formal script, a brief text read:

Today at Eight Thirty a.m.
Dead at the breast of all Devils
The Cowardly Assassin, Vile Inquisitor, Chief of the Rats

Miguel Cabrera

His Victims, the Business Community, and the People in General, sharing this pleasant news, invite you to celebrate the end of such a heavy oppression, and the rebirth in the deepest pits of hell the soul of such a rotten man.

Puebla, November 18, 1910

Another handbill, titled "From Beyond the Grave," referred to the earlier event of Arnulfo Arroyo as it exulted in verse over the death of the chief. The last line contains a reference to Joaquín Pita, the political boss of the city:

From the midst of the Pyre
The devils, with great glee
Congratulate Aquiles Serdán,
Who from Cabrera set us free.
His life was very despicable;
He was not the people's friend;
For that, the deadly bullet killed
He who brought Arroyo to his end.
So Cabrera arrived in Hell

Dressed up like a leader;
And a sorceress immediately asked him,
"Why didn't you bring Pita?"[6]

News of the circulation of such scandalous materials was most likely an open secret, and it is difficult to believe that Vanegas Arroyo did not know about them, because Puebla is only a short distance from the capital, and his family hailed from that city.

The sheet, figure 77, avoids notice of the strong anti-Cabrera sentiment, and similarly avoids the triumphalism of the official daily *El Imparcial* (fig. 78), which emphasizes the not incorrect impression that the authorities had matters under control. The second and third full-page headlines say that ten thousand shots were fired, with fifty casualties resulting. Just below, the first half-page headline tells of the death of Cabrera, who was "carrying out a search." Below that, in a box, is the alleged but unbelievable battle cry of General Valle, the army commander at the scene: "Long Live the Republic! Long Live General Díaz!" The final headline in that column labels the casualties the "tragic fruit of seditious propaganda." In the other column the headline confidently proclaims, "The Mexican Borders are Closely Guarded," an obvious reference to Madero's threat to return to the country to lead the revolt. On the left side below, it is helpfully pointed out that the people of Ciudad Juárez, the largest border town, are "loyal, and condemn the abuses of the revolutionaries." There are photographs of

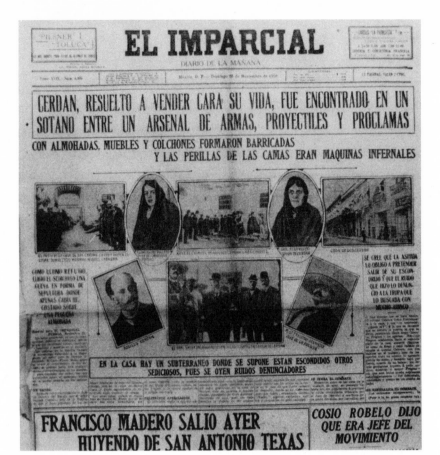

the provincial governor and of Chief Cabrera. This latter was obviously the source for Posada's plate, as the details of the uniform and the orientation of the body are very similar. The principal difference between them is that Posada makes the subject look much younger, a fact that could only have helped to render the sheet innocuous in the eyes of the authorities. The next day's editions of *El Imparcial* reported on the death of Serdán (fig. 79). The headline reads, "Serdán, determined to sell his life at high cost, was found in a basement amid an arsenal of weapons, ammunition and leaflets." The photographs below depict, from the upper left, the doorway of the house where Chief Cabrera met his death; two female members of the Serdán family who also died defending the house, flanking a view of the barracks with the body of Aquiles placed on display; a general view of the Serdán house from the street; below, the dead Aquiles; General Valle and civil authorities; and finally, the new police chief of Puebla. Immediately below this story on the Puebla raid is a headline about Francisco Madero's departure from San Antonio toward the border.

Using this information, a fairly close chronology can be assembled to describe the production of the broadsheet: During the day of the 18th, news may have spread by word of mouth about the attack. Puebla is, after all, only seventy-five miles from the capital, and was served by frequent rail service, not

to mention telegraph and telephone lines. The sheet was apparently planned, however, on the morning of the 19th, using information available from *El Imparcial* of that day as the basis for the text and the photo of Cabrera as the foundation for the illustration. The typesetting and image creation were done during that day, but before these tasks were complete, news probably began to arrive about the death of Aquiles Serdán. The later part of the text includes mention of this, despite its discrepancy with the earlier paragraphs. How the shop learned of the death of Serdán is not clear, but it seems certain that other information from the newspapers of the 20th—the names of the suspects rounded up in other cities—was also appended to the text. The image, however, was not altered in view of the new information available. There is no hint of Serdán's death in it, nor does the house depicted resemble the one illustrated in the editions of *El Imparcial* on the morning of the 20th. Probably because the shop sensed the time value of the information they were presenting, they updated the text but not the image. This case apparently differed in news value from the Bruno Apresa execution, for which a second plate was made when new images became available. So the typesetting was probably completed during the morning of the 20th, and the sheet was printed with its illustration so as to be ready for distribution late that afternoon, still in quite timely fashion for the other expected disturbances of that day. Such was the timetable under which this sheet, figure 77, and probably many others, were created.

If the Serdán house raid was indeed the opening of the revolution, its progress over the next few months was very slow and halting. Madero did appear at the border on November 19, but allies on the Mexican side failed to amass in sufficient numbers, so he aborted the attempt to cross. Meanwhile, Pascual Orozco, Abraham González, and Francisco Villa took up supporting guerrilla-style actions in the provinces of Guerrero and Chihuahua. The most important battles took place early in 1911 and centered around Ciudad Juárez, which had both a sizable federal garrison and access to customs revenues. By February 14, Madero was able to re-enter Mexico through that city and take up personal command of the revolutionary armies. Ciudad Juárez was the chief prize of these early revolutionary engagements, and large parts of the city changed hands several times.

In mid-March, the government suspended civil liberties, and began secret negotiations in Washington, D.C. with Madero's representatives. At the end of that month, General Díaz's cabinet resigned. In the president's annual message to Congress of early April, he began to talk of reforms, but guerrilla actions were spreading. Revolutionaries took the seaport of Acapulco in April 15. Agrarian rebel Emiliano Zapata became daily more assertive in Morelos. Violence erupted in the cities of Durango, Jalapa, Tehuacán, Saltillo, Torreón, and Culiacán. On May 10, Ciudad Juárez finally fell to armies commanded by Madero and Orozco. Said one historian, "The progress of the Revolution following the capture of Ciudad Juárez was nothing short of amazing."[7] General Díaz and his vice president agreed on May 17 to resign by the end of the month; on May 25, leaving behind as Provisional President Francisco León

de la Barra, they did so. On June 7, Madero made his triumphal entry into the capital before crowds estimated at one hundred thousand.

No broadsheet survives that tells of the events that happened prior to the eventual victory and entry of Madero. The major Posada collections contain many examples of works depicting military actions of the later phases of the revolution, but none can be securely dated before June 7. One possible reason for this hiatus could be simple lack of information. Newspapers of the capital were enjoined from reporting on most military engagements, as the government feared the spread of what it took to be sedition and propaganda. In addition, the broadsheet publishers were generally far from the first to break such rules, be they written or unwritten, on the reporting of controversial events. The strategy of neutrality was here observed by silence.

Once the political smoke cleared, however, with the triumph of Madero, the broadsides came in quick succession. One song sheet issued shortly after Madero's entry seemed to fill in the information gap, as it contained verses in praise of Roque Estrada, an associate of Madero who had been imprisoned with him in San Luis Potosí; lyrics on the capture of Ciudad Juárez; a song on the siege of the village of Ojinaga with praises for Villa and Orozco, and even a verse lauding "The Heroic Aquiles Serdán."[8] The lyrics read like drinking songs, full of grandiose and chest-filling emotion. "El Maderismo Triunfante," for example, intones at one point as follows:

He who refuses to shout with all his heart
"Viva Madero!" is merely a coward;
And he can never hope to have with me
Not even a drink at the appointed hour.
Long Live the Maderistas, every one
From all of our country's wide states;
Because even though it has cost us very dear,
We are now, all of us, free—not slaves.

Mentions of President Díaz are few. In its first stanza, the song celebrates not the fall of Don Porfirio, but the fact that his party has gone to its grave. The song of the siege of Ojinaga says only that it had earlier been victim of "Porfirismo." The most direct reference to the dictator is in the song about the capture of Ciudad Juárez, where his age and his disappearance seem to be the principal subject rather than his rule:

Very few of my friends now say
"What's happened to don Porfirio?"
He's just so old and disabled,
That we laugh ourselves delirious.

A sheet entitled *Great Triumphal March* is dated May 1911, corresponding to the brief lapse between the surrender of Díaz and the arrival of Madero in the

80. *Great Triumphal March.* Broadsheet with black-line illustration by Posada, 1911. Half Sheet. Amon Carter Museum. 1978.105

GRAN
MARCHA TRIUNFAL.

-CORO GENERAL.-

¡Oh, Madero! ¡Madero! clamemos
De la Patria empuñando el pendón
Y elevemos al cielo los ojos
Y salude rugiendo el cañón!

Hoy el pueblo saluda al insigne.
Redentor, más augusto de América
Que en Chihuahua vibró en nota feérica
La palabra que dió libertad.

Repitamos y unidos clamemos
De Madero su triunfo que es gloria
Y la voz del clarín escuchemos
Voz de v ces que hará éco en la historia.

Gloria eterna se han conquistado
Esas tropas de heróico valor
Que de México han extirpado
La ponzoña de un cruel Dictador.

¡Gloria, glória! clamemos unidos,
Recordando que México es libre
¡Y ser muerto, más nunca vencidos
Sea la voz que para todo vibre!

Gloria eterna se han conquistado
Las tropas de heróico valor
Que de México han extirpado
Un gobierno de tod s terror.

capital (fig. 80). Most sheets, if they are dated at all, give only the year of their creation; if this notation is accurate, the present example must have been made during this interval. The poetic text praises the valor of Madero's troops, who have "purged from Mexico the poison of a cruel Dictator." In verses perhaps more sober but in other ways no less enthusiastic than those noted above, the song intones:

Oh Madero, Madero! We acclaim you
As you grasp our Fatherland's banner;
And we raise our eyes to heaven
As, saluting, growls the cannon.
Together and united we salute you,
Madero; your triumph is pure glory;
We hear the voice of the trumpet resound,
The voice which will echo in history.

Clearly, such martial virtues are reserved for very few in broadsheets; only bullfighters merit such unalloyed praise. This sheet sets the tone for what would be the most vigorous exaltation of any public figure in Posada's career with the Vanegas Arroyo enterprise. The illustration, which covers more of the sheet than is usual, depicts nothing of warfare, presenting Madero in what looks, indeed, like triumphal procession. The entire atmosphere is solemn and some-what ceremonial as the group of figures proceeds to the left. The glories are reserved in their totality for Madero too, as none of his generals is recognizably depicted here, nor are they mentioned in the text below. This is something of an oversimplification, as Madero's military skills have often been criticized, and he certainly depended on the physical courage and lightning strikes of General Orozco and Colonel Francisco Villa as his campaign marched southward from the border. Yet it seems that the favorable depictions of Madero were not only efforts to curry favor, but were sincerely meant.

Posada's plate contains several spatial distortions, not all of which are expli-cable. The position of the horse's hooves is probably impossible; the front pair seem to be lined up one in front of the other, an unlikely arrangement, but the rear pair positively defy anatomy as the outer hoof seems nearer to the fore-ground than the inner one. Next to the rear leg stands a flag bearer who is impossibly short. He would reach only to Madero's necktie, and is thus only about four and a half feet tall, since Madero himself was by no means a tall man. Perhaps the need to insert the flag and pole caused the truncation of the stature of the bearer, but there would certainly be other ways to solve that prob-lem. The depiction of the hero himself leaves little to be desired, except that it is difficult to tell whether he is sitting or standing in the saddle. It is a good likeness, however, and accurately captures his dress, grave mien, and rather penetrating eyes. Posada has made him stand out from the crowd by position-ing him at the center of the composition and by highly contrasting his features.

The slightly more intense use of black in the figure of Madero seems to bring him forward just enough, and this is probably the one aspect of this plate that shows Posada's usual skills to some advantage. The tonal gradations in the shadows cast on the ground also indicate an effort at more subtle use of modeling. But the figure blowing the trumpet (next to the flag) is holding it at an impossible angle, and the companions at the left of the frame do not reach the ground. This may indicate that the entire background group was an afterthought. Most likely Posada first composed the picture with only Madero and the flag bearer; the perspective of the landscape at the left supports such an interpretation. But that arrangement probably seemed inadequate to the importance and solemnity of both the occasion and the verses, and caused Posada to add the surrounding figures. So we are left with a larger-than-usual plate that communicates the appropriate mood but contains strange disjunctions.

The sheet that deals with Madero's actual entry into the capital amounts to an example of high-tech folk art, since it is the earliest sheet that uses newspaper reproduction technology (fig. 81). The telltale black dots of varying density make half tones and modeling in light and shade possible on a scale that Posada's methods could never reach. Probably since this was a special occasion, the shop spent the money on the new look rather than having Posada make the illustration. Madero looks very official as he seems to rise incongruously out of the thicket of fruits, vegetables, and flags. The incongruity between the photo and the still life arises from the fact that the arrangement properly belongs around either a funeral portrait or a statuary bust; the realism of the photographic portrait is somewhat jarring, we have the right to expect to see the rest of his body below. The still life was probably a stock item, bought from a catalog of imported printers' goods, since nothing about it is specifically Mexican. In any case, the attempt is to establish the theme of flourishing patriotism. The poetic text reaches stratospheric heights of hyperbole as it describes his triumphal progress toward the capital:

> You are received on farm after farm
> By all your noble brothers and friends;
> Because you proved yourself in the noisy battle
> The Sainted One of all Mexicans.
> All is beautiful along your path;
> You see noble vistas which cause you delight;
> From above, you feel the graceful embrace
> Of a long line of Nereids, all dressed in white.

Elsewhere he is referred to as a "citizen of grand learning," and "redeemer of the beloved country."

Like the previous sheet, this one is marked with both month and year: June 1911. The high praises offered in both are apparently not out of keeping with the sentiments of a sizable segment of the public, which put almost impossible

ENTRADA TRIUNFANTE
DEL CAUDILLO DE LA REVOLUCION
Sr. D. Francisco I. Madero
A la Capital de la República.

Ven ¡oh Patria! ¡oh Patria! grandiosa
Que tus hijos se abrigan á tí;
Pues que tú eres del pueblo la Diosa,
Que te adora con gran frenesí.

Ya penetra triunfante Madero,
De la ruda campaña que tuvo;
Y en sus leyes se vé que es sincero
Y su noble estandarte sostuvo.

Un banquete se ofrece á tu honor;
Y con Mirtos y blancos azahares,
Con estrellas de vivo fulgor.
Se te rinde el cariño á millares.

Razgue el cielo su comba azulada
Y asteróides albeantes te rieguen,
Porque tú eres el alma inspirada
Que con fé tu cariño mantienen.

Te reciben de hacienda en hacienda
Tus amigos, tus nobles hermanos,
Porque fuistes en ruda contienda
El Dios santo de los Mexicanos.

Se engalanan por todo tu paso
Estaciones de bellos mirajes,
De cariño te dán un abrazo
Las Nereidas de blancos ropajes.

¡De Madero su grande figura
Se revela su acción y nobleza!
Ciudadano de grande cultura.
Hombre estóico de viva firmeza.

¡Redentor de mi Patria adorada!
Tu sublime serás en la historia,
Porque siempre tu ardiente mirada
Será ejemplo de viva memoria.

81. *Triumphal Entry of the Leader of the Revolution, Mr. Francisco I. Madero, to the Capital of the Republic.* Broadsheet with illustration using photomechanical processes, 1911. Half Sheet. Amon Carter Museum. 1978.236

expectations on the new leader. Some apparently thought that once Díaz was out of power, both money and work would be abolished. This spirit was somewhat cynically noted by an anti-Madero historian:

> The people at various points along the journey, and for miles around, hasten to be present at the procession of the Apostle; they hope to see the wonderful Savior and hear his plenteous words of redeeming prophecy, and to touch his body and his clothing as if they were sacred relics. . . . For each pain, he has a

82. *The Departure of General Díaz Yesterday and Today.* Broadsheet with white-line illustration by Posada, 1911. Half Sheet. Colorado Springs Fine Arts Center.

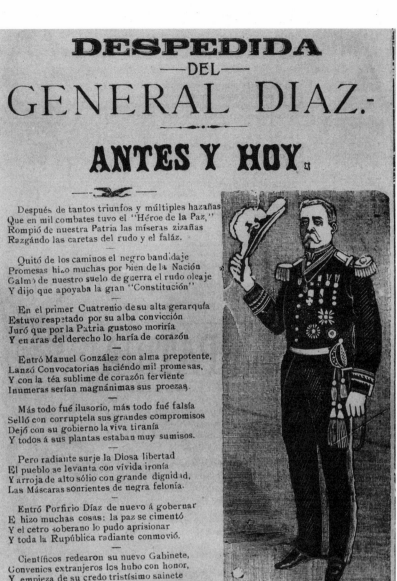

DESPEDIDA
—DEL—
GENERAL DIAZ.-

ANTES Y HOY.

Después de tantos triunfos y múltiples hazañas
Que en mil combates tuvo el "Héroe de la Paz,"
Rompió de nuestra Patria las míseras zizañas
Razgándo las caretas del rudo y el faláz.

Quitó de los caminos el negro bandidaje
Promesas hizo muchas por bien de la Nación
Calmó de nuestro suelo de guerra el rudo oleaje
Y dijo que apoyaba la gran "Constitución"

En el primer Cuatrenio de su alta gerarquía
Estuvo respetado por su alba convicción
Juró que por la Patria gustoso moriría
Y en aras del derecho lo haría de corazón

Entró Manuel González con alma prepotente,
Lanzó Convocatorias haciendo mil promesas,
Y con la téa sublime de corazón ferviente
Inumeras serían magnánimas sus proezas.

Más todo fué ilusorio, más todo fué falsía
Selló con corruptela sus grandes compromisos
Dejó con su gobierno la viva tiranía
Y todos á sus plantas estaban muy sumisos.

Pero radiante surje la Diosa libertad
El pueblo se levanta con vívida ironía
Y arroja de alto sólio con grande dignidad,
Las Máscaras sonrientes de negra felonía.

Entró Porfirio Díaz de nuevo á gobernar
E hizo muchas cosas: la paz se cimentó
Y el cetro soberano lo pudo aprisionar
Y toda la Rupública radiante conmovió.

Científicos redearon su nuevo Gabinete,
Convenios extranjeros los hubo con honor,
Y empieza de su credo tristísimo sainete
Y aplauden "Chanbelanes" con gozo y con amor.

García de la Cadena levantó su estandarte
El General Martínez le sigue en su misión
Construyen en sus pechos el sin igual baluarte
Y quieren igualdades, Concordia, Paz y Unión.

remedy; for each hurt a balm, for each anxiety a soothing word. They cheer him with frenzy and applaud him deliriously.[9]

The sheets on Madero treated him with a reverence that reflected aspects of popular opinion. But when the sheets dealt with the last days and exile of General Díaz, they did not roundly condemn him as a tyrant, but rather treated him gently. One sheet, which must have been issued quite near to the date of his actual departure, contains a fairly lengthy poem that attempts to size up

Díaz's entire regime (fig. 82). This lyric, signed Juan Flores del Campo and dated May 1911, opens by calling him the "Hero of Peace," referring to his popular reputation as restorer of civil peace after the Wars of the Reform and the fall of Benito Juárez. It respectfully points out that he held to his "no reelection" pledge after one term and stepped aside for the interregnum of Manuel González (1880–84), but alleges that this term was a disaster, practically forcing Díaz back into power. This return of Díaz was held to be a good thing, until the rise of the "Científicos," the Comtian positivists who welcomed European business culture into Mexico. These latter are blamed for the regime's ultimate failure:

> *Científicos* filled his Cabinet up to its very brim,
> They made deals with aliens on very liberal terms;
> From this belief began the farce that was the end of him
> As the sycophants applauded all the foreign firms.

There follows a list of abortive rebellions, beginning with that of Trinidad García de la Cadena, who, it may be recalled, was about to team up with Heraclio Bernal when he was murdered in 1886. These figures are portrayed as motivated primarily by simple patriotism, a desire to see Mexico controlled by Mexicans. Madero emerges in the poem as the last and best of these heroes:

> Madero then solemnly his Sovereign hand he raises
> Protesting the outrages in measured, soulful tones;
> He hates the Re-election and condemns it with strong phrases;
> And with clear conscience smashes the dictatorship's black bones.

This rather philosophical tone about the old regime is upheld in Posada's illustration, which depicts the dictator standing at attention in full military dress, doffing his cap as if in a ceremonial salute. It does not necessarily depict his actual farewell, however, and was used for other sheets about him. Posada here used the white-line technique in a new way that is especially notable in the background. He seems to have made an effort to capture the effect of the photomechanical dots of newspaper reproduction in the rather intricate crosshatching that forms the background to the silhouette of Díaz. The lines go only one way in the shadow at the lower left, leaving that area slightly darker. The medals and the light diagonal shading lines on the General's uniform show more clearly the characteristics of white-line printmaking. The whitest areas in Díaz's face and hat were made simply by hollowing out these areas of the plate, leaving the black areas in relief.

The same plate embellishes an even more favorable sheet that gave news of him in exile.[10] The text reports that Díaz is not in good health, and that he would like to return to his homeland to recover from the unidentified illness. It also recounts news of a party given by Díaz sympathizers in Orizaba. These partisans of the old regime apparently watched movies, and when the General

appeared in one of them, they shouted, "Viva Porfirio Díaz," and applauded for ten minutes. There follows a succinct summing-up of his rule which probably expresses the feelings of Vanegas Arroyo about the dictator:

> The interest shown in the health of the old soldier, the "Hero of Peace," shows that he is remembered and not forgotten in the hearts of good Mexicans. Though it is clearly recognized that, being human, he made certain mistakes, it is also true that he insured the peace of Mexico, increasing its greatness and material progress.

Another rather flattering sheet issued about General Díaz's life in exile used an image technique which, while nothing new in printmaking, was a new twist for the shop (fig. 83). The prose text tells the story of how Díaz, whom it again refers to as "The Hero of Peace," went to see some German military parades in mid-1912 which were under the direction of Kaiser Wilhelm II. Apparently Díaz went only as a private citizen, but when someone informed the Kaiser of the lapsed dictator's presence, the Kaiser, no doubt recognizing one of his own, invited Díaz to sit with him at the reviewing stand. There the Kaiser ordered his honor guard to "present arms" to the exiled leader, and Wilhelm told him that if he had known that Díaz was coming, he would have sent a royal coach after him, because he felt Díaz to be "one of the great statesmen of America, for whom I have the most profound respect." Thus was Díaz accorded full military honors. The moral of the story, according to the text, was that the homage shown to the dictator by Wilhelm, even though Díaz had no official status, "should be a source of pride for all good Mexicans, to see how their nation is honored and respected abroad in the person of one of its most prominent sons."

There is reason to doubt that the plate that depicts Díaz is by Posada. To be sure, the proportions and solemn alertness of the figure could be marks of his style, but the process makes it unlikely. This print began life as an engraving on steel, betrayed by the fine black-line work in the face and the crosshatching in the clothing. This is the same technique that is used on a great deal of the world's currency. Such plates are made by gouging intaglio lines in a metal plate that can take ink, the opposite of the relief printing techniques that Posada usually used. But it is practically impossible to print intaglio material at the same time as the relief material of the blocks of type, so the plate must have been converted through photomechanical means into a relief plate. How this was done is impossible to say with the evidence at hand, but it does indicate that the shop was experimenting with varying technical processes.

When Madero finally assumed the presidency on 6 November 1911, his problems were by no means over, and the reserve of good will that he carried into office was almost entirely dissipated within months. In March 1912, his formerly trusted general Pascual Orozco rose up in revolt in the province of Chihuahua (fig. 84). The only reason for this rebellion seems to have been that Orozco had not been given a cabinet post, as it rested on no apparently substantive issue.

83. *The Life of the Exiled
General Don Porfirio Díaz.*
Broadsheet with photo-
mechanically produced
image, 1912. Colorado
Springs Fine Arts
Center.

84. *The Campaign of
Pascual Orozco.* Broad-
sheet with black-line
illustration by Posada,
1912. Half Sheet. Amon
Carter Museum. 1985.13

The revolt presented quite a problem for Madero, however, as three different
generals headed the federal army which at various times struggled against
Orozco. The poetic text takes the federal side, praising the valor of the troops,
and comparing them to the Mexicans who fought against the American
invasion of 1846–48 and the French intervention of 1867. A longer section
on the reverse side again laments the loss of peace:

PASCUAL OROZCO EN CAMPAÑA.

Allí, en los campos del Norte,
Se traba ruda batalla
Se oyen quejas y lamentos
Se oye estallar la metralla.

Se mira rojear el fuego,
Y caer muertos y heridos
Descarrilarse los trenes,
Y los bosques consumidos.

Jiménez y Mapimí,
Corralitos y Rellano
Han presenciado combates,
De un valor muy espartano.

Allí pereció González
Y Blanquet, allí fué herido,
Trucy Aubert con valentía
Al gobierno ha defendido.

Han ido trenes blindados
Fuertes ametralladoras,
Cañones de tiro rápido,
En grandes locomotoras.

Combaten con gran bravura,
Todos y con gallardía
Siendo fieles á su causa
Pelean, con bizarría.

Se han lucido los soldados,
Los valientes federales
Que en mil combates triunfaron
Ayer en luchas fatales.

Allá en la Intervención,
Francesa y Americana
Los soldados del Gobierno
Como una hueste espartana.

Han luchado denodados
Defendiendo á la Nación
Y cayendo allí en los campos
Junto al humeante cañón.

Hoy, en heróicos combates,
Valientes han sucumbido,
Por ser fieles al gobierno
Pues allí lo han defendido.

En legendarios combates
Al son ronco de metrallas
Se han librado escaramuzas
Y muy sangrientas batallas.

Allí está el general Huerta
Trucy Aubert y otros campeones
Que con Rábago y con Villa
No temen á los cañones.

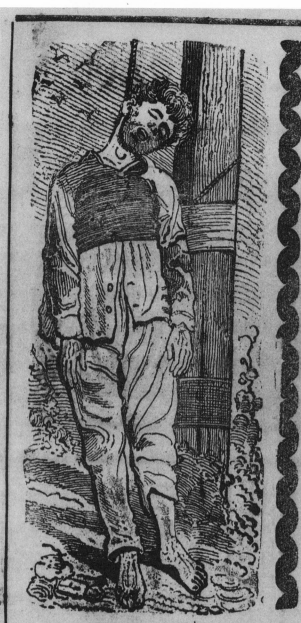

Ni á la batería ligera,
De los contrarios soldados
Y luchan tan decididos
Tan valientes, tan osados.

Que han quedado en los combates
Por roja sangre empapados,
Más por la Patria allí mueren
Como íntegros y esforzados.

¿En esta lucha tremenda
Quién en guerra vencerá....
Pascual Orozco ó Madero?
¡El tiempo decidirá!....

Pero en aquellas llanuras
Del Bolsón de Mapimí
Se han librado los combates,
Como en el pasado, allí.

Tierra de héroes y valientes,
De generales osados
No viertas más esta sangre
De hermanos siempre esforzados.

Es terrible la situación,
De contrarios ó enemigos
Y allí luchan con bravura
Siendo los campos testigos.

De mil heroicas proesas
Por una y por otra parte
Unos combaten á ciegas
Y otros combaten con arte.

Se paraliza el comercio,
Se acaba la agricultura,
Ya no hay comunicaciones,
Y está triste la natura.

Anáhuac, Patria querida
De Escobedo y Zaragoza
Al fin serás noble y grande
Y allí serás victoriosa.

Anáhuac, vergel de flores,
Tierra de heróica bravura;
Seas próspera y felíz
En una época futura.

Terminen ¡oh! Patria hermosa
Tus desdichas y tormentos,
Y florezcan aquí las artes,
Con la ciencia y los inventos.

Aquí terminan los versos,
De la lucha en la frontera,
Quiera el Cielo que termine,
En este país la guerra.

El jóven Trinidad Ríos
Infraganti fué encontrado,
Sacando clavos de rieles
Y en un poste fué ahorcado.

Fué triste su situación,
Lo que allí le sucedió,
Más por causar esos males
El mismo lo mereció.

Quedó colgado del poste
Y allí se quedó sin vida,
Escarmienten los que obran
Con cabeza enloquecida.

¡Oh jóven desventurado!
Que sufriste tal acción,
No fué tu suerte fatal,
Sino tu irreflección.

¡Oh tremenda desventura,
Tan jóven allí morir!;
Por eso debéis, amigos,
Aprender aquí á vivir.

Terminan aquí los versos,
La triste lamentación,
Del ahorcado, allí, en los postes,
De la Ciudad de Torreón.

IMPRENTA
DE A. VANEGAS
ARROYO,
2ª DE STA. TERESA,
NÚM. 43.
MÉXICO.— 1912.

85. Back of the sheet in Figure 84 with black-line print of hanged man by Posada.

86. *Rebel Hanged by Federals near Torreón*. News photograph by George Grantham Bain, 1912. Library of Congress, Prints and Photographs. Bain News Photo Service Collection.

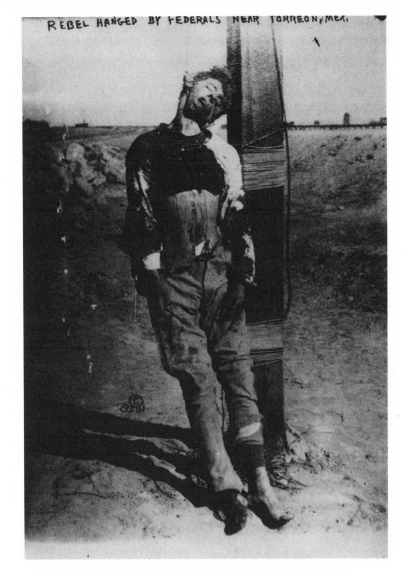

Land of *valientes* and heroes
And of generals very daring,
Don't spill any more blood
Of your brothers very caring.
The situation is frightening
Between enemies and foes;
Everyone bravely fighting,
As Mother Earth sees, and knows.

The illustration is a rather noncommittal combat scene that depicts uniformed soldiers grouped around a wagon. There is no hint of battle here, nor of the enemy, and indeed the plate could deal with almost any aspect of a military engagement. This is the first of several rather generic battle scenes that

The Coming of the Revolution 223

Posada created, probably at the request of Vanegas Arroyo when it began to seem that warfare would continue for some time; most of them have more action in them than this one. The Orozco revolt was finally put down in early July 1912 by forces under the command of General Victoriano Huerta, who would later turn against Madero.

The back of this sheet also contains a vivid illustration of a hanged man that contains telling information about the last phase of Posada's career (fig. 85). The overwhelming tragedy of this depiction goes well with the laments over the loss of peace described above, which are just to the right of the somewhat grisly picture. But it intends to tell the story of a solitary rebel who was caught attempting to cause train derailments by removing spikes from tracks near Torreón. His story is told in the six four-line stanzas immediately below the illustration. The execution of revolutionary justice apparently was swift, as he was immediately hung from one of the telegraph poles that frequently ran parallel to Mexican trains. As Tyler has shown, the source for this illustration was a news photograph which was probably published in Mexico City newspapers (fig. 86).[11] However, Posada took a few liberties with it. Rather than interpreting the subject according to his own artistic practices, as he had done in many other cases, here his alterations are minimal. In the photograph, the upper part of the torso is a fragmentary bloody garment, here suggested by parallel lines. Below in the photograph was bare skin and an exposed abdomen; Posada changed that, probably for puritanical reasons, so that the victim wears a rather baggy shirt. There was also a bandage on the exposed ankle in the photograph which Posada suppressed, but these are the only changes he introduced. Such matters as bodily proportions, use of space, and the sense of composition of this print are uncannily close to the original source. Moreover, this is the most fully dead figure that Posada ever drew; to speak quite literally, it hangs heavily. Thus the overall feeling of the print is quite similar to that of the photo, except that the covering of the belly makes it somewhat less horrifying. The fact that the image did not print in reverse of its source may indicate that Posada himself used some photomechanical means to make the plate.

Many artists in the European tradition made good use of photography—Edgar Degas and Thomas Eakins, for example, come immediately to mind—as a means of experimentation with composition or in the interests of accuracy of representation. Posada is not one of these artists. As we saw with the photograph of Jesús Negrete which had appeared three years earlier, he could introduce changes in his subjects and thus subtly reinterpret them; but near the end of his career they seem to have had a stultifying effect. If indeed his art is based on grasping and forcefully presenting the essential energies of a person or event, he was at his best when he was going beyond his sources in vividness and action. This was also noted in the case of the execution of Bruno Apresa, where he compressed and intensified the action in a newspaper drawing, and also in the depiction of Ponciano Díaz on horseback as it related to a Spanish popular print. But as he saw more and more photographs, his inspiration seems to have been blunted. If the diffusion of photography began to lead to a popular belief

87. *Zapata the Nuisance.* Back of a broadsheet with black-line illustration by Posada, 1912. Half Sheet. Amon Carter Museum. 1985.12

LA JERINGA
DE ZAPATA.

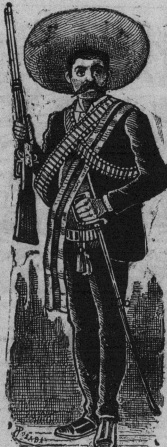

Amigo, ¡cuanta jeringa
De Zapata y zapatismo!
Mas, desde que comenzó
Parece seguir lo mismo.

Es un pretexto, parece,
Para robar, y robar,
De aquellos a quienes gusta
Al prójimo despojar.

En un ranchito cualquiera
Nomás con ¡Viva Zapata!
Cualquiera lo que le gusta
Sin más, ni más, arrebata.

Y se muestran orgullosos
Sin distinción de caballos,
Y cuando ya son algunos
Se estiran como los gallos.

Y se oyen los tamborazos,
Le dan fuerte al zapateado:
Y al ver a los federales
Huyen del fuego graneado,

Son valientes, con los ricos,
Cuando los ven sin defensa,
Por eso llegan de pronto
Cuando ninguno lo piensa.

Y se juntan....y se juntan
Que donde quiera hay bandidos
Y como son sin conciencia.
Son justamente temidos.

¡Pobre gente! ¡Pobre gente!
No sabe lo que le espera,
Anda sufriendo y robando
Para que pronto se muera.

Se necesita tener
La cabeza de *chiluca*
A fin de no comprender
Lo que esa gente se busca.

El gobierno constituido
Castiga tarde o temprano
Y hay que ver al zapatista
Solo cual mal mexicano.

El zapatismo es lo peor,
Es la semilla mas mala:
Para cada cabecilla
El castigo es una bala.

Si sabes, amigo, díme.
¿Que pasará en verdad?
¡Amo a mi patria querida,
Su honor y su libertad!

¡Amigo, amigo! ¿qué pasa
Con Emiliano Zapata,
Que el Estado de Morelos
Por poco ya no le aguanta?

Al principio lo querían
Por ser antiporfirista;
Pero se ha convertido
En un monstruo Zapatista.

Los zapatistas querían
Hacerlo dueño y señor
De aquellos pueblos del Sur
En donde son el terror.

Son como fieras que rugen
Cuando no hacen de las suyas
Roban y matan por gusto,
Y amantes son de las *buyas.*

Que triste es recordar
Lo que hacen los zapatistas
Que no tienen compasión
De niños ni señoritas.

¡Pobre Estado de Morelos,
Cuanto ahora has sufrido
Con esos cuantos salvajes
Que maldición solo han sido!

En los pequeños poblados
Haciendas y rancherías,
Han hecho derramar lágrimas.
Con todas sus fechorías.

Han incendiado los bosques
Y los campos desolado,
Honras y vida y dinero:
Cuanto han podido, han robado

Más, la justicia vendrá
Y todos esos bandidos
Acabarán con su jefe......
Jefe de los foragidos.

Ya la Nación ya no quiere
Que siga ese bandidaje,
Y no lo dudes, amigo,
De pensarlo dá coraje.

¡Que muera y muera Zapata!
Es grito de indignación,
Todos queremos la paz
¡Muera la revolución!

Ahora, vamos a darle,
A darle que es mole de olla.
Al fin Zapata está léjos......
¡Sino aquí nos *apergolla!*

IMPRENTA
2a.
De la Penitenciaría
Nº 29.
—=MEXICO=—

that the "camera does not lie," and that a photograph is a bearer of unprec-
edented truth, then Posada's talents for dramatization and for capturing *élan
vital* began to become irrelevant. Increasingly, he could not figure out how to
reinfuse with energy the photographic medium. It is as if he saw the photo-
graph as presenting life itself, and at this stage of his career he got out of its
way rather than add his own conception to it.

A similar thing happened when Posada was asked to make a portrait of
Emiliano Zapata (fig. 87). This plate was based on a news photograph by
Agustín Casasola which was widely reproduced.[12] The background behind the
revolutionary was suppressed, and the angle of the figure slightly adjusted to
face more forward, but other than that, the two are practically identical. The
broadsheet on which this plate was used presented a quite hostile attitude
toward the agrarian leader, and it is only one of several which roundly criticized
his movement. The heading refers to him as "a nuisance," and the text to
Zapatismo as only "a pretext to rob and rob." Accusing his partisans of bandit-
ry, useless violence, and cruelty to women and children, it calls for extreme
measures to defeat him:

Zapatismo is the very worst,
His men are only bad seeds;
The only punishment that they merit is
A bullet each for their deeds.

At the time this sheet was produced, Mexico City newspapers viewed Zapata
primarily as a bandit and a threat to public order, creating a great deal of bias
against him and his cause. The newspapers took this view partly because his
movement favored more indigenous forms of landholding such as communal
terrains known as *ejidos,* a form of tenure that was often categorized as back-
ward. Zapata's rebels also often carried out raids and robberies against the most
oppressive landlords, fomenting a class war that seemed antithetical to the cru-
sade of the more patrician and idealistic Madero. In addition, most of Zapata's
followers were less well educated and had more indigenous blood, another fac-
tor that encouraged the establishment as well as Maderistas to relegate their
demands to secondary importance. Provisional President de la Barra, for exam-
ple, said that he found it "truly unpleasant to deal with an individual with such
a background," and worked to hinder rather than encourage communication
between Madero and Zapata.[13] While at the beginning of Madero's campaign
southward toward the capital he referred to Zapata as his "Irreplaceable
General," communication between them eventually broke down and mistrust
arose. If Vanegas Arroyo were basing his opinion of Zapata on newspaper
accounts, many of these were false or exaggerated; seemingly random acts of
violence were attributed to Zapata's followers, with little or no investigation.[14]

In any case, Posada's depiction does not look nearly as unfavorable as that
presented in the text. To be sure, the revolutionary is armed to the teeth, but he
looks clean and alert, perhaps more virile than menacing. Any negative impres-

sion created by the sheet is at least as likely to come from the word "nuisance" in the headline than from the plate itself. If the headline instead read "Guardian of the People's Rights," for example, this illustration would work as well. The fact that Zapata wears a sash under the ammunition belt even indicates some sort of official status or title, though it is unclear what this might be. If Posada were editorializing on the character of Zapata, however, this was accomplished in the selection of the photograph, rather than in its treatment under his hands.

The breakdown in trust between Madero and Zapata was only one of the problems that the new President faced once the Orozco revolt was put down. In October 1912, Félix Díaz, Don Porfirio's nephew, rose up in revolt in Veracruz under a frankly restorationist banner. No broadsheet on this matter has survived, perhaps because of the family connection to the exiled dictator, but perhaps also because the insurrection was snuffed out in a matter of days, before it threatened Mexico City. Díaz was imprisoned in the Penitentiary of the Capital because Madero, as was the case previously in the Orozco revolt and in the capture of Ciudad Juárez, refused to execute his enemies. Despite these victories, however, "By the end of 1912," said one historian, "Madero found himself politically alone."[15] His sensitive temperament, patrician ways, and regard for procedure over decisive action alienated him from most potential allies.

Early the next year, Madero's final tragic act unfolded. On February 9, General Manuel Mondragón rose in revolt with the avowed purpose of liberating Félix Díaz and Bernardo Reyes, another old enemy of Madero. His successful attack on the capital led to the beginning of the Ten Tragic Days, in which hundreds of Mexico City residents lost their lives each day in urban warfare between the rebels and the allegedly loyal General Victoriano Huerta, who had earlier crushed the uprising of Orozco. However, it soon became clear that Huerta was secretly negotiating with Díaz and Mondragón behind the artillery barrages. With the active collaboration of American ambassador Henry Lane Wilson, Madero and Vice President José María Pino Suárez were arrested and taken to the Penitentiary. On the night of February 22, Madero and Pino Suárez were assassinated near the prison, allegedly killed in the crossfire of an attempt to free them. Colonel of Rurales Francisco Cárdenas, who was coincidentally the man credited with killing Santanón two and a half years before, dispatched Madero. Huerta was declared President.[16]

The broadsheets on these events make use of recycled plates to illustrate them, because Posada did not live that long. He had passed away three weeks before, the victim, according to his death certificate, of "acute alcoholic enteritis." The barrels of tequila that he reportedly kept in his house finally got the better of him. Since he did not leave enough money behind to pay for his own funeral, he was buried in a pauper's grave.

POSADA'S
REDISCOVERY

Posada enjoyed meager personal fame during his lifetime, and for at least ten years following his death he remained similarly unsung. The Vanegas Arroyo shop continued to function during the revolution much as it had before, with the exception that recycled plates were used for the bulk of its releases. The shop was forced to move across the street in late 1913, because the archaeologist Manuel Gamio began to unearth the ruins of the Aztec Great Temple near the shop's basement. Founder Antonio Vanegas Arroyo died in 1917, leaving the business to his son. Blas Vanegas Arroyo recalled that there were many sheets produced about revolutionary figures such as Orozco, Zapata, Huerta, and others. But, as they had done before, the owners of the enterprise thought first of prosperity and sales, rather than of influencing the chaotic course of events. Beyond a certain respect for whoever happened to be in power at the moment, there was little consistency to the positions the broadsheets took. Blas recalled issuing sheets with revolutionary themes that shifted with the political tides:

> We made corrido sheets, first for the partisans of Zapata, then for Carranza, then for Villa; also for González, Gutiérrez, and whomever. . . . It was natural that we should do it that way, because when some were not in power in the Capital, others were. Yet we were still subject to all kinds of tribulations, victims of whoever was there at the moment. . . . I served several prison sentences.[1]

So the shop was deeply enmeshed in the conflict, though in its own unique and non-partisan way. In 1920, in accordance with Mexican law, Posada's remains were unearthed to make room for those of wealthier patrons. Since

no family members came forward to claim the engraver's bones, they were mixed with others and reinterred in a common grave.

The decade of the 1920s, however, witnessed the birth of his reputation as one of Mexico's great artists. The popular spirit of Posada's art seemed to dovetail nicely with the agenda of the burgeoning mural movement, and Posada's merits were touted most loudly during that decade by muralists and other artists who saw themselves as working for "the people." In addition, Posada seemed to stand, as the revolution itself had, for values that were native and Mexican and popular over those that were foreign and elitist. In succeeding years, others have seen him in different ways, from pioneer Surrealist to recorder of Mexican life. In the early days of the recrudescence of his reputation, several visions of Posada competed for attention. Some of these were the product of non-Mexican minds; all of them have a grain of truth. The multifarious nature of his output, coupled with the desire of observers of Posada's plates to see themselves reflected in them, makes him difficult to pin down, and at the same time makes any assertion suspect.

For example, of the two muralists who claimed to have known or seen Posada, Rivera and Orozco, the account of José Clemente Orozco has far greater credibility. He recalled that as a boy on his way to primary school he passed Posada's shop four times a day, and would stop and observe the printmaker at work. Occasionally he risked entrance: "Sometimes I dared to enter the shop to spirit off some of the metal shavings which came from the path of the master's burin as it ran over the metal plate which he had painted with red lead." He testified that Posada was partly responsible for his early interest in art: "This was the first jolt which awakened my imagination, and led me to scribble on paper my first outlines; the first revelation to me of the existence of the art of painting."[2] Later, in the Academy of San Carlos, Orozco was never academically inclined as a student, but gravitated rather toward the more unconventional teaching of Gerardo Murillo, who is better known by his nickname Dr. Atl. Orozco's first studio, established in 1912, was located in the red-light district, and a great many of his early works depicted scenes in that neighborhood, a fact which may indicate his predilection for the sort of street-based art that Posada also produced. But we know little about this phase of Orozco's work, since most of it was confiscated and destroyed as immoral by customs agents when he crossed the border into the United States for the first time in 1917.

The fragmentary recollections of Orozco are inconclusive, but the stories told by Diego Rivera are completely spurious, although they contain sincere appreciation for the engraver. "The most important of my teachers," Rivera said of Posada in a way that suggests that the two had many intimate conversations: "He knew as much about form and movement as any man I have ever met. It was he who revealed to me the inherent beauty in the Mexican people, their struggle and aspirations. And it was he who taught me the supreme lesson of all art: that nothing can be expressed except through the force of feeling, that the soul of every masterpiece is powerful emotion."[3] Even though Posada

had been a teacher of lithography in his earlier career in León, the notion that he could have revealed such things to a student strains credibility. No one else has claimed any such interaction with the man. And this is the same Rivera who claimed to have been slashed on the back of the neck by a cavalryman's sword during his alleged participation in the Río Blanco textile mill strike of 1906, and to have plotted to assassinate Porfirio Díaz on 20 November 1910 as the first echoes of the Puebla gunfire were still resounding in the capital. When someone later expressed doubt as to the origins of the sword wound, Rivera said that a lover in Paris had tried to kill him by stabbing him in exactly the same place, so it was probably difficult to tell the two wounds apart!

This would not be the end of Posada's "role" in Rivera's life, however. He said that Posada had helped to arrange an exhibition of Rivera's work, in what would also have been the only such intervention by Posada in an artist's career. Later, when the muralist was in Paris trying to recover from his bout with Cubism and work his way back home, he told a story that amounted to a practical visitation by the engraver's spirit that changed his life. Rivera was apparently wandering the streets disconsolate one day when he came upon a cart of peaches, a sight that hit him with "unbelievable force." He returned immediately to his studio to begin experimenting with alternatives to modern art styles: "The beginning proved painful and tedious. In the process of tearing myself away from cubism, I met with repeated failures. But I did not give up. It was as if an invisible force was pushing me onward. During the worst hours, I would find comfort in the precept of my old Mexican tutor, Posada, to paint what I knew and felt. And I realized that what I knew best and felt most was my own country, Mexico."[4] In 1946 Rivera pictured Posada in one of his large murals, *Dream of a Sunday Afternoon in Alameda Park.*

Now Rivera did in fact know Posada's work, and he may have learned from it some of the lessons that he claimed to have received. His appreciation for Posada's "form and movement," for example, are consistent with an examination of the broadsheets. But this acquaintance almost certainly happened in the early or middle twenties, and it probably came through the intermediary of the French immigrant and fellow muralist Jean Charlot, who is probably most responsible for the "rediscovery" of Posada.

Of Mexican descent on his mother's side, Charlot arrived in Mexico in 1921, just as the mural movement was beginning under the leadership of José Vasconcelos, the new Secretary of Education in the post-revolutionary regime of Álvaro Obregón. Charlot brought with him socialist beliefs inherited from a father who was a Bolshevik sympathizer, which, coupled with an appreciation of popular arts manifested by his collection of *Images d'Epinal,* led him at some point to seek out the Vanegas Arroyo shop and become acquainted with its managers. This exploration almost certainly took place while Charlot, Rivera, Orozco, David Alfaro Siqueiros, and others were at work on their first large-scale mural projects, which involved decorating the walls of the National Preparatory School. Charlot's sympathy for popular arts led him to see strong

similarities between Posada's art and what the muralists were doing, and it was Charlot who first wrote about Posada as a forerunner of the Mexican mural movement.[5]

While there are indeed similarities between the goals of the muralists and those of Posada, the project of the mural painters was far more ambitious. Taking in the entire sweep of Mexican history, the muralists hoped to capture on walls the "cosmic spirit" of the Mexican people. Such, at least, was the hope of Vasconcelos with his somewhat Hegelian ideas. He stipulated little of the subject matter for the artists he engaged; he instead trusted them to produce organically visual evidence of the history and destiny of the Mexican totality as they each conceived it. In projecting this vision, the muralists reached both into the past and into Mexico's indigenous cultures. Charlot's first mural, for example, dealt with Cortéz's conquest of Tenochtitlán. Rivera painted a complex but vague allegorical mural titled *Creation* that depicted various Mexican types, some of them angels with halos, below a celestial symbol which is labeled "THE LIGHT ONE or PRIMAL ENERGY." Clearly Posada's art, with its urban and relentlessly contemporary character, had no room for such metaphorical perorations.

Yet there were similarities between the two projects, and in the next few years these became increasingly obvious to the Mexican artists as they saw that Posada's popular art already evidenced some of their avowedly socialist and Marxist goals. With the encouragement of President Obregón, many of the mural painters organized themselves in 1923 into the Syndicate of Technical Workers, Painters, and Sculptors and issued a manifesto that read in part:

> We reject so-called Salon painting. . . . We believe that any work of art which is alien or contrary to popular taste is bourgeois and should disappear because it perverts the aesthetic of our race. . . . We believe that while our society is in a transitional stage between the destruction of an old order and the introduction of a new order, the creators of beauty must turn their work into clear ideological propaganda for the people . . .[6]

A strong indigenist bias in the manifesto—which claimed that the now-oppressed native cultures, which had been collectively organized in their heyday—represented the "true Mexico" in opposition to the imported bourgeois capitalism against which the revolution had seemingly struggled and triumphed.

The manifesto was first published in 1924 in the newsletter *El Machete,* which became the official organ of the union.[7] The same year witnessed a crisis in both the mural movement and in the struggle to preserve Posada's memory. That fall, angry students at the Preparatory School vandalized several of the murals in a riot, claiming that they were immoral and inappropriate for an educational institution. The Syndicate protested to the government its lack of willingness to protect the physical safety of the art works, and by the end of the year Vasconcelos, feeling that his ability to support the muralists had become compromised, resigned and canceled all existing mural contracts. The Posada legacy

was also subjected to violence in that year. In June, the Vanegas Arroyo shop was likewise vandalized, this time by minions of a capital city political leader who was piqued by some recent sheets. Blas recalled that the raiders "smashed to bits everything in the store, knocking down even the walls."[8] Probably about half of the existing plates by Posada were lost.

Over the next few years, however, the first publications on Posada appeared. These laid the groundwork for the major split in opinion on the legacy of Posada: Was he merely "the people's artist" who recorded everyday life with its varied textures, or was he "precursor to the Revolution" who looked forward to the fall of Díaz and anticipated many positions that became dogma after 1917? In a representative sampling of earlier essays and books, both positions can be noted, sometimes even in the same document.

The editorial group of the magazine *Mexican Folkways* was the first to disseminate Posada's name and work among a more literate audience that straddled the U.S.–Mexico border. Besides Charlot, the editorial board consisted of Diego Rivera and the American expatriates Anita Brenner and Frances Toor. Beginning in 1926, this bilingual and irregularly-issued journal contained articles on "typical" Mexican folk arts such as pottery and mat-making, traditional medicine, and popular religion. In each issue appeared a restrike of a Posada plate, helpfully supplied by the Vanegas Arroyo shop. In 1928 a complete number was devoted to Posada's work, which included an essay by Toor and perhaps thirty plates reset in new type and struck on colored tissue paper.

Toor's essay shows clearly the rather rudimentary state of knowledge of Posada prevalent in those days. It stated both the wrong place and date of Posada's birth, claiming that he was born in León in 1864, rather than Aguascalientes in 1852. Toor also thought that Posada died in 1916, a date three years too late. Both erroneous dates she later attributed to Blas Vanegas Arroyo. Following the lead of Charlot, Toor held that Posada's art was a forerunner of the mural movement:

> It is less than a decade ago that the artists of the modern movement began to find their subjects and inspiration in the people—their every day life, their struggle for a better social orden [*sic*]—in short, the Indians and the Revolution. . . . Long before this modern movement started, Guadalupe Posada had the same conception of the function of art. He worked alone and unrecognized, yet he was the greatest artist produced by the Revolution.

Besides blending the goals of the muralists with those of Posada, Toor holds that Posada gave voice to many revolutionary stirrings. Indeed, she regarded the engraver as the chronicler of the conflict:

> His engravings crystallize all the stirring events of those days: the inevitable struggle of the middle class against feudalism and the reaction of the masses to politics, sport, miracles, crime, the parasitic church and budding imperialism.[9]

Only about half of the claims made here can be substantiated from the evidence of broadsheets. As to sport, miracles, and crime, she is on the firmest ground; certainly Posada dealt repeatedly with these subjects. But Posada had little sympathy for the middle class, and scorned it on many occasions; the sheets that he illustrated generally supported popular religion, and are in no sense anti-clerical; "budding imperialism" was a subject of only one sheet (*El Mosquito Americano*), and that was only an oblique attack. Her sympathy for the mural movement as the visual embodiment of the ideals of the revolution led her to recruit Posada for the cause in a way that does not square with what can be now reconstructed. It is true that Posada did many more explicit political works in magazines such as *El Hijo del Ahuizote* and *El Diablito Rojo,* but this aspect of his output was entirely unknown at that time. Part of the problem may be that Toor attributed revolutionary zeal to Posada because she was under the mistaken impression that he had lived through much more of the revolution than he actually did.

Two years later, the *Mexican Folkways* team produced the first book on Posada, which, besides being the most complete compendium of Posada's works to be published for the next thirty years, was significantly better in other respects.[10] Toor's brief new essay corrected the birth and death dates, claiming that the information came from a nephew of the printmaker. She mentioned his working for anti-Díaz periodicals, but reproduced none of that work. With the cooperation of Blas Vanegas Arroyo, mural painter Pablo O'Higgins collected all of the then available broadsheet metal plates and restruck them. The two-hundred-page book contained about twice that many illustrations, all without text. The titles given to some of them are erroneous, mislabeling bandits and a few celebrated criminal cases, but the volume of the work is unprecedented for the view it afforded of Posada's output. (Also included were four or five works that have since been held on stylistic grounds to be not by Posada.) The principal essay, by Diego Rivera this time, holds to the standard line on Posada as forerunner of the revolution, but also introduces new appreciations for Posada as recorder of Mexican life. Rivera claimed that Posada was "as great as Goya or Callot, an inexhaustible and rich creator." He was "interpreter of the sorrows, the happiness and the anguished aspirations of the Mexican people." He referred to Posada as "illustrator of stories and legends, songs and prayers of the poor people; a tenacious, mocking, and ferocious combatant; good as gold and full of fun." On the other hand, Rivera alleged that Posada was the precursor of the revolutionary Flores Magón brothers, Zapata, and Santanón, who "hurled the sharpest invective at the exploiters." He also knowledgeably praised Posada for certain technical achievements. His balancing of light and dark, "the inflection of line and proportion," and Posada's compositions, which were "strangely dynamic." Perhaps Rivera's most balanced assessment of Posada came near the close of the essay. If we think of Posada's depictions of the executions of common murderers, and contrast them with how Posada treated the character Don Chepito Mariguano, then Rivera's statement has a great deal of credibility:

His sharp graver spared neither rich nor poor. To the latter he showed their weaknesses with sympathy, and to the others, with each engraving he threw into their faces the vitriol that bit the metal on which Posada created his work.

Rivera omitted his claim to have studied with Posada in his youth, but Toor alluded to that item of Mexican folklore in her essay, so perhaps it was unnecessary to repeat it.

Anita Brenner, a friend of Charlot and Orozco who had worked with the *Folkways* group on the magazine, took the next step by discussing Posada in a book released by an American publisher. In her study of Mexican native arts, which was published in the same year as the *Monografía,* she included a chapter on Posada that retained the errors of the earlier special issue while holding to the Posada-as-precursor motif. Indeed the section on Posada, which compares him with Daumier, was entitled "Posada the Prophet." After describing the Francophile elite of those days with its "strong hangover of bibelot from the time of Maximilian," in a too-long sentence she explained her point:

> One may call Posada a prophet because he breaks sharply with the past, on the strength of the social philosophy and attitude which determined his position, his occupation, the choice of his subjects and the manner of portrayal; which links him with the revolution by mob, and the revolution on painted walls.[11]

How Posada broke with the past may be seriously debated. It seems rather that he depicted in a compelling way many cultural forms that had existed for a long time, and not only in Mexico. The arrival of the revolution and the vindication of popular taste that resulted from it emboldened Brenner to see Posada as prophet. Using the metaphor from the Old Testament story of Belshazzar's feast in which a debauched party is interrupted by the horrifying sight of the proverbial handwriting on the wall, Brenner made Díaz's Mexico into the party, and Posada into the prophet who "protested, foreboded, and with a full heart scribbled on a corner of the national slate a *mene, mene, tekel upharsin.*" This is truly a compelling analogy, which, except perhaps for the prints that satirize the middle class, surely goes too far.

The arrival of André Breton in Mexico City in February 1938 added another dimension to the Posada myth, one that had little to do with the engraver's Mexican nationality but was eminently palatable to European and American tastes, and indeed brought him into the mainstream of Modern Art. After seeing Posada's work (probably shown him by Rivera), Breton wrote in a Surrealist magazine that Posada was, in two-dimensional art, the "first and greatest practitioner" of *l'humor noir.* His brief paragraph accompanied a half dozen illustrations:

> The triumph of humor in its pure and manifest state, on the plastic plane, seems to be necessarily situated at a nearer time, and to recognize its first and greatest practitioner in the Mexican artist José Guadalupe Posada, whose

admirable wood engravings, destined for the masses, make us aware of every turn in the 1910 revolution. (The shadows of Villa and Fierro[?], concurrently with these compositions, interrogate, in a Mexico whose splendid funeral toys affirm it to be the chosen country of black humor, what can be the transition from speculative to active humor.)[12]

How Breton could have concluded that Posada was the harbinger of the revolution is left unsaid, but we may assume that he was exposed to this idea by the circles he frequented in the capital. The six works reproduced, all restrikes with no original text, show no evidence of revolutionary proclivities. Three are in the "sensational news" category: an earthquake, a collision of an electric trolley with a funeral cart, and a man hung from a stair railing. The remaining works contain errors. Two, for example, are plainly not by Posada: one is the rather well-known hairy insect with tail and skull face that is usually titled *Calavera Huertista* (*Skeleton of Huerta*), now generally rejected on stylistic grounds but attributed to Posada in Frances Toor's *Monografía;* the second is a temptation of St. Anthony in which devils shoot a cannon at the body of the saint, a work that looks much more medieval than Mexican. The third error is in the title of a print of a woman committing suicide by jumping from a church belfry. Its label, "Marie-Louise, la Suicidée," probably refers to María Luisa Noeker, who, as we know, killed herself with a pistol in 1910. Such was the information that Breton provided to fellow Surrealists.

If the plates presented do not attest to Posada's revolutionary sentiments, they partially support the concept of Posada as pioneer of black humor, an assertion that contains a real grain of truth when applied to other works by the artist. Breton's paragraph on Posada eventually appeared verbatim in 1940 in the introduction to his *Anthology of Black Humor* as part of a discussion of humor in visual art. Immediately preceding the mention of Posada, Breton pointed out that the incidence of black humor "will be noted more often in poetry, for example, than in painting," because humor in visual art has generally not avoided the pitfalls of mere caricature on the one hand, and moralizing satire on the other. Here he mentions Hogarth and Goya, probably thinking of the latter's social critiques in his series *Los Caprichos*. He then proceeds to define black humor by quoting at length some (uncited) writings of Freud, including the famous example of the story of the man led to the gallows on a Monday morning who, while ascending the steps, sighed, "What a way to begin the week." For Freud, this form of humor is a defense against terrible and implacable fate. It is the "victorious assertion of the ego's invulnerability. The ego refuses to be distressed by the provocations of reality, to let itself be compelled to suffer. It insists that it cannot be affected by the traumas of the external world; it shows, in fact, that such traumas are no more than occasions for it to gain pleasure."[13] The prints that Breton adduces to support his claim in *Minotaure* do not in fact give as clear evidence of the presence of black humor as do some of Posada's other *calaveras,* prints that depict dead persons come to life as vigorously active skeletons. In the work dealing with the arrival of electric trolleys at the

cemetery, for example (see fig. 70), the fears of the Mexico City populace about the trolleys' connections to possible diabolical forces are made light of, turned on their heads. Since the electric trolley cars are coming to the graveyard, then the spirits of the dead will simply be that much more active, and musicians at the Day of the Dead party can play on electric instruments. The other problem made light of in that work is the political defeat handed to tradition-minded Mexicans by the law that extended the rail lines. The march of tradition is seen as implacable as death itself, and if we laugh at both, the print seems to say, we can at least keep our egos intact if not our moral sense and political hopes. In the political realm, this resort to black humor on the part of marginalized urban classes thus promoted not revolution but stoical, adamant, cynical endurance.

Such were the boosts that launched Posada's posthumous career as a canonical Mexican artist. Such were the somewhat shaky foundations on which much accepted opinion on Posada is based. Such were the needs that Posada's art responded to. This book has added to the cacophony by offering its own version of the artist. As to which represents the "true Posada," that question remains as open as it ever was; indeed, with a creator of such vast and varied output, it may never be settled. Many other assertions about him could probably be shown to be partially correct. In that rather postmodern sense, as Jean Charlot said in another connection, "Guadalupe Posada now transcends time."[14]

NOTES

Introduction

1. Salvador Díaz Mirón, "Al Buen Cura," *Poesías Completas* (Mexico, D.F.: Porrúa, 1958), 317–20.

2. Mural painter Diego Rivera maintained that Posada produced fifteen thousand works. Others claim up to twenty thousand. I regard these numbers as too high to be believable. Perhaps one tenth of the higher count has survived, and there are no strong leads for finding a great many more. Yet even with two thousand plates to his credit, Posada is still a highly prolific creator.

3. This biographical data is based primarily on a typescript in the Museo Nacional de la Estampa, Mexico City.

4. See, for example, Ron Tyler, ed., *Posada's Mexico* (Washington, D.C.: Library of Congress, 1979); Jean Charlot, *Posada's Dance of Death* (New York: Pratt Graphic Art Center, 1964); Carlos Macazaga Ramírez de Arellano, ed., *Las Calaveras Vivientes de Posada*, 2nd Edition (Mexico, D.F.: Editorial Cosmes, 1977); and J. Rothenstein, ed., *Posada, Messenger of Mortality* (London: Redstone, 1989).

5. Helen MacGill, *News and the Human Interest Story* (Chicago: University of Chicago Press, 1940), xx.

6. Manilla's work has never been studied in detail, perhaps because far fewer sheets have survived than metal plates. See Manuel Manilla, *330 Grabados Originales* (Mexico, D.F.: Editorial La Catrina, 1971), for a large representative sample.

7. Occasionally, Posada remade plates with only subtle variations, a fact that has led at least one researcher to conclude that he first drew his designs on white scraperboard and transferred them to the metal plate by photomechanical means. The "original" could then be altered by reworking certain regions of the drawing and rephotographing it. See Thomas Gretton, "Posada's Prints as Photomechanical Artifacts," *Print Quarterly* 9 (December 1992): 335–56. While this is a plausible explanation of those plates (which are few in number), it is impossible to verify, and has certain problems associated with it. First, none of these alleged drawings has survived. Second, the conclusion was reached

by examining surviving Posada plates in the Library of Congress, a collection that contains many reworked and stereotyped copies of plates. So while I have doubts as to this thesis, I am unable to offer a better explanation. The points in this book, however, do not depend on an exact determination of his techniques.

8. Most of this information was gathered by Jean Charlot and Anita Brenner in the latter's book *Idols Behind Altars* (New York: Payson and Clarke, 1929).

9. Héctor Olea, *Supervivencia del Litógrafo José Guadalupe Posada* (Mexico, D.F.: Editorial Araña, 1963), 38.

10. The best accounts of battles between the Díaz regime and journalists can be found in Daniel Cosío Villegas, *Historia Moderna de México. El Porfiriato. Vida Política. Segunda Parte* (Mexico, D.F.: Hermes, 1972). The present example is on p. 544.

11. José López Portillo y Rojas, *Elevación y Caída de Porfirio Díaz* (Mexico, D.F.: Librería Española, 1921), 342.

12. Blas Vanegas Arroyo, quoted in Rafael Mendívil, "Bienaventurados los Vanegas Arroyo," *Todo,* 15 July 1943, 29ff.

13. Jean-Pierre Seguin, *Canards du Siecle Passé* (Paris: Pierre Horay, 1969), n.p.

14. Blas Vanegas Arroyo, "Antonio Vanegas Arroyo y su Época," *El Gallo Ilustrado: Suplemento Dominical de 'El Dia,'* (9 March 1980): 7.

15. On the influence of Spain on the Mexican corrido, see Vicente T. Mendoza, ed., *El Romance Español y el Corrido Mexicano* (Mexico, D.F.: Universidad Nacional Autónoma, 1939).

16. The best source for Spanish *romance* is Julio Caro Baroja, *Ensayo Sobre la Literatura de Cordel* (Madrid: Revista de Occidente, 1969).

17. Henri Bergson, *Creative Evolution,* trans. Arthur Mitchell. In Charles Harrison and Paul Wood, eds., *Art in Theory, 1900–1990* (London: Blackstone, 1994), 141.

18. Ibid.

19. José Lezama Lima, *La Expresión Americana* (1957); *Obras Completas* (Mexico, D.F.: Aguilar, 1977), II: 348.

20. Ibid., 360.

Chapter One

1. One such case dealt with a criminal who was trying diligently to improve himself by learning cabinetmaking in the Belén prison woodworking shop. He apparently built an armoire with a false bottom, hid in it, and effected a successful escape when furniture movers carried out the deed for him. A Vanegas Arroyo broadsheet on this subject is mentioned in a newspaper account, but the sheet remains unlocated.

2. Miguel S. Macedo, *La Criminalidad en México: Métodos de Combatirla* (Mexico, D.F.: Tipografía de la Secretaría de Fomento, 1897), 5, 6.

3. Ibid., 22, 23.

4. Julio Guerrero, *La Génesis del Crimen en México* (Paris: Ch. Bouret, 1901), 33–34.

5. Ibid., 125.

6. Ibid., 108.

7. Ibid., 154.

8. Ibid., 231.

9. Ibid., 235.

10. Ibid., 232–33.

11. Chart, "Consignaciones en la Ciudad de México," in Macedo, *Criminalidad en México,* 41.

12. "El Pasado y el Presente de la Cárcel de Belén," *Universal Gráfico* 5 (5 July 1927): 5.

13. This broken plate is in the collection of the Posada Museum in Aguascalientes, Mexico.

14. "La Bejarano en Libertad," *El Imparcial,* 28 June 1899.

15. The discussion of the social function of sensationalism is informed by the following books: David Ray Papke, *Framing the Criminal: Crime, Cultural Work, and the Loss of Critical Perspective* (Hamden, Conn: Archon Books, 1987); Dan Schiller, *Objectivity and the News: The Public and the Rise of Commercial Journalism* (Philadelphia: University of Pennsylvania Press, 1981); Michael Schudson, *Discovering the News* (New York: Basic Books, 1978). In Spanish, see Julio Caro Baroja, *Ensayo Sobre la Literatura de Cordel* (Madrid: Revista de Occidente, 1969); Carlos Monsiváis, *Los Mil y Un Velorios: Crónica de la Nota Roja* (Mexico, D.F.: Editorial Patria, 1994).

16. Papke, *Framing the Criminal,* 29.

17. Anita Brenner, *Idols Behind Altars* (New York: Biblo and Tannen, 1967), 194.

18. "Escandaloso Suceso en un Hotel," *El Imparcial,* 28 February 1899.

Chapter Two

1. Rafael Ruiz Harrell, "La Ciudad y el Crimen," *Reforma,* 30 May 1995, 13.

2. "Monosabio" (Carlos Quirós), *Mis 20 Años de Torero: El Libro Íntimo de Gaona* (Mexico, D.F.: Biblioteca Popular de El Universal, 1925), 97.

3. The statistics in this paragraph come from Miguel S. Macedo, *La Criminalidad en México: Métodos de Combatirla* (Mexico, D.F.: Tipografía de la Secretaría de Fomento, 1897), 41–42.

4. Ibid., 11.

5. Ibid., 19. Macedo did not consider the relative numbers of persons in each social class, which probably would have altered considerably his estimation. Also, the way in which crimes were defined, and apprehensions made for their violation, tended to intensify the focus on lower order offenders.

6. John Laurence Rohlfes, "Police and Penal Correction in Mexico City, 1876–1911," (Ph. D. diss., Tulane University, 1983), 172–73. The quotes are from the leading opposition newspaper *Diario del Hogar.*

7. Amado Nervo, "El Gendarme," *Obras Completas* (Madrid: Aguilar, 1951) I:614. Originally appeared as "Fuegos Fátuos" in *El Imparcial,* 10 July 1896.

8. Rohlfes, "Police and Penal Correction," 268, 277.

9. "Rateros y Cruzadoras," *El Imparcial,* 12 June 1908.

10. Rohlfes, "Police and Penal Correction," 249, 258.

11. This example supports the belief that Posada occasionally used photomechanical means to create his plates. See Thomas Gretton, "Posada's Prints as Photomechanical Artifacts," *Print Quarterly* 9 (December 1992): 334–56.

12. Rohlfes, "Police and Penal Correction," 253–58.

13. "El Enganche de Trabajadores," *El Imparcial,* 29 June 1899.

14. Carlo de Fornaro, *México Tal Cual Es* (Philadelphia: International Publishing Company, 1909), 87.

15. The 1877 and 1896 figures are from Macedo, *Criminalidad en México,* 45; the 1905 figure is from Rohlfes, "Police and Penal Correction," 204.

16. Guillermo Mellado, "La Vieja Cárcel de Belén," *La Prensa,* 27 July 1930, Revista Dominical.

17. "El Pasado y El Presente de la Cárcel de Belén," *Universal Gráfico,* 19 May 1927, 8.

18. "El Pasado y el Presente de la Cárcel de Belén," *Universal Gráfico,* 28 May 1927, 16.

19. Rohlfes, "Police and Penal Correction," 222.

20. "La Tragedia de Belén," *Diario del Hogar,* 27 October 1910.

21. On the rise of scientific penology during the Díaz years, see Robert Buffington, "Forging the Fatherland: Criminality and Citizenship in Modern Mexico," (Ph.D. diss., University of Arizona, 1994).

22. José María Romero, *La Penitenciaría,* Segunda edición (Mexico, D.F.: F. Díaz de León, 1892), 3–4. See also Robert Buffington, "Revolutionary Reform: The Mexican Revolution and the Discourse on Prison Reform," *Mexican Studies/Estudios Mexicanos* 9 (Winter 1993): 71–93.

23. Buffington, "Revolutionary Reform," 23.

24. "En la Cárcel de Belén," *El Imparcial,* 4 October 1900.

25. Rohlfes, "Police and Penal Correction," 312–13.

26. Quoted in Rohlfes, "Police and Penal Correction," 317.

27. Ibid., 320.

28. Carlos Roumagnac, "Mis Recuerdos de Belén," *El Nacional,* 16 July 1933, Sección Dominical.

29. "El Fusilamiento de Rosalío Millán," *El Imparcial,* 9 March 1906.

30. Circulation figures were given each day on page one for the previous day's editions.

31. "Fusilamiento de un Reo Militar," *El Imparcial,* 29 April 1904.

32. Ibid.

33. "La Ejecución de Bruno Apresa," *El Imparcial,* 30 April 1904.

34. This sheet is in the Jean Charlot Collection, University of Hawaii Library.

35. See, for example, among many others: Salvador Quevedo y Zubieta, *La Camada* (Mexico, D.F.: Librería de Ch. Bouret, 1912); Fornaro, *México Tal Cual Es,* 70–79; Daniel Cosío Villegas, *Historia Moderna de México. El Porfiriato: Vida Política Interior: Segunda Parte* (Mexico, D.F.: Hermes, 1972), 683–88; Eduardo Villagran, "La Voz del Agora: El Fuero y el Crimen en la Epoca del Gral. Porfirio Díaz," *Ultimas Noticias,* 4 November 1938; Juan Manuel Torrea, "El Asesinato de Arnulfo Arroyo," *Universal Gráfico,* 5 June 1932 and 12 June 1932; Alonso Gutiérrez, "¿Velázquez se Suicidó?" *Nosotros,* 22 September 1956.

36. Rodolfo Reyes, "Capítulos Trepidantes de la Historia de México: Un Crimen de la Policía," pt. 5, *Atisbos,* 21 June 1958, 10.

37. "Cómo Nació en México la Policía Secreta en Tiempos de Don Porfirio," *Universal Gráfico,* 2 March 1926, 12.

38. Reyes, "Capítulos Trepidantes de la Historia de México: Un Crimen de la Policía," pt. 4, *Atisbos,* 17 June 1958, 10.

39. Reyes, "Capítulos Trepidantes de la Historia de México," pt. 7, *Atisbos,* 26 June 1958, 6.

40. Rohlfes, "Police and Penal Correction," 116.

Chapter Three

1. Federico Gamboa, *Reconquista,* Segunda Edición (Mexico, D.F.: Botas, 1937), 92.

2. Ibid., 336.

3. Carlos González Peña, *La Fuga de la Quimera,* Segunda Edición (Mexico, D.F.: Stylo, 1949), 31.

4. Francisco Gutiérrez Nájera, *El Gavilán* (Mexico, D.F., 1939), 142.

5. See, for example, Peter Burke, *Popular Culture in Early Modern Europe* (New York: New York University Press, 1979).

6. Julio Caro Baroja, *Ensayo Sobre la Literatura de Cordel* (Madrid: Revista de Occidente, 1969), 164–66.

7. Gutiérrez Nájera, *El Gavilán,* 142.

8. For a comparison with a similar American rural boastful type, see Elliott J. Gorn, "Gouge and Bite, Pull Hair and Scratch: The Social Significance of Fighting in the Southern Backcountry," *American Historical Review* 90 (February 1985): 18–43.

9. In the first-act discussion between Don Diego and Don Juan.

10. In the hero's first soliloquy in the third act.

11. José López Portillo y Rojas, *Fuertes y Débiles* (Mexico, D.F.: Librería Española, not dated).

12. "Tipos del Boulevard: Los Valientes," *El Imparcial,* 27 June 1899.

13. Armando Morales Puente, "Historia de un Lagartijo," *La Prensa,* 16 October 1941, Magazin Dominical.

14. "De Macario Romero," in Vicente Mendoza, *El Romance Español y el Corrido Mexicano* (Mexico, D.F.: Universidad Nacional Autónoma, 1939), 436.

15. Ibid.

16. Romero's grandnephew reported this to Vicente Mendoza, in *Romance Español y Corrido Mexicano,* 441.

17. Merle E. Simmons, *The Mexican Corrido as a Source for the Interpretive Study of Modern Mexico, 1870–1950* (Bloomington: Indiana University Press, 1957), 43–44.

18. Posada made the horse black for reasons that have to do with pictorial composition. It is easy to imagine the print being far less successful with a historically more accurate grayish mount.

19. José Vasconcelos, *Ulises Criollo: La Vida del Autor Escrita por El Mismo,* Novena Edición (Mexico D.F.: Botas, 1945), 291.

Chapter Four

1. Eric Hobsbawm, *Bandits,* Revised Edition (New York: Pantheon, 1981), 56.

2. This discussion of Spanish bandits is informed by the following two books: Julio Caro Baroja, *Ensayo Sobre la Literatura de Cordel* (Madrid: Revista de Occidente, 1969), and Constancio Bernardo de Quirós, *El Bandolerismo en España y en México* (Mexico, D.F.: Edit. Jurídica Mexicana, 1959).

3. This meeting is described in Chapters 60 and 61 in Part II of *Don Quixote.*

4. Lope de Vega is responsible for only the first two acts of this play, which was finished by Lanini Sagredo.

5. Lope de Vega, *Antonio Roca, o La Muerte Más Venturosa,* Act II, in *Obras de Lope de Vega* (Madrid: Real Academia Española, 1916) I:680–81.

6. John S. Brushwood, *Mexico in Its Novel* (Austin: University of Texas Press, 1966), 82.

7. Ignacio Altamirano, *El Zarco* (Mexico, D.F.: Editorial J. Ballesca, 1901), 82–83.

8. Manuel Payno, *Los Bandidos de Río Frío* (San Antonio, Texas: Editorial Lozano, 1920), 646.

9. Francisco J. Santamaría, *Diccionario de Mejicanismos* (Mexico, D.F.: Porrúa, 1959), 541.

10. Moisés González Navarro, *Historia Moderna de México: El Porfiriato, Vida Social* (Mexico, D.F.: Hermes, 1957), 156.

11. Vicente T. Mendoza, ed., "De Valentín Mancera," in *El Romance Español y el Corrido Mexicano* (Mexico, D.F.: Universidad Nacional Autónoma, 1939), 501.

12. This summary of the deeds of Bernal is based on the following sources: Fausto Marín Tamayo, *Aquí Está Heraclio Bernal* (Culiacán: Universidad Autónoma de Sinaloa, 1988); Mario Gill, "Heraclio Bernal, Caudillo Frustrado," *Historia Mexicana* 4 (July 1954): 138–58; Paul Vanderwood, *Disorder and Progress: Bandits, Police, and Mexican Development* (Lincoln: University of Nebraska Press, 1981); Nicole Girón, *Heraclio Bernal, ¿Bandolero, Cacique, o Precursor de la Revolución?* (Mexico, D.F.: Secretaría de Educación Pública, 1976).

13. Gill, "Heraclio Bernal, Caudillo Frustrado," 149.

14. Ibid., 139.

15. Ruth Finnegan, *Oral Poetry: Its Nature, Significance, and Social Context* (London: Cambridge University Press, 1977), 12.

16. At least four feature films and numerous television specials have been made on Bernal; corridos about him continue to be sung to the present day.

17. A second sheet on Bernal (Jean Charlot Collection, University of Hawaii) was released with an illustration by Posada, but it is a very curious product with an unusually florid border and many factual inaccuracies. The text seems corrupt and meandering. The title misspells his first name; the corrido lists the reward as five hundred thousand pesos, says that it went to a General Ogazán, and says that Bernal committed suicide; none of this is true. The illustration was not made for the Bernal story, and depicts from behind a campesino being led away by a semicircle of rurales. Perhaps it was hastily put together to counteract some of the "bad effects" of the overtly pro-Bernal sheet illustrated by Manilla, thus to recoup some of the good graces of General Díaz's police. The sheet is undated, but both the type style of the headline and the address at the bottom correspond with other sheets produced between 1910 and 1913, and thus it may date from after the fall of Díaz or even Posada's death.

18. See, for example, *Otra Versión de Ignacio Parra,* in Antonio Avitia Hernández, *Corridos de Durango* (Mexico, D.F.: Instituto Nacional de Antropología e Historia, 1989), 41.

19. In 1903, 1905, and 1911; the fourth version is an undated sheet, with slightly different type styles, in the Library of Congress.

20. Vanderwood, *Disorder and Progress,* 88.

21. Amado Nervo, "La Semana, Sept. 24, 1899," in *Obras Completas* (Madrid: Aguilar, 1951), 1:991.

22. Daniel Cosío Villegas, *Historia Moderna de México. El Porfiriato. Vida Política. Segunda Parte* (Mexico, D.F.: Hermes, 1972), 248.

23. The best sources on Santanón are: Jacinto Barrera Bassols, *El Bardo y el Bandolero* (Puebla, Mexico: Universidad Autónoma, 1987); Vanderwood, *Disorder and Progress,* 94–95 (though this source is too trusting of newspaper accounts); and Bernardo de Quirós, *El Bandolerismo en España y en México.*

24. Quoted in Barrera Bassols, *El Bardo y el Bandolero,* 55–56.

25. Angel Escudero, *El Duelo en México* (Mexico, D.F.: Imprenta Mundial, 1936), 203.

26. "El Terrible Bandido Santanón Murió al Fin Acribillado de Balazos," *El Imparcial,* 19 October 1910.

27. "¿Ha Muerto Santanón?," *Diario del Hogar,* 21 October 1910.

28. "Cómo Nació en México la Policía Secreta en Tiempos de Don Porfirio," *Universal Gráfico,* 2 March 1926.

29. "Recordando los Crímenes Celebres," *Universal Gráfico,* 4 March 1926.

30. The "sad lament of the criminal" was already a recognizable genre of poetry in French broadsheet literature, a type which I believe influenced Vanegas Arroyo. At this early stage of the development of broadsheet culture in Mexico, however, it does not seem that the style had been firmly set. For more on the French sheets, see Michel

Foucault, *I Pierre Riviere, Having Slaughtered my Mother, my Sister, and my Brother . . .*, trans. Frank Jellinek (Lincoln: University of Nebraska Press, 1975).

31. Broadsheet, *Ultimas Noticias de Nevraumont y Compañeros,* 1891. Illustrated in *Fondo Editorial de la Plástica Mexicana* (Mexico, D.F.: F.E.P.M., 1992), 266.

32. "El Pasado y el Presente de la Cárcel de Belén," Pt. II, *Universal Gráfico,* 28 May 1927.

33. "Recordando los Crímenes Celebres," *Universal Gráfico,* 4 March 1926.

34. "Jesús Negrete: Un Balance de sus Crímenes," *El Imparcial,* 2 June 1908.

35. "Ya Sé que Acabaré en el Jardín;" *El Imparcial,* 2 June 1908.

36. The best sources on Negrete's life are the newspaper accounts of his trial and sentencing. In addition see Carlos Isla, *El Tigre de Santa Julia* (Mexico, D.F.: Universo, 1980). The latter is a novel, but it seems to be based on a reliable skeleton of historical fact.

37. John Laurence Rohlfes, "Police and Penal Correction in Mexico City, 1876–1911" (Ph.D. diss., Tulane University, 1983), 82.

38. William H. Beezley, *Judas at the Jockey Club and Other Episodes of Porfirian Mexico* (Lincoln: University of Nebraska Press, 1987), 115.

39. This sheet is in the Jean Charlot Collection, University of Hawaii, and of the Colorado Springs Fine Art Center.

40. To this day in Mexico a person may be compared to El Tigre de Santa Julia if he spends a long time in the bathroom. I am indebted to Alicia Lozano for pointing this out to me.

41. "Los Defensores de Negrete," *El Imparcial,* 3 June 1908.

42. "El Jurado del 'Tigre de Santa Julia'," *El Imparcial,* 12 June 1908, and "Llegamos al Último Acto del Sensacional Jurado," *El Imparcial,* 13 June 1908.

43. "Las Últimas Horas de Vida de un Gran Culpable," *El Imparcial,* 22 December 1910.

44. Ibid.

45. The version of the poem in the broadsheet is different in certain words from what was published in *El Imparcial* (see note above for location). The differences are not substantial, and I have tried to steer a middle course between them.

46. Salvador Díaz Mirón, "Consumatum," *Prosa,* ed. Leonardo Pasquel (Mexico, D.F.: Talleres Gráficos de la Nación, 1954), 210.

Chapter Five

1. Amado Nervo, "La Semana: Primera Serie, 15 January 1898," in *Obras Completas* (Madrid: Aguilar, 1951), 1:717.

2. Julio Caro Baroja, *Ensayo Sobre la Literatura de Cordel* (Madrid: Revista de Occidente, 1969), 223.

3. Vanegas Arroyo published a chapbook of such rhymed dedications.

4. Most of the sources that I cite on Ponciano Díaz and Luis Mazzantini also contain information on Zamora. See also the biographical entry on Zamora in José María de Cossío, *Los Toros: Tratado Técnico e Histórico,* vol. 4 (Madrid: Espasa-Calipe, 1961, 1971).

5. Posada also made many illustrations of bulls and bullfighting for various Mexico City magazines. I have analyzed some of these in "El Toreo en los Grabados de Posada," *Goya: Revista de Arte* 244 (Madrid, January 1995): 206–11.

6. This chapbook, called *Galería del Teatro Infantil: Una Corrida de Toros o el Amor de Luisa,* is in the collections of Colorado Springs Fine Arts Center and Jean Charlot Collection, University of Hawaii.

7. The best sources on Ponciano Díaz are Manuel Horta, *Ponciano Díaz: Silueta de un Torero de Ayer* (Mexico, D.F.: Imprenta Aldina, 1943), and Armando de María y Campos, *Ponciano: El Torero con Bigotes* (Mexico, D.F.: Xochitl, 1943).

8. José María de Cossío, *Los Toros,* 4:154.

9. Horta, *Ponciano Díaz,* 125–26.

10. Armando de María y Campos, *Ponciano,* 150–58.

11. Ibid., 162–63.

12. "Los Triunfos y Brindis de Ponciano en España," collection Colorado Springs Fine Arts Center.

13. Armando de María y Campos, *Ponciano,* 200.

14. On Segura, see "Flamenquillo," "Vicente Segura, El Torero Señorito," *Novedades,* 5 October 1947.

15. Enrique Guarner, *Historia del Toreo en México* (Mexico, D.F.: Editorial Diana, 1979), 98.

16. This sheet is in the collections of Colorado Springs Fine Arts Center and Jean Charlot Collection, University of Hawaii.

17. Frances Toor, ed., *Monografía: Las Obras de José Guadalupe Posada* (Mexico, D.F.: Talleres Gráficos de la Nacion, 1930), 143.

18. Guarner, *Historia del Toreo,* 105.

19. For biographical data on Gaona, see Lauro Treviño, *Rodolfo Gaona: Gloria Nacional* (Mexico, D.F.: SEI, 1975); also "Monosabio" (Carlos Quirós), *Mis 20 Años de Torero: El Libro Intimo de Gaona* (Mexico, D.F.: Biblioteca Popular de El Universal, 1925) is a dictated autobiography.

20. "Monosabio," *Mis 20 Años,* 30.

21. Ibid., 73.

22. Quoted in Treviño, *Rodolfo Gaona,* 20.

23. "Monosabio," *Mis 20 Años,* 62.

24. María Luisa Garza, *Los Amores de Gaona* (San Antonio, Texas: Art Advertising Co. 1922), 30–39.

25. "Monosabio," *Mis 20 Años,* 120, 125.

26. *El Heraldo,* 12 May 1909.

27. This sheet is in the Jean Charlot Collection, University of Hawaii.

28. This sheet, *Cancionero Popular Num. 5,* is in the collection of Colorado Springs Fine Arts Center.

29. "Monosabio," *Mis 20 Años,* 84.

30. Ibid., 99.

31. The following citations come from news stories, all unsigned, on the front page of *El Imparcial* between 4 December and 20 December 1909.

32. "Nuestra Actitud en el Asunto Gaona," *El Imparcial,* 14 December 1909.

33. "R. Gaona a Disposición de la Justicia Federal," *El Imparcial,* 19 December 1909.

34. "El Asunto Gaona," *El Heraldo de México,* 6 December 1909, and 17 December 1909.

35. "Una Joven Alemana Se Arrancó la Existencia," *El Pais,* 4 December 1909, and "La Sociedad No Quiere Un Simulacro de Justicia," *El Pais,* 9 December 1909.

36. "Monosabio," *Mis 20 Años,* 98.

37. Ibid.

38. Porfirio Parra, *Pacotillas* (Mexico, D.F., 1900). The main character, for whom the novel is named, becomes involved in opposition journalism and pays with his life. The novel, by an author who knew the territory, illustrates clearly the machinations that often occurred in Díaz era press relations.

39. "¡Nos Confesamos Vencidos! . . . " *El Imparcial,* 20 December 1909.

40. Treviño, *Rodolfo Gaona,* 55.

41. The event is discussed in "Monosabio," *Mis 20 Años,* 330, and Treviño, *Rodolfo Gaona,* 172.

Chapter Six

1. José E. Iturriaga, *La Estructura Social y Cultural de México* (Mexico, D.F.: Fondo de Cultura Económica, 1951), quoted in Moisés González Navarro, *Historia Moderna de México: El Porfiriato, Vida Social* (Mexico, D.F.: Hermes, 1957), 387.

2. González Navarro, *Historia Moderna,* 183.

3. Jesús Zavala, "Antonio Vanegas Arroyo," *El Nacional,* 3 October 1948, 5.

4. "Juvenal," "Los Lagartijos," *El Imparcial,* 22 June 1899.

5. Manuel Payno, *Los Bandidos del Río Frío* (San Antonio, Texas: Editorial Lozano, 1920), 77.

6. José Vasconcelos, *Ulises Criollo: La Vida del Autor Escrita por El Mismo,* Novena Edición (Mexico, D.F.: Botas, 1945), 203, 220, 221.

7. José C. Valadés, "Cómo Vivía la Ciudad de México en el Fin del Siglo en el Porfiriato," *Novedades,* Sección Dominical, 13 June 1943, 1–2.

8. Vasconcelos, *Ulises Criollo,* 309, 310.

9. Federico Gamboa, *Reconquista;* Segunda Edición (Mexico, D.F.: Botas, 1937), 321, 322, 325–26.

10. Quoted in Amado Nervo, "Mujeres y Bicicletas," in *Obras Completas* (Madrid: Aguilar, 1951), 1:503. Originally appeared in *El Mundo,* 26 November 1895.

11. Nervo, *Obras Completas,* 1:954. The statistic on numbers of bicycles is on p. 949.

12. Amado Nervo, "La Semana, Jan. 21, 1900," in *Obras Completas,* 1:1039.

13. Jorge Joseph, "Los Tranvías en México; Su Historia y Sus Problemas," *Hoy,* 21 January 1945, 64.

14. The electric trolleys in Brooklyn, New York were similarly plagued, forcing pedestrians to frequently jump out of the way of the oncoming vehicles. This caused the city's first professional baseball team to be named the Brooklyn Dodgers.

15. Moisés González Navarro, *Historia Moderna de México: El Porfiriato, Vida Social* (Mexico, D.F.: Hermes, 1957), 695.

16. In the Jean Charlot Collection, University of Hawaii.

17. González Navarro, *Historia Moderna,* 131.

18. Carlo de Fornaro, *México Tal Cual Es* (Philadelphia: International Publishing Co., 1909), 88.

19. Francisco Castillo Nájera, *El Gavilán* (Mexico, D.F.: Editorial México Nuevo, 1939), 33–34.

20. Rubén M. Campos, *El Folklore Literario de México* (Mexico, D.F.: S.E.P., 1929), 52–53.

21. Howard P. Vincent, *Daumier and His World* (Evanston, Ill.: Northwestern University Press, 1968), 72.

22. *Los Ciento Uno Roberto Macario* (Mexico, D.F.: Editorial Lara, 1860). This work is mentioned in Manuel Toussaint, *La Litografía en Mexico en el Siglo XIX* (Mexico, D.F.: Estudios Neolito M. Quesada, 1934), xx.

23. I am indebted to Lic. Ricardo Pérez Escamilla for pointing this figure out to me. She is illustrated in Fondo Editorial de la Plástica Mexicana, *José Guadalupe Posada, Ilustrador de la Vida Mexicana* (Mexico, D.F.: F.E.P.M., 1992), 452.

24. José López Portillo y Rojas, *Fuertes y Débiles* (Mexico, D.F.: Librería Española, 1919), 296.

25. William H. Beezley, *Judas at the Jockey Club and Other Episodes of Porfirian Mexico* (Lincoln: University of Nebraska Press, 1987), 33–35.

26. The sheet, titled *Gran Corrido de Los Indios Mayas con el 28 Batallón,* is in the collection of Amon Carter Art Museum.

Chapter Seven

1. James Creelman, "President Díaz, Hero of the Americas," *Pearson's Magazine,* March 1908.

2. Charles C. Cumberland, *The Mexican Revolution: Genesis Under Madero* (Austin: University of Texas Press, 1952), 99.

3. Enrique Krauze, *Místico de la Libertad: Francisco I. Madero* (Mexico, D.F.: Fondo de Cultura Económica, 1987), 46.

4. The best sources on the house raid are: Ignacio Herrería, *Sucesos Sangrientos de Puebla* (Mexico, D.F.: Biblioteca "La Ilustración," 1911), a thorough and nearly contemporary account; Gustavo Casasola, *Seis Siglos de Historia Gráfica de México* (Mexico, D.F.: Editorial Gustavo Casasola, 1968), 203–8; and Porfirio del Castillo, *Puebla y Tlaxcala en los Días de la Revolución* (Mexico, D.F.: Unknown, 1956). In addition, the Serdán house in Puebla is now a museum of the revolution.

5. Herrerías, *Sucesos Sangrientos,* 9.

6. Both items are illustrated in Casasola, *Historia Gráfica,* 208. The "funeral announcement" is also described in Herrerías, *Sucesos Sangrientos,* 31.

7. Cumberland, *Mexican Revolution: Genesis,* 144.

8. This sheet, titled "Canciones Populares Maderistas," is in the collection of Colorado Springs Fine Arts Center.

9. Jorge Vera Estañol, *La Revolución Mexicana: Orígenes y Resultados* (Mexico, D.F.: Porrúa, 1957), 222.

10. This sheet, called *La Vuelta del Desterrado* (The Exile's Return) is in the Library of Congress, Prints and Photographs division. It is also illustrated in Ron Tyler, *Posada's Mexico* (Washington, D.C.: Library of Congress, 1979), 243.

11. Tyler, *Posada's Mexico,* 249.

12. For example, in Tyler, *Posada's Mexico,* 254.

13. Krauze, *Místico de la Libertad,* 71.

14. See Cumberland, *Mexican Revolution: Genesis,* 172–85.

15. Krauze, *Místico de la Libertad,* 85.

16. The standard account of these events is still Michael C. Meyer, *Huerta: A Political Portrait* (Lincoln: University of Nebraska Press, 1972).

Chapter Eight

1. Blas Vanegas Arroyo, quoted in Rafael Mendívil, "Bienaventurados los Vanegas Arroyo," *Todo,* 15 July 1943, 29ff.

2. José Clemente Orozco, *Autobiografía* (Mexico, D.F.: Ediciones Occidente, 1945), 10.

3. Diego Rivera, *My Art, My Life: An Autobiography* (New York: Dover, 1991), 18.

4. Ibid., 67. The stories of the assassination plot, the exhibition, and the sword wound(s) are also in this autobiography.

5. Jean Charlot, "Un Precursor del Movimiento de Arte Mexicano," *Revista de Revistas,* August 1925.

6. *Manifesto of the Syndicate of Technical Workers, Painters, and Sculptors, 1923.* In Dawn Ades, *Art in Latin America: The Modern Era, 1820–1980* (New Haven: Yale University Press, 1989), 324.

7. For more on this paper, see Alicia Azuela, "El Machete and Frente a Frente: Art Committed to Social Justice in Mexico," *Art Journal* 52 (Spring 1993): 82–87.

8. Mendívil, "Bienaventurados los Vanegas Arroyo," 29.

9. Frances Toor, "Guadalupe Posada," *Mexican Folkways* 3 (July 1928): 140.

10. *José Guadalupe Posada, Monografía,* with an introduction by Diego Rivera, edited by Frances Toor, Paul O'Higgins, and Blas Vanegas Arroyo (Mexico, D.F.: Mexican Folkways, 1930; reprinted 1991 by Ediciones Toledo), not paginated.

11. Anita Brenner, *Idols Behind Altars* (New York: Payson and Clarke, 1929; reprinted New York: Biblo and Tannen, 1967), 190–92.

12. The paragraph originally appeared as "Bois de Posada" in *Minotaure* No. 10 (1938), 18–19. This translation is from André Breton, *Anthology of Black Humor* (excerpts), in *What is Surrealism? Selected Writings of André Breton,* trans. Stephen Schwartz, ed. Franklin Rosemont (New York: Pathfinder Press, 1978), 189.

13. Freud quoted by Breton in "The Lightning Rod," in the introduction to *Anthology of Black Humor,* ibid.

14. Jean Charlot, "Posada and His Successors," *Posada's Mexico,* ed. Ron Tyler (Washington, D.C.: Library of Congress, 1979), 57.

BIBLIOGRAPHY

Books

Ades, Dawn. *Art in Latin America: The Modern Era, 1820–1980*. New Haven: Yale University Press, 1989.

Altamirano, Ignacio. *El Zarco*. Mexico, D.F.: Editorial J. Ballesca, 1901.

Avitia Hernández, Antonio. *Corridos de Durango*. Mexico, D.F.: Instituto Nacional de Antropología e Historia, 1989.

Barrera Bassols, Jacinto. *El Bardo y el Bandolero*. Puebla: Universidad Autónoma, 1987.

Beezley, William H. *Judas at the Jockey Club and Other Episodes of Porfirian Mexico*. Lincoln: University of Nebraska Press, 1987.

Brenner, Anita. *Idols Behind Altars*. New York: Biblo and Tannen, 1967.

Breton, André. *What is Surrealism? Selected Writings of André Breton*. Translated by Stephen Schwartz. Edited by Franklin Rosemont. New York: Pathfinder Press, 1978.

Brushwood, John S. *Mexico in Its Novel*. Austin: University of Texas Press, 1966.

Burke, Peter. *Popular Culture in Early Modern Europe*. New York: New York University Press, 1979.

Campos, Rubén M. *El Folklore Literario de México*. Mexico, D.F.: Secretaría de Educación Pública, 1929.

Caro Baroja, Julio. *Ensayo Sobre la Literatura de Cordel*. Madrid: Revista de Occidente, 1969.

Charlot, Jean. *Posada's Dance of Death*. New York: Pratt Graphic Art Center, 1964.

Cosío Villegas, Daniel. *Historia Moderna de México: El Porfiriato. Vida Política. Segunda Parte*. Mexico, D.F.: Hermes, 1972.

Cossío, José María de. *Los Toros: Tratado Técnico e Histórico,* 4 vols. Madrid: Espasa-Calipe, 1961, 1971.

Díaz Mirón, Salvador. *Poesías Completas*. Mexico, D.F.: Porrúa, 1958.

———. *Prosa*. Edited by Leonardo Pasquel. Mexico, D.F.: Talleres Gráficos de la Nación, 1954.

Escudero, Angel. *El Duelo en México*. Mexico, D.F.: Imprenta Mundial, 1936.

Finnegan, Ruth. *Oral Poetry: Its Nature, Significance, and Social Context*. London: Cambridge University Press, 1977.

Fondo Editorial de la Plástica Mexicana. *José Guadalupe Posada, Ilustrador de la Vida Mexicana*. Mexico, D.F.: F.E.P.M., 1992.

Fornaro, Carlo de. *México Tal Cual Es*. Philadelphia: International Publishing Company, 1909.

Foucault, Michel. *I Pierre Riviere, Having Slaughtered my Mother, my Sister, and my Brother* Translated by Frank Jellinek. Lincoln: University of Nebraska Press, 1975.

Gamboa, Federico. *Reconquista;* Segunda Edición. Mexico, D.F.: Botas, 1937.

Garza, María Luisa. *Los Amores de Gaona*. San Antonio, Texas: Art Advertising Co. 1922.

Girón, Nicole. *Heraclio Bernal: ¿Bandolero, Cacique, o Precursor de la Revolución?* Mexico, D.F.: Secretaría de Educación Pública, 1976.

González Navarro, Moisés. *Historia Moderna de México: El Porfiriato. Vida Social* (Mexico, D.F.: Hermes, 1957).

González Peña, Carlos. *La Fuga de la Quimera;* Segunda Edición. Mexico, D.F.: Stylo, 1949.

Guarner, Enrique. *Historia del Toreo en México*. Mexico, D.F.: Editorial Diana, 1979.

Guerrero, Julio. *La Génesis del Crimen en México*. Paris: Ch. Bouret, 1901.

Gutiérrez Nájera, Francisco. *El Gavilán*. Mexico, D.F., 1939.

Harrison, Charles, and Paul Wood, eds. *Art in Theory, 1900–1990*. London: Blackstone, 1994.

Hobsbawm, Eric. *Bandits;* Revised Edition. New York: Pantheon, 1981.

Horta, Manuel. *Ponciano Díaz: Silueta de un Torero de Ayer*. Mexico, D.F.: Imprenta Aldina, 1943.

Isla, Carlos. *El Tigre de Santa Julia*. Mexico, D.F.: Universo, 1980.

Iturriaga, José E. *La Estructura Social y Cultural de México*. Mexico, D.F.: Fondo de Cultura Económica, 1951.

Lezama Lima, José. *La Expresión Americana* (1957); *Obras Completas*. Vol 2. Mexico, D.F.: Aguilar, 1977.

Lope de Vega, *Antonio Roca, o La Muerte Más Venturosa. Obras de Lope de Vega*. Madrid: Real Academia Española, 1916.

López Portillo y Rojas, José. *Fuertes y Débiles*. Mexico, D.F.: Librería Española, 1919.
——— . *Elevación y Caída de Porfirio Díaz*. Mexico, D.F.: Librería Española, 1921.

Macedo, Miguel S. *La Criminalidad en México: Métodos de Combatirla*. Mexico, D.F.: Tipografía de la Secretaría de Fomento, 1897.

MacGill, Helen. *News and the Human Interest Story*. Chicago: University of Chicago Press, 1940.

Manilla, Manuel. *330 Grabados Originales*. Mexico, D.F.: Editorial La Catrina, 1971.

María y Campos, Armando de. *Ponciano: El Torero con Bigotes*. Mexico, D.F.: Xochitl, 1943.

Marín Tamayo, Fausto. *Aquí Está Heraclio Bernal*. Culiacán: Universidad Autónoma de Sinaloa, 1988.

Mendoza, Vicente T., ed. *El Romance Español y el Corrido Mexicano*. Mexico, D.F.: Universidad Nacional Autónoma, 1939.

Monsiváis, Carlos. *Los Mil y Un Velorios: Crónica de la Nota Roja*. Mexico, D.F.: Editorial Patria, 1994.

Museo Nacional de Arte. *Nación de Imágenes: La Litografía en México del Siglo XIX*. Mexico, D.F.: Museo Nacional de Arte, 1994.

Nervo, Amado. *Obras Completas*. Madrid: Aguilar, 1951.

Olea, Héctor. *Supervivencia del Litógrafo José Guadalupe Posada*. Mexico, D.F.: Editorial Araña, 1963.

Orozco, José Clemente. *Autobiografía*. Mexico, D.F.: Ediciones Occidente, 1945.

Papke, David Ray. *Framing the Criminal: Crime, Cultural Work, and the Loss of Critical Perspective*. Hamden, Conn.: Archon Books, 1987.

Parra, Porfirio. *Pacotillas*. Mexico, D.F., 1900.

Payno, Manuel. *Los Bandidos de Río Frío*. San Antonio, Texas: Editorial Lozano, 1920.

Quevedo y Zubieta, Salvador. *La Camada*. Mexico, D.F.: Librería de Ch. Bouret, 1912.

Quirós, Carlos ["Monosabio"]. *Mis 20 Años de Torero: El Libro Íntimo de Gaona*. Mexico, D.F.: Biblioteca Popular de El Universal, 1925.

Quirós, Constancio Bernardo de. *El Bandolerismo en España y en México*. Mexico, D.F.: Edit. Jurídica Mexicana, 1959.

Ramírez de Arellano, Carlos Macazaga, ed. *Las Calaveras Vivientes de Posada*, 2nd Edition. Mexico, D.F.: Editorial Cosmes, 1977.

Rivera, Diego. *My Art, My Life: An Autobiography*. New York: Dover, 1991.

Romero, José María. *La Penitenciaría; Segunda Edición*. Mexico, D.F.: F. Díaz de León, 1892.

Rothenstein, James, ed. *Posada, Messenger of Mortality*. London: Redstone, 1989.

Santamaría, Francisco J. *Diccionario de Mejicanismos*. Mexico, D.F.: Porrúa, 1959.

Schiller, Dan. *Objectivity and the News: The Public and the Rise of Commercial Journalism*. Philadelphia: University of Pennsylvania Press, 1981.

Schudson, Michael. *Discovering the News*. New York: Basic Books, 1978.

Seguin, Jean-Pierre. *Canards du Siecle Passé*. Paris: Pierre Horay, 1969.

Simmons, Merle E. *The Mexican Corrido as a Source for the Interpretive Study of Modern Mexico, 1870–1950*. Bloomington: Indiana University Press, 1957.

Toor, Frances, ed. *Monografía. Las Obras de José Guadalupe Posada*. Mexico, D.F.: Talleres Gráficos de la Nación, 1930.

Toussaint, Manuel. *La Litografía en México en el Siglo XIX*. Mexico, D.F.: Estudios Neolito M. Quesada, 1934.

Treviño, Lauro. *Rodolfo Gaona: Gloria Nacional*. Mexico, D.F.: SEI, 1975.

Tyler, Ron, ed. *Posada's Mexico*. Washington, D.C.: Library of Congress, 1979.

Vanderwood, Paul. *Disorder and Progress: Bandits, Police, and Mexican Development*. Lincoln: University of Nebraska Press, 1981.

Vasconcelos, José. *Ulises Criollo: La Vida del Autor Escrita por El Mismo*. Novena Edición. Mexico, D.F.: Botas, 1945.

Vincent, Howard P. *Daumier and His World*. Evanston, Ill.: Northwestern University Press, 1968.

Articles and Unpublished Manuscripts

Azuela, Alicia. "*El Machete* and *Frente a Frente*: Art Committed to Social Justice in Mexico." *Art Journal* 52 (Spring 1993): 82–87.

Breton, André. "Bois de Posada." *Minotaure* No. 10 (1938): 18–19.

Buffington, Robert. "Forging the Fatherland: Criminality and Citizenship in Modern Mexico." Ph.D. diss., University of Arizona, 1994.

——— . "Revolutionary Reform: The Mexican Revolution and the Discourse on Prison Reform." *Mexican Studies/Estudios Mexicanos* 9 (Winter 1993): 71–93.

Charlot, Jean. "Un Precursor del Movimiento de Arte Mexicano." *Revista de Revistas*, August 1925.

Frank, Patrick. "El Toreo en los Grabados de Posada." *Goya: Revista de Arte* No. 244 (January 1995): 206–11.

Gill, Mario. "Heraclio Bernal, Caudillo Frustrado." *Historia Mexicana* 4 (July 1954): 138–58.

Gorn, Elliott J. "Gouge and Bite, Pull Hair and Scratch: The Social Significance of Fighting in the Southern Backcountry." *American Historical Review* 90 (February 1985): 18–43.

Gretton, Thomas. "Posada's Prints as Photomechanical Artefacts." *Print Quarterly* 9 (December 1992): 335–56.

Reyes, Rodolfo. "Capítulos Trepidantes de la Historia de México: Un Crimen de la Policía." Part 4: *Atisbos* (Mexico, D.F.), 17 June 1958, 10. Part 5: *Atisbos,* 21 June 1958, 10. Part 7: *Atisbos,* 26 June 1958, 6.

Rohlfes, John Laurence. "Police and Penal Correction in Mexico, D.F., 1876–1911." Ph. D. Diss., Tulane University, 1983.

Sáenz, Olga. "José Guadalupe Posada Entre Cometas y Terremotos." *Anales del Instituto de Investigaciones Estéticas* (Mexico, D.F.) vol. 14 n. 56 (1986): 205–21.

Toor, Frances. "Guadalupe Posada." *Mexican Folkways* 3 (July 1928): 140–50.

Newspapers

Chávarri, Enrique ["Juvenal"]. "Los Lagartijos." *El Imparcial* (Mexico, D.F.), 22 June 1899.

"Cómo Nació en México la Policía Secreta en Tiempos de Don Porfirio." *Universal Gráfico* (Mexico, D.F.), 2 March 1926.

"El Asunto Gaona." *El Heraldo de México* (Mexico, D.F.), 6 December 1909.

"El Enganche de Trabajadores." *El Imparcial* (Mexico, D.F.), 29 June 1899.

"El Fusilamiento de Rosalío Millán." *El Imparcial* (Mexico, D.F.), 9 March 1906.

"El Jurado del 'Tigre de Santa Julia'." *El Imparcial* (Mexico, D.F.), 12 June 1908.

"El Pasado y el Presente de la Cárcel de Belén." Part 1 *Universal Gráfico* (Mexico, D.F.), 19 May 1927. Part 2: 28 May 1927. Part 5: 5 July 1927.

"El Terrible Bandido Santanón Murió al Fin Acribillado de Balazos." *El Imparcial* (Mexico, D.F.), 19 October 1910.

"En la Cárcel de Belém [*sic*]." *El Imparcial* (Mexico, D.F.), 4 October 1900.

"Escandaloso Suceso en un Hotel." *El Imparcial* (Mexico, D.F.), 28 February 1899.

"Fusilamiento de un Reo Militar." *El Imparcial* (Mexico, D.F.), 29 April 1904.

Gutiérrez, Alonso. "¿Velázquez se Suicidó?" *Nosotros* (Mexico, D.F.), 22 September 1956.

"¿Ha Muerto Santanón?" *Diario del Hogar* (Mexico, D.F.), 21 October 1910.

"Jesús Negrete: Un Balance de sus Crímenes." *El Imparcial* (Mexico, D.F.), 2 June 1908.

Joseph, Jorge. "Los Tranvías en México; Su Historia y Sus Problemas." *Hoy* (Mexico, D.F.), 21 January 1945.

"La Bejarano en Libertad." *El Imparcial* (Mexico, D.F.), 28 June 1899.

"La Ejecución de Bruno Apresa." *El Imparcial* (Mexico, D.F.), 30 April 1904.

"La Sociedad No Quiere Un Simulacro de Justicia." *El Pais* (Mexico, D.F.), 9 December 1909.

"La Tragedia de Belém [*sic*]." *Diario del Hogar* (Mexico, D.F.), 27 October 1910.

"Las Últimas Horas de Vida de un Gran Culpable." *El Imparcial* (Mexico, D.F.), 22 December 1910.

"Llegamos al Último Acto del Sensacional Jurado." *El Imparcial* (Mexico, D.F.), 13 June 1908.

"Los Defensores de Negrete." *El Imparcial* (Mexico, D.F.), 3 June 1908.

Mellado, Guillermo. "La Vieja Cárcel de Belém [*sic*]." *La Prensa* (Mexico, D.F.), 27 July 1930, Revista Dominical.

Mendívil, Rafael. "Bienaventurados los Vanegas Arroyo." *Todo* (Mexico, D.F.), 15 July 1943.

Morales Puente, Armando. "Historia de un Lagartijo." *La Prensa* (Mexico, D.F.), 16 October 1941, Magazin Dominical.

Negrete, Jesús. "Ya Sé que Acabaré en el Jardin." *El Imparcial* (Mexico, D.F.), 2 June 1908.

"¡Nos Confesamos Vencidos! . . . " *El Imparcial* (Mexico, D.F.), 20 December 1909.

"Nuestra Actitud en el Asunto Gaona." *El Imparcial* (Mexico, D.F.), 14 December 1909.

"R. Gaona a Disposición de la Justicia Federal." *El Imparcial* (Mexico, D.F.), 19 December 1909.

"Rateros y Cruzadoras." *El Imparcial* (Mexico, D.F.), 12 June 1908.

"Recordando los Crímenes Celebres." *Universal Gráfico* (Mexico, D.F.), 4 March 1926.

Roumagnac, Carlos. "Mis Recuerdos de Belém [*sic*]." *El Nacional* (Mexico, D.F.), 16 July 1933, Sección Dominical.

Ruiz Harrell, Rafael. "La Ciudad y el Crimen." *Reforma* (Mexico, D.F.), 30 May 1995.

"Tipos del Boulevard: Los Valientes." *El Imparcial* (Mexico, D.F.), 27 June 1899.

Torrea, Juan Manuel. "El Asesinato de Arnulfo Arroyo." *Universal Gráfico* (Mexico, D.F.), 5 June and 12 June 1932.

"Una Joven Alemana Se Arrancó la Existencia." *El Pais* (Mexico, D.F.), 4 December 1909.

Valadés, José C. "Cómo Vivía la Ciudad de México en el Fin del Siglo en el Porfiriato." *Novedades* (Mexico, D.F.), 13 June 1943, Sección Dominical.

Vanegas Arroyo, Blas. "Antonio Vanegas Arroyo y su Época." *El Gallo Ilustrado: Suplemento Dominical de 'El Dia.'* (Mexico, D.F.), 9 March 1980.

"Vicente Segura, El Torero Señorito." *Novedades* (Mexico, D.F.), 5 October 1947.

Villagran, Eduardo. "La Voz del Agora: El Fuero y el Crimen en la Epoca del Gral. Porfirio Díaz." *Últimas Noticias* (Mexico, D.F.), 4 November 1938.

Zavala, Jesús. "Antonio Vanegas Arroyo." *El Nacional* (Mexico, D.F.), 3 October 1948.

INDEX